RECOVERING
BENJAMIN
FRANKLIN

RECOVERING BENJAMIN FRANKLIN

An Exploration of a Life of
Science and Service

JAMES CAMPBELL

OPEN COURT
CHICAGO AND LA SALLE, ILLINOIS

Selections from Benjamin Franklin's writings are reprinted with the permission of the Yale edition of *The Papers of Benjamin Franklin*, Leonard Labaree, William Willcox, and Barbara Oberg, *et al*., eds. (34 vols., New Haven: Yale University Press, 1959-).

Cover painting: Franklin, Benjamin, 1706–1790. Author, statesman, scientist, diplomat. Joseph Siffred Duplessis, 1725–1802. Oil on canvas, 72.4 × 59.6 cm. (28½ × 23½ in.), c.1785. NPG.87.43. National Portrait Gallery, Smithsonian Institution; Gift of the Morris and Gwendolyn Cafritz Foundation. Reproduced with permission.

To order books from Open Court, call toll-free 1-800-815-2280.

Open Court Publishing Company is a division of Carus Publishing Company.

Printed and bound in the United States of America.

Library of Congress Cataloging-in-Publication Data

Campbell, James, 1948–
 Recovering Benjamin Franklin : an exploration of a life of science and service / James Campbell.
 p. cm.
 Includes bibliographical references (p.) and index.
 ISBN 0-8126-9387-6 (pbk. : alk. paper). — ISBN 0-8126-9386-8 (cloth : alk. paper)
 1. Franklin, Benjamin, 1706–1790. 2. Statesmen—United States—Biography. 3. Scientists—United States—Biography. 4. Printers—Political and social views. I. Title.
E302.6.F8C227 1999
973.3′092—dc21
[B] 98-38063
 CIP

For Julie—
the road is steep but wondrous

Contents

Preface

In his *Pragmatism*, William James lays out a surprising ancestry for
what he calls his 'new name for some old ways of thinking.' He
suggests that, while Charles Sanders Peirce was the founder of the
modern Pragmatic movement, in some form or other Pragmatism
had been practiced by such seemingly diverse thinkers as Socrates,
Aristotle, Locke, Berkeley, Hume, and James Mill.[1] While James's
listing may accurately delineate the roots of the Pragmatic spirit that
he felt existed in the Western philosophical tradition, it fails to
explore any possible American roots. This listing thus fails to offer
any indication why Pragmatism flourished in America. As we at
present think more and more about the future direction of Pragma-
tism, and of American philosophy in general, in the twenty-first
century, and about how philosophical inquiry can function to
advance human well-being, it should be of value to examine more
carefully the American soil that supported the growth of Pragma-
tism.

 As we turn over this ground, newly uncovered roots will force us
to think more about the work of many figures of importance in the
American intellectual tradition. These were individuals who contrib-
uted to our realization—unfortunately, a realization that has had to
be again and again recovered—of such central facts as our essential

[1] Cf. James, *The Writings of William James*, 360, 363, 379. [Full bibliographical
information for all sources mentioned can be found in the list of works cited below.]

location within natural processes, the need for a focus upon experience, the role of possibility as we move into the future, and the ongoing importance of community. The names of these individuals, of course, are familiar; it is their place in the Pragmatic tradition that too often goes unrecognized. But, when we come to recognize what they contributed to the Pragmatic tradition, we will develop a better sense of the potential of this tradition and of who we might become.

To point to just one grouping of these thinkers, we can consider some figures born in in the decade of the 1810s. One such individual is Frederick Douglass (1818–1895), whose message was the equality of all members of the human race. Walt Whitman (1819–1892) is another, calling us to the recognition of the possible contributions of the lives of 'common' persons. Elizabeth Cady Stanton (1815–1902), who fought for the rights of women to contribute fully to the life of the community, is a third. Finally, we can point to Henry David Thoreau (1817–1862), who focussed new light on the need to draw out the particular value of our natural experience.

Surely, this partial listing of American thinkers who should be considered within the broad Pragmatic tradition is no more surprising than James's list. It is moreover, a partial listing that can be expanded at will. More recent figures come easily to mind; earlier ones, perhaps less so. About one figure, however, there can be no question. Benjamin Franklin, the subject of this study, was at the head of the Pragmatic tradition, working to advance human well-being through science and service.

This volume is thus an attempt to explore what H. S. Thayer calls the "nascent" pragmatism of Benjamin Franklin in order to discover the nature and value of his thought.[2] My work on Franklin has been simplified greatly by the ongoing Yale University edition of *The Papers of Benjamin Franklin* that began over four decades ago under the editorship of Leonard W. Labaree, and has continued under William B. Willcox and Barbara B. Oberg. I was repeatedly helped by Kate M. Ohno, the Editorial Assistant of the Franklin Papers project. My work has also been assisted generally by the staff of the Carlson Library of the University of Toledo, especially Joanne L. Hartough. I was also helped greatly by the American Philosophical Society, held in Philadelphia, for Promoting Useful Knowledge. The Society is one of those founded by Franklin, and it awarded me a Mellon

[2] Thayer, *Meaning and Action*, 7.

Resident Research Fellowship to use its magnificent resources. While there, and in the years since, I have benefitted from the generous help of Roy Goodman, the Society's Curator of Printed Materials. I would also like to thank Peter H. Hare, editor of the *Transactions of the Charles S. Peirce Society*, for publishing my essay, "The Pragmatism of Benjamin Franklin," from which this present volume has grown.

In writing this volume, I have attempted as much as possible to let Franklin speak for himself. While there are definite costs to this approach in terms of simplicity and precision, I believe that the benefits of hearing his tone and phrasing outweigh them. I have also included the comments of a large number of other thinkers, although I am not in agreement with all of them, to enable readers to get some sense of the richness of the commentary that Franklin has called forth. Overall, I hope that readers will come away with the recognition that Franklin was central to the growing democratic and practical conception of the pursuit of wisdom that Pragmatism is still working to advance.

CHAPTER 1

Introduction

In the *ALMANACK* for 1733, Benjamin Franklin's alter ego Poor Richard notes: "Men and Melons are hard to know" (1:316).[1] Anyone who has ever brought home a melon only to find that its taste did not measure up to expectations can verify how difficult it is to 'know' a melon; and, since our human fellows are far more complex than are melons and our expectations of the former are far higher than those of the latter, we can certify that humans are indeed 'hard to know' as well. The subject of this study was himself no exception. In this chapter, we will begin our attempt to recover Franklin with some indications of the complexity of the task. Next we will consider a survey of the events of his long and rich life. Finally, we will consider briefly a series of interpretations of the meaning and importance of his thought and work. Included among these will be my own interpretation, to be developed in the course of this volume, that Franklin should be seen as an essential figure in the history of American Philosophy. Specifically, I see him at the head of the tradition that we now call Pragmatism.

1.1. Approaching Benjamin Franklin

For a philosopher to approach a ubiquitous cultural icon like Benjamin Franklin with a claim of 'recovering' him requires initially some consideration of the role that he has played, and continues to

[1.] The writings of Benjamin Franklin will be cited when possible from the Yale University Press critical edition: *The Papers of Benjamin Franklin* (1959–), indicating volume and page number [for example, "(10:129)" for volume 10, page 129]. The *Autobiography* will be cited from this edition also, using an "A" in the place of a volume number [for example, "(A:129)"]. Material from those years not yet reached in the new edition will be cited from the Smyth edition of *The Writings of Benjamin Franklin* (1907) cited as "W" followed by the volume and page number [for example, "(W10:129)"]. Full bibliographical information for the sources mentioned can be found in the list of works cited below.

play, in American life. Franklin's is, after all, the face on the postwar 50¢ piece, on the $100 bill, and on any number of postage stamps. As Herbert Hoover has noted: "Millions of parents have striven to implant his qualities of character in their offspring by endowing them with the surname of Franklin."[2] As a glance at almost any American telephone book will attest, Franklin is our primary symbol of thrift and responsibility, chosen as the namesake for a substantial number of commercial endeavors in the areas of sales, banking, investment, and insurance. His labors as a printer have earned him a place as the patron saint of innumerable printing establishments; and his efforts to raise the educational level of society caused numerous high schools, colleges and other institutions of learning to appropriate his name. In addition, throughout America, numberless towns, counties, and even an ill-fated state have styled themselves 'Franklin.'[3] But does our familiarity with him in these various cultural roles really help us to understand Franklin the person any better?

I do not mean to suggest that these numerous roles are undeserved. Through his efforts in any number of areas of life, Franklin earned his place as a representative American. He was involved, it seems, in almost everything. One commentator points to Franklin's activities in "[p]rinting, commerce, public service, diplomacy, mathematics, meteorology, astronomy, geology, ethnology, education, physics, chemistry, agriculture, medicine, hygiene, navigation, aeronautics, cookery" and then reminds us that "this does not exhaust the long list of his activities."[4] The set of necessary additions would include music, journalism, economics, religion, and (as I hope to demonstrate) philosophy. Another commentator has called him "a foremost representative" and "a perfect symbol" of the "American way of life." In his own day, a third writes, he was "the most famous

[2] Hoover, "Benjamin Franklin," 81.

[3] The self-proclaimed 'state' of Franklin, now part of Tennessee, existed from 1784 to 1788. Cf. W9:534–35; W10:483–86; John Anthony Caruso, *The Appalachian Frontier*, 280–310; Samuel Cole Williams, *History of the Lost State of Franklin*.

[4] F. L. Lucas, *The Art of Living*, 207. The numerous celebratory essays in *The Amazing Benjamin Franklin*, ed. J. Henry Smythe, Jr., include such topics as: "Franklin and the Navy," "Franklin and Agriculture," "Franklin, the Philosopher of Health," "Labor's Patron Saint," "Franklin, the First American Spelling Reformer," "Franklin, America's First Cartoonist," "Franklin, the Father of Daylight Saving," and "Franklin, the Athlete." One area of endeavor that Franklin did not undertake was that of detective, although he has been portrayed as one by Robert Lee Hall in an ongoing series of clever detective novels, beginning with *Benjamin Franklin Takes the Case*.

man in the Western world." A fourth calls Franklin "beyond question, America's leading man of letters of the eighteenth century . . ."; and to a fifth he was "the most extraordinary man of the century . . ." A sixth commentator asserts that Franklin had "the most eminent mind that has ever existed in America." Yet another notes that "his mind was in complete harmony with the fundamental thinking of his age. In his shrewdness and simplicity he was to contemporaries the perfect embodiment of the new America . . ."[5] Clearly, recovering Benjamin Franklin will not be an easy task. His ubiquity, and hence his seeming availability, complicates any adequate interpretation of the rich meaning of his life and work, especially as a thinker.

Whatever else Franklin was, he was certainly one of the Founders of the American Republic. In our attempts to recover him, it would thus seem not at all out of place to take a brief look at him through the eyes of two other workers in that struggle. The first, John Adams (1735–1826), wrote in 1811 that Franklin's reputation in Europe "was more universal than that of Leibnitz or Newton, Frederick or Voltaire, and his character more beloved and esteemed than any or all of them." Adams continued his litany of praise as follows:

> Franklin's fame was universal. His name was familiar to government and people, to kings, courtiers, nobility, clergy, and philosophers, as well as plebeians, to such a degree that there was scarcely a peasant or a citizen, a *valet de chambre*, coachman or footman, a lady's chambermaid or a scullion in a kitchen, who was not familiar with it, and who did not consider him as a friend to human kind.

It is important to note, however, that statements like these constituted Adams's report on Franklin's social status rather than his personal opinion. Adams's own evaluation of Franklin is far less favorable, perhaps best summed up in this 1783 comment: "His whole Life has been one continued Insult to good Manners and to Decency," full of "Outrages to Morality and Decorum, which would never have been forgiven in any other American."[6]

[5.] I. Bernard Cohen, "Introduction" to *Benjamin Franklin: His Contribution to the American Tradition*, 33; J. A. Leo Lemay, "Benjamin Franklin: Universal Genius," 23; Robert E. Spiller, "Franklin on the Art of Being Human," 304; Clinton Rossiter, *Seedtime of the Republic*, 312; Carl Van Doren, "Meet Doctor Franklin," 1; Ralph Barton Perry, *Puritanism and Democracy*, 177.

[6.] Adams, *Works of John Adams*, 1:660; Adams to James Warren, 13 April 1783, *Warren-Adams Letters*, 2:209.

4 INTRODUCTION

Adams, of course, never denied that Franklin had a marvelous intellect, writing for example that:

Franklin had a great genius, original, sagacious, and inventive, capable of discoveries in science no less than of improvements in the fine arts and the mechanic arts. He had a vast imagination, equal to the comprehension of the greatest objects, and capable of a steady and cool comprehension of them . . . he has added much to the mass of natural knowledge, and contributed largely to the progress of the human mind, both by his own writings and by the controversies and experiments he has excited in all parts of Europe.

While Adams, however grudgingly, held Franklin in high "intellectual" regard, his estimation of Franklin's "moral" worth was far lower. Adams maintained that, once Franklin was examined through an ethical lens, he had "great Faults." So, while Adams might allow that Franklin was "a great Genius, a great Wit, a great Humourist and a great Satyrist, and a great Politician . . . ," he continues that the point of whether Franklin "was a great Phylosopher, a great Moralist and a great Statesman is more questionable." Adams seemed particularly upset by what he saw as Franklin's lack of religious orthodoxy, his lack of good work habits, and his love for the gaity and diversions of Paris, all of which he characterizes as Franklin's "extreme indolence and dissipation."[7] The stiff-backed and self-righteous Adams was also greatly troubled by Franklin's personal reluctance to initiate or aggravate social discord. This reluctance he describes as Franklin's "constant Policy, never to say Yes or no decidedly, but when he cannot avoid it . . ."[8] (As Franklin admits in his *Autobiography* in 1784, "perhaps for these Fifty Years past no one has ever heard a dogmatical Expression escape me" [A:159–160]). After five years of personal interaction with Franklin, Adams writes: "I can have no Dependence on his Word. I never know when he speaks the Truth, and when not. If he talked as much as other Men, and deviated from the Truth as often in proportion as he does now, he would have been the Scorn of the Universe long ago. But his perpetual Taciturnity has saved him." Added to this was Adams's belief that Franklin courted his overblown fame, that he

[7.] Adams, *Works*, 1:663–64, 659; *Diary and Autobiography of John Adams*, 2:392, 4:69; *Works*, 1:655.
[8.] Adams to Samuel Adams, 7 December 1778, *Papers of John Adams*, 7:256.

had "a Passion for Reputation and Fame, as strong as you can imagine, and his Time and Thoughts are chiefly employed to obtain it, and to set Tongues and Pens male and female, to celebrating him." When Adams added to this array of presumed character flaws Franklin's advanced age and general ill-health, the resulting sum presented Franklin as anything but an adequate representative of the fledgling American Republic in Europe. "He may be a Philosopher, for what I know," Adams concedes, "but he is not a sufficient Statesman . . ." Adams continues that Franklin "is too old, too infirm[,] too indolent and dissipated" to continue to fulfill his far-ranging duties in France as "Ambassador, Secretary, Admiral, Commercial Agent, Board of War, Board of Treasury, Commissary of Prisoners, etc. etc. etc. . . ."[9]

Thomas Jefferson (1743–1826), another close Revolutionary colleague of Franklin, evaluated him completely differently. For Jefferson, Franklin was "the greatest man and ornament of the age and country in which he lived" and "the father of American philosophy." Following Franklin in the position of ambassador to France in 1785, Jefferson writes, "was an excellent school of humility," because when he recognized all that Franklin had meant to the American cause in France, Jefferson was forced to admit that "no one can replace him . . . I am only his successor." In his *Notes on the State of Virginia* (1787), Jefferson used Franklin as one of his examples to counter Buffon's charges of degeneracy in America. "In physics we have produced a Franklin," Jefferson writes, "than whom no one of the present age has made more important discoveries, nor has enriched philosophy with more, or more ingenious solutions of the phaemonena of nature." And after Franklin's death in 1790, it was Jefferson who assured President Washington that the young Republic could safely go into mourning in memory of its first dead statesman without setting a dangerous precedent. As Jefferson later notes, he told Washington at that time that "the world had drawn so

[9.] Adams to James Warren, 13 April 1783, *Warren-Adams Letters*, 209–10; Adams, *Diary and Autobiography*, 2:367; Adams to Thomas McKean, 20 September 1779, *Papers*, 8:162; cf. *Works*, 1:660–61. Franklin at times was also less than complimentary about Adams, writing in 1783, for example, that Adams "means well for his Country, is always an honest Man, often a wise one, but sometimes, and in some things, absolutely out of his senses" (W9:62; cf. 33:162–64). For more on Franklin and Adams, see: William B. Evans, "John Adams' Opinion of Benjamin Franklin"; Alfred Owen Aldridge, *Benjamin Franklin*, 259–60, 353–56; Robert Middlekauff, *Benjamin Franklin and His Enemies*, 170–202.

broad a line between himself and Dr. Franklin, on the one side, and the residue of mankind, on the other, that we might wear mourning for them, and the question still remain new and undecided as to all others."[10]

Clearly, Adams and Jefferson could not agree on what Franklin's life and thought meant; and the disagreement between these two witnesses was basic and far-reaching. They differed on Franklin's fundamental qualities as a person. For Adams, Franklin's personality was split between high intellectual achievements and low moral character; for Jefferson there was only one Franklin, and he was uniformly good. On another question, of whether they think that Franklin was a *philosopher*, Adams was undecided and Jefferson was strongly affirmative; but the fact that the question came up at all is perhaps more surprising to us at present than their differing answers. What would *we* today make of a disagreement between two former presidents about whether a third person whom they had known was legitimately to be considered a 'philosopher'? Moreover, in any contemporary analysis of philosophy and its role in American culture, it would seem that for any figure to be considered a truly representative American it would be necessary that she or he be a nonphilosopher.[11] Still, Franklin's contemporary, David Hume (1711–1776), seemed untroubled in his evaluation when he writes to Franklin in 1762: "America has sent us many good things, Gold, Silver, Sugar, Tobacco, Indigo, etc.: But you are the first Philosopher, and indeed the First Great Man of Letters for whom we are beholden to her ..." (reprinted in 10:81–82).[12] Moreover, on the two-hundredth anniversary of Franklin's birth in 1906, President Charles

[10.] Jefferson to Samuel Smith, 22 August 1798, *Writings*, ed. Peterson, 1052; Jefferson to Jonathan Williams, 3 July 1796, *Writings*, ed. Ford, 7:87; Jefferson to William Smith, 19 February 1791, *Papers of Thomas Jefferson*, 19:113; *Writings*, ed. Peterson, 190; Jefferson to Benjamin Rush, 4 October 1803, *Writings*, ed. Ford, 8:265; cf. *Writings*, ed. Peterson, 53; William Macdonald, "The Fame of Franklin," 450–53.

[11.] I hesitate to remind readers that those who claim that Franklin was not a philosopher are not necessarily claiming that he was an unimportant figure. Cf., for example, Louis B. Wright: "For the past two centuries, Benjamin Franklin's homely aphorisms and observations have influenced more Americans than the learned wisdom of all the formal philosophers put together" ("Franklin's Legacy to the Gilded Age," 268).

[12.] Cf. Paul K. Conkin: Franklin was "the most imposing figure in eighteenth-century America ... the first representative of the American intellect to the world" (*Puritans and Pragmatists*, 73).

William Eliot of Harvard University—where he had built a philosophy department that then included William James, Josiah Royce,
George Santayana, George Herbert Palmer, and Hugo Münsterberg—had no qualms about discussing Franklin as a 'philosopher,'
because of Franklin's long-term dedication to "four perennial subjects of human interest—education, natural science, politics, and
morals."[13]

These individuals are not alone in characterizing Franklin as a
philosopher. The general secondary literature contains not-
infrequent references to him as a philosopher of one sort or another:
a political philosopher, natural philosopher, philosophical revolutionist, philosopher of human rights, philosophical engineer,
statesman-philosopher, philosopher moralist, philosopher of dissent,
and so on.[14] What this liberal use of the term indicates, of course, is
that up until quite recently, and outside of the fairly narrow bounds
of academia, a conception of 'philosophy' in the broad sense of the
pursuit of wisdom as a means to render human life more secure and
fulfilling was the operative one. Franklin clearly belongs within this
broad, eighteenth-century understanding of 'philosopher,' however
much the meaning of the term has narrowed in the interim. From
the beginning of the twentieth century, with the increasing professionalization of academia, 'philosophy' has come to carry a more
precise and narrow meaning, concerned with technical questions
related to isolated topics of interest primarily to academics. By 1925,
Herbert W. Schneider was ready to report that Franklin was all but
abandoned by academic philosophers: "Although Benjamin Franklin
was regarded by his contemporaries both here and in Europe as the
foremost philosopher of America, he is rarely mentioned in philosophical circles today."[15] The approach adopted by most historians
of the American philosophical tradition, then and now, has been to

13. Eliot, *Four American Leaders*, 11.

14. Cf. James Brown Scott, "Franklin—Political Philosopher"; Michael I. Pupin,
"Franklin, the Natural Philosopher"; Bernhard Knollenberg, "Benjamin Franklin:
Philosophical Revolutionist"; Henry B. Allen, "Benjamin Franklin—Philosopher
for Human Rights"; Henry B. Allen, *Benjamin Franklin, Philosophical Engineer*;
Wilbur R. Jacobs, ed., *Benjamin Franklin: Statesman-Philosopher or Materialist?*;
Edward Everett Hale, "Franklin as Philosopher and Moralist"; Alice J. Hall,
"Philosopher of Dissent: Benjamin Franklin"; William W. L. Glenn, "Benjamin
Franklin: Physician and Philosopher"; James B. Nolan, *General Benjamin Franklin:
The Military Career of a Philosopher*.

15. Schneider, "The Significance of Benjamin Franklin's Moral Philosophy,"
293.

allude to his intellectual and political importance but to avoid discussing his ideas as 'philosophy.' Some of its historians have even attempted to write him out. With the exception of Schneider and Elizabeth Flower (whose work we will consider below), Franklin plays at best a very minor role in discussions of the history of American philosophy.

What are we to say now, at the end of the twentieth century, about Franklin as philosopher? In particular, recognizing that our understandings of 'philosophy' and 'American philosophy' remain unsettled, what role might we assign to Franklin in the history of the American philosophical tradition. Perhaps the question might be better formulated if we were to ask, what reconstruction of our understanding of the American philosophical tradition would be necessary for it to have a significant place for Franklin? If we find that there is value in his work, how are we to rethink ourselves and our tradition so that Franklin becomes an ancestor? One of the aims of this volume is to try to recover a role for Franklin in the American philosophical tradition, and to demonstrate thereby its Pragmatic core.

How are we to start such a recovery? A large part of the problem of understanding Franklin as a thinker results from the difficulty of classifying his thought. Franklin is not the composer of interconnected systematic treatises that might aid us in placing him. Rather, he is the author of letters and essays, primarily short and often fragmentary, that were intended for, and now appeal to, radically divergent audiences. This comment is not, of course, intended as a criticism of his thinking; but, as a result of the range of his interests, Franklin's thought appears disjointed. By the segmented standards of contemporary academic life, he was an individual whose intellectual life had no tight focus.[16] Moreover, an additional factor contributing to the difficulty of grasping Franklin's thought as a whole is that, because of his willingness to conciliate and his inclination towards the humorous, we cannot simply assume at all times that what he has written represents his own thoughts accurately. We must also take into consideration that during his writing career of over fifty years, Franklin changed his mind on numerous particular

[16.] Carl Van Doren phrases this point more positively: "the more you study Franklin the more lines you find running out from him in all directions . . ." ("Meet Doctor Franklin," 6).

points. As he writes in 1787, "having lived long, I have experienced many instances of being obliged, by better information or fuller consideration, to change my opinions even on important subjects, which I once thought right, but found to be otherwise" (W9:607). In addition, it is also important to remember that at least part of his important political writing was done as a colonial agent in London.[17] Finally, there is the ongoing dispute about material that Franklin may or may not have written.[18] Given these problems, our initial uncertainty about classifying Franklin's thought seems justified. Moreover, part of the problem of placing Franklin may also be that we are basing our evaluation of Franklin too narrowly upon the disputed meaning of his written legacy. We need in addition to emphasize that he was an extraordinary creator and nurturer of practical institutions designed to engage citizens in projects to advance the common good (below, 2.4), and that, as we shall see in chapter 5, he was also engaged in a public career for over half of his life.

All of these complexities in interpreting the meaning of Franklin's life and work are before us in this attempt to recover him for contemporary philosophical use. Was Franklin a thinker whose interests were nearly universal, or was he a dabbler who flew from topic to topic? Was he a minor intellectual who was incapable of sustained theoretical work or was he a thinker who recognized that thought must function in a highly complex world? What is the relationship between action and thought in the life of a public figure, and can we extract a philosophical perspective from those actions? Was Franklin a philosopher; and, if so, what sort of philosopher? As I have already suggested, rather than attempting to decide whether Franklin would fit in our present sense of philosophy, it would seem more valuable to see if his work is 'philosophic' in a broad sense. Such an examination would give us a better evaluation of Franklin

[17.] Cf. Malcolm R. Eiselen: "Franklin, the public servant, sometimes in the line of duty gave voice to sentiments which Franklin, the private individual, repudiated" (*Franklin's Political Theories*, 1).

[18.] Cf. J. A. Leo Lemay, *The Canon of Benjamin Franklin, 1722–1776*. Franklin himself seemed to be little concerned with keeping a record of his writings, as he remarks to his sister, Jane Mecom, in 1767: "You desire me to send you all the political Pieces I have been the Author of. I have never kept them. They were most of them written occasionally for transient Purposes, and having done their Business, they die and are forgotten. I could as easily make a Collection for you of all the past Parings of my Nails" (14:345).

and, not incidently, a chance to rethink our present understanding of this key term. It would also give us the opportunity to rethink our understanding of Pragmatism.

1.2. Franklin's Life

Franklin was born in Milk Street in Boston on 6 January 1706.[19] His father, Josiah Franklin (1657–1745), was a candle- and soap-maker who had come to Boston from England in 1683 with his wife, Ann Child (1654–1689), and the first three of their seven children for reasons both religious and economic. Franklin's mother, Abiah Folger (1667–1752), was born on Nantucket and became Josiah's second wife in November of 1689 after the death of Ann in July of that year. Over the next decades the new couple had ten children together, of whom Benjamin was the eighth.[20] His parents were deeply religious people, and Franklin was baptized on the day of his birth by Samuel Willard, the vice-president of Harvard College, across the street from their house in Boston's Old South Church.

Josiah originally intended Benjamin, his tenth son, for the pulpit as a tithe to God; and Benjamin's education initially reflected this clerical plan. At the age of eight he was enrolled in the Boston Grammar School. Josiah soon began to have serious doubts about the costs of such a classical education and the likely prospects of a ministerial career[21]; and, after a year, he transferred young Benjamin to George Brownell's English School where the educational focus was upon more practical subjects like writing and mathematics. At the age of ten, after a year at Brownell's, the economic realities of the Franklin household brought his formal education to a close. Benja-

[19.] Franklin's birthday is celebrated on January 17 to reflect the addition of eleven days when the "New Style" calender was adopted in 1752 (cf. A:47 n.1; 1:3 n.1; 4:243–47; 20:15–16).

[20.] For the details of Franklin's genealogy, see: 1:xlix–lxv.

[21.] Cf. Bernard Faÿ: "Josiah Franklin, in looking around him, had noticed that the service of the Lord carried with it some of its old-time honor but that it required an expensive education, well beyond the means of a candle merchant's son. Besides, he had ascertained that this holy profession did not always provide for the physical necessities, in spite of the glory it implied and the erudition it called for. How many of the young men with bachelor's degrees from Harvard went out with holes in their shoes to preach in rural communities, leading a miserable life in a crude village or ending sadly in a dark shop, keeping accounts for rich and ignorant merchants!" (*Franklin, The Apostle of Modern Times*, 12).

min began his work career as an apprentice with his father; but he found the family business insufficiently interesting for a life's work. The young fellow was strongly attracted by the sea; and, to prevent him from running off (as had his older brother, Josiah), Benjamin's father allowed the boy to survey other possible trades. Among the ones he considered were carpentry, bricklaying, wood working, and brass working. These experiences benefitted Franklin in a number of ways, two of which he mentions: "It has ever since been a Pleasure to me to see good Workmen handle their Tools; and it has been useful to me, having learnt so much by it, as to be able to do little Jobs my self," especially later when he wanted "to construct little Machines for my Experiments . . ." (A:57).

Even as a child, Franklin's love of books was apparent; and the choice was made to follow this inclination and turn him into a printer. Consequently, at the age of twelve, Benjamin was apprenticed for nine years to his twenty-one-year-old brother, James, who had recently returned to Boston from London with the materials necessary to set up his own printing house. While young Benjamin had little respect for James, who saw their relationship to be more economic than fraternal, he found the printing trade itself fascinating. For one thing, it presented all of the mechanical and manual challenges that he had found so interesting in the other trades that he had considered. What is more, it fostered his recognition of the power of words—both in print and in discussions around the shop—and opened Franklin up to the broader life of the mind.[22] In addition, the print shop provided an outlet for his own writing. The first of his publications were the two now-lost ballads from 1718–1719, "The Lighthouse Tragedy" and "The Taking of Teach the Pirate" (cf. 1:6–7), that he printed up and sold himself on the streets of Boston. After his brother began printing *The New England Courant* in early 1721, Franklin published in it a series of fourteen anonymous essays attributed to one 'Silence Dogood' between April and October of 1722. These essays, full of the wit and satire that

[22.] Cf. Ernest Sutherland Bates: "The role of printers in the development of American culture deserves a special study. At a time when they often combined the functions of printers, publishers, newspaper editors, and librarians, they were, more than any other group, in direct touch with the contemporary thought of the world. The literature of the past was to be found in the colleges; the center of living literature was the printing shop" (*American Faith*, 227; cf. Carl Bridenbaugh and Jessica Bridenbaugh, *Rebels and Gentlemen*, 70–86).

were so much the spirit of his brother's printshop, ranged over questions like politics and religion, education and women's rights, and freedom of speech (cf. 1:8–45).

The irreverent and questioning spirit of the *Courant* quickly landed James Franklin, as its editor, in jail for giving "Offence to the Assembly" (A:69). After his release and under orders not to continue printing the *Courant*, James appointed Benjamin, now seventeen years old, the new editor early in 1723. To make this role seem more plausible to the authorities, Benjamin had to be released from his apprenticeship; and, although James required him to sign a new and secret indenture, Benjamin did not feel himself bound by it. After continued strife with his brother, and knowing that James dared not produce the second indenture that would hold him, he left Boston one September night for New York City. Unable to find any work there, Franklin moved on to Philadelphia. He entered the city (as he enjoyed portraying himself later in his *Autobiography*) early on a Sunday morning, tired and dirty and near penniless, buying "three great Puffy Rolls" and soon falling asleep in the serenity of the Friends' Meeting (A:76).[23]

As the remark goes, Franklin was born in Philadelphia on 6 October 1723 at the age of 17.[24] The Quaker City was bigger and livelier than Boston, a city more welcoming to a young man with Franklin's talents. Still, his road to success was neither short nor direct. He worked initially in a third-rate printshop run by the religious eccentric, Samuel Keimer. Through a connection that he developed with Pennsylvania's Deputy Governor, William Keith, Franklin travelled to London on 5 November 1724 to acquire the materials necessary to set up the first adequate print shop in Philadelphia. Since Keith had failed to provide him with the necessary letters of credit, however, Franklin found himself in effect stranded in London (although it hardly seems proper to describe a year and a half sojourn by an eighteen-year-old man as inquiring and resourceful as Franklin in the capital of the British empire as being

[23.] Cf. R. Jackson Wilson: "He is caught in midair, without resources and hindrances, simultaneously lost and free, hungry and broke but content with bread and water, alert and watchful but able to sleep innocently in that silent meeting-house. He is on his own, without family, property, or job. He is pure possibility" (*Figures of Speech*, 25).

[24.] This remark is attributed to S. Weir Mitchell. See: Whitfield J. Bell, "The Worlds of Benjamin Franklin," 31–32; Ralph L. Ketcham, *Benjamin Franklin*, 49–50.

'stranded').[25] Franklin, although initially without any contacts, soon found work as a pressman and compositor in a major printshop, and later in an even larger one. Among his other projects, Franklin worked on the third edition of William Wollaston's *The Religion of Nature Delineated* (1725), a volume that as we shall see (below, 3.2) had a major impact on his thinking, and led to his publication of *A Dissertation on Liberty and Necessity, Pleasure and Pain* in 1725.

By July of 1726, Franklin was ready to leave London; and he returned to Philadelphia as a clerk in the retail business of Thomas Dedham, a Quaker merchant with whom he had travelled to London in 1724. When they landed in Philadelphia on 11 October 1726, Franklin was not twenty-one years old and he was to spend the next thirty-one years building his economic security and advancing the public interest in Pennsylvania. Dedham's business faltered due to his illness and collapsed on his untimely death, and Franklin found himself once again in the employ of Keimer. This time, however, Franklin was a London-trained printer, more experienced and more confident of himself; and he soon set up a printing house of his own, in partnership with Hugh Meredith. In 1727, Franklin established the Junto, a group of young workmen who, as we shall see (below, 2.4), shared his interests in ideas and their application to the problems of society. 1729 saw the appearance of *A Modest Enquiry into the Nature and Necessity of a Paper-Currency* (1:141–57), and the purchase from Keimer of the failing *Pennsylvania Gazette* that Franklin was to make famous. The following year, Franklin became the official printer for Pennsylvania and was able to buy out Meredith. In addition, 1730 was the year that Franklin 'took to wife' Deborah Read (1707–1774) in a common-law arrangement.[26] In 1731, Franklin joined the Freemasons and established the Library Company, a cooperative lending library that grew out of the Junto.

[25] Cf. Carl Van Doren: "Franklin, accustomed only to small, provincial, transatlantic towns, lived for a year and a half in the capital of his world in one of its brilliant ages" (*Benjamin Franklin*, 50; cf. John Dos Passos, "Two Eighteenth-Century Careers: I—Benjamin Franklin," 656).

[26] While Franklin had courted Deborah during his first stay in Philadelphia, he had let the relationship lapse while he was in London. During his absence, she married a potter, John Rogers, who may have already been married and from whom in any case she soon separated. Rogers then went to the West Indies and was reported dead. To preclude any questions of bigamy and to avoid any potential debts that Rogers might have left behind, Franklin and Deborah lived together in common-law marriage (cf. A:89, 92, 96, 107, 129).

The next year saw the birth of his short-lived son, Francis Folger (1732–1736). This was also the year of his failed German-language newspaper, the *Philadelphische Zeitung* (cf. 1:230–31, 233–34), and the beginning of his phenomenally successful *Poor Richard's Almanack*, that amalgam of calendar and weather forecaster, practical advisor and moral guide, that he published yearly in one form or another until 1758.[27] Franklin continued to be active in public affairs, addressing such problems as fire protection and the night watch. He became clerk of the Pennsylvania Assembly in October 1736, and began his long association with the mail as postmaster for Philadelphia in 1737. His mechanical interests led to his invention of the Pennsylvania fireplace, which he presented for sale in late 1741. In 1743, largely as a result of his pamphlet, "A Proposal for Promoting USEFUL KNOWLEDGE," the American Philosophical Society was established and Franklin was appointed its Secretary (below, 2.4). This was also the year of the birth of Deborah's second child, Sarah, known as "Sally" (1743–1808).

In the midst of this life of practical activity, Franklin developed an intense interest in natural philosophy or science. His fascination with electricity began in mid-1743, when he saw Dr. Archibald Spencer in Boston demonstrating some of its properties; and he soon began to experiment himself, using equipment received from Peter Collinson, the Library Company's agent in London. Franklin's research, conducted in cooperation with a number of his local colleagues, began to incorporate more and more equipment and absorb an increasing part of his life until he brought in David Hall as a managing partner of his printing business and retired to his electrical researches in 1748. As one commentator puts it, Franklin left "the pursuit of living for the pursuit of life."[28] Franklin's reports

[27] In one of his children's stories, Nathaniel Hawthorne writes (through a character): "'Poor Richard's Almanac' did more than anything else towards making him familiarly known to the public. As the writer of those proverbs which Poor Richard was supposed to utter, Franklin became the counsellor and household friend of almost every family in America" (*Tales, Sketches, and Other Papers*, 202; cf. 1:280–83; Spiller, "Benjamin Franklin on the Art of Being Human," 311–12; Richard E. Amacher, *Benjamin Franklin*, 51–66; Aldridge, *Benjamin Franklin*, 64–68).

[28] Robert E. Spiller, "Benjamin Franklin: Promoter of Useful Knowledge," 31. Elsewhere, Spiller notes that "Franklin retired in order to become a scientist and philosopher, but the times made him a politician and statesman" (*The Cycle of American Literature*, 15).

to the Royal Society of London on the experiments were gathered together by Collinson and published in London in 1751 as *Experiments and Observations on Electricity*. Continued experimentation and speculation led to the kite experiments in mid-1752 and Franklin's advocacy of the potential values of lightning rods in the *Almanack* for 1753. His discoveries brought Franklin the Copley Medal of the Royal Society in 1753 and membership in the Royal Society in 1756 (below, 2.2).

During these years of electrical experimentation, Franklin was not inactive as a social or political figure. In 1751 he was elected to the Pennsylvania Assembly, where he served for over a decade. In and around Philadelphia, he took part in the activities of the Masons, rising to Provincial Grand Master in 1749.[29] He played an essential role in the founding of the Pennsylvania Hospital (chartered in 1751) and the Philadelphia Contributionship for the Insurance of Houses from Loss by Fire in 1752.[30] In addition, his 1749 pamphlet, "Proposals Relating to the Education of Youth in Pennsylvania," led to the opening of the Philadelphia Academy in 1751 (below, 2.4). On the broader scene, he was promoted to Joint Deputy Postmaster General of North America in 1753. During King George's War (1744–1748), Franklin also undertook serious efforts to improve the defenses of Pennsylvania and elsewhere in British colonial America. In late 1747 he published *Plain Truth*, a call to the citizens of Philadelphia and Pennsylvania to take cooperative action in their self-defense; and he led the organization of a voluntary citizens' militia, the Association, to embody this plan of self-defense. Franklin represented Pennsylvania at the Albany Conference in 1754 to develop a common colonial strategy for building a working friendship with the Six Nations to resist the French (below, 5.2). Early in the French and Indian War (1754–1763), Franklin also worked on the Pennsylvania frontier (April–May 1755) to obtain transportation for Gen. Edward Braddock's ill-fated mission against Ft. Duquesne. Franklin also was assigned by the Assembly to supervise the building of defenses in the area of Bethlehem and Gnaddenhütten from December of 1755 to February of 1756.

The financing of this ongoing frontier conflict led to continued

[29.] Cf. Faÿ, *Franklin, the Apostle of Modern Times*, vi, 145–49, 172, 178–84, 354, 419, 478–79, 484–85.
[30.] Cf. 4:281–95; 13:379–80.

three-way disputes among the Quaker-dominated Assembly, the proprietary Penn family (through their Deputy Governor, William Denny) and the frontier settlers. The Assembly's call for increased taxation on the land of the proprietors led to Franklin's agency to London in June 1757, a trip that was to keep him away until November 1762. On the voyage to England, Franklin gathered and reworked pieces of earlier editions of the *Almanack* into "Father Abraham's Speech" for the 1758 edition of *Poor Richard*, the last one issued under his direction. (We will consider this piece, also known as *The Way to Wealth*, in our examination of Franklin's moral thought [below, 4.1]). In London again, Franklin was no longer a lowly workman in a printshop as he had been thirty-one years earlier. Now he was a famous colonial, a 'philosopher' and fellow of the Royal Society; and, after receiving an LL.D. from St. Andrews University in 1759, he was "Doctor" Franklin (cf. 8:277–80). He met with fellow philosophers like Adam Smith, Lord Kames, and David Hume, and toured widely, both in the north of England and Scotland and in the Lowlands. He busied himself with the charitable activities of the educational organization, the Associates of Dr. Bray (below, 5.5), and developed the glass harmonica. His success in winning approval for increased taxation of the land-holdings of the proprietors led to his departure for Philadelphia in August of 1762 for a brief, if eventful, interval.

Back in Pennsylvania in November, he celebrated the appointment of his (illegitimate) son, William Franklin (c.1731–1813), as Royal Governor of New Jersey. In the middle of 1763, Franklin began a tour of the middle and northern colonies as Joint Deputy Postmaster General of North America. He was elected speaker of the Pennsylvania Assembly in May of 1764. Mixed in with these triumphs were troubles. For example, in December 1763 a group of hotheads in Lancaster County carried out two massacres of friendly Indians; and Franklin, in part through the publication of *A Narrative of the Late Massacres* (cf. 11:47–69), was instrumental in preventing the threatened spread of their slaughter to Philadelphia (below, 5.5). The internal tensions in Pennsylvania were further evidenced when Franklin lost his Assembly seat in a bitter election campaign in October 1764 (cf. 11:369–94, 397–98). On 7 November 1764, Franklin was returned to London by his anti-proprietary party, which still held the majority, as agent of the Assembly to attempt to have the proprietors replaced through the imposition of a

royal charter. His wife, Deborah, reluctant as ever to brave the ocean, would not travel with him; and, when he returned to Philadelphia in 1775, it was as a widower.

Questions related to the nature and financing of the American defenses were being just as hotly debated in London. One method for raising the money—the Stamp Act—passed the House of Commons and gained royal assent in early 1765, with an effective date of November 1. Franklin, as a citizen and agent of Pennsylvania, opposed this act both as an ineffective source of revenue and as an imposition on the colonials by a distant Parliament in which they had no representation. As a businessman, however, he tried to suffer as little as possible personally from its effects and some of these commercial actions were mistakenly seen in America as indicating support for the Act.[31] As the summer of 1765 wore on, the approach of the Act was greeted with riots in North America. In September, the rioters even threatened his friends and property in Philadelphia; but Deborah stood firm and eventually eight hundred of his supporters arose to protect his house from the mob. Boycotts and disorders successfully prevented the enforcement of the Stamp Act; and, in England, Franklin continued his campaign against it. Early in 1766, he was examined in the House of Commons about the likely impact and effectiveness of the Stamp Act. Franklin's responses were instrumental in its repeal on 22 February of that year, and the publication of the record of his examination secured the recognition of Franklin as the premier spokesman for America in London (below, 5.1).

It should not be overlooked here that, despite the repeal of the Stamp Act, the question of how to finance the colonial defenses in America remained unresolved. Partly in an attempt to raise the money and partly in an attempt to reassert its taxing authority over the colonies, Parliament replaced the Stamp Act in mid-1767 with the Townsend Acts which placed duties on the importation of glass, lead, paint, paper, and tea. Franklin summarizes the American case against continued taxation by Parliament the next year in his *Causes of the American Discontents before 1768* (15:3–13). The relations between the colonies and London continued to worsen, in spite of

[31.] Cf. 12:65–67, 145–46 n.8, 206–8, 234–36, 267–74, 315–17, 365–66; Aldridge, *Benjamin Franklin*, 174–79; Van Doren, *Benjamin Franklin*, 318–22, 327–31.

all of Franklin's efforts. In other activities he began to serve as agent
for Georgia in 1768, for New Jersey in 1769, and for Massachusetts
in 1770. Franklin also participated in the unsuccessful efforts of the
Walpole Company to set up a new colony in the West to be called
'Vandalia.'[32] In 1769, he was elected President of the revamped
American Philosophical Society (a position he was to hold until his
death). In these years he also did some extensive travelling: to
Germany (1766), France (1767 and 1769), and Ireland and Scotland
(1771).

A final break between Britain and the colonies, while still not
inevitable, was becoming ever more likely. The death of five mem-
bers of an unruly mob at the hands of the occupying British Army
was immortalized as the Boston 'Massacre' of 5 March 1770. The
Boston 'Tea Party' of 16 December 1773 demonstrating opposition
to the Tea Act of May of that year brought on the Coercive (or
'Intolerable') Acts of 1774, which were designed to crush colonial
resistance. In the midst of these sinking possibilities for peace,
Franklin attempted to conciliate, suggesting that the colonists offer
to voluntarily compensate the East India Company for the lost tea.
He also published in September 1773 two satirical essays attempting
to prod the more open-minded members of the British public to try
to see the colonial situation from the American point of view:
"RULES *by which a* GREAT EMPIRE *may be reduced to a* SMALL ONE"
and "An Edict by the King of Prussia" (below, 5.1). A third action
was to send secretly to the Massachusetts House of Representatives a
series of three- to five-year-old letters from individuals including the
current governor of Massachusetts, Thomas Hutchinson, to British
authorities. Franklin hoped that revealing the content of these
letters, in which Hutchinson, at the time the chief justice and
lieutenant governor of Massachusetts, advocated the adoption of
stronger measures against colonial resistance, would indicate that at
least some of the Americans' difficulties were originating on their
own side of the Atlantic. The letters were published, however; and,
when Franklin's role in this affair became public, he was attacked in
the 'Cockpit' of Parliament by Solicitor General Alexander Wedder-
burn on 29 January 1774 and removed from his postmaster position

[32] Cf. Van Doren, *Benjamin Franklin*, 365–67, 394–400; Ronald W. Clark,
Benjamin Franklin, 220-24; David T. Morgan, *The Devious Dr. Franklin, Colonial
Agent*, 72–76, 116–17, 139–43,172–74, 193–95, 229–32; Alfred P. James,
"Benjamin Franklin's Ohio Valley Lands."

two days later.[33] No longer useful in London as an agent of conciliation between England and the American colonies, and personally skeptical of any possibility of conciliation, Franklin packed up and returned to America.

Landing in Philadelphia on 5 May 1775, Franklin believed that separation was inevitable. Almost immediately after his arrival he proceeded to the Second Continental Congress. The Battles of Lexington and Concord had been fought on 19 April 1775 while he was still at sea; and the Battle of Bunker Hill followed on 17 June 1775. Franklin worked both with the Continental Congress, especially with regard to strengthening the colonial confederation, and with the Pennsylvania Committee of Safety (cf. 22:91–93). The colonies were declared in rebellion by King George in August of 1775, confirming what they knew already. As the winter of 1775/76 was ending, the seventy-year-old Franklin was making his way to Montréal with several others in an unsuccessful attempt to enlist the support of Québec in the rebellion. He was back in Philadelphia in late May, and soon he was serving with John Adams, Robert R. Livingston, Roger Sherman, and Thomas Jefferson on a committee to shape the ideas behind the American rebellion into a formal declaration of independence. Although some of Franklin's suggestions were rhetorically significant, Jefferson was the primary author. American Independence was declared on 4 July 1776, and Franklin began serving almost immediately as the President of Pennsylvania's convention to write a post-colonial constitution for the new commonwealth. He also served in the Continental Congress as it debated the form of the new confederation in anticipation of war with Britain. Franklin travelled to Staten Island in September with John Adams and Edward Rutledge to meet with Admiral Richard Howe in the hope of averting further bloodshed. These efforts failed (cf. 22:598–605); and, on 27 October 1776, Franklin sailed from Philadelphia to serve with Silas Deane and Arthur Lee as one of the American ministers to France.

Franklin arrived in Paris on 21 December 1776 to seek French assistance for the American cause. Although his political presence was necessarily low-keyed, since France and Britain were officially at peace, socially he was a great hero. In Franklin, the French saw an

[33.] Cf. 19:399–413; 21:37–70; 73–75; Clark, *Benjamin Franklin*, 224–50; Van Doren, *Benjamin Franklin*, 443–51, 458–78.

authentic frontier philosopher, a combination of a natural rustic who lived life without the artificialities of cultured society and a sage who understood the complex workings of the natural and social order.[34] In addition he had been since 1772 one of the eight foreign members of the Académie Royale des Sciences in Paris. Franklin was the embodiment of the natural order become self-conscious, who had travelled to France to lead his troubled country from the cruel enslavement of the British monarchy into a free and equal place among the nations of the earth. From the day of his arrival, Franklin worked to win over the French and their government. Notice of Gen. John Burgoyne's defeat at Saratoga on 17 October 1777 stiffened France's willingness to support the young American Republic, and treaties of trade and mutual defense were signed on 6 February 1778. France itself declared war on Britain in June.

Franklin was over seventy-two and in ill health on the day these initial treaties were signed; and his duties in France would have cowed any normal person, however young and healthy. Within the American delegation, he had to deal with an impossible level of internal suspicions and squabbling that eventually led to his appointment as minister plenipotentiary (14 September 1778). His most pressing job was to secure the constant flow of weapons and other supplies to the revolutionaries in America. He was also engaged with efforts to create diplomatic and consulor relations with various countries. In addition, he kept up a number of streams of correspondence with various individuals in Britain, especially negotiating exchanges of prisoners. He was the focus for questions involving privateering and other naval matters. He was also beset with a tidal wave of other correspondence: for example, requests for recommendations from persons interested in travelling to America.[35] So great

[34.] Cf. Carl Van Doren: "Franklin, by no means a philosopher of the backwoods, for thirty years had lived among scholars and scientists, merchants and politicians, clergymen and men of fashion. His manners were as urbane and expert as his prose. But the French were looking for a hero who should combine the reason and wit of Voltaire with the primitive virtues celebrated by Rousseau, and they were sure they had found their hero in Franklin. He denied them nothing they expected" (*Benjamin Franklin*, 570; cf. Alfred Owen Aldridge, *Franklin and His French Contemporaries*, 59–73, 235–38).

[35.] The great crush of requests led Franklin to develop the following humorous "Model of a Letter of Recommendation of a Person You Are Unacquainted with": "Sir[,] The Bearer of this who is going to America, presses me to give him a Letter of Recommendation, tho' I know nothing of him, not even his Name. This may seem extraordinary, but I assure you it is not uncommon here. Sometimes indeed one

was this pressure that in mid-1780 he wrote to one correspondent, "my time is more taken up with Matters extraneous to the function of a Minister, than you can possibly imagine," and to another "every body writes to me for orders, or advice, or opinion, or approbation, which is like calling upon a blind Man to judge of Colours" (32:516, 364).[36] His primary duty remained cultivating relations with the French government, and he succeeded both in developing political support for the American cause and in keeping open the flow of essential supplies.

Notification of the surrender of Gen. Charles Cornwallis at Yorktown, Virginia, on 19 October 1781 reached Franklin in November, and the increasingly invalid seventy-five-year-old immediately began to plan his return to Philadelphia "to enjoy the little left me of the Evening of Life in Repose, and in the sweet Society of my Friends and Family" (W9:141). The complicated process of negotiating the peace, however, moved slowly. Along with John Jay and John Adams, Franklin signed the preliminary peace treaty on 30 November 1782 and the final treaty on 3 September 1783. While awaiting permission to leave his post in France, Franklin once again had time to turn his attention to science. He attended some early manned balloon flights in 1783 and investigated Friedrich Anton Mesmer's claims of 'animal magnetism' in 1784.[37] The range of his activities was increasingly circumscribed, however, by his failing health. Franklin was finally authorized to leave France in July of 1785; and, after a few days in Southampton meeting with British friends and his estranged Loyalist son, William, he sailed for Philadelphia cherishing hopes for a peaceful retirement of 'philosophy' and family.

Franklin arrived to great celebration in Philadelphia on 14

unknown Person brings me another equally unknown, to recommend him; and sometimes they recommend one another! As to this Gentleman, I must refer you to himself for his Character and Merits, with which he is certainly better acquainted than I can possibly be; I recommend him however to those Civilities which every Stranger, of whom one knows no Harm, has a Right to, and I request you will do him all the good Offices and show him all the Favour that on further Acquaintance you shall find him to deserve" (23:549–50).

[36.] Cf. 32:285; 33:161, 219–20.

[37.] Franklin's appreciation of these early flights will be considered (below, 2.3). For the investigation of Mesmer, see: Van Doren, *Benjamin Franklin*, 713–17; James Parton, *Life and Times of Benjamin Franklin*, 2:516–21, 528.

September 1785; but, instead of the anticipated retirement, he was faced with further duties. The seventy-nine-year-old was almost immediately elected president (i.e., governor) of Pennsylvania, a position he held for three consecutive one-year terms, from October 1785 to October 1788. In 1787, Franklin, now eighty-one years old, was also a delegate to the Constitutional Convention that met in Philadelphia from 28 May to 17 September. At the Convention he was far from a dominating force; but he offered a moderating presence, calling for rational compromise to advance the common good. In these final years, he also served as the President of the Society for Political Enquiries and as the President of the Pennsylvania Society for Promoting the Abolition of Slavery (below, 5.4, 5.5). The end came slowly for Franklin; and, even on his death bed, he could not resist one final joke. When being repositioned so that he might be able to breathe easy, he replied: "A dying man can do nothing *easy*."[38] Franklin died on 17 April 1790, at the age of eighty-four years and three months.

1.3. Interpretations of Franklin

Given what we have just considered about the broad range of Franklin's interests and activities, it seems not at all surprising that interpretations of his life and work have tended to be partial. Individual interpreters are most interested in one or another aspect of his broad career, more familiar with some themes than others, and discussions of Franklin reflect this partiality.[39] These partial interpretations may also reflect the fact that he has often been simplified by friends (or enemies) so that he could function as a hero (or fiend).[40] Or these partial interpretations may result from the fact that he

[38.] Aldridge, *Benjamin Franklin*, 410; cf. Whitfield J. Bell, *The Colonial Physician and Other Essays*, 129–30.

[39.] Cf. Paul W. Conner: "There are those who know Franklin the Newtonian, Franklin the Deist, or Franklin the Pythagorian, but scarcely anyone who knows Franklin. He has been the specialists' delight" (*Poor Richard's Politicks*, 3; cf. Theodore Parker, *Historic Americans*, 18–19).

[40.] Cf. Richard D. Miles: "Americans wanted only morally correct heroes, and they wanted them badly. Thus, since Franklin's political conduct was not above suspicion in the opinion of some, it was convenient to skip it. When historians began to do their work on a more generous scale, they flexed their muscles and with strong hands shaped Franklin's 'public services' to resemble their ideals: Franklin was a patriot, Franklin was a democrat" ("The American Image of Franklin," 134).

seems to some commentators to be too full of contradictions to be manageable without simplification.[41] Whatever their causes, these partial interpretations are inadequate; and those who are seeking a broader interpretation of his life and thought must be prepared for many hours of careful study.

The problem of partial readings of Franklin has persisted *in spite of* or perhaps in part *because of* his own extraordinarily famous memoirs. The book that we now know as Franklin's *Autobiography* was written in a number of stages over the last two decades of his life.[42] The project itself was never completed, reaching up only to 1758 when (as we have just seen) the fifty-one-year-old author was beginning his first official mission to England. The first part—up to 1731, when Franklin was twenty-five—was written as a long letter to his son, William, in 1771 when the father was sixty-five and the son about forty. In this presentation of his early years, Franklin hopes to inform William and his descendants about the events of his life, especially about his rise to prominence through a combination of hard work and good fortune. He writes:

> Having emerg'd from the Poverty and Obscurity in which I was born and bred, to a State of Affluence and some Degree of Reputation in the World, and having gone so far thro' Life with a considerable Share of Felicity, the conducing Means I made use of, which, with the Blessing of God, so well succeeded, my Posterity may like to know, as they may find some of them suitable to their own Situations, and therefore fit to be imitated. (A:43)

When he returned to complete the other three sections of his memoirs after the victorious struggle for American independence, William, now a disgraced Loyalist living in England, is no longer in

[41.] Cf. John William Ward: "Part of the difficulty in comprehending Franklin's meaning is due to the opposites he seems to have contained with complete serenity within his own personality. He was an eminently reasonable man who maintained a deep skepticism about the power of reason. He was a model of industriousness who, preaching the gospel of hard work, kept his shop only until it kept him and retired at forty-two. He was a cautious and prudent man who was a revolutionist. And, to name only one more seeming contradiction, he was one who had a keen eye for his own advantage and personal advancement who spent nearly all his adult life in the service of others" (*Red, White, and Blue*, 126).

[42.] Part One was written in 1771 in Twyford, England; Part Two, in 1784 in Passy. Parts Three and Four were written in Philadelphia between 1788 and 1790. For the textual history of the *Autobiography*, see: A:22–40; J. A. Leo Lemay and Paul M. Zall, "Introduction" to their genetic edition of the *Autobiography*, xvii–lviii.

the picture. Rather, Franklin was spurred on to resume the story by the responses of readers of the initial segment, one of whom maintained that "[a]ll that has happened to you is also connected with the detail of the manners and situations of *a rising* people" and that the publication of the story of his life would advance "the forming of future great men . . ." (A:135). While the impetus of the memoirs had changed, the didactic message remained the same.[43] "I omit all facts and transactions, that may not have a tendency to benefit the young reader," Franklin writes in 1788. In this way, he hoped to indicate "from my example, and my success in emerging from poverty, and acquiring some degree of wealth, power, and reputation, the advantages of certain modes of conduct which I observed, and of avoiding the errors which were prejudicial to me" (W9:675–76). In another letter of the same year, he admitted that it had taken him a long time to get to the events of his later life, when his story contains the historically "more important Transactions." Still, he maintained his tutorial stance, suggesting that "what is done will be of more general Use to young Readers; as exemplifying strongly the Effects of prudent and imprudent Conduct in the Commencement of a Life of Business" (W9:665). And, while this didactic aim might in advance seem unpromising for an autobiography, readers have confirmed Franklin's own initial evaluation of the memoirs as "entertaining, interesting, and useful" (W9:676).

The *Autobiography* is, as its Yale editors gently point out, "not notably accurate" (A:6)[44]; but, given Franklin's didactic aims in writing it, factual accuracy in every detail is perhaps less important than its overall spirit. Many commentators on the *Autobiography* have substantiated Franklin's hope, especially with regard to the volumes being 'entertaining' and 'interesting.' For Robert E. Spiller, Franklin's *Autobiography* is "one of the finest literary products of the eighteenth century . . ." Richard E. Amacher characterizes the *Autobiography* as "the first great book written in America" and "probably

[43.] Cf. John William Ward: "When Franklin resumed his story, he did so in full self-consciousness that he was offering himself to the world as a representative type, the American" (*Red, White, and Blue*, 129; cf. J. A. Leo Lemay, "Benjamin Franklin," 240).

[44.] Franklin, working at many years distance and without adequate documentation, made a number of factual mistakes and perhaps offered a few historical revisions in the *Autobiography*. Some of these discrepancies are pointed out by the editors in their footnotes. Cf. Francis Jennings: "Franklin's *Autobiography* is about as valid as a campaign speech" (*Benjamin Franklin, Politician*, 18).

the most famous autobiography in the world." Carl Van Doren writes that it "was the first masterpiece of autobiography by a self-made man: made, that is, neither in war nor in art but in peaceful business." In a similar fashion, J. A. Leo Lemay writes that the *Autobiography* is "the first great book in American literature, and, in some ways, it remains the most important single book." One of the ways it remains important, Lemay continues, is the manner in which Franklin incorporates into the *Autobiography* the American Dream: "the rise from impotence to importance, from dependence to independence, from helplessness to power."[45]

Such glowing evaluations are not universal. Many other readers maintain that however entertaining and interesting the *Autobiography* may be, and independent of any questions of its factual accuracy, its ultimate impact has been negative. Although granting that the *Autobiography* is "the most influential book ever written by an American," for example, Brian M. Barbour continues that it presents "a concept of human life that is seriously deficient but which does not know itself to be so." E. Digby Baltzell suggests that the *Autobiography* is "the *first* and the greatest manual of careerist Babbittry ever written." For Theodore Hornberger, to cite another critic, Franklin's explanation of how he rose in the world "is not a wholly pretty story" and is beset with an "aura of finagling and of elasticity of conviction." Rather than address these important issues, however, Franklin attempts to convince us that the good life is "the attainment of economic independence and social position" rather than "the pursuit of simple saintliness or spiritual serenity . . ." Others see the *Autobiography*'s judicious omissions and didactic aims as his deliberate attempts to influence our understanding of him, suggesting that Franklin was not offering himself as a representative American so much as attempting to improve his image. Mitchell Robert Breitwieser, for example, writes: "Though he may have been confident that he would be remembered, he wrote the *Autobiography* to intervene into how he would be remembered . . ." The volume thus becomes a careful contrivance of masks and *personae* arranged to make himself seem the benevolent friend of humanity. To penetrate this screen, Breitwieser suggests that we avoid either "emotional

[45.] Spiller, "Franklin on the Art of Being Human," 312; Amacher, *Benjamin Franklin*, 38; Van Doren, *Benjamin Franklin*, 415; Lemay, "Benjamin Franklin: Universal Genius," 21, 23.

acceptance" or rejection of "Franklin's projected face" and approach the *Autobiography* through analysis as "a coherent and deliberate rhetorical project."[46]

I doubt that the most sensible reading of the *Autobiography* is as a deliberate contrivance of manipulation. Such a reading, I think, gives Franklin both too organized an intention and too successful a result. Still, a sense of skeptical distance from the volume does set the stage for a broader consideration of his thought and work. My assumption here is that, while it remains important to examine Franklin's self-constructed presentation of his life and ideals—what *he* thought his life meant—we cannot hope to understand him fully through a reading that overemphasizes the *Autobiography*. Other key texts need to be given equal weight; in fact, we need to read our way through all of Franklin to get an adequate sense of his thought and work. Only in this way can we avoid the sorts of problems that infect the series of representative negative interpretations of his life and work that is to follow. These evaluations of Franklin present him as being overly concerned with money and the kind of life that it makes possible, as lacking a spiritual side, and ultimately as undermining the possibility of true culture. These interpretations, I think, are at best partial or slanted, and at times simply false; but examining their attractiveness should tell us much about ourselves and our understandings of human well-being and philosophy, and set the stage for a thorough examination of Franklin.

We can begin with Max Weber's 1904–1905 study, *The Protestant Ethic and the Spirit of Capitalism*. In this study, Weber draws upon two very brief Franklin essays — "HINTS for those that would be Rich" (1737) and "ADVICE TO A YOUNG TRADESMAN, WRITTEN BY AN OLD ONE" (1748)[47]—because, as he writes, such texts from Franklin embody the spirit of capitalism "in almost classical purity." Weber cites such *formulae* as the following:

[46.] Barbour, *"The Great Gatsby* and the American Past," 293; Baltzell, *Puritan Boston and Quaker Philadelphia*, 55; Hornberger, *Benjamin Franklin*, 6–7; Breitwieser, *Cotton Mather and Benjamin Franklin*, 231, 173. For still more readings of the *Autobiography*, see: Richard L. Bushman, "On the Uses of Psychology: Conflicts and Conciliation in Benjamin Franklin"; Melvin H. Buxbaum, *Benjamin Franklin and the Zealous Presbyterians*, 7–46; John Griffith, "Franklin's Sanity and the Man behind the Masks"; Robert Freeman Sayre, *The Examined Self*, 12–33; Ormond Seavey, *Becoming Benjamin Franklin*; R. Jackson Wilson, *Figures of Speech*, 21–65.

[47.] Weber does not discuss the related essay, *The Way to Wealth* (1758).

Remember that Time is Money. (3:306)

He that idly loses 5 *s.* worth of time, loses 5 *s.* and might as prudently throw 5 *s.* in the River. (2:165)

Money can beget Money, and its Offspring can beget more, and so on. (3:306)

Of such passages, Weber writes, "no one will doubt" that "it is the spirit of capitalism which here speaks in characteristic fashion." Weber's interpretation of Franklin's ideas and of capitalism is that in this "philosophy of avarice" there is "a duty of the individual toward the increase of his capital, which is assumed as an end in itself." As Weber continues, "the *summum bonum* of this ethic, the earning of more and more money, combined with the strict avoidance of all spontaneous enjoyment of life" dominates all of its adherents. The earning of increased amounts of money, Weber believes, "is thought of so purely as an end in itself, that from the point of view of the happiness of, or utility to, the single individual, it appears entirely transcendental and absolutely irrational." When this ethic has taken control of its adherents, he continues "acquisition" becomes "the ultimate purpose" of life. Our interest, of course, is not so much in Weber's understanding of Protestantism or capitalism as it is in his understanding of Franklin; and, on this point, Weber's position is clear: "The earning of money within the modern economic order is, so long as it is done legally, the result and the expression of virtue and proficiency in a calling; and this virtue and proficiency are . . . the real Alpha and Omega of Franklin's ethic, as expressed . . . in all his works without exception."[48]

Weber's characterization of Franklin as a proponent of the view that "anyone should be able to make it the sole purpose of his life-work, to sink into the grave weighed down with a great material load of money and goods . . ."[49] is, as we shall see (below, 4.4), simply false; but for the most part Weber's interpretation of Franklin is slanted, partial rather than wrong. Critics of Weber have emphasized

[48.] Weber, *The Protestant Ethic and the Spirit of Capitalism*, 48–54. Cf. Werner Sombart: "In Benjamin Franklin . . . the middle-class view of life reached its zenith. The sobriety and exactness of this American almost take one's breath away. Everything with him became a rule, and was measured by the proper standard, and his every action was governed by economy" (*The Quintessence of Capitalism*, 116; cf. V. F. Calverton, *The Liberation of American Literature*, 185–91).
[49.] Weber, *The Protestant Ethic and the Spirit of Capitalism*, 71–72.

the extremeness of his interpretation of Franklin and the narrowness of his sources within Franklin's thought. One commentator, for example, writes that Weber offers us "a one-dimensional figure, a flat abstraction . . ."[50] Still, even though Weber may present an extreme reading of a narrow slice of Franklin's thought, he should not be too severely criticized when others who should know better largely mirror him. Herbert Hoover, for example, writes that Franklin embodies a particularly American version of the Protestant ethic. "Benjamin Franklin should be the patron saint of that altogether characteristic American, the self-made man," Hoover maintains. "Those real men were the product from the noblest of American ideals—that each human being had the birthright of opportunity for self-advancement, that no one was by birth limited in achievement." The capitalist core is obvious here, and it is made even more so by Hoover's 1938 attack on the responses of his successor in the White House, Franklin Delano Roosevelt, to the Depression: "the ideal today has shifted from the self-made man toward the government-coddled man."[51] Further, if it is true, as one commentator writes, that to the "enormous audience" of *The Way to Wealth* "Franklin and Poor Richard were indistinguishable," and that, as another commentator suggests, these various sources establish Franklin's "reputation as the high priest of business morality, as the expert guide to success and wealth in the world of commerce,"[52] how are we to respond but with a call for a broader study of Franklin's life and thought?

Van Wyck Brooks offers a more cultural, although still strongly negative, interpretation of Franklin in his 1915 essay, "America's Coming of Age." In this piece, Brooks distinguished between two "attitudes of mind" that he calls "Highbrow" and "Lowbrow." Brooks finds these "twin values," which he describes as "on the one hand, a quite unclouded, quite unhypocritical assumption or transcendent theory ('high ideals'), on the other a simultaneous accept-

[50.] William L. Hedges, "From Franklin to Emerson," 142; cf. Melvin H. Buxbaum, "Introduction" to *Critical Essays on Benjamin Franklin*, 7–8.

[51.] Hoover, "On Benjamin Franklin," 366; cf. Hoover "Benjamin Franklin," 84–85.

[52.] Hornberger, *Benjamin Franklin*, 6; Gerald Stourzh, *Benjamin Franklin and American Foreign Policy*, 5. Cf. Kenneth B. Murdock: "Even when he is most philosophic, there is still the clink of cash" ("Jonathan Edwards and Benjamin Franklin," 118; cf. Brian M. Barbour, "*The Great Gatsby* and the American Past," 291; Louis B. Wright, "Franklin's Legacy to the Gilded Age").

ance of catchpenny realities," to be "equally undesirable"; but, at the same time, he believes that "they divide American life between them." Brooks associates these values originally with two colonial figures: "no one has ever more fully than Jonathan Edwards displayed the infinite inflexibility of the upper levels of the American mind, nor has anyone displayed more fully than Franklin the infinite flexibility of its lower levels." While in his essay Brooks also considers in detail the 'highbrow' current in American culture, a current that he associates with Edwards, Ralph Waldo Emerson, and others, our interest is in the 'lowbrow' current "of catchpenny opportunism, originating in the practical shifts of Puritan life, becoming a philosophy in Franklin . . . and resulting in the atmosphere of our contemporary business life." Brooks continues by wondering "[w]ho can deny that in *Poor Richard* the 'Lowbrow' point of view for the first time took definite shape, stayed itself with axioms, and found a sanction in the idea of 'policy'?" Franklin thus offers us a "two-dimensional wisdom, a wisdom shorn of overtones," a vision of "unmitigated practicality"—in general, a Pragmatic account of what it is to be a human being that, Brooks believes, represents at best half of a decent human existence.[53]

Continuing on in this cultural vein, we come to a stronger criticism of Franklin's deliberate and organized approach to living that suggests that he represents a good deal less than half of an adequate life. The most obvious critic here is D. H. Lawrence, who wrote a pair of closely related essays on Franklin in 1918 and 1923. The theme of both of these essays is that Franklin represents the worst aspects of a rationalized and homogenizing world and that any use of him as a model for living will be disastrous. In Lawrence's version of Franklin's world, where efficiency replaces spontaneity and God has become "the everlasting Wanamaker," humans must mechanize their lives to adapt to the mechanical efficiency of the industrial age. Lawrence, however, refuses: "I am not a moral machine. I don't work with a little set of handles or levers." Lawrence further interprets Franklin's struggle for moral perfection as a destructive mechanization of self. "Franklin proceeded to automatise himself," he writes, "to subdue life so that it should work automatically to his will." The first victims of this automatization were the passions—for Lawrence, the essence of life—which had to be subdued to reason.

[53.] Brooks, *America's Coming-of-Age*, 3–7.

> A man whose passions are the obedient servants of his mind, a man whose sole ambition is to live for the bettering and advancement of his fellows, a man of such complete natural benevolence that the interests of self never obtrude in his works or his desires—such was to be the Perfect Man of the future, in the Millenium of the world. And such a man was Benjamin Franklin, in the actual America.[54]

Much to his discredit, Franklin *was* able to make his passions obey; and, Lawrence continues, enclosed within his self-made "barbed wire moral enclosure," Franklin becomes "a wonderful little snuff-coloured figure, so admirable, so *clever*, a little pathetic, and, somewhere, ridiculous and detestable." Most detestable of all, according to Lawrence, was that Franklin "is never a man. It did not seem to matter at all to him that he himself was an intrinsic being. He saw himself as a little unit in the vast total of society. All he wanted was to run well, as a perfect little wheel within the whole." Thus, when Lawrence reads of Franklin's goal of service to others, he understands only enslavement: "Benjamin doesn't let me have a soul of my own. He says I am nothing but a servant of mankind—galley-slave I call it . . ." Organized and selfless, dedicated to improving human life—something that his own life demonstrates he does not even vaguely understand—Franklin, "[t]he pattern American, this dry, moral, utilitarian little democrat,"[55] presents an ideal of human existence that is harmful to us all.

One commentator describes Lawrence's evaluation as a portrait of Franklin "as the Antichrist of imagination and spirituality, the pattern, shallow dummy American from whom all other such democratic dummies originate." Another points to Lawrence's failure to recognize that the "purely disciplinary virtues" that Franklin is willing to adopt are not "final" but only "instrumental

[54.] Lawrence, *Studies in Classic American Literature*, 10, 16; "Benjamin Franklin," 403, 397. Cf. Alfred Owen Aldridge: "Franklin was dedicated to the principle that man's whole life should be rational in the eighteenth-century sense of methodical, disciplined and ordered" (*Benjamin Franklin*, 4).

[55.] Lawrence, *Studies*, 14; "Benjamin Franklin," 405; *Studies*, 19, 21. Cf. Michael T. Gilmore: "If the principle of delayed gratification, the crown of Franklin's system, built libraries and paved the streets, it also denied man's deepest needs. Its inevitable consequence was the faceless, dehumanized public servant of the last pages of the *Autobiography* . . ." (*The Middle Way*, 63).

virtues."[56] Still, Lawrence's evaluation is one with which many commentators remain in agreement. Mitchell Robert Breitwieser, for example, writes that:

> the gist of Lawrence's critique is not that Franklin attains to clarity . . . but that Franklin's clarity disavows any essential relation with the dense complexity of the person in which it originates by making that complexity into the object of its calculations. Franklin's clarity is "comfortable" because it never admits the tension of contradiction between itself and the remainder of the whole.[57]

Franklin thus presents only a partial analysis of human life. Brian M. Barbour follows in this same vein: "What is at issue here . . . is the vision of life that he so memorably articulated and to which he deliberately lent his enormous prestige." For Barbour, Franklin's vision demonstrated "an implicit forswearing of the need to know life in its depths and, in the long run, a denial that such depths exist." Whether such an evaluation of Franklin is justified remains to be seen. At this point we can only attempt to understand its criticism that Franklin has a too narrow grasp of life. "In Franklin's world the social, public reality is the only reality and the inner self is of no concern," Barbour concludes, "man is what he is perceived to be by his society."[58] As I hope to demonstrate, a broader study of Franklin that elaborates its Pragmatic assumptions will dispel this interpretation.

An even stronger negative evaluation of Franklin was offered by Charles Angoff in his 1931 study. According to Angoff, Franklin's

[56] Buxbaum, "Introduction" to *Critical Essays on Benjamin Franklin*, 9; Herbert W. Schneider, *The Puritan Mind*, 250. Cf. Robert E. Spiller: "it is easy to see why this romantic, mystical Englishman, who doubtless knew no other Franklin than that he extracted from the *Autobiography* and the *Almanacks*, should rebel against what seemed to him to be a self-appointed Chief Justice of Human Nature . . ." ("Benjamin Franklin: Student of Life," 92; cf. Middlekauff, *Benjamin Franklin and His Enemies*, xviii–xix).

[57] Breitwieser, *Cotton Mather and Benjamin Franklin*, 286. Cf. Gerald Stourzh: "Franklin's philosophy does not contain that quality of the tragic sense of life which inevitably presents itself wherever a recognition of the discrepancy of man's actual depravity and the loftiness of his aspirations exists" (*Benjamin Franklin and American Foreign Policy*, 14).

[58] Barbour, "Introduction: Franklin, Lawrence, and Tradition," 1, 4; cf. Barbour, "*The Great Gatsby* and the American Past," 292–93; William L. Phelps, "Two Colonial Americans," 199.

shallow practicality had resulted in a great deal of cultural harm. The fact that Franklin's work achieved "amazing popularity," he writes,

> was probably a colossal misfortune to the United States, for, despite his good fellowship and occasional good sense, Franklin represented the least praiseworthy qualities of the inhabitants of the New World: miserliness, fanatical practicality, and lack of interest in what are usually known as spiritual things. Babbittry was not a new thing in America, but he made a religion of it, and by his tremendous success with it he grafted it upon the American people so securely that the national genius is still suffering from it.

The core of the problem, as Angoff sees it, is Franklin himself. "The essential commonplaceness of the man is in every line" of the *Autobiography*. Angoff continues that Franklin was "incapable of dreaming, of doubting, of being mystified. The only mysteries he understood were those that lent themselves easily to experimentation. The mysteries of poetry, of philosophy, and even of religion were beyond him." This negative evaluation should not suggest that Angoff thought that Franklin was unintelligent. On the contrary, he wrote that Franklin had "an excellent mind." The problem simply was that Franklin was not "a philosopher." Although functioning as a thinker and writer, Franklin was not interested in the life of the mind. "Abstract ideas," Angoff continues, "save those of the corner grocery store, somehow irked him." As evidence for his negative evaluation, Angoff considers Franklin's misguided emphases: "He extolled the virtues of honesty, industry, chastity, cleanliness, and temperance—all excellent things. But it never occurred to him that with these alone life is not worth a fool's second thought. Philosophy, poetry, and the arts spring from different sources." Even in his pursuit of what he takes to be moral perfection (below, 4.1), Franklin's values of moderation and frugality and sincerity are pathetic and shallow. "Not a word about nobility," Angoff laments, "not a word about honor, not a word about grandeur of soul, not a word about charity of mind!" Ultimately, Franklin had "a cheap and shabby soul, and the upper levels of the mind were far beyond his reach." As a consequence, Franklin should not be seen (as Thomas Carlyle had suggested [cf. W10:141]) as "the father of all the Yankees"—which Angoff takes as libel on Thoreau and others—but rather as "the father of all the Kiwanians," who "by his international prominence and by the wide circulation of his two-penny

philosophy . . . left a lasting impression on the national culture."
While granting that his practical virtues were essential in the
building of the new nation, "they were not, then or at any other time
in history, of sufficient human dignity to build a life philosophy on."
Franklin succeeded in pushing his vision on the American people;
and, as Angoff concludes, "[t]he vulgarity he spread is still with
us."[59]

Angoff's evaluation of Franklin both serves as the culmination of
the series of interpretations we have been considering and demon-
strates most clearly what is problematic about all of them. Certainly,
at this point it is simply not enough to reject these specific
interpretations, as in the following response to Angoff: "It would be
difficult to match the debonair ignorance of this violently hostile
essay."[60] Moreover, neither is it enough to attempt to deflect such
attacks by, for example, adopting a social perspective that would
redirect any hostility away from Franklin himself toward the culture
that he represents. I have in mind here such interpretations as that of
V. F. Calverton. "Much ink has been wasted in castigating Franklin
for the cheap and uninspired nature of his doctrines," he writes, "but
when we realize that Franklin did nothing more than crystallize the
spirit and sentiment which characterized the changing petty bour-
geoisie of his time, we can see that it is not Franklin who should be
attacked but the class and the country that produced him."[61] What
needs to be done, rather, is to offer an interpretation of Franklin that
takes a critical look at the sense of human well-being that these
criticisms assume: a vision of human existence that separates cultural
and philosophical values from the natural processes of living, that
privileges the private and the passionate over the cooperative and the
rational, and that questions delayed gratification and the potential
for advancing the common good.

As will become clear in this study, Franklin did value economic
security and strive for a rational ordering in his own life. He sought

[59.] Angoff, *A Literary History of the American People*, 296, 302, 299–300, 296,
304, 309, 304, 310. Cf. Paul Elmer More: "There is a certain embarrassment in
dealing with Franklin as a man of letters, for the simple reason that he was never, in
the strict sense of the word, concerned with letters at all . . . his pen still lacked that
final spell which transmutes life into literature" ("Benjamin Franklin," 129–30; cf.
William Carlos Williams, *In the American Grain*, 153–57).

[60.] Frank Luther Mott and Chester E. Jorgenson, "Introduction" to *Benjamin
Franklin*, clviii.

[61.] Calverton, *The Liberation of American Literature*, 187–88.

to bring clarity and a social perspective to his personal actions, and
he suggested a practical rather than a 'spiritual' life as a model for
those who would follow. However, my own sense of the meaning of
this deliberate ordering suggests a Franklin very different from the
pedestrian and unimaginative figure of these critics. In particular, I
believe that these negative evaluations of Franklin as being exces-
sively social and rationalistic and monetary and practical are better
addressed by a response that defends him as being 'Pragmatic.'
Approached in this way, Franklin would not be automatically
evaluated on some supposed absolute scale of culture or quality
according to which his presumed 'deficiencies' are declared to be
faults and his admitted commonness is presented as his greatest flaw.
Rather, under a Pragmatic approach, it would be possible to main-
tain that, as one commentator has written, "Franklin is in some ways
a most representative man, perhaps the closest thing we have to being
the ordinary man's philosopher and a spokesman for sense that is
genuinely common,"[62] without having this evaluation interpreted as
being somehow negative. Franklin was an individual who, in the
words of another commentator, wrote "not to explicate authoritari-
an mysteries, but to clarify the confusions of men's ordinary
existence,"[63] and who acted to address the common, that is the
shared and simple, problems of ordinary people's lives. By emphasiz-
ing his status as a common person, however extraordinary the events
of his life may have been, we will be better able to grasp the meaning
of his life and thought.

 From such a Pragmatic approach, Franklin would not be criti-
cized as a modestly talented trespasser in the intellectual world.[64]
Rather, he would be appreciated for his very practicality and lack of

 [62] John Griffith, "Franklin's Sanity and the Man behind the Masks," 123. Cf.
Melvin H. Buxbaum: Franklin "makes many of his middle-class descendants
uncomfortable. He seems to stand for much that is unlovely in American life of the
past and the present . . . many of us pride ourselves on the fact that we set our sights
on higher things, which Franklin was either unconcerned with or involved with in
only a grubby, utilitarian way . . ." (*Benjamin Franklin and the Zealous Presbyterians*,
7).
 [63] Perry Miller, *Nature's Nation*, 221.
 [64] Cf. Perry Miller: Franklin "was an ingenious Yankee who promoted a knack
for tinkering and for employing the written word to gain his usually homely ends
into a reputation which, actually, he never had sufficient intellect to sustain—
though he never allowed the world to realize his deficiency!" ("Benjamin Franklin,
Jonathan Edwards," 96).

intellectual distance.[65] This sense of intimate connections with "the common . . . the familiar, [and] the low" has been praised before by Ralph Waldo Emerson, and who had long recognized the practical core in Franklin. In a letter to his aunt, Mary Moody Emerson, the twenty-year-old Emerson wrote that Franklin was "one of the most sensible men that ever lived . . . a transmigration of the Genius of Socrates—yet more useful, more moral, and more pure, and a living contradiction of the buffoonery that mocked a philosophy in the clouds . . ." At times, Emerson suggests that Franklin might be a bit more 'Transcendental'—for example, "Franklin's man is a frugal, inoffensive, thrifty citizen, but savors of nothing heroic"—but for the most part he and Franklin share a spirit of advancing public intellectual life which attempts to improve the common lot of humankind through an understanding of nature and human nature.[66] This Pragmatic spirit also connects Franklin—and Emerson—up with later Pragmatic figures like William James and John Dewey.

Without suggesting that they are the only central figures in the Pragmatic tradition, it is fair to recognize these four figures as bench-marks in the development of American Pragmatism. Moreover, although Franklin's position at the beginning of the development of this tradition is seldom recognized, in this volume I hope to make it more obvious. A brief sketch of Franklin as Pragmatist is possible here. Pragmatism, as a historical strand within American Philosophy, is acutely concerned with the *natural place* of humans, especially with regard to their values; and Franklin presents humans as experiment-ers attempting to understand the limits and possibilities of our natural situation. Pragmatism is also concerned with the nature and meaning of *experience* as our criterion of belief and action, and Franklin advances experiential criteria especially through his hypo-thetical and cooperative challenges to the tyranny of inherited

[65.] Cf. William Cabell Bruce: Franklin was first of all "a man of action . . . a doer of good . . . [who] . . . never lost sight of the sound working principle, which the mere academician or closet philosopher is so prone to forget, that the game cannot be played except with the chess-men upon the board" (*Benjamin Franklin Self-Revealed*, 1:4; cf. Henry A. Beers, *Initial Studies in American Letters*, 36).

[66.] Emerson, "The American Scholar," *Complete Works*, 1:111; *Journals*, 1:375–76; "Milton," *Complete Works*, 12:255. For more on the relationship between Franklin and Emerson, see: Jesse Bier, "Weberism, Franklin, and the Transcendental Style"; Hedges, "From Franklin to Emerson."

dogma. Pragmatism in addition presents a world of *possibility*, in which melioristic efforts are not without purpose, and Franklin was unsurpassed in making room for possibility. Finally, Pragmatism emphasizes *community* as both the source of human well-being and the focus of our endeavors to organize improvements; and Franklin's efforts to advance the common good, especially through the construction of institutions, are at the heart of his public career.

This sketch of Franklin as Pragmatist will be expanded in the four succeeding chapters. In them, I will explore in sequence some central aspects of Franklin's understanding of the nature and workings of science, religion, ethics, and politics to see what sort of philosophic and Pragmatic sense of his life and work emerges. The question of the philosophic meaning of Franklin's Pragmatism as the search for the wisdom to advance human well-being will then be addressed directly in chapter 6. Readers will at some point have to decide for themselves how they wish to interpret Franklin.

CHAPTER 2

Franklin's Life in Science

"BEING IGNORANT IS not so much a Shame," Poor Richard tells us, "as being unwilling to learn" (5:474). If there is anything that can be said of Franklin without fear of contradiction, it is that he was willing to learn about virtually anything that had to do with the workings of the world. In this chapter, we will begin with a general consideration of the nature of eighteenth-century science. Then we will take up Franklin's breakthrough work on electricity and lightning. This will be followed by a general survey of his work in science, considering such areas of interest as: the physics of heat, geology, navigation and flight, music, and medicine. Finally, we will consider Franklin's ideas on the social role of a working scientist and the nature of scientific inquiry. Throughout, instances of his Pragmatism will be apparent.

2.1. Natural Philosophy in the Eighteenth Century

Any discussion of natural science in the eighteenth century is necessarily a discussion of the broad notion of natural philosophy. Our more narrow contemporary understandings of 'science' as the diversified and cooperative inquiry into the phenomena of the natural world, and of 'scientist' as an individual with years of specialized training and a career in an institutionalized laboratory setting, post-date Franklin.[1] In his day, 'natural philosophers' carried forward their interest in understanding the complex workings of the world in semiformal clusters of like-minded generalists who inquired using available materials into the accessible aspects of such topics as medicine, botany, mathematics, chemistry, mechanics, and geogra-

[1] Sydney Ross suggests that the clear split between the meanings of 'philosophy' and 'science' took place in English only after the year 1850 (cf. "*Scientist*: The Story of a Word").

phy (cf. 2:381). Perhaps the closest that these natural philosophers came to our specialized and professionalized institutional practice of science was with their keen interest in the publication of their research results through various national societies.[2]

This generalist level of engagement seems to be in line with the most that could be expected of natural philosophers in pre-Revolutionary America. Franklin was, according to one commentator, "a pioneer in a scientific wilderness, as others were in the primitive Colonies."[3] Another commentator writes of the potential research conditions in this 'wilderness,' "Americans were handicapped in their scientific endeavors by a lack of equipment . . . there was not a single scientific laboratory in the colonies . . . even a telescope was a treasure . . ." As this commentator continues, "Franklin performed his most notable experiment with nothing more than a kite."[4] That the colonists recognized the very real limitations of their situation can be seen in the comment that Franklin himself offers in 1753: "it is not without Reluctance that the Europeans will allow that they can possibly receive any Instruction from us Americans" (4:463).[5] As we look back on their situation, we can recognize that the presumed superiority of the European researches was itself quite marginal, while still allowing

[2] Cf. J. L. Heilbron: "A mix of these characteristics—sporadic engagement in experiments and demonstrations, reliance on wide-ranging analogy and an appealing style, active membership in scientific societies, concern with popularization and natural religion, and hope for utility—defines not the modern scientist but the natural philosopher in the Age of Reason" ("Franklin as an Enlightened Natural Philosopher," 197; cf. Antonio Pace, *Benjamin Franklin and Italy*, 71).

[3] Howard McClenahan, "Franklin, the Philosopher and Scientist," 172.

[4] John C. Miller, *This New Man, the American*, 497. Cf. Thomas J. Wertenbaker: "While Newton was discovering the laws of gravity, Harvey was studying the circulation of the blood, Milton, Jonson, Defoe, Pope, and others were writing their immortal works, Americans were busy chiefly with the axe, the hoe, and the saw" (*The Golden Age of Colonial Culture*, 1; cf. Raymond Phineas Stearns, *Science in the British Colonies of America*, 4).

[5] Some commentators see an advantage to Franklin that resulted from his scientifically backward situation in America. Cf. Daniel Boorstin: "On a rare occasion, an American could discover something, even in physics, simply because he was less learned than his European colleagues. Ignorance of the respectable paths of scientific thought might leave him freer to wander off wherever facts beckoned . . . To exploit naivete in a subject as cumulative as physics required great genius, but at least one colonial American—Benjamin Franklin—was able to do so . . . his achievement illustrated the triumph of naivete over learning" (*The Americans*, 1:251–52; cf. I. Bernard Cohen, *Benjamin Franklin's Experiments*, 70–71; J. L. Heilbron, *Electricity in the 17th and 18th Centuries*, 329–30, 334–35).

that the relative difference was strongly felt on both sides of the Atlantic.

Two further points are in order with regard to the scientific environment in the American colonies. The first is that as the eighteenth century progressed Franklin's home base of Philadelphia became increasingly Europe's most prominent outpost in the Western hemisphere, a place where a rising level of scientific sophistication became possible.[6] Philadelphia was also consciously attempting to make itself the center of intellectual life in the New World, whether in the words of Franklin "the Seat of the American Muses" (2:405), or of his friend, Joseph Breitnall, "the future Athens of America."[7] William Penn's capital city was an especially tolerant place by eighteenth-century standards; intellectual life was relatively free, and religions seldom clashed with each other or with those working in natural philosophy. It was, in addition, a cosmopolitan city with links through its various commerical ties to the recognized scientific centers of Europe. Philadelphia was also a quickly growing city, coming to self-consciousness in part through the recognition of and response to problems like water pollution, yellow fever, and crime.[8] Not insignificantly for our concern with Franklin, the mood of Philadelphia was generally a democratic one[9] and the aim of much of its science was utilitarian. The fact that, as one commentator notes, Philadelphia was a city of great intellectual activity but little scholarship[10] is, from this point of view, hardly a criticism. Thus,

[6.] Cf. John C. Van Horne: "Franklin was in the right place at the right time to encourage people to work collectively to accomplish laudable purposes—a fact that contributed mightily to his reputation. He arrived in Philadelphia as a young, energetic, and imaginative man. He arrived in a city that was poised on the verge of an era of incredibly rapid growth and that would prosper in an unprecedented fashion" ("Collective Benevolence and the Common Good in Franklin's Philanthropy," 431).

[7.] Reprinted in 1:321. For more on Philadelphia and its scientific atmosphere, see: Whitfield J. Bell, "The Scientific Environment of Philadelphia, 1775–1790"; Bridenbaugh and Bridenbaugh, *Rebels and Gentlemen*, 1–28, 304–58; John C. Greene, *American Science in the Age of Jefferson*, 37–59; Brooke Hindle, *The Pursuit of Science in Revolutionary America, 1735–1789*; Frederick B. Tolles, *Meeting House and Counting House*, 205–29; Wertenbaker, *The Golden Age of Colonial Culture*, 62–84.

[8.] Cf. A. Michal McMahon, "'Small Matters': Benjamin Franklin, Philadelphia, and the 'Progress of Cities.'"

[9.] Cf. Carl Bridenbaugh and Jessica Bridenbaugh: "Philadelphia presented therefore the outstanding, probably the first, example in the Western world of a culture resting on a broadly popular base" (*Rebels and Gentlemen*, x; cf. 359–72).

[10.] Cf. Baltzell, *Puritan Boston and Quaker Quaker*, 140.

whatever distance needs to be recognized between Philadelphia and the more advanced intellectual life of Europe, the gap was growing smaller with every passing year.

Second, to admit that America lagged behind in the more technical aspects of scientific research is not to suggest any lack on the part of its residents in what is arguably more important: the thirst for scientific knowledge. Philadelphians shared equally in this spirit of finding out how the natural world works with natural philosophers elsewhere. It was, as Franklin writes, "the Age of Experiments" (A:257); and uncovering the mysteries of engineering and astronomy and behavior and agriculture all drew the attention of individuals with a thirst for explanations. Whitfield J. Bell comments that in this enlightened eighteenth-century world, "[l]aymen discussed medical principles as they did eclipses, humming birds, and Greek forms of government." Bell continues that overall the eighteenth century "was an age of brilliant amateurs, when an English dissenting clergyman [Joseph Priestley] discovered oxygen, a German music-master [William Hershel], self-taught in astronomy, found another planet [Uranus], and a Philadelphia printer [Franklin] laid the foundation of the new science of electricity." In the eighteenth century, the thirst for scientific knowledge led to inquiries throughout the Western world:

> From St. Petersburg to Manchester, from Palermo to Edinburgh, Europe was a bubbling cauldron of ideas. No man of any respectability at all failed to toss his contribution into the pot. Literary and scientific societies were formed; papers were written, read, and printed; transactions were issued; grand plans for an empire of science, reason, and enlightenment were projected—on the Delaware as over the seas.[11]

Natural philosophy, while not yet become science, was beginning to blossom in the hands of amateur researchers throughout the world of the Enlightenment.

This spirit of amateur inquiry brought with it both advantages and disadvantages. On the negative side, nascent science and pseudo-science frequently interpenetrated in the hands of enthusi-

[11.] Bell, *The Colonial Physician and Other Essays*, 119; "The Scientific Environment of Philadelphia, 1775–1790," 6–7.

astic but unskilled neophytes (and the occasional charlatan). As a result, Bell notes, "truth and nonsense alternated."[12] In this climate, the theoretical and the complex were particularly vulnerable; the former to neglect, the latter to limited imagination. On the positive side, however, the New World played a special role as a source of primary materials for biological study. In the ongoing Linnean project of collection and classification, the New World proved to be a font of novelties where any hilltop or lake or cave might yield a new specimen. "Because America afforded an abundance of exotic plants and animals unknown to Europeans, Americans excelled in botany and zoology," John C. Miller continues. "Moreover, the collecting and, to a lesser extent, cataloguing were perfectly suited to the talents and equipment of the amateur scientists who constituted the personnel of the American scientific world."[13]

While admitting that these eighteenth-century natural philosophers were amateurs, it is important to recognize that however crude their situation and limited their eventual contributions, it was still possible for them to pursue their work seriously. While these dedicated natural philosophers may have had limited preparation and may have performed their researches in time stolen from their other activities—as Franklin notes "business sometimes obliges one to postpone philosophical amusements" (4:341)—their interest in inquiry was scientific rather than personal. They strove to uncover the reasons behind the workings of nature, not just fill their idle hours. They wanted to advance science and human well-being rather than, like mere scientific 'dilettanti' or 'virtuosi,' to look good. J. A. Leo Lemay writes:

The true scientists were interested in pure science and in applied science. They were interested in such questions as, Of what use is this knowledge and how may it benefit mankind? On the other hand, the virtuoso was interested in science as the ornament of a gentleman. An interest in science was considered one of the distinguishing characteristics of a gentleman, almost as necessary as foreign travel and the ability to dance proficiently; like a taste for antiquities and

[12] Bell, "The Scientific Environment of Philadelphia, 1775–1790," 8.
[13] Miller, *This New Man, the American*, 495–96.

paintings, it was a desideratum for every well-trained gentleman. But science was supposed not to be vulgarly useful.[14]

Franklin was, of course, no 'gentleman,' either by inclination or economic status; and his researches were invariably concerned with advancing human well-being.

The world of the Enlightenment was a new world. Its natural philosophers turned away from the cosmology that they had inherited, the Aristotelian vision that saw the natural world of existence to be maintained by the continuous and direct intervention of a Prime Mover who kept matter, itself 'naturally' at rest, in motion. With the ongoing developments in science, it seemed possible to these new natural philosophers to eventually explain all the workings of nature as the result of immutible laws of motion, gravity, and so on, acting mechanically upon physical objects.[15] Further, these natural laws were assumed to have analogues in human nature. All of these natural and human regularities were assumed to be uncoverable through experience. The possibility of progress through empirical study was the central assumption of the Enlightenment. In the words of Kerry S. Walters:

> The study of nature provided evidence of order, harmony, and regularity in the physical cosmos. The study of reason revealed the same attributes in the human faculty of understanding. Reality more and more appeared as a vast continuum whose laws applied with clocklike precision to all facets of existence. And the meticulous charting of the lawful operations of the cosmic clockwork, all felt assured, would inevitably lead to perfection in human knowledge, virtue, and happiness.[16]

All who became infected with this new scientific perspective left behind a static world and a vengeful God, assuming that, as Miller

[14.] Lemay, "Benjamin Franklin: Universal Genius," 14. While maintaining the distinction between the dedicated amateur scientist and the dilettante is important, we need to remember that the term, 'virtuoso,' did not carry a universally negative connotation. Franklin's call for a scientific society, that we shall consider (below, 2.4), describes the potential members as "Virtuosi or ingenious Men" (2:381) and Cotton Mather's original title for *The Christian Philosopher* was "The Christian Virtuoso" (cf. Winton U. Solberg: "Introduction" and notes to *The Christian Philosopher*, xliii; 11 n.25; Michael Kraus, *The Atlantic Civilization*, 161).

[15.] Cf. Arthur H. Compton, "The World of Science in the Late Eighteenth Century and Today," 299–302.

[16.] Walters, *The American Deists*, 10.

writes, "a benevolent Deity had arranged that men's discoveries in pure science—that is, unlocking the mysteries of nature—would lead inevitably to discoveries of practical value to mankind."[17]

In the background as the inquiries of these amateurs were developing into science, we find Bacon and Newton and Locke, the three central prophets of this new scientific vision.[18] The first of these is Francis Bacon (1561–1626), of whom Franklin writes: "He is justly esteem'd the father of the modern experimental philosophy" (3:339). Bacon was the author of *Instauratio Magna* of 1620 that included the *Novum Organum*. In this and other works, Bacon laid out a new approach to nature, an approach based on empiricism and rooted in inductive, rather than deductive, logic. The inherited, deductive approach Bacon saw as harmful: "The logic now in use serves rather to fix and give stability to the errors which have their foundation in commonly received notions than to help the search after truth. So it does more harm than good." Bacon saw in the empirical and inductive approach a means that first of all undercuts the authority of the past: "For let a man look carefully into all that variety of books with which the arts and sciences abound," he writes, "he will find everywhere endless repetitions of the same thing, varying in the method of treatment, but not new in substance . . ." In the place of this certification by authority, Bacon's empirical and inductive approach fostered a regard for the power and usefulness of knowledge. Thus he writes that the aim of his new work is to refocus human thinking: "in behalf of the business which is in hand I entreat men to believe that it is not an opinion to be held, but a work to be done; and to be well assured that I am labouring to lay the foundation, not of any sect or doctrine, but of human utility and power."[19]

Second in chronological order—although primary in importance for the age that adopted his name—is Isaac Newton (1642–1727), whom Franklin calls "the prince of astronomers and philosophers"

[17.] Miller, *This New Man, the American*, 500.

[18.] Cf. Thomas Jefferson: "I consider them [Bacon, Locke, and Newton] as the three greatest men that have ever lived, without any exception, and as having laid the foundation of those superstructures which have been raised in the Physical and Moral sciences . . ." (Jefferson to John Trumbull, 15 February 1789, *Writings*, ed. Peterson, 939–40).

[19.] Bacon, *Selected Writings*, 463, 428, 437. Cf. James Hayden Tufts on the vision of Bacon: "Let man turn from metaphysics and theology to nature and life; let him follow reason instead of instinct or prejudice. 'Knowledge is power'" (Dewey and Tufts, *Ethics*, 154; cf. Walters, *The American Deists*, 7–8).

(3:250). Newton's *Philosophiae Naturalis Principia Mathematica* of 1687 and the *Optics* of 1704 demonstrated what Bacon had earlier promised: that, if we hope to understand the workings of the natural world, observation and experimentation and mathematical inductions were more productive than speculations based upon deductive reasoning from assumed truths. As Newton writes, "the main business of natural philosophy is to argue from phenomena without feigning hypotheses . . ." Rather, his analytic method "consists in making experiments and observations, and in drawing general conclusions from them by induction . . ." In his work, he uncovered universal laws that displayed the larger harmony of nature as a wondrous machine with a distant Mechanic as its first cause. As an empirical perspective, Newton's work also anticipated the need for refinement over time. "*In experimental philosophy,*" he wrote, "*we are to look upon propositions inferred by general induction from phenomena as accurately or very nearly true, notwithstanding any contrary hypotheses that may be imagined, till such time as other phenomena occur, by which they may either be made more accurate, or liable to exceptions.*"[20] Perfection, if it is to be sought, will be found in the wondrous system of nature, not in our fragmentary and incomplete accounts.

The third central Enlightenment figure is John Locke (1632–1704), whom Franklin calls "the Newton of the *Microcosm*" (3:259). Locke's *Essay concerning Human Understanding* of 1690, that Franklin read when still a youth in Boston (A:64), applied these analytical methods to the understanding of the human mind. Of particular interest to Locke was attempting to determine "what *objects* our understandings were, or were not, fitted to deal with." His inquiries led him to reject innate ideas and to propose on the contrary an empirical psychology grounded in the assumption that the mind is originally "white paper, void of all characters, without any ideas . . ." The mind is thus furnished by experience, by the individual encounters of daily living whose impacts it refines and

[20.] Newton, *Optics*, 528, 543; *Principia Mathematica*, 271. Cf. John Herman Randall, Jr.: "Newton's name became a symbol which called up the picture of the scientific machine-universe, the last word in science, one of those uncriticized preconceptions which largely determined the social and political and religious as well as the strictly scientific thinking of the age. Newton *was* science, and science was the eighteenth-century ideal" (*The Making of the Modern Mind*, 260; cf. Kerry S. Walters, *The American Deists*, 8–9; I. Bernard Cohen, *Franklin and Newton*; Frederick Edward Brasch, "The Newtonian Epoch in the American Colonies").

remembers.[21] The explanatory and investigative power of this new vision is summarized by Kerry S. Walters: "The New Learning's emphasis on experience and nature, then, was founded on Bacon's advocacy of instrumental reason, Newton's demonstration that physical nature conforms to universal laws, and Locke's analogous claim in the realm of human psychology."[22] Collectively their work grounded the Enlightenment's stance that the natural world was fundamentally rational and thus open to the rational inquiries of individuals like Franklin.

To present Franklin in the company of this august trio as a fully worthy Enlightenment figure might seem initially mistaken; but it was Newton, the trio's brightest light, with whom Franklin's contemporaries compared him. Joseph Priestley writes in 1767, for example, that Franklin's demonstration of the identity of electricity and lightning was "the greatest, perhaps, that has been made in the whole compass of philosophy, since the time of Sir Isaac Newton . . ."[23] To suggest that Franklin was seen as the 'new' Newton is not to imply, of course, that he in any sense had overcome or displaced Newton. It is simply to suggest that Franklin carried Newton's theoretical work forward into a new and more practical area.[24] Still, recognizing the range of Newton's work, it may be more accurate to say that what Franklin did was to emphasize one Newton over another, the Newton of the *Optics* over the Newton of the *Principia*.

[21.] Locke, *An Essay concerning Human Understanding*, 1:9, 121. Cf. Frank Luther Mott and Chester E. Jorgenson: "Conceiving the mind as *tabula rasa*, discrediting innate ideas, Lockian psychology undermined such a theological dogma as total depravity . . . and hence was itself a kind of *tabula rasa* . . ." ("Introduction" to *Benjamin Franklin*, xvii; cf. Kerry S. Walters, *Rational Infidels*, 17–19).

[22.] Walters, *The American Deists*, 10. Cf. Lawrence A. Cremin: "A flood of pamphlets, periodicals, almanacs, children's books, and manuals of advice deliberately undertook to instruct the public in the precepts of 'Lord Bacon, the incomparable Mr. Newton, and the great Mr. Locke,' as the litany went . . ." (*American Education*, 365; cf. Walters, *Rational Infidels*, 12–21).

[23.] Reprinted in 4:368; cf. Cohen, *Franklin and Newton*, 37; Mott and Jorgenson, "Introduction" to *Benjamin Franklin*, cxiv.

[24.] Cf. John C. Miller: Franklin "challenged the absolute ascendancy Newton had long enjoyed in the world of science. By the middle of the eighteenth century, many scientists had come to believe that too much reliance had been placed upon mathematical ingenuity at the expense of experimentation and observation. As a result, more attention began to be paid to electricity, geology, and chemistry and to the experimental method. Benjamin Franklin's scientific career foreshadowed this broadening of the spectrum of science and the importance attached to experimentation . . . He came close to replacing Newton as the symbol of science and its importance for mankind" (*This New American, the American*, 501).

I. Bernard Cohen writes that it is "one of the paradoxes of Benjamin Franklin's career that his contemporaries considered him to be a foremost Newtonian scientist even though he did not have the skill or training to be able to read Newton's *Principia*."[25] The fact of Franklin's inability to deal with the *Principia* should not surprise us: lacking almost all formal education, he quite understandably lacked the mathematical background requisite to understand fully Newton's *Principia*, the keystone of eighteenth-century theoretical physics.[26] The matter becomes less paradoxical, however, when we follow Cohen further: "The very fact that Franklin was referred to as a 'Newton' indicates that the concept of 'Newtonian' science in the eighteenth century had a connotation quite different from that which is generally found in our present-day histories." The Newtonian perspective then was broader than it is at present, when the emphasis upon theoretical physics has become primary. The meaning of Newtonianism in the early eighteenth century drew more upon his *Optics*; and, unlike the *Principia*, twice removed from many potential readers by the requirements of both Latin and mathematical facility, the vernacular *Optics* was more approachable to Franklin and his colleagues in Philadelphia (cf. 3:237; 4:354). "Written in a graceful English rather than in the severe Latin of the *Principia*," Cohen continues, "the *Opticks* was almost totally devoid of mathematics." The differences between the two volumes go further, as Cohen indicates: "Newton, in the *Opticks*, had given for each theorem a 'proof by experiment,' whereas in the *Principia* he had given only mathematical proofs; but the eighteenth-century Newtonians presented the dynamical principles based on experiment rather than geometry, in a large number of treatises." Their interests were experimental rather than mathematical; and, as Cohen again notes, "the *Opticks* was a work readily accessible to experimental scientists . . ." Thus, Cohen's solution to the paradox of Franklin as a

[25.] Cohen, *Benjamin Franklin's Science*, 14.

[26.] For Franklin's admissions of mathematical weakness, see: 3:67–68; 89–93; 4:463–65. Franklin was not alone here. Cf. Verner Winslow Crane: "Few men in the colonies pretended to master it [the *Principia*] and certainly Franklin was not one . . . Men read popularizations of the work . . ." (*Benjamin Franklin and a Rising People*, 40). At least one of these popularizations of Newton's experimental philosophy that was available to Franklin was *A View of Sir Isaac Newton's Philosophy* (1728) by Henry Pemberton, whom Franklin had met in London (cf. A:97; 1:249 n.4; Cohen, *Franklin and Newton*, 209–10; Carl L. Becker, *The Heavenly City of the Eighteenth-Century Philosophers*, 61).

nonmathematical Newtonian was that Franklin's "Newtonian science was derived from the *Opticks*, which for eighteenth-century experimental scientists was a manual of the experimental art" and Franklin's place was thus as "a leading exponent of the Newtonian school of experimental Newtonian natural philosophy."[27]

In this Enlightenment context of a rational world whose secrets could be progressively uncovered to the advancing well-being of humankind, Franklin served for many as the primary example of the scientific inquirer. This life of learning from everyday experiences, recognizing problems and envisioning possible solutions, hypothesizing and testing, and publicizing his results in clear prose suggested to many the image of the 'new Newton.' When we recognize how far Franklin was able to proceed in his experimental work with only minimal mathematical ability, we need to credit particularly his extraordinary scientific inventiveness. "His prime scientific faculty," writes Stuart P. Sherman, "was the imagination which bodies forth the shapes and relations of things unknown—which constructs the theory and the hypothesis. His mind was a teeming warren of hints and suggestions."[28] And, while Franklin did not develop the implications of his work in any theoretical fashion, his failure to do so did not cancel out these extraordinary experimental accomplishments. It was these accomplishments, moreover, that brought Franklin to prominence as, in the words of another commentator, "the prototype of the typical American scientist and engineer—the enthusiastic, resourceful, and ingenious searcher for new facts and relationships, who relies largely upon others for their systematic elucidation, but is alert to put the new knowledge to useful work."[29]

Normally at present, we fail to see Franklin as a 'real' scientist. One part of this failure is our own narrow conception of the term that puts the inclusion of broadly interested amateurs like him in doubt. The point is not whether Franklin was a scientist in our

[27.] Cohen, *Franklin and Newton*, viii; *Benjamin Franklin's Science*, 14; *Franklin and Newton*, x; *Benjamin Franklin's Science*, 14–15; *Franklin and Newton*, 14; cf. *Franklin and Newton*, 3–26, 177–98, 205–362; *Science and the Founding Fathers*, 141; John Herman Randall, Jr., *The Making of the Modern Mind*, 253–66; Randall, *The Career of Philosophy*, 1:574–82.

[28.] Sherman, "Franklin," 108; cf. Adrienne Koch, *Power, Morals, and the Founding Fathers*, 16; Van Doren, *Benjamin Franklin*, 171; Spiller, "Benjamin Franklin: Student of Life," 88.

[29.] Compton, "The World of Science in the Late Eighteenth Century and Today," 296.

contemporary sense of the term. Clearly he was not. As J. L. Heilbron suggests, his value was as an amateur generalist:

> Franklin had no specialized training in any branch of science; he pursued no discipline and did not work steadily at any research, except in electricity . . . His contributions to natural knowledge ranged from casual bright ideas to formal theories, from driblets on the Gulf Stream to the fountainhead of electrostatics. The wellspring of his creativity lay in the play of his great power of analogy across all the arts and sciences.[30]

To fully appreciate Franklin's life in science, therefore, we must adopt a looser, more historically sensitive understanding of the term that continues to leave room for the generalist natural philosopher. A second aspect of our problem of seeing Franklin as a scientist is that we usually tend to misunderstand the centrality of his interest in science. "The usual portrayal of Franklin presents him as a political figure who, in his spare time, dabbled in science," Cohen writes. "His own century, on the other hand, considered him a scientist who had entered the arena of international politics, and many of his contemporaries wrote to him beseeching him to give up the illusory career of international diplomacy and domestic politics in order to return to the more 'useful' career of scientific investigator."[31] This second aspect of our failure to understand Franklin as a scientist also indicates our too easy acceptance of a bifurcation of the realms of science and politics, especially if we hope to understand eighteenth-century thinkers who sought to develop social and moral science. A third aspect of our failure to understand Franklin is that he is generally misportrayed in histories of American thought as an inveterate gadgeteer or tinkerer, or perhaps a clever inventor, and thus not as a 'real' scientist.[32] Rejecting for the moment the dichotomy, it is clear that Franklin often focussed upon the applications of his work in science to the concerns of everyday life. Some of his inventions proved to be of lasting social value: like the "Double Spectacles" or bifocals (W9:265; cf. 337–38), a flexible catheter (4:385–87), the writing

[30.] Heilbron, "Franklin as an Enlightened Natural Philosopher," 196.

[31.] Cohen, "Benjamin Franklin as Scientist and Citizen," 474.

[32.] Cf. Clinton Rossiter: "Franklin is remembered as a tinkering inventor . . . more often than as conscious scientist" (*Seedtime of the Republic*, 285; cf. Dixon Wecter, *The Hero in America*, 62–63; I. Bernard Cohen, *Benjamin Franklin: Scientist and Statesman*, 46; Crane, *Benjamin Franklin and a Rising People*, 46).

chair, the lightning rod, and the Pennsylvania Fire-Place.[33] Other of his contrivances met with less enduring success: like his new alphabet (15:173–78, 216–20; W9:518), the glass harmonica, the fanning rocker, the chair/step-ladder, the three-wheel clock (8:216–19; W9:316), and the Long Arm, "an Instrument for taking down Books from high Shelves" (W9:483).[34] The problem comes from our willingness to separate the process of invention from the rest of science. Up to at least World War II, according to I. Bernard Cohen, the historical portrait of Franklin failed to appreciate the importance of his contribution to theoretical science: "Invention, yes; practical or applied science, yes; but pure or basic science, or fundamental research? Not really." The reality, however, was quite different. As Cohen continues:

> In his own lifetime, Franklin was generally acknowledged by contemporary scientists to be one of the truly great scientific luminaries of the age. Joseph Priestley declared that Franklin's book on electricity bade fair "to be handed down to posterity as expressive of the true principles of electricity; just as the Newtonian philosophy is of the true system of nature in general." Franklin was awarded every scientific honor that his contemporaries had the power to bestow.[35]

Further, we might note that recognition that Franklin was working at the highest levels of scientific inquiry can be found in the fact that during the course of his long life he was elected to membership in virtually every existing scientific association.

Perhaps one more primary aspect of our inability to see Franklin as a 'real' scientist needs to be considered. This final reason is that his discoveries passed so quickly into the realm of what we consider 'common sense.' The results of his scientific endeavors at the cutting edge of electrical research, for example, are now the material of secondary education in general science.[36] We can perhaps capture

[33.] The final two will be considered further in 2.2 and 2.3 respectively.

[34.] For a recent brief listing of his contributions, see: Esmond Wright, *Franklin of Philadelphia*, 356–57.

[35.] Cohen, *Benjamin Franklin's Science*, 2; "In Defense of Benjamin Franklin," 36; cf. *Benjamin Franklin: Scientist and Statesman*, 11; *Franklin and Newton* 27–41.

[36.] Cf. Raymond Phineas Stearns: "Around the world today school children master scientific laws which the greatest minds of the colonial era were only beginning to comprehend" (*Science in the British Colonies of America*, 5). This point is not just relevant to Franklin, of course. As Cohen writes, "since knowledge in science is cumulative, every college senior majoring in physics knows more about physics than Newton . . ." (*Franklin and Newton*, 39).

some sense of the original power of his work if we explore his scientific writings less for specific content and more for method. We find in his studies in natural philosophy, in the words of Charles William Eliot, "remarkable directness, patience, and inventiveness, absolute candor in seeking the truth, and a powerful scientific imagination."[37] In the consideration of Franklin's life in science that follows, we will find his extraordinary ability to demonstrate through his reports a modesty in and carefulness of assertion, a clarity and simplicity of style, and always a fundamental interest in finding out, through cooperative inquiry, just how the world works. As he writes at one point: "If my Hypothesis is not the Truth itself, it is at least as naked: For I have not with some of our learned Moderns disguis'd my Nonsense in Greek, cloth'd it in Algebra, or adorn'd it with Fluxions" (4:442).

It is a central feature of Franklin's work in science that he stayed close to what John Dewey later called "primary experience," the objects and events of the natural world as distinct from their formulations in intellectual abstraction that Dewey calls "secondary experience."[38] In the following passage, Robert E. Spiller no doubts goes too far in suggesting that Franklin was uninterested in abstractions; but clearly Spiller's general approach is correct:

> Phenomena themselves first attracted him—smoky chimneys, the common cold, oil on water, lightning striking barns and steeples. Then followed a few simple experiments to determine the conditions under which each operated. When he had satisfied his curiosity on this point, he did not, as would most experimental scientists, formulate a law or hypothesis and push the problem further into theoretical regions. Rather, he turned about and sought to harness the lightning with rods and wires, make a ladder for his bookshelves, or work out a system of diet and exercise that would check the common cold. Such abstractions as atoms, calories, and vitamins would have had no interest for him. But he was tireless in the observation of phenomena.[39]

[37.] Eliot, *Four American Leaders*, 17.

[38.] Dewey makes a distinction "between gross, macroscopic, crude subject-matters in primary experience and the refined, derived objects of reflection [in secondary experience]. The distinction is one between what is experienced as the result of a minimum of incidental reflection and what is experienced in consequence of continued and regulated reflective inquiry" (*Experience and Nature*, 15; cf. James Campbell, *Understanding John Dewey*, 72–75).

[39.] Spiller, "Benjamin Franklin: Student of Life," 88.

Included in this interest in phenomena was a strong desire to find the causes for the workings of nature when they could be found. To know the causes of natural phenomena, Franklin writes, makes us more useful to ourselves and to others: "Workmen, ignorant of Causes, are like Quacks, always tampering; applying the Remedy proper in one Case to another in which it is improper, as well as attempting the Cure of what from the Nature of Things is not to be cured" (10:29). While Franklin was interested in finding the meanings of phenomena, especially their places within the various causal chains, he had little interest in taking these abstractions any further into a theoretical realm. His interest remained in the experiential applications of science.[40] Franklin moreover would seem to have been little troubled by any evaluation of his work as being short on theory. He writes in 1750, for example, that it is not of "much Importance" to us

> to know the Manner in which Nature executes her Laws; 'tis enough, if we know the Laws themselves. 'Tis of real Use to know, that China left in the Air unsupported, will fall and break; but how it comes to fall, and why it breaks, are Matters of Speculation. 'Tis a Pleasure indeed to know them, but we can preserve our China without it. (4:17)

Thus, if the experiments work successfully, we need not understand the theoretical basis of their working, especially if the pursuit of this understanding were likely to take us away from advancing valuable practical applications.[41]

His emphasis was thus contrary to our normal approach to scientific analysis that focusses more comfortably on intellectual abstractions, often to the point of losing interest in the practical results. Franklin's Pragmatic inclination in no way rejected the potential usefulness of intellectual abstractions. He writes, for example, that "a new appearance, if it cannot be explain'd by our old principles, may afford us new ones, of use perhaps in explaining some other obscure parts of natural knowledge" (10:159–60). His

[40.] Cf. Robert E. Spiller: Franklin "believed that discovered truth was valuable only after it had been reapplied in the light of reason to the improvement of life on this earth" ("Franklin on the Art of Being Human," 309).

[41.] We need to remember, of course, that this seeming lack of concern was with gravitational matters that in his world—that is, prior to the initial manned flights that he witnessed in France in 1783—*were* for the most part astronomical questions that were speculative and useless.

emphasis, however, was at the more Pragmatic end: given a limited amount of time and energy we should concentrate our inquiries close to practical results. In 1783 he writes to another colleague in experimentation: "I would recommend it to you to employ your time rather in making experiments, than in making hypotheses and forming imaginary systems, which we are all too apt to please ourselves with, till some experiment comes and unluckily destroys them" (W9:53). Franklin had, of course, long recognized the attractiveness of such system-building. He writes in 1752, for example, that he himself had "too strong a penchant to the building of hypotheses" against which he had to struggle with "patience and accuracy in making observations, on which, alone, true Philosophy can be founded" (4:341). Five years earlier, he had similarly written that in the ongoing process of experimentation, "how many pretty Systems do we build, which we soon find ourselves oblig'd to destroy!" (3:171).

2.2. Electricity and Lightning

The question of Franklin as tinkerer returns in a consideration of his writings on electricity and lightning. We often have a sense of his work in electricity that makes central the whimsical image of the middle-aged experimentalist romping through a field with his kite in a thunderstorm. To get a more accurate understanding of his contribution, it is necessary to examine his electrical work more fully and in the context of the even less sophisticated work of his contemporaries. In the course of such an examination, we may still find his electrical writings painfully full of guess-work, overlooked problems, and antique notions like "Electrical Fire" (3:127); but we will certainly find as well the encounter of a real inquirer with one of the central mysteries of the natural world. For some of his contemporaries, the questions that Franklin was addressing were supernatural; and, as we shall see later in this section, the theological aspects of the issue never strayed far from the center of the discussion.

Arthur Compton writes that "Franklin stepped into a field of study that was of very live interest among amateurs in science but was for the most part thought of as a novel form of parlor entertainment." Describing this mood of electricity-as-entertainment, Compton continues:

One reads of the Burgomeister of Danzig lighting with an electric spark a candle that he had just blown out, and of igniting alcohol vapor by sparks drawn from an electrified jet of water. People line up to receive the jolt of an electric discharge. It would seem that the appearance of improved machines for producing frictional electricity was a profitable business chiefly because of orders from those for whom these experiments were a fascinating hobby.[42]

Such interests were, as we have seen, far removed from Franklin's focus. When he sketches out the course of his electrical inquiries in the *Autobiography*, Franklin tells us that he was originally drawn to the study of electricity by his attendance at demonstrations by Archibald Spencer in Boston in 1743 and in Philadelphia the next year. So intrigued by these demonstrations was Franklin that he bought all of Spencer's equipment in order to experiment with electricity himself (cf. A:196). In 1746 he turned forty years old; and he began to take steps to turn his business affairs over to his partner, David Hall, so that he would have more "Leisure to read, study, make Experiments, and converse at large with such ingenious and worthy Men as are pleas'd to honour me with their Friendship or Acquaintance, on such Points as may produce something for the common Benefit of Mankind, uninterrupted by the little Cares and Fatigues of Business" (3:318). As part of these 'experiments,' he took the opportunity of a gift to the Library Company of Philadelphia from Peter Collinson—the London Quaker merchant and member of the Royal Society who served as the book agent of the Library Company—of "a Glass Tube, with some Account of the Use of it in making such Experiments" (A:241). Making use of this apparatus and additional equipment fashioned locally or supplied in 1747 by the proprietor, Thomas Penn (cf. 3:164–65), Franklin set up what amounted to the first scientific research laboratory in America. He was assisted in these experiments by a cooperative team of colleagues, including Ebenezer Kinnersley, Thomas Hopkinson,

[42] Compton, "The World of Science in the Late Eighteenth Century and Today," 296. Cf. Whitfield J. Bell: "Franklin found electricity something of a spectacular parlor game; he left it a science, with a body of observations, a series of experiments, some proven laws, and a nomenclature" ("The Father of All Yankees," 72; cf. Cohen, *Benjamin Franklin's Experiments*, 47–56; Lemay, "Benjamin Franklin: Universal Genius," 19).

and Philip Syng.[43] Between 1747 and 1751, when other demands on Franklin's life forced him to limit his involvement, the Philadelphians proceeded with a series of fundamental experiments into the nature of static electricity, experiments that combined imaginative innovations and painstaking diligence with pure fascination for what Franklin called "these new Wonders" (A:241). As Franklin wrote to Collinson in 1747, "I never was before engaged in any study that so totally engrossed my attention and my time as this study has lately done . . ." (3:118–19).

In mid-1747, Franklin began a process of detailing the results of these experiments in letters to Collinson. In this correspondence he hoped to show that "the Instruments put into our Hands are not neglected" (4:9). Franklin's letters showed far more; and Collinson later gathered them together and published them in London as *Experiments and Observations on Electricity, Made at Philadelphia in America* (1751). This volume, in its expanded editions[44] and numerous translations, made Franklin world famous. Having appeared in English and French, Franklin writes, "my Book was translated into the Italian, German and Latin Languages, and the Doctrine it contain'd was by degrees universally adopted by the Philosophers of Europe . . ." (A:244). Far from being seen in his own day as what we would now consider an 'amateur,' Franklin was proclaimed the world's premier electrician—that is, experimental physicist.[45] Although this is not the place for a minute study of what Franklin and his colleagues discovered, we will still be able to consider the general shape of their findings.[46]

Franklin considered *Experiments and Observations* to be a straightforward and nonspeculative work, "a Description of Experiments,

[43.] Cf. A:241–42; 8:188–90; B. F. J. Schonland, "Benjamin Franklin: Natural Philosopher," 434–35; Heilbron, *Electricity in the 17th and 18th Centuries*, 324–26.

[44.] Franklin's *Experiments and Observations* began as an eighty-six page pamphlet in 1751; but by the time the fifth edition appeared in 1774 it included much nonelectrical material and its length had grown to nearly five hundred pages (cf. 3:117–18; 4:123–30; 21:292–97).

[45.] Cf. I. Bernard Cohen: "Franklin was considered by his contemporaries to be the foremost experimental physicist of the age" ("Foreword" to *Benjamin Franklin: His Contribution to the American Tradition*, xvi; cf. Cohen, *Franklin and Newton*, 27–39; Elizabeth Flower and Murray G. Murphey, *A History of Philosophy in America*, 1:282).

[46.] For a more detailed examination, see: Cohen, *Benjamin Franklin's Experiments*.

which any one might repeat and verify, and if not to be verify'd could not be defended . . ." (A:243). For the most part, the equipment that he and his fellow researchers used consisted of simple and familiar objects like wax and metal, amber and glass rods, silk cloth and gun barrels and animal skins.[47] There were, however, two unusual pieces of equipment. The first was the device by which they collected the 'electrical fire' (or charge). To avoid the fatigue of rubbing a glass tube, they contrived a friction machine consisting of a glass sphere mounted on an axle and turned with a handle "liked a common Grind-Stone" (3:134).[48] By means of this device, they were able to collect the 'fire' on various items, especially the second piece of their specialized equipment: "Mr. Muschenbroek's wonderful Bottle" (3:157). This bottle was the early condenser or capacitor also called the Leyden jar, developed in the mid-1740s by Pieter van Musschenbroek of Leyden. The Leyden jar was a (non-conducting) glass bottle partly filled with conducting metal shot or water with an embedded conducting lead running from within through the insulated neck to an external ball or ring, and sheathed about two-thirds of the way up the outside with a conducting metal. The jar was 'charged' by bringing the ball or ring (and therefore the inner surface) in contact with the friction machine while the outer surface was 'grounded.' The jar was discharged, with bright sparks and loud cracks when fully charged, by bringing the two conductors—directly or indirectly—into contact. What made the Leyden jar of such interest to early experimentalists like Franklin was its ability to hold extremely strong charges.[49] Moreover, when connected with other jars—there was no apparent limit to how many, beyond "what Expence and Labour give"—the resultant battery was capable of producing "[t]he greatest known Effects of common Lightning . . ." (4:202). These discharges were capable of producing a shock power-

[47.] Cf. Daniel Boorstin: "In Franklin's day it was possible to carry on important electrical experiments with kitchen equipment because the subject was still in its infancy, and had not yet begun to become mathematical" (*The Americans*, 1:253; cf. Rossiter, *Seedtime of the Republic*, 284).

[48.] Unknown to the Philadelphians, such devices were already in use in Europe (cf. Cohen, *Benjamin Franklin's Experiments*, 60–61; Heilbron, *Electricity in the 17th and 18th Centuries*, 280–82, 327 n.11).

[49.] Cf. I. Bernard Cohen: "The discharge seemed to have a power or force that was beyond comprehension—enough to cause hundreds of persons holding hands to leap into the air simultaneously" (*Benjamin Franklin's Science*, 24; cf. Heilbron, *Electricity in the 17th and 18th Centuries*, 309–23, 330–34).

ful enough to kill small animals (cf. 3:364–65), and, as Franklin found out on more than one occasion, to completely stun humans. He describes one of his accidents as follows:

> I inadvertently took the whole [discharge] thro' my own Arms and Body . . . the flash was very great and the crack as loud as a Pistol; yet my Senses being instantly gone, I neither Saw the one nor heard the other . . . I . . . felt what I know not how well to describe; an universal Blow thro'out my whole Body from head to foot which seem'd within as well as without; after which the first thing I took notice of was a violent quick Shaking of my body . . . (4:82–83; cf. 5:525; W9:308–9)

While Franklin is able to report as the finding of this unintended experiment that "a Man can without great Detriment bear a much greater Electrical Shock than I imagin'd" in a distant scientific fashion, he also admits to being ashamed "to have been Guilty of so Notorious A Blunder . . ." (4:113, 83).

Franklin understood the physics of these electrical experiments to be simple and Newtonian.[50] First of all, he emphasized that "the Electric Fire is a real Element, or Species of Matter, not *created* by the Friction, but *collected* only" (3:143; cf. 129). As he presents further these findings in his "Opinions and Conjectures" of 1750, the "Electric Matter" consists of minute particles capable of permeating "common Matter, even the densest Mettals, with such Ease and Freedom, as not to receive any perceptible Resistance." This electric matter differs from common matter in that "the Parts of the latter mutually attract, [while] those of the former mutually repel each other . . ." But, while "the Particles of Electrical Matter do repel each other, they are strongly attracted by all other Matter." As a result, Franklin writes, the nature of common matter is "a Kind of a Spunge to the Electrical Fluid." He further notes that there is normally a kind of natural balance or equilibrium of electrical charges, but that the electrical fluid can be pumped out "by the Globe or Tube" and stored as a surplus or positive charge on insulated bodies like the Leyden jars (4:9–11).

The electrical discoveries that Franklin describes in his *Experiments and Observations* were numerous and fundamental. One was

[50.] Cf. Cohen, *Benjamin Franklin's Science*, 25; Schonland, "Benjamin Franklin: Natural Philosopher," 435–36.

that, based upon their ability to establish and reverse a created imbalance of charges, it is possible to discuss a body as being positively or negatively charged. When a body has an excess of electrical fluid, Franklin describes it as "electrised *positively*"; when it has a deficit, "*negatively*" (3:131; cf. 157). In this way, he was able to offer a single-fluid theory of electricity that replaced the then-reigning notion of two distinct kinds of electricity: vitreous and resinous.[51] A second advance was his replacement of the mistaken current notions of "*Electric per se*" for bodies that were assumed to contain "electric Matter in their Substance" and "*Non Electric*" for bodies "suppos'd to be destitute of it," with the more accurate notions of "Conductors" and "Non Conductors" for bodies that respectively did or did not easily pass on electrical charges. This distinction was based upon Franklin's recognition that all bodies have electrical properties but that "some Bodies will *conduct* Electric Matter, and others will not . . ." His explanation of the difference was that those bodies that conduct electricity better are constructed differently. "Perfect Conductors of Electric Matter are only Metals and Water; other Bodies conducting only as they contain a Mixture of those, without more or less of which they will not conduct at all" (4:203; cf. 297–98; 14:261). A third advance elaborated in *Experiments and Observations* was the recognition that any shift from the natural equilibrium to an imbalance of positive and negative charges can only be local. He writes, for example, that to charge the jar it must be grounded to allow for the movement of the charge: "Whatever Quantity of Electrical Fire is thrown in at [the] Top, an Equal Quantity goes out of the Bottom" (3:157; cf. 354). Franklin describes the ongoing balancing of higher positive and negative charges as the conservation of charge; and he indicates that "the Leyden Bottle has no more Electrical Fire in it, when charg'd, than before; nor less when discharg'd" (4:65–66; cf. 3:354). What it has is strongly increased localized imbalances that represent equal and opposite charges.

Certainly the most useful discovery that Franklin and his colleagues made was related to the shape of the conductors. Franklin elaborated this discovery as "the doctrine of *points*" (3:472), the fact

[51.] Cf. 4:423–28; Cohen, *Benjamin Franklin's Science*, 9–13; Millikan, "Benjamin Franklin as a Scientist," 21–22; Heilbron, *Electricity in the 17th and 18th Centuries*, 284–89.

that the ease with which the charge is transmitted depends on the shape of the conductor. He begins with a round object. "The Atmosphere of Electrical Particles surrounding an electrify'd Sphere, is not more disposed to leave it, or more easily drawn off from any one Part of the Sphere than from another, because it is equally attracted from every Part." Franklin indicates, however, that other shapes react differently. "From a Cube it is more easily drawn out at the Corners than at the plane sides; and so from the Angles of a Body of any other Form, and still most easily from that Angle, that is most acute" (4:14). This discovery is the origin of the doctrine of 'points.' Franklin demonstrates this as follows: a charged body will repel a suspended cork ball; but should you present to the charged body "the Point of a long, slender, sharp [grounded] Bodkin at 6 or 8 Inches Distance, the Repellency is instantly destroy'd, and the Cork flies to it." The result is far different, however, when something other than a pointed body is used. "A blunt Body must be brought within an Inch, and draw a Spark to produce the same Effect" (3:127; cf. 4:17–18). Franklin's tentative explanation for these data went as follows:

> the Force with which the electrified Body retains it's Atmosphere, by attracting it, is proportioned to the Surface over which the Particles are plac'd; i.e. four square Inches of that Surface retain their Atmosphere with 4 times the Force, that one square Inch retains it's Atmosphere. And, as in Plucking the Hairs from the Horse's Tail, a Degree of Strength, insufficient to pull away a Handful at once, could yet easily strip it Hair by Hair; so a blunt Body presented, cannot draw off a Number of Particles at once; but a pointed one, with no greater Force, takes them away easily, Particle by Particle. (4:16)

While not completely confident of this explanation, Franklin was more confident that "to know this Power of Points may possibly be of some Use to Mankind, tho' we should never be able to explain it" (4:17).[52] The use that Franklin had in mind was that "houses, ships, and even towns and churches may be effectually secured from the stroke of lightening" by means of such points (3:473).

[52] For a consideration of some of the problems with Franklin's theory of electricity, see: Cohen, *Benjamin Franklin's Experiments*, 75–76; *Benjamin Franklin's Science*, 9–13; Heilbron, *Electricity in the 17th and 18th Centuries*, 334–39, 387.

The centrality of 'points' to Franklin's overall vision of the nature of electricity becomes more obvious when we turn to a consideration of his greatest invention: the lightning rod, by means of which (as Turgot wrote) he snatched lightning from the sky.[53] Drawing upon this work with static discharges, Franklin conjectured that the imbalances of electrical fire created in the laboratory experiments and found naturally in storm clouds were the same. In the log of his experiments for 7 November 1749, Franklin lists the following similarities:

Electrical fluid agrees with lightning in these particulars:

1. Giving light.
2. Colour of the light.
3. Crooked direction.
4. Swift motion.
5. Being conducted by metals.
6. Crack or noise in exploding.
7. Subsisting in water or ice.
8. Rending bodies it passes through.
9. Destroying animals.
10. Melting metals.
11. Firing inflammable substances.
12. Sulphureous smell. (5:524)

The most obvious difference between the experimental discharges and lightning, of course, was one of amount. Franklin considers this disparity in the power of strikes as follows: "if two Gun Barrels electrified will strike at two Inches Distance, and make a loud Snap; to what a great Distance may 10,000 Acres of Electrified Cloud strike and give its Fire, and how loud must be that Crack!" (3:372).[54] All in all, it seemed quite clear to Franklin that the two were instances of the same phenomenon: on the one hand, that the clouds were full of the sort of static electricity with which he and his

[53.] Anne Robert Jacques Turgot: "Eripuit coelo fulmen sceptrumque tyrannis" ["He snatched the lightning from the sky and the scepter from tyrants"] (cf. Van Doren, *Benjamin Franklin*, 606; Aldridge, *Franklin and His French Contemporaries*, 124–34).
[54.] Cf. 4:18–19, 139; 14:26.

colleagues had been working in the laboratory; and, on the other, that their laboratory work, however simplified, pointed to core issues in natural philosophy. And, while Franklin was not the first to suggest the identity of electricity and lightning, he was the first to propose some workable method for testing the hypothesis.[55]

Franklin's proposal was dated 29 July 1750. He writes that to determine "[w]hether the Clouds that contain Lightning are electrified or not, I would propose an Experiment to be try'd where it may be done conveniently." He thought that the experiment would not yet be 'convenient' in Philadelphia because there were as yet no buildings that he thought were sufficiently tall. The experiment was proposed to run as follows:

> On the Top of some high Tower or Steeple, place a Kind of Sentry Box big enough to contain a Man and an [insulated] electrical Stand. From the Middle of the Stand let an Iron Rod rise, and pass bending out of the Door, and then upright 20 or 30 feet, pointed very sharp at the End. If the Electric Stand be kept clean and dry, a Man standing on it when such Clouds are passing low, might be electrified, and afford Sparks, the Rod drawing Fire to him from the Cloud.

Franklin did not anticipate any danger to the person standing in the sentry box as the charge was passed to the grounded person nearby—or to that other person. He suggested, however, a slight modification by means of which the person himself would not become charged but would simply connect up the rod with a grounded wire: "let him stand on the Floor of his Box, and now and then bring near to the Rod, the Loop of a Wire, that has one End fastened to the Leads; he holding it by a Wax-Handle. So the Sparks, if the Rod is electrified, will Strike from the Rod to the Wire and not affect him" (4:19–20). Franklin's proposal was published as part of the *Experiments and Observations* in April 1751; and on 10 May 1752 the challenge was successfully taken up by Thomas-François Dalibard, who had translated the volume into French, in Marly-la-Ville near Paris. In at least one way, Dalibard's experiment was more

[55.] Cf. I. Bernard Cohen: "For at least fifty years before Franklin's research people had speculated that lightning was probably electrical. But what distinguished Franklin from his predecessors was the fact that he was able to design an experiment to test this hypothesis" ("In Defense of Benjamin Franklin," 39; cf. Compton, "The World of Science in the Late Eighteenth Century and Today," 298).

successful than Franklin had anticipated because Dalibert used a pointed iron rod that rose only forty feet from the ground rather than the twenty or thirty feet from the top of a tall building that Franklin had anticipated would be necessary.[56]

In the meantime and without having heard the results of this experiment, Franklin devised a variant of his 'Philadelphia experiment'—the name that it had picked up in France—that did not require a high building. Franklin's idea was to carry his rod aloft on a silk kite. He tried out this kite experiment sometime in June 1752, and described it in the 19 October 1952 edition of his *Pennsylvania Gazette*. He begins with a discussion of the kite that he built and the proper method of its use:

> To the Top of the upright Stick of the Cross is to be fixed a very sharp pointed Wire, rising a Foot or more above the Wood. To the End of the Twine, next the Hand, is to be tied a silk Ribbon, and where the Twine and the silk join, a Key may be fastened. This Kite is to be raised when a Thunder Gust appears to be coming on, and the Person who holds the String must stand within a Door, or Window, or under some Cover, so that the Silk Ribbon may not be wet; and Care must be taken that the Twine does not touch the Frame of the Door or Window.

Franklin then described the results that he achieved:

> As soon as any of the Thunder Clouds come over the Kite, the pointed Wire will draw the Electric Fire from them, and the Kite, with all the Twine, will be electrified, and the loose Filaments of the Twine will stand out every Way, and be attracted by an approaching Finger. And when the Rain has wet the Kite and Twine, so that it can conduct the Electric Fire freely, you will find it stream out plentifully from the Key on the Approach of your Knuckle. At this Key the Phial may be charg'd; and from Electric Fire thus obtained, Spirits may be kindled, and all other Electric Experiments be perform'd, which are usually done by the Help of a rubbed Glass Globe or Tube; and thereby the *Sameness* of the Electrical Matter with that of Lightning compleatly demonstrated (4:367).[57]

[56.] Cf. 4:302–10, 315–17; Van Doren, *Benjamin Franklin*, 163–64; Heilbron, *Electricity in the 17th and 18th Centuries*, 346–52.

[57.] Cf. 4:360–69; Cohen, *Benjamin Franklin's Science*, 66–109.

Having in this way proven the identity of electricity and lightning, and the ability of a conducting rod to draw a spark from the clouds, he immediately turned his thoughts to the application of this knowledge to advance human well-being.

Earlier, Franklin had speculated that if the laboratory electrical discharges and lightning strikes were identical it might be possible to protect against the damage of lightning. The key to his speculation was the obvious similarity between his laboratory 'points' and the "high Trees, lofty Towers, Spires, Masts of Ships, Chimneys etc." (3:374) that are so often the target of lightning strikes. If in the laboratory charges could be safely led to ground, Franklin assumed that similarly lightning discharges could be safely grounded. "I am of opinion," Franklin writes on 2 March 1750, "that houses, ships, and even towns and churches may be effectually secured from the stroke of lightening" by using points. The procedure that he suggested ran as follows: "there should be put a rod of iron 8 or 10 feet in length, sharpen'd gradually to a point like a needle, and gilt to prevent rusting, or divided into a number of points, which would be better—the electrical fire would, I think, be drawn out of a cloud silently, before it could come near enough to strike . . ." (3:472–73; cf. 4:19). Having tested his hypothesis with the kite experiment in mid-1752, later that year he published "*How to secure Houses, etc. from* LIGHTNING" in *Poor Richard's Almanack* for 1753:

> Provide a small Iron Rod . . . of such a Length, that one End being three or four Feet in the moist Ground, the other may be six or eight Feet above the highest Part of the Building. To the upper End of the Rod fasten about a Foot of Brass Wire, the Size of a common Knitting-needle, sharpened to a fine Point; the Rod may be secured to the House by a few small Staples. If the House or barn be long, there may be a Rod and Point at each End, and a middling Wire along the Ridge from one to the other. A House thus furnished will not be damaged by Lightning, it being attracted by the Points, and passing thro the Metal into the Ground without hurting any Thing. (4:408–9)[58]

[58.] This procedure is essentially as Franklin presented it a decade later to David Hume (cf. 10:17–23, 82–83; 14:260–64).

With this simple natural discussion, Franklin offered his readers the means to free themselves from the recurring danger of terror from the sky.

Many issues regarding lightning and its control by means of lightning rods remained unsettled. Some matters—for example whether the rods should have sharp or blunt ends, and whether the use of rods might call down extra strikes that would have passed harmlessly over[59]—were decided in Franklin's mind although they remained matters of ongoing public discussion. Other matters left Franklin puzzled as well. He was unclear, for example, about the source of the electrification of the clouds and uncertain about the direction of the strike.[60] Still, in the words of I. Bernard Cohen, Franklin had "subjected one of the most mysterious and frightening natural phenomena to rational explanation."[61] He had proven that it was possible to prevent damaging strikes to steeples and towers, even though they were tall, to the masts of ships, even though they were isolated, and to gunpowder magazines, even though they were highly explosive.

The discovery of this knowledge, of course, did not mean its immediate and total acceptance in the face of inherited superstition about the theological meaning of lightning and charges of presumption against anyone who would dare to 'interfere' with the workings of God's will. In Franklin's day, throughout much of America (and Europe), the workings of nature *were* the direct workings of God. In the American context, this was especially true of the Puritans. For them, as Herbert W. Schneider writes, "[n]o event was merely natural; it was an act of God . . . To one who is accustomed to think of each event as the direct handiwork of God and who understands it only when he can relate it to the economy of redemption, the study

[59] Cf. 6:97–101; 19:244–55; 260–65; Cohen, *Science and the Founding Fathers*, 166–71; Schonland, "Benjamin Franklin: Natural Philosopher," 441–42; Heilbron, *Electricity in the 17th and 18th Centuries*, 381–84.

[60] Cf. 3:365–67; 4:463–64; 5:15, 68–72, 330, 524–25; Heilbron, *Electricity in the 17th and 18th Centuries*, 342–43, 374.

[61] Cohen, *Benjamin Franklin, Scientist and Statesman*, 65. Cf. Charles William Eliot: "his demonstration that lightning was an electrical phenomenon brought deliverance for mankind from an ancient terror. It removed from the domain of the supernatural a manifestation of formidable power that had been supposed to be a weapon of the arbitrary gods; and since it increased man's power over nature, it increased his freedom" (*Four American Leaders*, 26).

of nature is necessarily a moral and teleological inquiry."[62] There was a special fascination among the Puritans with electrical storms as a sign of God's wrath. Cotton Mather wrote that: *"Thunder has in it the Voice of God . . .* There is nothing able to stand before those *Lightnings*, which are stiled the *Arrows of God*."[63] For Jonathan Edwards, similarly, lightning had divine import: "I felt God, so to speak, at the first appearance of a thunder storm; and used to take the opportunity, at such times, to fix myself in order to view the clouds, and see the lightnings play, and hear the majestic and awful voice of God's thunder . . ."[64]

Franklin, of course, had a completely different understanding of natural phenomena.[65] He saw little sense in accepting lightning as an indication of God's wrath, or in continuing the ineffective Christian tradition of ringing church bells during electrical storms to ward off lightning strikes and to break up the storms.[66] In fact, their researches led Franklin and his colleagues to the recognition of a direct causal chain explaining why churches themselves were frequently struck, and how the bell cord itself often conducts the strike and kills the bellringer. Franklin would have none of the doctrine that to attempt to protect ourselves and our property against lightning strikes demonstrates opposition to the will of God. For him, the control of lightning was simply a matter of the application of science to the advancement of human well-being. "It has pleased God in his Goodness to Mankind," he writes in *Poor Richard* for 1753, "at length to discover to them the Means of securing their Habitations and other Buildings from Mischief by Thunder and Lightning" (4:408). He continued later in 1753 that Jean-Antoine Nollet, a critic of his electrical work, "speaks as if he thought it Presumption in Man, to propose guarding himself against the *Thunders of Heaven*! Surely the Thunder of Heaven is no more supernatural than the

[62] Schneider, *The Puritan Mind*, 48, 42.

[63] Mather, *The Christian Philosopher*, 72.

[64] Edwards, "Personal Narrative," 61; cf. Alfred Owen Aldridge, "Benjamin Franklin and Jonathan Edwards on Lightning and Earthquakes"; Breitwieser, *Cotton Mather and Benjamin Franklin*, 209–11.

[65] Cf. Herbert W. Schneider: For the Puritans, "the knowledge of nature is not an end in itself, it is valued for its religious improvements. It would have been as idle to ask the Puritan to experiment on the causes of lightning as it would have been to ask Franklin to make religious improvements on his discoveries" (*The Puritan Mind*, 46–47; cf. A. Whitney Griswold, "Three Puritans on Prosperity," 487–88).

[66] Cf. Cohen, *Benjamin Franklin's Science*, 119–25.

Rain, Hail or Sunshine of Heaven, against the Inconveniencies of which we guard by Roofs and Shades without Scruple" (4:463).[67]

In a climate of the continued belief in direct Divine involvement in the events of the natural world, the religious prejudice against scientific intervention could, of course, simply retreat slightly and suggest that, although the interception of lightning may appear to the faithless to forestall Divine wrath without apparent harm, in fact the use of lightning rods would only lead to disastrous results elsewhere. One claim, for example, was that the use of lightning rods would result in increases in earthquakes. One proponent of such a view, Thomas Prince, wrote of the futility of attempting to evade the wrath of an omnipotent God:

> The more *Points* of *Iron* are erected round the *Earth*, to draw the *Electrical Substance* out of the *Air*; the more the *Earth* must needs be charged with it. And therefore it seems worthy of Consideration, Whether *Any Part* of the *Earth* being fuller of *this terrible Substance*, may not be more exposed to *more Shocking Earthquakes* . . . O! there is no getting out of the mighty Hand of *God*![68]

This religious mind-set remained impervious to scientific challenges, although the notion that earthquakes resulted from pent-up electrical charges was demolished almost immediately by John Winthrop.[69] Years later, Winthrop wrote to Franklin on 6 January 1768 of his amazement that there were still unprotected steeples: "How astonishing is the force of prejudice even in an age of so much knowledge and free enquiry!" (reprinted in 15:14). In response, Franklin writes:

> It is perhaps not so extraordinary that unlearned men, such as commonly compose our church vestries, should not yet be acquainted with, and sensible of the benefit of metal conductors, in

[67.] While Franklin was in London in 1760, the Junto Minute Book contained the following passage: "tho the rending Peal of Thunder may fill the Minds of the Ignorant with Terror who from an Ignorance of its Cause and their natural Superstition may imagine that it is the immediate Voice of the Almighty and the Streaming Lightening are Bolts launched from his Right Hand and commissioned to execute his Vengeance[,] yet in Reason's Eye Lightening or Thunder is no more an Instrument of Divine Vengeance than any other of the Elements" (cited in Cohen, *Benjamin Franklin's Science*, 142).

[68.] Prince, *Earthquakes, the Works of God* (1755) cited in Cohen, *Benjamin Franklin's Science*, 145.

[69.] Cf. Cohen, *Benjamin Franklin's Science*, 148–53.

averting the stroke of lightning, and preserving our houses from its violent effects; or that they should be still prejudiced against the use of such conductors, when we see how long even philosophers, men of extensive science and great ingenuity, can hold out against the evidence of new knowledge that does not square with their preconceptions, and how long men can retain a practice that is conformable to their prejudices, and expect a benefit from such practice, though constant experience shows its inutility. (15:168)

Franklin's recognition of the comfortableness and power of customs, and of our need to resist them in the pursuit of scientific advance, demonstrated his understanding of the rootedness of scientific practice within the life of the culture and the importance of trying to distance ourselves from what is commonly thought to be true.

Finally, while much of what we have been considering in this section may sound at present like course work from the secondary school curriculum, it is necessary to remember that at the time it was revolutionary. For his volume, *Experiences and Observations* and his related work in electricity, Franklin was awarded the Copley Medal of the Royal Society in 1753; and three years later the Society elected him a Fellow (cf. 5:126–34; 6:375–76). He was hailed by Joseph Priestley in 1770 as *"the father of modern electricity"* (reprinted in 17:259). However familiar his experimental results may seem today, Franklin was the major figure in the birth of electrical science,[70] allowing it to take its place as an equal component in the study of nature.[71] Franklin was truly a central figure in the advance of natural philosophy in the eighteenth century.

[70.] Cf. Robert A. Millikan: Franklin "laid the real foundations on which the whole superstructure of electrical theory and interpretation has been erected . . . Franklin without any previous training whatever in either the technique or the history of physics and with almost no contact with what others were doing or had done, within two years of the time of his first experiment had acquired a keener insight into the fundamental nature of electrical phenomena, not merely than any one had acquired up to his time, but even than any of his successors acquired for the next hundred and fifty year . . ." ("Benjamin Franklin as a Scientist," 12–14; cf. Cohen, *Franklin and Newton*, 205–80).

[71.] Cf. I. Bernard Cohen: After Franklin's lightning experiments, "no natural philosophy could be considered a complete or adequate account of nature if it did not include electrical phenomena along with those of mechanics, heat, optics, magnetism, pneumatics, hydrostatics, chemical interactions, and gravitational celestial mechanics" (*Benjamin Franklin's Science*, 29).

2.3. The Range of Franklin's Natural Philosophy

Up to this point, our consideration of Franklin's life in science has been concentrating fairly narrowly on the area of his greatest successes: electricity and lightning. But Franklin was, as we recall, interested in literally every aspect of natural philosophy. He wanted to understand how the natural world works.[72] The breadth of his interest was one of the reasons I offered (above, 2.1) for our frequent underestimation of his contributions to science. Carl L. Becker hints at Franklin's extraordinary range in the following passage: "Every sort of natural phenomenon enlisted his interest and called forth some ingenious idea. In one short letter he speaks of linseed oil, hemp land, swamp draining, variations in climate, northeast storms, the cause of springs on mountains, sea-shell rocks, grass seed, taxation, and smuggling."[73] Franklin was not able to do the sort of systematic laboratory work in these areas that he and his colleagues had done with electricity. In most cases, he began with some particular phenomenon that gave rise to puzzlement. His fertile mind then gave birth to a series of conjectures based largely on analogy and whatever experiments he could develop. These were followed by the dissemination of his positions in hopes of sparking further inquiries. In all of these diverse areas, we see his lack of mathematical skills that we saw in the consideration of electricity and lightning, and his practical inclination toward application rather than theoretical speculation. Some of the problems that Franklin considered were: heating and heat, the structure of the earth, issues of navigation and flight, music and musical instruments, and medicine and health. We can consider these various areas in turn.

In the winter of 1739–1740, Franklin invented "an open Stove, for the better warming of Rooms and at the same time saving Fuel" (A:191). In 1744, he described this stove in the pamphlet: *An*

[72.] Carl L. Becker describes this sense of natural wonder as follows: "Nature, it seemed, was, after all, just the common things that common men observed and handled every day, and natural law only the uniform way these things behaved. Steam bubbling from the spout of a kettle, smoke whisking up a chimney, morning mist lifting from meadows—here was nature all about . . ." (*The Heavenly City of the Eighteenth-Century Philosophers*, 58).

[73.] Becker, "Benjamin Franklin," 588. The letter from 1747 is to be found in 3:147–52.

Account of the New Invented Pennsylvanian Fire-Places (2:419–46). The principle on which this stove worked was a combination of the radiant and conductive heat of the familiar stove with improvements in convection that led to a more controlled airflow. After a brief account of the physics of fire that emphasizes the relationship between increased heat and the consequent rising of the rarified air, Franklin describes the ineffectiveness of a number of stoves then in use to deal with the convection problem (cf. 2:422–29). These preliminaries set the stage for his discussion of the physical properties and method of use of his new stove, detailing especially how it draws the heated air back down inside the stove before it is allowed to escape up the chimney (2:429–35). Among the fourteen advantages he lists for his new stove are:

1. That your whole Room is equally warmed; so that People need not croud so close round the Fire, but may sit near the Window and have the Benefit of the Light for Reading, Writing, Needle-work, etc. . . .

2. If you sit near the Fire, you have not that cold Draught of uncomfortable Air nipping your Back and Heels, as when before common Fires, by which many catch Cold, being scorcht before and as it were froze behind . . .

5. In common Chimneys the strongest Heat from the Fire, which is upwards, goes directly up the Chimney, and is lost . . . But here the upright Heat, strikes and heats the Top Plate, which warms the Air above it, and that comes into the Room . . .

6. Thus as very little of the Heat is lost, when this Fire-Place is us'd, *much less Wood* will serve you, which is a considerable Advantage where Wood is dear . . . (2:435–37).

Although his stove proved to be quite successful, Franklin refused to apply for a patent for it, noting *"as we enjoy great Advantages from the Inventions of others, we should be glad of an Opportunity to serve others by any Invention of ours, and this we should do freely and generously"* (A:192).[74]

Related to Franklin's interest in heating homes was his broader interest in heat and its transmission. He experimented, for example,

[74] For a critical evaluation of the effectiveness of Franklin's stove, see: Samuel Y. Edgerton, Jr., "The Franklin Stove."

with the differing rates at which different colored patches of cloth absorbed the heat of the sun (cf. 9:250–51). He was also struck by the fact that objects made of metal conduct their heat better to the touch than those made of wood. So, for example, he writes:

> My Desk, on which I now write, and the Lock of my Desk, are both expos'd to the same Temperature of the Air, and have therefore the same Degree of Heat and Cold; yet if I lay my Hand successively on the Wood and on the Metal, the latter feels much the Coldest; not that it is really so, but being a better Conductor, it more readily than the Wood takes away and draws into it self the Fire that was in my Skin. (7:187)

A more extreme example of this same phenomenon involves holding equal sized wooden and metal disks in the flame of a candle. In this case, Franklin writes, "tho' the Edge of the wooden Piece takes Flame and the metal Piece does not, yet you will be oblig'd to drop the latter before the former, it conducting the Heat more suddenly to your Fingers" (5:147; cf. 7:185). Franklin recognized that our sensation of heat or cold results from the transmission of the heat more than from the temperature of the material itself. "Our Sensation of Cold is not in the Air *without* the Body," he writes, "but in those Parts of the Body which have been depriv'd of their Heat by the Air" (5:147). He recognized further the role of humidity in this transmission process. In particular, Franklin continues, "a damp moist Air shall make a Man more sensible of Cold, or chill him more than a dry Air that is colder, because a moist Air is fitter to receive and conduct away the Heat of his Body" (7:186; cf. 5:146). That this loss of heat is related to evaporation was demonstrated by an experiment in which he participated in Cambridge in 1758. By repeatedly applying a room-temperature liquid that evaporates quickly, in this case ether, to a thermometer, and hastening its evaporation with a bellows, Franklin and some colleagues were able to reduce the temperature of the thermometer from 65° to 7°, and to encase the ball of the thermometer in ice (cf. 7:184–85; 8:108–9). Based on these remarkable findings, Franklin was willing to extrapolate on "the possibility of freezing a man to death on a warm summer's day, if he were to stand in a passage thro' which the wind blew briskly, and to be wet frequently with ether . . ." Further, he commented on other instances of "cooling bodies by evaporation,"

and he suggested the future possibility of using these discoveries to develop the means for cooling meat and dairy products during the summer in a chimney (8:109; cf. 197; 10:265).

Franklin's interest in the structure of the earth seems to have been initially whetted by the discoveries of fossilized sea animals at unlikely elevations. He writes that "the great Apalachian Mountains, which run from York River back of these Colonies to the Bay of Mexico, show in many Places near the highest Parts of them, Strata of Sea Shells, in some Places the Marks of them are in the solid Rocks." These unlikely data led him to suspect a past history of serious geological shiftings. "'Tis certainly the *Wreck* of a World we live on!" (3:149). While willing to admit that our world was a 'wreck,' Franklin certainly did not mean to imply that it was thereby a 'ruin.' He writes that, on the contrary, "what has been usually looked upon as a *ruin* suffered by this part of the universe, was, in reality, only a preparation, or means of rendering the earth more fit for use, more capable of being to mankind a convenient and comfortable habitation." By means of a design argument just as convoluted as the one that had opposed the use of lightning rods, Franklin suggests that "those convulsions which all naturalists agree this globe has suffered" have actually benefitted us: "Had the different strata of clay, gravel, marble, coals, lime-stone, sand, minerals, etc. continued to lie level, one under the other, as they may be supposed to have done before those convulsions, we should have had the use only of a few of the uppermost of the strata, the others lying too deep and too difficult to be come at . . ." (7:357). For this sort of geological change to be possible, he speculated late in his life, the earth was probably not a solid. Rather, he suggested that "the internal parts might be a fluid more dense, and of greater specific gravity than any of the solids we are acquainted with; which therefore might swim in or upon that fluid." In this view, the surface of the earth would be "a shell, capable of being broken and disordered by the violent movements of the fluid on which it rested" (W8:598; cf. 10:226–31; W9:654). Franklin was also interested in the meaning of other fossils. Commenting on a collection of "elephants' tusks and grinders" that had been discovered at the Big Bone Lick in present-day Kentucky, a collection that he had been able to examine in London, he writes:

It is remarkable, that elephants now inhabit naturally only hot countries where there is no winter, and yet these remains are found in a winter country; and it is no uncommon thing to find elephants' tusks in Siberia . . . though Siberia is still more a wintery country than that on the Ohio; which looks as if the earth had anciently been in another position, and the climates differently placed from what they are at present. (14:221–22)[75]

His hypothesis was that over the ages the earth had developed and changed, and where it was now cold it had once been hotter. Franklin did not speculate, however, on any possible changes in the elephants themselves through a process of animal evolution.

Issues of navigation and flight had a special fascination for Franklin. Beginning with the former, we saw (above, 1.2) that he had an early desire to go to sea; and, during his lifetime he frequently sailed here and there along the east cost of North America, made eight Atlantic crossings, and travelled around the British Isles, and back and forth to the Continent, during his approximately twenty-five years away from Philadelphia. From his many naval experiences, Franklin drew the conclusion that shipbuilding techniques in his day were far from scientific. He believed, however, that this unhappy circumstance could be fairly easily addressed: "a Set of Experiments might be instituted, first to determine the most proper Form of the Hull for swift sailing; next the best Dimensions and properest Place for the Masts; then the Form and Quantity of Sails, and their Position as the Winds may be; and lastly the Disposition of her Lading" (A:257). In 1767 or 1768, he himself conducted a series of scale-model experiments (cf. 15:115–18); and, late in his life, he offered a number of maritime observations and proposed a series of naval experiments having to do with, among other things, ship construction and repairs, accidents and safety, and the health and well-being of passengers and crew (W9:372–413). Franklin was also interested in the effects of what he called the "Gulph Stream" (15:246), the strong northeasterly and easterly Atlantic current capable of advancing eastbound ships and likewise retarding west-bound ships by as much as seventy miles per day, and even of carrying becalmed ships backwards toward Europe. After consulta-

[75.] Cf. 10:165; 14:25–29; W9:653–54.

tions with his friend and in-law, Capt. Timothy Folger, Franklin prepared a map of the Gulf Stream to help ships travelling in either direction to adjust.[76] Finally, Franklin's interest in navigation addresses what he considers its proper uses:

> Navigation, when employed in supplying necessary provisions to a country in want, and thereby preventing famines, which were more frequent and destructive before the invention of that art, is undoubtedly a blessing to mankind. When employed merely in transporting superfluities, it is a question whether the advantage of the employment it affords is equal to the mischief of hazarding so many lives on the ocean. But when employed in pillaging merchants and transporting slaves, it is clearly the means of augmenting the mass of human misery. (W9:403–4)

With regard to the American situation, he notes in 1785 that there is no real need for transporting such products as tea, coffee, sugar, and tobacco. All of which, he writes, "our ancestors did well without" (W9:404). Far worse is the use of navigation to do harm, as in the case of the slave trade (below, 5.5).

Franklin's interest in flight was piqued by his presence at the first balloon flight in Paris on 27 August 1783. Although in failing health at the time, and thus unable to take any direct part in the experiment, the seventy-seven-year-old natural philosopher offered Joseph Banks "an early Account of this extraordinary Fact . . ." The sphere, twelve feet in diameter and full of highly flammable hydrogen gas, lifted off before fifty-thousand spectators. "It diminish'd in Apparent Magnitude as it rose," Franklin writes, "till it enter'd the Clouds, when it seemed to me scarce bigger than an Orange, and soon after became invisible, the Clouds concealing it." Franklin comments prophetically on this flight that "it may pave the Way to some Discoveries in Natural Philosophy of which at present we have no Conception" (W9:80–81; cf. 118, 254).[77] As part of this ongoing series, experimental flights were later attempted with animals onboard (cf. W9:106) and eventually with humans. On 20 November, Franklin witnessed the ascent of two "courageous Philosophers" (W9:115) in a hot-air balloon; and on December 1, the flight of two

[76.] Cf. 3:67–68; 15:246–48; 22:16, 54–55; W9:394–98, 405–6, 480–81.

[77.] The question of the usefulness of flight was the context for Franklin's apocryphal comment: "What is the use of a new-born baby?" (W1:77; cf. Aldridge, *Franklin and His French Contemporaries*, 188).

more in a hydrogen balloon. "Never before," he writes of the latter event, "was a philosophical experiment so magnificently attended" (W9:119). About this human flight, Franklin continued to be amazed: "A few months since the idea of witches riding thro' the air upon a broomstick, and that of philosophers upon a bag of smoke, would have appeared equally impossible and ridiculous" (W9:117). Now that flight had become a reality, moreover, Franklin was much taken with its possible applications: for refrigeration, for sightseeing, for military intelligence and communication, and even (sadly mistakenly) for "[c]onvincing Sovereigns of the Folly of wars" by making defense so much more difficult (W9:156). One final suggested application that he offered, more humorous than practical, was that he himself might ride around Philadelphia in less pain from his kidney stone in a balloon-supported carriage (cf. W9:572–73).

Franklin was also a musician of sorts. Van Doren reports that during his long lifetime he learned to play the violin (as had his father), the guitar, the harp, and the armonica—or glass harmonica—an instrument of his own devising. Franklin took the musical curiosity of the haunting tones produced by rubbing the rims of partially filled glasses and constructed a series of 36 tuned hemispheres arrayed concentrically on a horizontal spindle and rotated by a foot pedal.[78] He describes the construction of this instrument in a letter of 13 July 1762 to Giambatista Beccaria, along with a consideration of its "advantages": "that its tones are incomparably sweet beyond those of any other; that they may be swelled and softened at pleasure by stronger or weaker pressures of the finger, and continued to any length; and that the instrument, being once well tuned, never again wants tuning" (10:130; cf. 180–82).[79] In addition to his interests in musical instruments, Franklin also addresses matters of musical taste with particular praise for what he took to be the simplicity and naturalness of folk melodies and particular criticism for the contemporary music which he saw as being pleasing only to *"practised* ears." The latter music he saw as full of *"Drawling* . . . [and] . . . *Stuttering* . . .

[78.] For more on the armonica, see: 10:116–26; 31:311–14; Van Doren, *Benjamin Franklin*, 297–99; Pace, *Benjamin Franklin and Italy*, 271–82.

[79.] Beccaria later responds that: "to you it is given to enlighten human minds with the true principles of the electric science, to reassure them by your conductors against the terrors of thunder, and to sweeten their senses with a most touching and suave music" (reprinted in 18:109).

[and] . . . *Screaming*" among other faults (11:539–40);[80] and as
appealing to its audience not through "the natural Pleasure arising
from Melody or Harmony of Sounds," but through "the same kind
with the Pleasure we feel on seeing the surprizing Feats of Tumblers
and Rope Dancers, who execute difficult Things" (12:162). Good
music, he believed on the contrary, concentrates not on such
exhibitions of practiced skill but on simple tunes performed in
unaffected ways (cf. 12:163–64; W10:73–74).

We have already seen (above, 2.1) Whitfield J. Bell's suggestion
that almost every educated man in the eighteenth century had some
acquaintence with medicine. He writes further: "They bought, read,
and annotated medical texts, treated illnesses in their own house-
holds, sometimes even attended anatomical lectures."[81] This level of
amateur interest is not surprising, given the facts that on one hand
medical practice was itself in a very primitive state and that on the
other medicine was perceived to be the most direct way to apply
science to human betterment. Franklin was no exception to this
generalization, although while with regard to medicine he was more
of a publicist than a practitioner. Franklin is perhaps best known
with regard to medicine for his opposition to the reigning prejudice
of "*Aerophobia*" (W9:435) and for his advocacy of fresh air as a
means to increased health. "People often catch Cold from one
another," he writes, "when shut up together in small close Rooms,
Coaches, etc. and when sitting near and conversing so as to breathe
in each others Transpiration . . ." (20:315). In response, Franklin
advocated cold air baths, and especially increased ventilation.[82]
Franklin was also, after a false start in Boston, a strong supporter of

[80] Franklin offers musical examples of these faults chosen from George Frederick
Handel's *Acis and Galatea* (1732) and *Judas Maccabaeus* (1747). Cf. Andrew
Schiller: Franklin did not doubt that "the praised composers of his day—Gluck,
Handel, Monteverdi, Bach—were ephemeral purveyors of tortured preciosities, and
their admirers vain faddists" ("Franklin as a Music Critic," 506).

[81] Bell, *The Colonial Physician and Other Essays*, 119. Cf. William Pepper:
"Benjamin Franklin lived in an age when men of education and genius in varying
paths of life did not consider it strange or peculiar to think, discuss, or write about
medical matters" (*The Medical Side of Benjamin Franklin*, 9).

[82] Cf. 15:180–81; 19:133–34; 20:240–42, 444–45, 529–38; W9:435–36;
W10:133–34. Franklin's advocacy of ventilation is best known through his
dispute with the decidedly 'aerophobic' John Adams (cf. 22:598; Adams, *Diary
and Autobiography*, 3:418–19; Bell, *The Colonial Physician and Other Essays*,
122–23).

inoculation against smallpox[83] and an early recognizer of the workings of lead poisoning (cf. 15:51–52; W9:530–33). Franklin invented a flexible silver catheter (cf. 4:385–86) and bifocals (W9:337–38). In addition, he tried his hand at electrotherapy— called by some "Franklinism"—using the practical experience he had gained from his electrical experiments to treat, without any recognizable long-term benefits, the victims of various paralyses.[84] Franklin played an important role in medical treatment and education as well, through his efforts on behalf of the Pennsylvania Hospital (below, 2.4).

Other areas of scientific inquiry that Franklin explored include meteorology, the nature of light, and the aurora borealis.[85] Overall, this range of interests is of fascinating breadth; and, if we were to hope for more, it could only be for increasing depth. Beyond electricity, and even there only briefly, he never had the opportunity to carry his research deeply into any specific area. He was never able to develop his various hunches or coordinate his various areas of interest; and, as time went on and his public commitments grew, he was not able to even continue his generalist endeavors in natural philosophy. He had so little time to devote to science because he had other, more pressing, duties. As Franklin writes to Jan Ingenhousz on 29 April 1785, as he was about to leave Paris for Philadelphia: "I am once more a Freeman: after Fifty Years Service in Public Affairs. And let me know soon if you will make me happy the little Remainder left me of my Life, by spending the Time with me in America. I have Instruments if the Enemy did not destroy them all, and we will make Plenty of Experiments together" (W9:321). Of course, Franklin's intended retirement from "Politicks" to "Philosophical Amusements" (W9:318) did not turn out quite as he envisaged it; and, as soon as he landed in Philadelphia, he was reimmersed in Pennsylvania and national politics. While he no doubt had some ongoing regrets that he had so little time to do

[83.] Cf. A:170; 1:8, 200; 2:154; 8:281–86; Bell, *The Colonial Physician and Other Essays*, 120–21; Clark, *Benjamin Franklin*, 18–19; Van Doren, *Benjamin Franklin*, 19–20.

[84.] Cf. 7:298–300; W9:656; Bell, *The Colonial Physician and Other Essays*, 124–27; Pepper, *The Medical Side of Benjamin Franklin*, 12.

[85.] Cf. 3:149, 392–93 n.8, 463–65; 4:299–300; 9:110–12; 19:239; 28:190–200.

scientific research, he clearly recognized the primary importance of advancing human well-being, of which his scientific work was just one means. The purpose behind his work as a natural philosopher was to do good, not to provide himself with interesting diversions or a heightened reputation.[86]

2.4. Science as Cooperative Method Pursuing the Common Good

In commenting in his *Autobiography* on his reading as a child, Franklin mentions among other titles, Bunyan's *Pilgrim's Progress* and Plutarch's *Lives*. He then continues: "There was also a Book of Defoe's, called an Essay on Projects, and another of Dr. Mather's, call'd Essays to do Good which perhaps gave me a Turn of Thinking that had an Influence on some of the principal future Events of my Life" (A:58).[87] In his *Essay on Projects* (1697), Daniel Defoe (c.1660–1731) begins with a consideration of the general theme of the human need for cooperation to facilitate success. "Man is the worst of all God's Creatures to shift for himself," Defoe writes. Unlike the animals, who can rely directly on nature and instinct, humans must use reason to have any hope of continued success. He urges us to turn our reason to the advancement of cooperative projects, and he praises the "Honest Projector" who would develop proposals to advance human well-being. Some of the projects that Defoe suggests in this volume are a pension plan for merchant seamen, an academy to advance the English language, and an academy for women.[88]

[86.] Cf. I. Bernard Cohen: "According to his standards, the scientist was, above all, simply a member of the community. Socially, he was like every other citizen; he was entitled to no special privileges, no exemptions from service. According to Franklin's credo, moreover, the needs of the community are always of greater importance than the needs of any single individual, be he scientist or any other kind of citizen" ("Benjamin Franklin as Scientist and Citizen," 475; cf. *Benjamin Franklin's Experiments*, 9–10; Mott and Jorgenson, "Introduction" to *Benjamin Franklin*, cx–cxiii).

[87.] Cf. Ralph L. Ketcham: "Mather, the Puritan clergyman, gave to Franklin an earnest sense of moral duty which, combined with Defoe's buoyant optimism about applying reason to social problems, produced a nearly ideal stimulus for effective action to alleviate human want and suffering" (*Benjamin Franklin*, 30).

[88.] Defoe, *Selected Writings*, 24–25. Cf. Gilbert D. McEwen: Both Defoe and Franklin "approached any problem with 'What if?,' exhibiting a new kind of pragmatism in a century that to both of them seemed to have unprecedented possibilities" ("'A Turn of Thinking': Benjamin Franklin, Cotton Mather, and Daniel Defoe on 'Doing Good,'" 62).

Franklin's connection with Cotton Mather (1663–1728) is perhaps more apparent. Growing up in Boston, Franklin had heard Mather preach on numerous occasions; and, on a later visit to Boston, Franklin visited the elderly divine in his home (cf. 20:287; W9:209). In 1710, Mather published a volume entitled *Bonifacius: An Essay upon the Good*, more frequently referred to under the title, *Essays to do Good*, in which he discusses our various possibilities for doing good works in our roles as family member, neighbor, minister, schoolmaster, magistrate, physician, and so on. "Let no man pretend unto the name of *a Christian*," Mather writes in this volume, "who does not approve the proposal of *a perpetual endeavor to do good in the world.*" Further, he admonishes, "*we might every one of us do more good than we do.*" Mather also peppers the volume with Calvinistic passages which assert that for doing good, "the *first* thing, and indeed the ONE thing, that is *needful*, is, a glorious work of GRACE on the soul" such that "no *good works* can be done by any man until he be *justified.*" However, these defenses of the primacy of the Covenant of Faith over that of Works stand side-by-side in *Essays to do Good* with more Pragmatic assertions like: "A *workless faith* is a *worthless faith.*"[89] While as a young man Franklin bristled at the former aspects of this volume—it was at this time that he wrote his fourteen 'Silence Dogood' essays (cf. 1:8–45)—as he grew older he came to recognize the potential importance of the latter aspects. He writes to Mather's son, Samuel, on 12 May 1784 that *Essays to do Good* had "an influence on my conduct through life; for I have always set a greater value on the character of a *doer of good*, than on any other kind of reputation . . ." (W9:208).[90]

For Franklin, the combined message of these two authors was the importance of cooperation to do good; and he took this message as one of the central themes of his life. The need for cooperation was a

[89.] Mather, *Bonifacius*, 18, 20, 27, 29. Cf. Robert H. Bremner: "Mather's real contribution to the practice of philanthropy lay in his recognition of the need for enlisting the support of others in benevolent enterprises. He was a tireless promoter of associations for distributing tracts, supporting missions, relieving needy clergymen, and building churches in poor communities" (*American Philanthropy*, 14).

[90.] Cf. Mitchell Robert Breitwieser: "for Mather . . . the aim of such work was to glorify God and promote the glorification of God by others, rather than to advance secular comfort; for Franklin, however, . . . works were good if they advanced the general social and physical happiness of himself and of his countrymen . . ." (*Cotton Mather and Benjamin Franklin*, 13; cf. Conner, *Poor Richard's Politicks*, 199–200; Mott and Jorgenson, "Introduction" to *Benjamin Franklin*, xxxiii–xxxiv).

point that had been brought home to him especially clearly by his familiarity with the nature of scientific advance. As he wrote, for example, during the efforts to establish the Pennsylvania Hospital "the Good particular Men may do separately, in relieving the Sick, is small, compared with what they may do collectively, or by a joint Endeavour and Interest" (4:150). In the words of Ralph L. Ketcham, Franklin's "social outlook" was that "men of good will acting together *could* make a difference, both in their individual self-discipline and in the well-being of the community. Franklin seems never to have despaired of being able to *do something* about the ills of mankind. It required only that men organize, work together, and apply their hearts and minds and energy to the problem at hand."[91] Guided by this spirit of meliorism,[92] Franklin was able to approach the increasing social problems of his growing society in the same way that he approached scientific problems; and he responded with calls for informal ties and voluntary associations to insure and protect, to build and maintain, to discover and disseminate. He called for voluntary institutions to address social ills. As Whitfield J. Bell phrases this point, "no man in his day better understood, or more often and successfully practiced, the techniques of cooperative action than Franklin. He applied principles of mechanics to benevolence. By uniting many small private energies into a voluntary joint stock association, he created engines with power for infinite good in the American community."[93] We can consider a number of these 'engines' more carefully.

The first of Franklin's social institutions was the Junto. This organization, also called the Leather Apron Club, was an informal association of mechanics, artisans, and tradesmen established in 1727 and interested both in improving the well-being of its members

[91.] Ketcham, "Introduction," to *The Political Thought of Benjamin Franklin*, xxx.

[92.] Cf. John Dewey: "Meliorism is the belief that the specific conditions which exist at one moment, be they comparatively bad or comparatively good, in any event may be bettered" (*Reconstruction in Philosophy*, 181–82; cf. Carl Bridenbaugh, "Philosophy Put to Use," 76).

[93.] Bell, "Benjamin Franklin as an American Hero," 129. Cf. Malcolm R. Eiselen: "in the application of united effort to the common problems of human society, he was consistently in advance of contemporary thought. Cooperation for the common good was with him a religion, more real to him perhaps than any orthodox creed" (*Franklin's Political Theories*, 95–96; cf. Bell, "The Worlds of Benjamin Franklin," 39–40; Rossiter, *Seedtime of the Republic*, 287; Conner, *Poor Richard's Politicks*, 65; John C. Van Horne, "Collective Benevolence and the Common Good in Franklin's Philanthropy," 430–33).

and in advancing the interests of society. Franklin describes this club as a semi-secret organization of twelve individuals who would assemble on Friday evenings to discuss one or another "Point of Morals, Politics or Natural Philosophy" (A:117). The deliberately low profile of the group was intended "to avoid Applications of improper Persons for Admittance, some of whom perhaps we might find it difficult to refuse" (A:170). In their weekly meetings, the members of the Junto considered a series of twenty-four questions, including the following:

1. Have you met with any thing in the author you last read, remarkable, or suitable to be communicated to the Junto? particularly in history, morality, poetry, physic, travels, mechanic arts, or other parts of knowledge . . .

7. What unhappy effects of intemperance have you lately observed or heard? of imprudence? of passion? or of any other vice or folly? . . .

11. Do you think of any thing at present, in which the Junto may be servicable to *mankind?* to their country, to their friends, or to themselves? . . . (1:257)

Each member was also expected quarterly to "produce and read an Essay of his own Writing on any Subject he pleased." In their discussions, the Junto members pledged to be guided by "the sincere Spirit of Enquiry after Truth, without Fondness for Dispute, or Desire for Victory" (A:117); and Franklin reports that these discussions functioned as a testing ground for many ideas and proposals for civic improvement, offering such examples as the city watch, or police, and the Union Fire Company (cf. A:173–75; 2:12–15). When looking back in his *Autobiography*, Franklin proudly describes the Junto as "the best School of Philosophy, Morals and Politics that then existed in the Province" (A:118).[94]

Another of the Junto's attempts at civic improvement was the establishment of "a common Library," a project that lasted only briefly, Franklin reports, because of "want of due Care" of the books (A:130). The clear benefits of the low cost availability of books had

[94] For more on the Junto, see: 1:259–64; Dorothy F. Grimm, "Franklin's Scientific Institution," 439–44; Parton, *Life and Times of Benjamin Franklin*, 1:47–48, 157–62; Van Doren, *Benjamin Franklin*, 73–79, 101–6; Douglas Anderson, *The Radical Enlightenments of Benjamin Franklin*, 13–15; Beatrice Marguerite Victory, *Benjamin Franklin and Germany*, 110, 119.

demonstrated itself, however, and Franklin was soon proposing "to render the Benefit from Books more common by commencing a Public Subscription Library" (A:142). The spirit behind the Library Company of Philadelphia can be found in the words of its secretary (and Junto member), Joseph Breitnall, who wrote that now that the colony had moved out of its "Infancy," the thoughts of its residents could turn more to "the Refinements of Life" and the "Provision for a publick generous Education," to which common library would be a strong contribution (reprinted in 1:320–21). The Library Company was established on 1 July 1731 with an initial goal of fifty members willing to contribute a membership fee of 40 shillings and annual dues of 10 shillings to buy books; but it grew over the first decade well beyond that number of subscribers and spawned numerous copies elsewhere in the colonies. The books themselves—nearly four hundred after a decade and over two thousand by 1770—came mostly from England, where the Company's initial agent was the previously encountered Peter Collinson (above, 2.2). Franklin, long one of the directors of the Company, acted as agent himself during many of his years in London.[95]

An additional instance of this same cooperative spirit to advance the common good was the American Philosophical Society, which Franklin, developing upon a suggestion by John Bartram (cf. 2:378–79), called for in 1743. As Franklin writes in his "Proposal for Promoting USEFUL KNOWLEDGE among the British Plantations in America": "The first Drudgery of Settling new Colonies, which confines the Attention of People to mere Necessaries, is now pretty well over; and there are many in every Province in Circumstances that set them at Ease, and afford Leisure to cultivate the finer Arts, and improve the common Stock of Knowledge." Unfortunately, he continues, because of the great distances beween these individuals, many of the "Hints" and "Observations" of particular individuals "remain uncommunicated, die with the Discoverers, and are lost to Mankind." In response, Franklin proposes an organization of "Virtuosi or ingenious Men" based in Philadelphia to provide a social memory for gathering and publicizing what had been uncovered or devised in electricity, medicine, agriculture, chemistry, mathematics,

[95.] For more on the Library Company, see: 2:308–9; Bridenbaugh, "Philosophy Put to Use," 76–78; Austin K. Gray, *Benjamin Franklin's Library*, 7–17; Van Doren, *Benjamin Franklin*, 104–6.

geology, and the various other areas of natural philosophy that "let Light into the Nature of Things" so as "to increase the Power of Man over Matter, and multiply the Conveniencies or Pleasures of Life" (2:380–82). The subsequent establishment of the American Philosophical Society in 1744 proved to be a false start and it soon foundered (cf. 2:379–80); but it was reborn in 1769 under its present name of the "American Philosophical Society, held in Philadelphia, for Promoting Useful Knowledge," with Franklin— although then in London—as its president (cf. 15:259–62).[96]

Yet another of the institutions that Franklin played a significant role in founding was the Pennsylvania Hospital. The idea of a hospital in Philadelphia was initially conceived by one of the original members of the American Philosophical Society, the Maryland-born and European-educated physician, Thomas Bond. Despite the obvious value of having a hospital to relieve the suffering of the sick and insane in the province, the proposal itself languished—Franklin thought because it was "a Novelty in America" (A:199)—until he conceived of a plan to combine a public appeal to the citizens with a call for a matching grant from the Pennsylvania Assembly. In his August 1751 public appeal for the Hospital, Franklin combines the themes of the insecurity of the human situation with regard to illness and the need for charity towards the unfortunate with a presentation of the potential improvements of treating the sick "according to the best Rules of Art, by Men of Experience and known Abilities in their Profession" (4:153) in a permanent facility dedicated to that purpose. Working through the Assembly, he managed to secure a conditional grant of £2,000 if an equivalent amount could be raised (cf. A:200–201; 4:108–11). It was, and the Hospital opened in temporary quarters in 1752, with the construction of a permanent building beginning the next year.[97]

As a final example of Franklin's efforts to establish social institutions to advance the good of the community, we can consider the Philadelphia Academy (that has since grown into the University of Pennsylvania). Franklin suggests that he first conceived of the idea of

[96.] For more on the American Philosophical Society, see: Brooke Hindle, *The Pursuit of Science in Revolutionary America, 1735–1789*, 121–45; Bridenbaugh and Bridenbaugh, *Rebels and Gentlemen*, 321–22, 334–41.

[97.] For more on the Pennsylvania Hospital, see: 5:283–330; Van Doren, *Benjamin Franklin*, 194–96; Bridenbaugh and Bridenbaugh, *Rebels and Gentlemen*, 243–49.

establishing an institution for the education of the young men of
Philadelphia and Pennsylvania in 1743 (cf. A:181–82); but the first
published record of his interest appeared in his *Pennsylvania Gazette*
in 1749. In agreement with a number of other Philadelphians "of
whom the Junto furnished a good Part" (A:192–93), he placed in
the *Gazette* an anonymous appeal to his readers to recognize that it
was time to establish some sort of academy, with the eventual goal of
developing it into a college. Up to this time, he writes, people had
been legitimately concerned more with "the necessaries of life" and
"the *culture* of *minds* by the *finer arts* and *sciences*, was necessarily
postpon'd to times of more wealth and leisure" (3:385–86). It was
Franklin's view that by 1749 those better times had come. He
followed this brief appeal with a full-blown plan, *Proposals Relating
to the Education of Youth in Pennsylvania* (3:397–421; cf. 4:34–37),
that laid out his ideas in explicit detail.[98] In his proposal, he writes of
the importance of the project to help the children growing up in the
New World achieve their potential as had their elders, who had had
the benefit of a European education: "The present Race are not
thought to be generally of equal Ability: For though the American
Youth are allow'd not to want Capacity; yet the best Capacities
require Cultivation, it being truly with them, as with the best
Ground, which unless well tilled and sowed with profitable Seed,
produces only ranker Weeds" (3:399). The academy opened in
January 1751, and it was instructing over one hundred students by
September (cf. 4:194). The academy received a proprietary charter in
1753 and became a college (and thus able to confer degrees) in 1755
(cf. 5:7). Franklin himself served as president of the Board of
Trustees until 1756; but his years away—June 1757 to November
1762, November 1764 to May 1775, and October 1776 to Septem-
ber 1785—in London and Paris prevented much first-hand engage-
ment with the college after that. While he was gone, curricular issues
that we will examine (below, 5.3) led to discords within the college,
and the Pennsylvania legislature's suspicions of Loyalism within the
college during the Revolution led to its replacement by the Universi-
ty of the State of Pennsylvania in 1779. The post-Constitutional

98. Cf. Robert Ulich: "Franklin's 'Proposals' contain no fundamentally new
ideas. He refers in the introductory remarks and in the footnotes which accompany
the text in great number to such men as Milton, Rollin, Turnbull, Hutchinson,
Walker, and particularly to Locke; yet he would not have accepted their theories had
they not complied with his own judgment" (*History of Educational Thought*, 239).

legislature restored the original college in 1789, leaving two compet-
ing institutions; and the two were merged by the legislature into the
University of Pennsylvania in 1791.[99]

Each of these institutional projects—all of which, except for the
Junto, are still in existence after well over two centuries—reflects
Franklin's overall vision of the possibility of scientific advancement
by creating places that foster learning about nature and the applica-
tion of what has been learned to human well-being. It would perhaps
be of value to make explicit at this point a number of Franklin's
methodological emphases, beginning with the social importance of
publicity in science. He notes, for example, in 1786 the prior failure
to deal in any organized fashion with the harmful effects of lead, in
spite of the long-term recognition of medical problems among the
various groups of workmen who regularly came into contact with the
material. He writes that, even though "the Opinion of this mischie-
vous Effect from Lead is at least above Sixty Years old," nothing was
done. For Franklin, such inaction is proof that there can be far too
long of a period when "a useful Truth may be known and exist,
before it is generally receiv'd and practis'd on" (W9:533). Moreover,
for Franklin the obvious correction was to create institutions of
publicity so that scientific discoveries would be broadly disseminated
rather than lost.[100]

A corollary to the value that Franklin placed in publicity was his
willingness to see himself proven wrong in the interest of social
progress. We find him writing at the end of a long discussion of the
nature and workings of lightning, for example, that:

> if I were merely ambitious of acquiring some Reputation in Philoso-
> phy, I ought to keep them [my thoughts] by me, 'till corrected and
> improved by Time and farther Experience. But . . . even short Hints
> and imperfect Experiments in any new Branch of Science, being
> communicated, have oftentimes a good Effect, in exciting the
> attention of the Ingenious to the Subject, and so becoming the

[99.] For more on the Academy of Philadelphia, see: Bridenbaugh and Briden-
baugh, *Rebels and Gentlemen*, 41–48, 55–63; Edward Potts Cheyney, *History of the
University of Pennsylvania, 1740–1940*, 27–45, 104–69.

[100.] Cf. Michael Kraus: "A large part of the history of the scientific interrelations
of Europe and America in the latter half of the eighteenth century can be written
around the personality of Benjamin Franklin . . . He was one of the most important
channels through which Americans and Europeans kept abreast of each other's
achievements" (*The Atlantic Civilization*, 184).

Occasion of more exact disquisitions . . . and more compleat
Discoveries . . .

Thus, while uncertain of the correctness of his ideas, Franklin was
willing to undergo the risk of their publication. Such communication,
while no doubt painful should the authors later be proven wrong, was
still to be preferred, since, as he writes, "it being of more Importance
that Knowledge should increase, than that your Friend should be
thought an accurate Philosopher" (5:79).[101] Moreover, when these
opinions have been made public, they must fend for themselves. "I
have never entered into any Controversy in defence of my philosophi-
cal Opinions; I leave them to take their Chance in the World," he
writes. "If they are right, Truth and Experience will support them. If
wrong, they ought to be refuted and rejected" (25:26; cf.20:129–30).
Elsewhere Franklin offers a further value of publicity: "a bad Solution
read, and it's Faults discovered, has often given Rise to a good one in
the Mind of an ingenious Reader" (4:17). Furthermore, he backs up
his fallible stance with a compromising style of presentation, one that
eliminates as far as possible such terms as 'certainly' and 'undoubtedly'
and uses in their stead "*I conceive, I apprehend*, or *I imagine* a thing to
be so and so, or it so appears to me at present" (A:159; cf. 64–65).

Still other instances of this tentative and hypothetical stance—that
no human product is perfect, that advance comes from recognizing
and overcoming mistakes—can be pointed to in areas beyond the
range of natural philosophy. We can consider, for example, Franklin's
support for signing the just-completed Constitution in Philadelphia in
1787 as about the best that could be hoped for from the delegates'
most sincere efforts, given "all their prejudices, their passions, their
errors of opinion, their local interests, and their selfish views"
(W9:608). Returning to natural philosophy, we have seen (above, 2.1)
how ongoing experimentation can force us to abandon many of our
hypothetical systems, however "pretty" they may be (3:171). Such
mistakes are uncovered by the sharing of results; and science advances
by admitting the possibility of error and persevering in our experi-
ments "till we are instructed by Experience" (18:180).[102]

[101.] Cf. Charles Sanders Peirce: "Franklin said a century ago that nothing was
certain" (*Collected Papers*, 1.152).

[102.] Cf. I. Bernard Cohen, who points to Franklin's background as a printer:
"Every printer, especially if he is the publisher of a newspaper as Franklin was, is
aware that he cannot help making errata. What counts is not so much the making of
mistakes as the frank acknowledgement of them and the correction of them in a later
issue" (*Franklin and Newton*, 74).

Franklin's belief is that in any area of social inquiry we have but two options. Our most comfortable option, to judge from past experience, would seem to be to assume that we are right and all who might disagree with us are wrong. Franklin found this view, not surprisingly, completely alien:

> when the natural Weakness and Imperfection of Human Under-standing is considered, with the unavoidable Influences of Educa-tion, Custom, Books, and Company, upon our Ways of thinking, I imagine a Man must have a good deal of Vanity who believes, and a good deal of Boldness who affirms, that all the Doctrines he holds, are true; and all he rejects, are false. (2:203)

Franklin put this rejection more poetically in his *Autobiography*, where he writes that this blind confidence in one's own belief is "Like a Man travelling in foggy Weather: Those at some Distance before him on the Road he sees wrapt up in the Fog, as well as those behind him, and also the People in the Fields on each side; but near him all appears clear." His point, one that applies with equal validity to beliefs of scientific and of nonscientific sorts, is that "in truth he is as much in the Fog as any of them" (A:191). Franklin thus advocated the second, although less comfortable, option: admitting that mis-takes are always possible, and asking others for assistance, clarifica-tions, and criticisms. "I find a frank acknowledgment of one's ignorance is not only the easiest way to get rid of a difficulty," he writes, "but the likeliest way to obtain information . . ." (5:526). A fuller formulation of this point runs as follows:

> Nothing certainly can be more improving to a Searcher into Nature, than Objections judiciously made to his Opinions, taken up perhaps too hastily: For such Objections oblige him to restudy the Point, consider every Circumstance carefully, compare Facts, make Experi-ments, weigh Arguments, and be slow in drawing Conclusions. And hence a sure Advantage results; for he either confirms a Truth, before too slightly supported; or discovers an Error and receives Instruction from the Objector. (4:429)

As an instance of Franklin's own practice of this cooperative policy, we can consider the conclusion of his 1729 essay in support of paper currency that includes the following request: "I sincerely desire to be acquainted with the Truth, and on that Account shall think my self obliged to any one, who will take the Pains to shew me, or the

Publick, where I am mistaken in my Conclusions . . ." (1:156).[103]
Although I suspect that Franklin, like the rest of us, might still have
an emotional interest at times in maintaining his own views that
could slow the process of their improvement, we should recognize
the importance of this scientific spirit of cooperative advance of the
common good present in his thought and attempt to develop it
ourselves.

Just as important as these emphases on adopting a tentative or
hypothetical stance and on fostering publicity is Franklin's empha-
sis on advancing the common good. This practical emphasis,
central to all of his thinking to improve human well-being is what,
for example, led him to issue a passport for Captain James Cook
and his crew in 1779 as "common Friends to Mankind" (29:87)
that even in wartime they might return unmolested to Britain with
their scientific discoveries. This practical emphasis also fostered his
development of the Pennsylvania fireplace and prevented him from
seeking a patent on it. In general, his scientific work was in large
part the imaginative attempt to use human rationality to advance
the common good. A meliorist rather than an optimist, a believer in
potential rather than necessary progress, Franklin writes in 1788 of
"the growing felicity of mankind, from the improvements in
philosophy, morals, politics, and even the conveniences of com-
mon living, by the invention and acquisition of new and useful
utensils and instruments . . ." (W9:651). Moreover, he expected
that our continued efforts would be met with continued progress.
Recognizing the work of the growing number of societies and
academies of science, and of the technological breakthroughs that
were being made, Franklin writes at least half-seriously in 1783 "I
begin to be almost sorry I was born so soon, since I cannot have the
happiness of knowing what will be known 100 years hence"
(W9:74–75).[104]

This Pragmatic view that the discoveries of natural philosophy
must be put to use in the practical affairs of people, that we must
apply the knowledge we have gained in science to advance human
well-being, is central to Franklin's way of thinking. This was a

[103.] Cf. 2:95, 446–47; 4:388; 17:5–8. Cf. Charles Sanders Peirce: "I earnestly
beg that whoever may detect any flaw in my reasoning will point it out to me, either
privately or publicly; for, if I am wrong, it much concerns me to be set right
speedily" (*Collected Papers*, 6.65).

[104.] Cf. 31:455–56; W9:436.

viewpoint, moreover, that was widely shared. The restructured American Philosophical Society, for example, formulates this point as follows in the preface to the first volume of its *Transactions* in 1771:

> Knowledge is of little use, when confined to mere speculation: But when speculative truths are reduced to practice, when theories, grounded upon experiments, are applied to the common purposes of life; and when, by these, agriculture is improved, trade enlarged, the acts of living made more easy and comfortable, and, of course, the increase and happiness of mankind promoted; knowledge then becomes really useful.[105]

In such a social context, chemistry and botany were never abstract research topics; but, as Whitfield J. Bell writes, they were "the handmaidens of medicine and agriculture . . ."[106] This understanding of the role of wisdom in society gives it a practical, rather than a theoretical role. It implies as well a more complete sense of democracy, in that the common concerns of common people are to be addressed. Perhaps Franklin at times went too far in this direction for our contemporary tastes, as when he writes that "I confess that if I could find in any Italian Travels a Receipt for making Parmesan Cheese, it would give me more Satisfaction than a Transcript of any Inscription for any old Stone whatever" (16:172–73).[107] Still, it would be unfair to characterize Franklin's overall Pragmatic viewpoint as being expedient or opportunistic, or to equate his distinctly practical approach to scientific work with the advocacy of the blind mechanization of America, as was suggested by some of his critics (above, 1.3). Rather, it is important to emphasize that the deliberate choice to focus cooperative effort upon advancing the common good through increasing our power to control nature is highly imaginative, prudent, and demonstrative of a democratic spirit. This was Franklin's vision: "to extend the Power of Man over Matter, avert or diminish the

[105.] *Transactions of the American Philosophical Society*, 1:i; cf. xix.

[106.] Bell, "The Scientific Environment of Philadelphia, 1775–1790," 11.

[107.] Cf. 19:25; 20:464, 506–8. Cf. Clinton Rossiter: "If Franklin had any major limitation in his character as a scientist, it was the overly practical, utilitarian, unspeculative mood in which he approached his experiments, which is another way of saying that he was a notable representative of the developing American mind" (*Seedtime of the Republic*, 285; cf. Bell, "The Scientific Environment of Philadelphia, 1775–1790," 11).

Evils he is subject to, or augment the Number of his Enjoyments"
(W8:593).[108]

Finally, Franklin's emphasis upon the usefulness of knowing how
the world works, rather than not knowing, should not diminish our
estimation of him as a scientist. We cannot doubt his seriousness and
dedication to advancing natural philosophy. Franklin pursued sci-
ence because its questions fascinated him. His research was moti-
vated by his desire to understand the workings of nature. In true
Baconian fashion, he believed as well that practical benefits would
come from this knowledge; but seeking them was not necessarily the
cause of any particular experimental undertaking, nor failing to have
attained such benefits necessarily a cause for abandoning a line of
inquiry.

> It does not seem to me a good reason to decline prosecuting a new
> experiment which apparently increases the power of a man over
> matter, till we can see to what use that power may be applied. When
> we have learnt to manage it, we may hope some time or other to find
> use for it, as men have done for magnetism and electricity, for which
> the first experiments were mere matters of amusement . . . [Any
> experiment] may be attended with important consequences that no
> one can foresee. (W9:117–18)

In the back of Franklin's mind was always the belief that scientific
discoveries would prove somehow useful; in the front of his mind
was some specific and attractive natural problem. This attitude of
long-term practicality combined with short-term fascination is pre-
sumably the attitude of any working scientist.[109] We can attack a
crippling disease, for example, knowing in advance that its eventual
elimination will increase human well-being; but we cannot know in
advance whether any particular line of attack will bring us closer to

[108.] Cf. I. Bernard Cohen: "Franklin stands in the American tradition for the
proposition that reflections about society should produce useful institutions for the
improvement of the conditions of life; considerations about the estate of man
should yield more than eternal principles and noble concepts, and must be fruitful
of a system of government and laws to safeguard man's rights . . ." ("Introduction"
to *Benjamin Franklin: His Contribution to the American Tradition*, 50; cf. 57).

[109.] Cf. Adrienne Koch: "Only the proper passion for theoretical understanding
can explain Franklin's sustained and highly constructive inquiry into the nature of
electrical phenomena—an inquiry which might or might not have had ultimate
practical significance . . ." (*Power, Morals and the Founding Fathers*, 16).

success.[110] Franklin's discoveries in electricity might well have proven to be as apparently useless as his discoveries of "magic Squares, or Circles" (A:197), the mathematical curiosities with which he occupied his mind during wearying debates when he was clerk of the Pennsylvania Assembly.[111] It is also true, of course, that these mathematical diversions might have led to some future discoveries useful for more than fighting sleep. A final point with regard to the potential practicality of scientific work has to do with one further unanticipatable practical use of Franklin's scientific work: it gave him the kind of credibility and access in European political circles that no other self-educated shopkeeper from the wilderness of America could have had. It was as a world-famous 'natural philosopher' that Franklin entered the world of politics. This was true in England and even more so in France where he was, as I. Bernard Cohen writes, "not an unknown man from an English colony" but "one of the best-known living scientists and benefactors of the age."[112]

[110.] Cf. I. Bernard Cohen: "The success of Franklin's invention of the lightning rod must have given him great pleasure in having produced something useful to humanity But, in this case as in many others, no one could have predicted the practical result since no one knew at the beginning of the research where the experiments would lead" (*Benjamin Franklin's Science*, 37; cf. Bell, "The Father of All Yankees," 71–72; Schneider, "The Significance of Benjamin Franklin's Moral Philosophy," 304).

[111.] Franklin did allow that, while some question of whether we should spend our time with "things that were merely *difficiles nugae* [complicated trifles], incapable of any useful application," working with such 'trifles' might not be "altogether useless . . . if it produces by practice an habitual readiness and exactness in mathematical disquisitions, which readiness may, on many occasions, be of real use" (4:393–94; cf. 392–403; 12:146–49; Van Doren, *Benjamin Franklin*, 143–46.

[112.] Cohen, *Benjamin Franklin's Science*, 38. Cohen continues: "when Franklin arrived in France on that grave mission he was already a public figure, well known to the French court and to the French public at large in a sense that would have been true of no other American in the political diplomatic arena, and this was so because of his stature as a scientist and because of the spectacular nature of his work on lightning" (*Benjamin Franklin's Science*, 9; cf. Vernon Louis Parrington, *Main Currents in American Thought*, 1:167).

CHAPTER 3
Franklin's Religious Thought

"SERVING GOD IS Doing Good to Man," Poor Richard tells us, "but Praying is thought an easier Service, and therefore more generally chosen" (4:406; cf. 3:105). From this brief passage we can extrapolate much of Franklin's view of religion, a view that has much in common with the understanding of science that we have just considered. The locus of activity in each case is the public world of nature and our fellows, and the purpose of activity in each case is the advancement of human well-being. In this chapter we will begin with an exploration of the impact of the Puritan tradition on Franklin's religious perspective. Next comes an examination of his early religious thinking that constitutes a radical reaction to his Puritan background. This is followed by a study of his more mature Deistic thinking. Finally, we shall consider Franklin's analysis of the positive social role of religion. At each point, we will encounter the strong Pragmatic current that underlies his religious thought.

3.1. Puritan Origins

One friend wrote of Franklin in 1765, "Theology I believe is of all the Sciences the only one in which I suspect he is not perfectly sound."[1] Whether this evaluation is accurate or not is ultimately up to the reader to decide; but it will become clear in this section that religion as a broad area of human concern remained an important issue for Franklin throughout his life. He presents himself as being descended from a long line of Protestants who prided themselves on

[1.] William Robertson to William Strahan, 18 February 1765 (reprinted in 12:70). Cf. Joseph Dorfman: "Franklin was typical of the enlightened eighteenth-century cosmopolitan figure. Religion sat lightly on him . . ." (*The Economic Mind in American Civilization, 1606–1865*, 1:195; cf. Leonard Woods Labaree, "Franklin and the Presbyterians," 220).

their zealousness against "Popery" (A:50).[2] He writes, for example, that in the mid-sixteenth century during the bloody reign of Queen Mary, the Catholic daughter of Henry VIII, the family of his great-great-grandfather, Thomas Francklyne, "had got an English Bible, and to conceal and secure it, it was fastned open with Tapes under and within the Frame of a Joint Stool." In this way, they were able to read their Bible in family religious services, secure against the sudden appearance of any ecclesiastical officer:

> When my Great Great Grandfather read in it to his Family, he turn'd up the Joint Stool upon his Knees, turning over the Leaves then under the Tapes. One of the Children stood at the Door to give Notice if he saw the Apparitor coming, who was an Officer of the Spiritual Court. In that Case the Stool was turn'd down again upon its feet, when the Bible remain'd conceal'd under it as before. (A:50; cf. 2:230–31)

It was in part because of this sort of religious oppression, later practiced by the established Anglican Church against dissenters from its practices, that Franklin's father moved to America to practice his religion free from interference (cf. 8:350–51; 19:163–68).

Franklin himself grew up in Puritan Boston, attending religious services with his family in the Old South Church where he had been baptized by Samuel Willard on the day of his birth.[3] As we have seen

[2.] Franklin displayed elements of anti-Catholicism throughout his life. He writes, for example, on 13 April 1785 of the conversion of a Boston Protestant clergyman to Catholicism: "Our ancestors from Catholic became first Church-of-England men, and then refined into Presbyterians. To change now from Presbyterianism to Popery seems to me refining backwards, from white sugar to brown" (W9:303; cf. 9:17; Alfred Owen Aldridge, *Benjamin Franklin and Nature's God*, 222–49). In his anti-Catholicism, Franklin was not unlike such British figures as John Locke, who characterized Catholic Communion beliefs as "false and absurd" and who found them suspect citizens because they "deliver themselves up to the Protection and Service of another Prince" (*A Letter concerning Toleration* [1689], 46, 50); and David Hume, who characterized Catholicism as a "superstition" and its ceremonies as "mummeries" (*An Inquiry concerning Human Understanding* [1748], 64). Franklin was also not unlike the founder of Pennsylvania, William Penn, who wrote "A Seasonable Caveat against Popery" [1670], or such patriotic and religious colonial figures as Elisha Williams, the author of *The Essential Rights and Liberties of Protestants* [1744], Samuel Adams, the author of a series of three anti-Catholic articles signed "A Puritan" [1768] (*Writings*, 1:201–12), and Jonathan Mayhew, the author of *Popish Idolatry* [1765].

[3.] Cf. James Parton: "When Franklin was born, fourteen years had elapsed since the great execution of witches at Salem. Men and women were, however, still obliged to confess before the congregation; no man could hold office who was not a

(above, 1.2), his father had originally intended to devote him as his tenth son to the ministry; but with Josiah's growing recognition of the expenses involved in a college education and the uncertain future that many young men so educated faced came a redirection of young Benjamin's life into a more mundane vocation. Still, Benjamin hungered for knowledge; and this hunger could be satisfied conveniently only in the "little Library" of his father which "consisted chiefly of Books in polemic Divinity, most of which I read . . ." (A:58).[4] All in all, Franklin notes, "[m]y Parents had early given me Religious Impressions, and brought me through my Childhood piously in the Dissenting Way" (A:113). Elsewhere, he writes that he "had been religiously educated as a Presbyterian" (A:145), although it would be more accurate to locate Franklin's upbringing within Presbyterianism's Calvinist cousin, New England Congregationalism.[5] In any case, it remains important to consider whether he was influenced in any lasting way by his Boston Puritan background before his departure for Quaker Philadelphia at the age of seventeen in 1723.

It is easy to find suggestions that Franklin was himself a Puritan: for example, that "he exhibits all the essential characteristics of the Puritan" or that "in his writings, he was the soul of Puritanism."[6] As might be suspected, however, it is just as easy to find suggestions that he was not, that "[t]he Calvinism in which he was bred left not the slightest trace upon him . . ."[7] It is even possible to find intermediate positions like the following: "Franklin was no Puritan, yet he had

member of the established church; it was a criminal offense for people to ride or children to play on Sundays; and to worship according to the rites of the Catholic Church was a capital offense" (*Life and Times of Benjamin Franklin*, 1:62).

[4.] Cf. Carl Van Doren: Franklin's religious "skepticism was bred by the disputatious theologians whom he read in his father's library" ("Introduction," to *Benjamin Franklin and Jonathan Edwards*, xiv).

[5.] Presumably Franklin, writing in France at this point, described his religious education this way because of Presbyterianism's stronger presence outside of New England. Cf. Leonard Woods Labaree: "In the eighteenth century a New Englander moving to Pennsylvania might well think that it was apt to be much simpler and would do no great violence to the truth to say that he had been brought up as a Presbyterian . . . in the eyes of most of the world New England Calvinists and Pennsylvania Presbyterians were the same thing . . ." ("Franklin and the Presbyterians," 219; cf. A:145–46; 9:17; 19:165; Fischer, *Albion's Seed*, 795–797).

[6.] Stuart P. Sherman, "What is a Puritan?" 353; A. Whitney Griswold, "Three Puritans on Prosperity," 484.

[7.] Vernon Louis Parrington, *Main Currents in American Thought*, 1:165; cf. Alfred Owen Aldridge, "The Alleged Puritanism of Benjamin Franklin."

the strictest sort of Puritan ancestry and upbringing in his boyhood, the effect of which never left him."[8] These contradictory positions cannot all be true, of course; and the safest initial assumption would seem to be that the simpler claims that Franklin either was a Puritan or that he was not should be rejected. Still, without first making explicit what being a Puritan might entail, it is impossible to decide whether any such attributions should be either accepted or rejected. Moreover, deciding just what exactly makes a Puritan will be a difficult task. The first commentator cited above, for example, who finds in Franklin "all the essential characteristics" of a Puritan, lists as these Puritan characteristics the idiosyncratic set of "dissatisfaction, revolt, a new vision, discipline, and a passion for making the new vision prevail." The second commentator contrasts the "soul of Puritanism" found in Franklin's writings with the admission that in his life Franklin was "a Deist, if not an out-and-out agnostic . . ."[9] And finally, the third commentator, for whom Franklin retained "not the slightest trace" of Calvinism would appear to be drawing too fine a line between Puritanism as a religion and its broader meaning. Only within this sort of relaxed confusion, in which theological and moral and other matters are variously emphasized without ever being distinguished, is it possible for Franklin to both be and not be a Puritan. A resolution to the question of whether Franklin is a Puritan will be possible only when we have clarified the notion of Puritanism to which he is being compared.

We need first to narrow our inquiry and ask a more manageable question. Specifically, was Franklin a Puritan in the religious sense? (The consideration of Franklin's possibly 'Puritan' morality can thus be put off until chapter 4). As a religious group, the Puritans were, historically, Protestant Christians who drew their strongest guidance from the writings of John Calvin (1509–1564).[10] In England, Puritanism's long and painful conflict with the established Protestant Church led ultimately to the Civil War (1642–1649) and the Puritan Commonwealth (1649–1660). In the American context, the Puritans were a group of nonseparating Protestants who travelled to the rocky soil of Massachusetts beginning in 1630 to be able to

[8.] James Madison Stifler, *The Religion of Benjamin Franklin*, 65.

[9.] Sherman, "What is a Puritan?" 353; Griswold, "Three Puritans on Prosperity," 484.

[10.] Franklin praises Calvin as "[a] man of equal *temperance* and *sobriety* with Luther, and perhaps yet greater *industry*" (3:340).

practice their religion free from the interference of the established Anglican Church. (They were 'nonseparating' in the sense that they hoped some day to be able to return to reform the established Church). As Cotton Mather writes in his ecclesiastical history of the English colonies in America, *Magnalia Christi Americana*, these simple reforming Christians were driven by "a party very unjustly arrogating to themselves the venerable name of *The Church of England* . . . to seek a place for the exercise of the Protestant Religion, according to the light of their consciences, in the desarts of America."[11]

The understanding of Christianity that accorded with the light of the Puritan consciences was one that emphasized first of all the majesty of God as the supreme and omnipotent Creator of all that exists. Again quoting Mather, "[t]he whole *World* is indeed a *Temple* of GOD, *built* and *fill'd* by that Almighty *Architect* . . ."[12] This God moreover remained responsible for directly sustaining all of creation—from the stars and planets to the insects and blossoms—in existence, as we have seen (above, 2.2). For the Puritans, humans in their 'natural' state—morally corrupt and mortal as a result of the sin of Adam—would be of no particular importance within this majestic system had not God in his mercy offered some of them, through the redemptive suffering of Christ, a second chance at eternal salvation. The 'elect' who benefitted in this process of limited atonement could not *earn* salvation. That possibility had been lost through Adam's rejection of God's Covenant of Works. The saved were simply chosen by God for reasons of His own under a new Covenant. In this Covenant of Grace, God freely makes available to some the gift of irresistible grace in which the elect will persevere. The Puritans further believed that all individuals, although some were predestined to salvation and others to damnation and torment, should praise through prayer and communal worship the majesty of God and His plan in which they had the privilege of participating. While no individual could be certain to which group he or she belonged, the Puritans believed that in the day-to-day practices of the religious life the signs of individuals' election would be revealed. Puritanism also called for efforts on the part of individuals to prepare themselves to receive this grace, and it provided them with the means

[11.] Mather, *Magnalia Christi Americana*, 1:26.
[12.] Mather, *The Christian Philosopher*, 7.

to uncover its workings in the successes and failures of their lives. Theologically-inclined chroniclers of the Puritan experience realize that there were extraordinary emotional stakes involved in their individual and social quests for salvation, especially in the internal tension that arose from the responsibility to prepare for election without any power to effect it, and in the external success or failure of the Puritans' errand of building the New Jerusalem in the Wilderness. Less theologically-inclined chroniclers recognize that the apparent inconsistencies within the Puritan perspective had any number of possible resolutions, either through heretical simplifications—like the Arminian belief that people *could* earn salvation through their good works—or through socially- and psychologically-forced conversion experiences—like the Great Awakening of the 1740s. When maintained in its inconsistent fullness, however, Puritanism drove its adherents to the depths of introspective questioning and to the heights of religious experience.[13]

If this religious interpretation of Puritanism is to provide our definition of the term, then even the most cursory understanding of Franklin would recognize that he was no Puritan. Still, the question of Franklin as Puritan does continue to arise; and perhaps we need to reconsider the same question in a slightly different fashion by exploring the extent to which Franklin did or did not resemble other individuals who are considered to be paradigms of late Puritanism. One such figure was Cotton Mather, whom we have encountered already. Mather, grandson of John Cotton and Richard Mather and son of Increase Mather, chronicler of the Puritan experiment in New England in his *Magnalia Christi Americana*, prominant player in the witchcraft trials of 1692 in Salem, and long-time divine at Boston's North Church from 1685 to his death in 1728, surely was a paradigm Puritan. He was also a figure in whose thought the tension just considered, between the inward life of self-examination for signs of grace and the outward life of advancing the Puritans' Divine errand in New England, was prominent.[14] We saw (above, 2.4), for

[13.] For more on Puritanism, see: Sydney E. Ahlstrom, *A Religious History of the American People*, 121–65; Perry Miller, *The New England Mind*; Darrett B. Rutman, *American Puritanism*.

[14.] Cf. John Ward: "In Puritan religious thought there was originally a dynamic equipoise between two opposite thrusts, the tension between an inward, mystical, personal experience of God's grace and the demands for an outward, sober, socially responsible ethic, the tension between faith and works, between the essence of religion and its outward show" (*Red, White, and Blue*, 138).

example, his call in *Bonifacius* for unstinting efforts to do good combined with his assertion of the futility of the efforts of the 'unjustified.' This tension between the need for inward piety and the demand for its worldly demonstration developed increasing instability in late Puritanism. The tensions present in Mather's thought are perhaps the best indication of his success at keeping the centrifugal components of Puritanism together, at least during his lifetime; but these same tensions clearly separate him from Franklin. If Mather is our ideal Puritan, then Franklin is surely not one.[15]

The same conclusion must be drawn when Franklin is compared to the other great luminary of late Puritanism, Jonathan Edwards (1703–1758). The familiar presentation of their relationship offers a picture of Edwards trying to recommit society to Puritanism, with Franklin striving to break it free. In the words of Carl Van Doren, for example, the role of Edwards was that of "the resounding voice of a whole party which wanted to restore New England to the apostolic virtues of its first century," whereas Franklin's role was to oppose this attempt "to drive New England back to the dusky, witch-haunted forests wherein the first settlers had lived, body and soul . . ." It is an analysis like this that enables Van Doren to write that the two figures can be understood "as protagonists and symbols of the hostile movements which strove for the mastery of their age."[16] Another recent commentator portrays this familiar picture as follows: "They seem to divide the [eighteenth] century—Edwards, as the apologist of the declining New England theocracy, summarizing the Puritan past, and Franklin, the scientist and man of affairs, exemplifying the technology and tolerant pluralism of the coming democracy . . . Franklin is prophetic, Edwards appears reactionary."[17] As this commentator recognized, however, the familiar

[15.] Cf. Paul W. Conner: "Mather himself was a Franklin of the cloth. He represented what Franklin might have become had he been born a few decades earlier, stayed in Boston, and followed his father's wish that he serve the church" (*Poor Richard's Politicks*, 197–98).

[16.] Van Doren, "Introduction" to *Benjamin Franklin and Jonathan Edwards*, x, ix. Cf. Barbara B. Oberg and Henry S. Stout: "while other colonial figures exerted comparable, or even greater, influence on their age, none so completely anticipated the subsequent shape of an American culture, at once material and spiritual, piously secular and pragmatically sacred, as did Edwards and Franklin" ("Introduction" to *Benjamin Franklin, Jonathan Edwards, and the Representation of American Culture*, 3).

[17.] John F. Lynen, *The Design of the Present*, 87. Cf. Vernon Louis Parrington: "The greatest mind of New England had become an anachronism in a world that bred Benjamin Franklin" (*Main Currents in American Thought*, 1:162).

picture, benefitting as it does from great temporal and theological distance, simplifies a highly complex issue.

The issue between Edwards and Franklin is a religious one, but 'religious' in the broadest sense of the whole understanding of nature and the place of humankind within it. Edwards and Franklin were two pre-eminent figures with roots in the Puritan past. As Perry Miller puts it, they came "from the same parent stock" and were "heirs of a once unitary tradition." Both were also heirs to the New Science of Bacon and Newton and Locke that we have seen (above, 2.1). The question to be considered is how the inherited religious tradition and the New Science interacted differently in their thinking. Miller continues:

> Edwards understood at once that in this awful perspective everything that Christian theology supposed it had achieved before the advent of a psychology based upon physical sensation and the mechanistic cosmos was made hopelessly obsolete. If religion was to survive, and especially if the Calvinism of New England was to be retained, then every doctrine would have to be restated in the radically altered philosophical context.[18]

Franklin's understanding was far different from Edwards's, because his working familiarity with the intricacies of the new science came long after the Puritanism of his upbringing had been overcome. For Franklin the issue was never that of securing the survival of the Puritan theological tradition, but rather that of advancing the natural possibilities inherent in the New Science. Adrienne Koch writes that while the New Science provided Edwards with "an armory of new ideas with which to fortify the languishing doctrine of predestination and original sin," it suggested to Franklin "the active, 'interfering' aspects of scientific knowing and the human ends which experimental knowledge may come to serve."[19] Thus, instead of an Edwardsean focus upon humans exploring their intimate relationship with an immanent God to uncover what was expected of them, we find in Franklin a confident self-direction. He believed that he knew what any God worthy of the name would want of us. This was simply that we work with our reason and with the tools that the New Science was making available to make the

[18.] Miller, "Benjamin Franklin, Jonathan Edwards," 83, 84, 91.
[19.] Koch, *Power, Morals, and the Founding Fathers*, 14.

world a better place for our fellows. As he writes in this naturalistic spirit:

> 'Tis surprizing to me, that Men who call themselves Christians, and more especially those who pretend to preach Christianity to others, should say that a God of infinite Perfections would make any thing our Duty, that has not a natural Tendency to our Happiness; and if to our Happiness, then it is agreeable to our Nature, since a Desire of Happiness is a natural Principle which all Mankind are endured with. (2:51; cf. 15:245)

Franklin thus rejected any seemingly arbitrary God who would desire of us compliance with plans of action revealed only to a select few. The point is not that Franklin rejected God as the creator of the universe, or saw Divine Will as unimportant to human well-being; it is, rather, that our means of uncovering God's will are those of public and natural inquiry.

Perhaps another way to phrase this same point would be to suggest that Franklin had little interest in the 'inward' life that transfixed the attention of Edwards. Rather, he focussed almost exclusively on the 'outward' calling.[20] For Franklin, the Puritans' interest in self and in salvation as the core of personal piety was replaced by the call for virtues like industry, frugality, and duty that were unconcerned with any demonstration of election and fostered in the place of this concern efforts to advance human well-being.[21] (These virtues are characterized by some as 'Puritan,' as we shall see [below, 4.5]). As Franklin grew to adulthood, the unwieldy Puritan perspective that Mather had striven to hold together with condemnations of declension and backsliding in the New Jerusalem, with constant admonitions "lest the *enchantments* of this world make them to forget *their errand into the wilderness*,"[22] had come apart.

[20.] Cf. Alfred Owen Aldridge: "The Puritans were known for their constant introspection, fretting about sins, real or imaginary, and agonizing about the uncertainty of their salvation. Absolutely none of this soul-searching appears in Franklin. One can scrutinize his work from first page to last without finding a single note of spiritual anxiety" ("The Alleged Puritanism of Benjamin Franklin," 370; cf. Paul E. More, "Benjamin Franklin," 149–50).

[21.] Cf. Whitfield J. Bell: "Franklin's temper was not heroic or poetic. Moderation, balance, reason, discipline never are . . . If he never knew the ecstasy of those whom God intoxicates, neither did he succumb to despair and self-flagellation, which paralyze a man for action" ("Benjamin Franklin as an American Hero," 132).

[22.] Mather, *Magnalia Christi Americana*, 1:64.

Edwards took up the task of recalling sinners to their Divine errand, and his efforts led him in a direction different from Franklin's.[23] Franklin refused to take up this 'errand' just as he refused to accept that he lived in a 'wilderness.'[24] While it will remain an open question until chapter 4 whether Franklin's morality was in some sense 'Puritan,' our examination of Franklin's long religious journey will continue to make clear that his religious thought is in no way recognizable as such.

3.2. Early Radicalism and Its Abandonment

Franklin notes in his *Autobiography* that some of the religious dogmas that he received in his childhood "such as the Eternal Decrees of God, Election, Reprobation, etc. appear'd to me unintelligible, others doubtful" and that, as a consequence, he gave up church attendance as soon as he could (A:145; cf. 113). Franklin's problems with his Puritan inheritance began while he was still living at home,[25] and they grew much more severe in the print shop of his brother James's *New England Courant*. Here the twelve-year-old apprentice gained access to "better Books" than were available in his father's library—books about mathematics and reasoning and broader aspects of religion (A:59; cf. 63–64; 113–14)—and became a full participant in the generally skeptical mood of the print shop.

[23.] Cf. Norman S. Fiering: "One indication of the confusion that afflicts discussions of the eighteenth-century legacy of Puritanism is that both Edwards and Franklin have been considered descendants in some fashion of the culture of the Bay colony. Yet the very quality that Franklin supposedly inherited from Cotton Mather—the spirit of doing-good, which is the paramount evidence of the perpetuation of Puritanism in Franklin—was a quality that Edwards explicitly minimized. Franklin valued public spirit and philanthropy, whereas Edwards cared almost nothing for worldly results in comparison to piety" ("Benjamin Franklin and the Way to Virtue," 219).

[24.] For more on the relationship between Franklin and Edwards, see: Brooks, *America's Coming-of-Age*, 4–7; Larzer Ziff, *Puritanism in America*, 306–12; Fiering, "Benjamin Franklin and the Way of Virtue," 219–23; Oberg and Stout, eds., *Benjamin Franklin, Jonathan Edwards, and the Representation of American Culture*.

[25.] Consider the following apocryphal story from James Parton: "The boy, we are told, found the long graces used by his father, before and after meals, very tedious. One day, after the winter's provisions had been salted, 'I think, father,' said Benjamin, 'if you were to say grace over the whole cask, once for all, it would be a vast saving of time'" (*Life and Times of Benjamin Franklin*, 1:50).

Franklin himself made a significant contribution to this mood with his fourteen, anonymously contributed 'Silence Dogood' papers, one of which included a severe attack on the religious atmosphere of Harvard College. Among other complaints, this essay suggests that too many of the young men who enter *"The Temple of Theology"* are drawn there by the love of *"Pecunia"* (1:17). This and other skeptical pronouncements, and his absenting himself from church services, brought young Franklin into disrepute in theocratic Boston—as he later winks to us in his *Autobiography*, he was considered "an Infidel or Atheist" (A:71)—and strongly contributed to his surrepticious departure for (New York and) Philadelphia. After barely a year in Philadelphia, Franklin was off for London where his religious ideas became more radical.

The most striking product of this radical period was his 1725 essay, *A Dissertation on Liberty and Necessity, Pleasure and Pain*. Franklin wrote it in London in response to William Wollaston's *The Religion of Nature Delineated* (1722), a volume that he had studied carefully while composing the type for the third edition of 1725 (cf. A:96).[26] Wollaston's volume was an attempt to combine a presentation of the growing Newtonian-influenced natural theology with a defense of the historical tenets of Christian revelation. Wollaston hoped to show, for example, the continued possibility of believing in freedom of the will in spite of the acceptance of immutible laws of nature, and in personal immortality in spite of our fundamental experiential connections to our physical bodies. In response, Franklin wrote what he called "a little metaphysical Piece" (A:96) that has been found puzzling enough to be characterized by even careful readers as both 'atheism' and 'pantheism.'[27]

The first section of this *Dissertation*, "Of Liberty and Necessity," lays out Franklin's steely vision of a thoroughly mechanical world that he saw as a fitting tribute to the creative power of the Mosaic God of Puritanism. Franklin first asserts the existence of a Creator God who is *"all-wise, all-good, all-powerful."* From this triad of Divine attributes he easily draws the conclusion: *"If He is all-powerful, there can be nothing either existing or acting in the Universe* against *or* without *his Consent; and what He consents to must be good,*

[26.] Cf. Douglas Anderson: "A printer is by necessity a meticulous reader, word by word and line by line" (*The Radical Enlightenments of Benjamin Franklin*, xv).

[27.] Cf. Aldridge, *Benjamin Franklin and Nature's God*, 17; Van Doren, *Benjamin Franklin*, 51.

because He is good; therefore Evil *doth not exist*." The ongoing problems of living with which we are all familiar—"*Pain, Sickness, Want, Theft, Murder, etc.*"—are not denied in Franklin's account. Rather, he recognizes them for what they must be in this majestic view: parts of some larger good. Moreover, he is willing to face these assumed 'evils' head on, not hiding behind the evasion that God only *permits* or *tolerates* them. Franklin maintains that to permit or tolerate such evils, if they were actually evil, would demonstrate that God "wants either *Power* or *Inclination*" to prevent them (1:59–60). In Franklin's steely view, real evil is something that a perfectly wise and good and powerful God would not allow.

Franklin continues with the further deduction that "*a Creature can do nothing but what is good*." To allow otherwise would be to admit, as he had just denied, that God was not the master of creation. Franklin allows that our fellow creatures may not always fully appreciate this subtle point, and thus may respond to what they perceive as evils with punishments upon those whom they mistakenly hold personally responsible for the necessary workings of nature; but he maintains that humans "cannot act what will be in itself really Ill, or displeasing to God." Moreover, following closely from this claim that humans' actions are in accordance with the will of the Master of creation is the obvious corollary that creatures "*can have no such Thing as Liberty, Free-will or Power to do or to refrain an Action*." To allow such free choices would be to allow for consequences that were not part of God's plan, and to diminish thereby Divine majesty. As Franklin puts it, "there is every Moment something *best* to be done, which is alone then *good* . . ." Human creatures, of course, could not be expected to determine unfailingly what this good was. "Is it not necessary, then," he asks, "that our Actions should be over-rul'd and govern'd by an all-wise Providence?" Otherwise, creation would necessarily be less than perfect. Franklin's final point in Section I follows without challenge from what has preceeded it: "*there can be neither Merit nor Demerit in Creatures*." All creatures, he continues, "*must be equally esteem'd by the Creator*" (1:60–63); and, in consequence, none can be 'elect' while other are 'damned.' Franklin's unblinking acceptance of a deterministic view of a Newtonian God at work rejects all the compromises Wollaston had hoped to retain. The creation of a perfectly wise and good and powerful God must be just as that God intended, and it must be good.

Franklin begins the second section of his *Dissertation*, "Of Pleasure and Pain," by pointing to the essential connection between pain or uneasiness and life. "To know or be sensible of Suffering or being acted upon," he writes, "is *to live*; and whatsoever is not so, among created Things, is properly and truly *dead*." He continues that the human machine is set in motion by pain, and "the whole succeeding Course of our Lives is but one continu'd Series of Action with a View to be freed from it" (1:63–64).[28] Remembering his earlier determinism and its basis in divine majesty, he continues along the same line with the assertion that pain must be a "necessary" part of life and is thus "beautiful." The origin of pleasure is Franklin's next topic. "*Freedom from Uneasiness* is the End of all our Actions," he writes, and the removal of this uneasiness "*produces the Sensation of* Pleasure, *great or small in exact proportion to the* Desire" to be free from uneasiness. Thus, since "*Pleasure* is wholly caus'd by *Pain*, and by no other Thing at all," it follows that "*the Sensation of* Pleasure *is equal, or in exact proportion to the sensation of* Pain." That is, the amount of discomfort produced by hunger is exactly equal to the subsequent pleasure involved in eating, the pleasure of liberty is exactly equal to the prior pain of confinement, "[t]he *Pain* of Labour and Fatigue causes the *Pleasure* of Rest, equal to that *Pain*" (1:64–66).

At this point, the theological import of this apparent detour emerges. "One of the most common Arguments for the future Existence of the Soul," Franklin writes, "is taken from the generally suppos'd Inequality of Pain and Pleasure in the present . . ." Some individuals, it is popularly believed, go through life with too much good fortune, others suffer from too little; some make the world a better place, others make it worse. As a consequence, Divine justice is required to re-establish a balance in an afterlife. If, on the other hand, this popular assumption of imbalance is mistaken and the amounts of pleasure and pain in life are already equal, then no post-mortem adjustments are necessary. This is Franklin's view. He writes that: "since *Pain* naturally and infallibly produces a *Pleasure* in proportion to it, every individual Creature must, in any State of *Life*, have an equal Quantity of each"; and, as a result, "there is not, on that Account, any Occasion for a future Adjustment" (1:66). Holding

[28.] Franklin offers the following analogy: "If a continual Weight is not apply'd, the Clock will stop" (1:64).

this view requires Franklin to brush aside any anecdotal challenges to his deduced principle of equality. He does so with the empirical reminder that "we cannot be proper Judges of the good or bad Fortune of Others . . . We can judge by nothing but Appearances, and they are very apt to deceive us." He then begs the final question by asserting that, since "we cannot make a true Estimate of the *Equality* of the Happiness and Unhappiness of others" (1:67–68), we must by default assume them to be equal.

Having thus rendered immortality unnecessary as a component of Divine justice, Franklin goes on to show that immortality—as it is popularly understood—is impossible, or at least highly unlikely. He grants that it may be possible for the soul, as immaterial, to live on after the death of the body. However, since there may be "Cessation of *Thought*, which is its Action" (1:69), such immateriality does not necessarily yield immortality of any worthwhile sort.[29] In good empiricist fashion, Franklin writes, our thought processes are dependent upon the body: "When the Body is but a little indispos'd it has an evident Effect upon the Mind; and a right Disposition of the Organs is requisite to a right Manner of Thinking." Further, he notes that at some times, as when asleep or fainted, "we cease to think at all; tho' the Soul in not therefore then annihilated, but *exists* all the while tho' it does not *act* . . ." It is this condition of existence without action, he believes, that is "probably . . . the Case after Death . . ." Since with death and the destruction of the body "the Ideas contain'd in the Brain, (which are alone the Subjects of the Soul's Action) [are] then likewise necessarily destroy'd," the soul must then cease thinking. As he writes, "to cease to *think* is but little different from *ceasing to be*." Thus, while Franklin admits that the soul may be immaterial and therefore indestructible, this fact alone does not yield personal immortality. Even the possibility for the soul to be passed on to a new body "will no way concern us who are now living; for the Identity will be lost, it is no longer that same *Self* but a new Being." Franklin thus closes his examination of God's majesty and human insignificance; and, while he grants that this is not necessarily a pretty picture, it is one that we must accept: "Truth will be Truth tho' it sometimes prove mortifying and distasteful" (1:69–71).

The historical impact of this *Dissertation* was very modest, in

[29.] Cf. Flower and Murphey, *A History of Philosophy in America*, 1:101; Alfred Owen Aldridge, "Benjamin Franklin and Philosophical Necessity," 306–7.

large part because of its general unavailability. Franklin himself writes that he soon came to believe that the printing of this pamphlet was an "Erratum," one which he did his best to correct: "There were only a hundred Copies printed, of which I gave a few to Friends, and afterwards disliking the Piece, as conceiving it might have an ill Tendency, I burnt the rest, except one Copy . . ." (A:96; 31:59). After that, the *Dissertation* remained only spottily available until the critical edition of 1959.[30] Considering the fact that there was never any doubt of Franklin's authorship, and the further fact that almost everything that was attributed to his pen was reprinted again and again over the years, it remains puzzling that a philosophical essay thought to be even potentially significant would not be readily available. What sort of 'ill Tendency' was it thought to have that as recently as 1907 one of Franklin's editors would feel it necessary to omit the *Dissertation* from his edition to prevent any negative impact on Franklin's reputation?[31]

Franklin writes in the *Autobiography* that Samuel Palmer, the owner of the printing house in London where he was working when he produced the *Dissertation*, praised the "Ingenuity" of the pamphlet but "seriously expostulated with me upon the Principles of my Pamphlet which to him appear'd abominable" (A:96). With regards to Palmer's former point, Franklin, though a self-educated teenager, did clearly demonstrate a great deal of ingenuity in manipulating the central religious symbols of the Western tradition; and his theodicy did manage to resolve the problem of evil in the face of Divine omniscience, omnipotence, and love for His creatures, if only by means of a determinism that makes whatever happens 'good.' The crux of Palmer's latter point, that Franklin's principles were 'abomi-

[30.] The *Dissertation* was reprinted in: Parton, *Life and Times of Benjamin Franklin* (1865); Isaac Woodbridge Riley, *American Philosophy* (1907); Mott and Jorgenson, eds., *Benjamin Franklin: Representative Selections* (1936); and Nathan G. Goodman, ed., *A Benjamin Franklin Reader* (1945). A facsimile edition appeared in 1930, edited by Lawrence C. Wroth.

[31.] Jared Sparks mentions the *Dissertation* in his ten-volume *Works of Benjamin Franklin* (1840) but he reports that "[n]o copy of this tract is now known to be in existence" (8:405 n.). John Bigelow does not reprint it in—or note that it is missing from—his twelve volume *Works of Benjamin Franklin* (1904). Albert Henry Smyth deliberately omits the *Dissertation* from his ten volume *Writings of Benjamin Franklin* (1907), defending his omission as follows: "I have not reprinted this pamphlet. It has no merit. Franklin regarded his printing it as an *erratum*, and he would have been distressed at its republication . . . The work has no value, and it would be an injury and an offence to the memory of Franklin to republish it" (W1:296 n., W2:vi).

nable,' presumably begins with this same determinism and includes the challenge to moral responsibility that results from the denial of free will and the assertion that whatever is is 'right.' Palmer might also have been reacting to Franklin's further conclusions that call an afterlife into question.

The aim of the *Dissertation*, Franklin later writes, was "to prove the Doctrine of Fate" (31:59), to demonstrate the majesty of God's creation. In its steely consistency, the *Dissertation* challenged the easy theodicies of either natural or Puritan theology that would maintain immutible natural mechanism or omnipotent Divine sovereignty without paying the price of the abandonment of human freedom and responsibility. Franklin was at least consistent. Whether we wish to characterize this consistency as "relentless logic" or "sheer free-thinking" or "logical absurdity,"[32] Franklin was willing to pay the price necessary for his acceptance of Divine majesty. His theodicy came, however, at the cost of undermining much of the perceived value of living. As he writes: "*Life is not preferable to Insensibility . . .*" (1:71).[33] In his later religious writings, Franklin abandoned this concentration on logical consistency and placed his emphasis upon human well-being. Theology was more distant for the older Franklin; questions of human life—especially those having to do with conduct and improving the quality of life—became central. In the aftermath of the *Dissertation*, Franklin writes in the *Autobiography*, "I grew convinc'd that *Truth, Sincerity and Integrity* in Dealings between Man and Man, were of the utmost Importance to the Felicity of Life . . ." Goods like these seemed possible only in a world of freedom and responsibility. In this light, Franklin continues that the *Dissertation*, "appear'd now not so clever a Performance as I once thought it; and I doubted whether some Error had not insinuated itself unperceiv'd into my Argument, so as to infect all that follow'd, as is common in metaphysical Reasonings" (A:114).[34]

[32.] Elizabeth E. Dunn, "From a Bold Youth to a Reflective Sage," 512; Schneider, *The Puritan Mind*, 239; Mott and Jorgensen, "Introduction" to *Benjamin Franklin*, cxxv.

[33.] Cf. Alfred Owen Aldridge: Franklin's theory "offers us no more reason to live than to die, no reason to prefer to be a human being than a lump of matter" ("Benjamin Franklin and Philosophical Necessity," 308; cf. Donald H. Meyer, "Franklin's Religion," 155; Edwin Scott Gaustad, *Dissent in American Religion*, 44).

[34.] Cf. Richard E. Amacher: "even at the age of nineteen Franklin was clever enough to value common sense more than rigid logicality . . ." (*Benjamin Franklin*,

As a deductive system, the *Dissertation* carries its assumptions forward without any compromise; as a presentation of the meaning of life, it is so painful that even Franklin soon grew unwilling to accept those assumptions.[35] Further, Franklin began to question metaphysical speculations in general and to set them aside as harmful.

During his return trip from London to Philadelphia in 1726, the now twenty-year-old Franklin developed a plan "for regulating my future Conduct in Life" that embodied this shift from deductive speculations to considerations of the impact of his conduct on himself and others; and he writes that he "pretty faithfully adhered to" this plan "quite thro' to old Age" (A:106). The plan itself included the intention to "live in all respects like a rational creature" (1:100); but rationality now meant not the deductive ratiocination of the *Dissertation* but the ordering of conduct according to long-term consequences and the deliberate cultivation of the practical virtues of frugality, truthfulness and sincerity, industriousness and patience, and speaking well of others. Back in Philadelphia, Franklin threw himself into the development of these virtues during his brief stint as a shop-clerk for Thomas Dedham, before the latter's illness and death in 1728, his subsequent brief return to work in Keimer's print shop, his partnership with Hugh Meredith (from 1728–1730) and his years of combined business, boosterism, and public service that filled his life until 1748 (above, 1.2).

Franklin's emphasis upon rationality and virtues did not eliminate his religious uncertainties; and, in addition to his cultivation of practical virtues, he continued to experiment with aspects of Divine worship. On 28 July 1743, he writes to his sister, Jane Mecom, in hopes of modifying her apparent misunderstanding of his religious views. While freely admitting some disagreement with her "New England Doctrines and Worship," he rejects her impression that he was somehow "against Worshipping of God." On the contrary, he writes, "I am so far from thinking that God is not to be worshipped, that I have compos'd and wrote a whole Book of Devotions for my own Use . . ." (2:385). Franklin is referring here to his unpublished *Articles of Belief and Acts of Religion* of 1728, which he later describes as "a little Liturgy or Form of Prayer for my own private Use"

149; cf. William H. Marnell, *Man-Made Morals*, 141; Charles Lyttle, "Benjamin Franklin's Change from Radicalism to Conservatism in Religious Thought," 12).

[35.] Cf. Robert E. Spiller: the *Dissertation* was "the beginning and the end of the philosopher Franklin" ("Benjamin Franklin: Student of Life," 87).

(A:148). This little service, of which only the first part is extant, begins with the affirmation of the existence of "one Supreme most perfect Being" who "expects or requires no Worship or Praise from us." Franklin asserts that *"the Infinite Father"* is "INFINITELY ABOVE IT." While this Being has no need for human worship, Franklin finds that "there is in all Men something like a natural Principle which enclines them to DEVOTION or the Worship of some unseen Power . . ." This natural longing seems to require some response from us. It is "my Duty," he writes, "as a Man, to pay Divine Regards to SOMETHING." Franklin's resolution to this apparent impasse of humans who need a worship relationship to a Creator who has distanced himself from any such relationship comes through the assertion "that Man is not the most perfect Being but One, rather that as there are many Degrees of Beings his Inferiors, so there are many Degrees of Beings superior to him." Franklin does not claim to have full knowledge of these "created Gods." He suspects that they are multiple in number and "vastly superior to Man." They may or may not be immortal: "it may be that after many Ages, they are changed, and Others supply their Places." Franklin is certain, however, that "each of these is exceedingly wise, and good, and very powerful; and that Each has made for himself, one glorious Sun, attended with a beautiful and admirable System of Planets" (1:101–3).[36] In the middle sections of these *Articles of Belief and Acts of Religion*, Franklin devotes himself to the "Praise and Adoration" of "that particular wise and good God, who is the Author and Owner of our System . . ." (1:103). Franklin follows these sections with a series of petitions to this created God for assistance in his "Continual Endeavours and Resolutions of eschewing Vice and embracing Virtue . . ." He prays, for example: "That I may be just in all my Dealings and temperate in my Pleasures, full of Candour and Ingenuity, Humanity and Benevolence, Help me, O Father . . ." Franklin then concludes the service with a series of expressions of gratitude to this created God, giving thanks, for example: "For all thy innumerable Benefits; For Life and Reason, and the Use of Speech, for Health and Joy and every Pleasant Hour, *my Good God, I thank thee*" (1:107–9).

[36.] For interpretations of Franklin's polytheism, see: Aldridge, *Benjamin Franklin and Nature's God*, 25–33; Flower and Murphey, *A History of Philosophy in America*, 1:130–32 n.262; Donald H. Meyer, "Franklin's Religion," 156–58; C. M. Walsh, "Franklin and Plato," 129–31; Kerry S. Walters, "A Note on Benjamin Franklin and Gods," 796–801; Walters, *Rational Infidels*, 63–68.

The final piece of evidence we have of Franklin's return from radical freethinking to a more conventional conception of religion is "On the Providence of God in the Government of the World," one of the papers that he prepared for the Junto about the year 1732.[37] In this essay he approached the theological question of freedom and determinism through the same assumptions that he had used in the *Dissertation* of 1725—that there is a "Creator of the Universe" who is "infinitely Powerful, Wise and Good" (1:265, 269)—but this time, rather than arriving at a conclusion of determinism, he comes to the contradictory conclusion of the reality of freedom. Franklin does this by presenting us with four potential scenarios for the natural world. The first three of these are that the course of nature is fully determined, or fully free, or mixed (that is, only partly determined). In none of these possibilities, Franklin assumes further, is there any direct Divine intervention in the workings of nature: God "never alters or interrupts." Things just work themselves out in their predetermined, or undetermined, or partly determined, ways. The fourth possibility, however, is that God "sometimes interferes by his particular Providence and sets aside the Effects which would otherwise have been produced by any of the Above Causes." Franklin favors the final option of particular or special providences—although it contradicts the *Dissertation*—as being most in line with "the common Light of Reason" (1:266–67).[38]

The Creator of a determined world—Franklin's earlier favorite—"has ty'd up his Hands, and has now no greater Power than an Idol of Wood or Stone . . ." Moreover, such a God has condemned people to harm each other "without Cause" and to offer up "their earnest Prayers" for deliverance which cannot come (1:267; cf. 31:59).[39] The Creator of a fully free world treats events in it as "*none of my Business*" and lives "utterly unconcern'd what becomes of the

[37.] This essay is perhaps the one that Franklin described in 1779 as being "long lost" (31:59; cf. Flower and Murphey, *A History of Philosophy in America*, 1:105–6).

[38.] Here Franklin is appealing not to abstract principles of reason, but to *consensus gentium*, the testimony of humankind.

[39.] Cf. William James: "determinism leads us to call our judgments of regret wrong, because they are pessimistic in implying that what is impossible yet ought to be. But how then about the judgments of regret themselves? If they are wrong, other judgments, judgments of approval presumably, ought to be in their place. But as they are necessitated, nothing else *can* be in their place; and the universe is just what it was before,—namely, a place in which what ought to be appears impossible" (*Writings*, 598).

Beings and Things he has created . . ." The Creator of the partly determined world of the third possibility who does not intervene by particular providences similarly "has nothing to do." Thus, Franklin maintains, we are driven to the following conclusion:

> that Being which from its Power is most able to Act, from its Wisdom knows best how to act, and from its Goodness would always certainly act best . . . sometimes interferes by his particular Providence, and sets aside the Events which would otherwise have been produc'd in the Course of Nature, or by the Free Agency of Men . . .

Franklin continues further that "[i]f God does not sometimes interfere by his Providence tis either because he cannot, or because he will not . . ."; and these are both options that he finds unacceptable. Finally, and perhaps most importantly, Franklin asserts that a religion that includes these special instances of Divine providence "will be a Powerful Regulater of our Actions, give us Peace and Tranquility within our own Minds, and render us Benelovent, Useful and Beneficial to others" (1:268–69). Thus we see that by the age of twenty-six Franklin has returned from his earlier period of religious radicalism; and, while still tangled up in metaphysical questions like whether or not the world is predetermined, he was inclining away from such metaphysical topics toward more practical religious concerns.

3.3. Franklin's Life in Deism

Franklin writes in the *Autobiography* that about the age of fifteen some of his readings had led him "to doubt of Revelation it self." He was led further astray by reading additional volumes, written specifically to refute Deism, which had the unintended reverse effect of turning him into "a thorough Deist" (A:113–14). We have considered developments in Franklin's religious thought up to his mid-twenties as he moved through a period of radicalism. We will now turn to consider the sort of religious perspective that he developed after this period and maintained for the rest of his life. Franklin simplified this process in hindsight, characterizing all of the phases as 'Deism,' a term accurately applied only to the final phase.[40] He writes

[40.] Cf. Isaac Woodbridge Riley: "In making himself out a moderate deist, for this creed was nothing but Herbert of Cherbury's five points common to all religions,

in the *Autobiography* that throughout his life he was never "without some religious Principles," principles of the sort we associate with Deism. "I never doubted," he enumerates, "the Existance of the Deity, that he made the World, and govern'd it by his Providence; that the most acceptable Service of God was the doing Good to Man; that our Souls are immortal; and that all Crime will be punished and Virtue rewarded either here or hereafter . . ." (A:146; cf. 162). On 9 March 1790, Franklin offered in response to an inquiry from Ezra Stiles, the president of Yale College, a similar account.

> Here is my Creed. I believe in one God, Creator of the Universe. That he governs it by his Providence. That he ought to be wor- shipped. That the most acceptable Service we render to him is doing good to his other Children. That the soul of Man is immortal, and will be treated with Justice in another Life respecting its Conduct in this.

It seemed to Franklin that to go much beyond this handful of minimal dogmas, which he describes as "the fundamental Principles of all sound Religion" (W10:84) and "the Essentials of every Religion," by including specific articles derived from revelation or other forms of authority, "serv'd principally to divide us and make us unfriendly to one another" (A:146).[41] This set of simple, general religious beliefs that we will consider in more detail shortly com- prises the essence of what I am calling Franklin's Deism.[42]

Discussions of eighteenth-century Deism recognize that it was not a single position but rather a pluralistic and processive philo- sophical and theological perspective that emphasized the rational and natural aspect of religion. Still, certain elements seem to have been common to the various versions of the perspective. There was,

Franklin was inclined to slur over those earlier metaphysical flights, which began with a deistic fatalism and ended with a Platonic polytheism" (*American Philosophy*, 244; cf. J. A. Leo Lemay, "Franklin and the *Autobiography*," 202).

[41.] Cf. A:162; 9:17–18; W10:419.

[42.] Cf. Karl J. Weintraub: "He believed in a God who had created this world, who governed it by his laws and his generalized Providence, and who demanded that man do good to his fellowmen. He never questioned these beliefs deeply; he never thought them through deeply. But some such vague belief in the purposeful order of the created world was still a necessary supporting frame within which such a man had to function. For all the rest, he could afford to be religiously tone-deaf" ("The Puritan Ethic and Benjamin Franklin," 232; cf. Donald H. Meyer, "Franklin's Religion," 149; Theodore Parker, *Historic Americans*, 33–34).

first of all, a God who was both the Creator of the universe and Father to humankind. Unlike the more familiar Mosaic religions, however, this Fatherly role was carried on at a distance and indirectly, through the immutible laws of nature rather than through direct interventions.[43] The workings of the world-machine demonstrate God's love through a general providence; and discovering what we are to do in life requires of us neither theological study nor supernatural revelations but only deliberate empirical inquiry into the wonders of God's creation by means of natural reason. By means of uncovering and using natural laws, humans would be able to live better. This goal includes improving our *material* conditions through uncovering the patterns of natural regularity and formulating testable explanations in such areas of human well-being as economics and health. It includes as well improving our *moral* conditions through efforts to serve the needs of our less fortunate fellows.[44] Finally, while the God of Deism does not interfere in the workings of the world through special providences that would contravene the laws by which He had ordered nature, He does take account of our actions; and, after death, individuals are rewarded or punished for the types of lives they have led. For the Deist, salvation—although usually of some indeterminate sort—can and must be earned through reasoned efforts to improve the human state.

As critics of revealed religion, Deists stood in opposition to all traditional or institutional dogmas or beliefs that they did not think were grounded in reason. Included among these accretions to the 'essentials' of religion were claims by various religions to special direct revelations or to inspired messages and scriptures, claims about the requirement for—and efficacy of—prayers, and other claims about

[43.] Cf. Harold A. Larrabee: Deism was "[a] popularized version of Newton's orderly universe of natural law, which man could exploit for his own benefit by the use of his reason, filled the foreground; while God retreated into the distant background as 'proprietor' or 'great first cause'" ("Naturalism in America," 333; cf. Riley, *American Philosophy*, 192; Spiller, "Franklin on the Art of Being Human," 308).

[44.] Cf. Kerry S. Walters: "Reason, experience, orderliness, lawlike functionality—these were the primary characteristics of the worldview of American deism . . . That the human intellect was capable of discerning the rational nature of physical reality in turn pointed to the fact that humans themselves were preeminently rational creatures . . . The human intellect, then, was a microcosm of the rational universe" (*The American Deists*, 31–32).

the miraculous manifestations of special providence.[45] In fact, Deism set itself against anything that gave an indication of resorting to supernatural means to circumvent the natural order. Deism also took special pains to oppose all religious doctrines that it saw as harmful to the good working of true religion, such as beliefs in the arbitrariness or tyranny of God, the corruptness of human nature, the need to suppress 'apostates,' 'heretics,' and others who might disagree with the current orthodoxy, and so on.[46] Deism challenged as well all attempts by inherited religious institutions to use their power to control others by means of supernaturally justified authority.[47] Deism sought to remove all of these accretions and return religion to its rational and natural state.

In Franklin's American context, Deism offered an especially clear alternative to the theology of Calvin and to his engaged God whose regard or wrath could be read, as we have seen, in the success or failure of every childbirth and harvest. In place of such a God, the caring but distant God of Deism, who was to be known indirectly through the study of the ordered workings of creation, was connected with an increasing respect for both general providence and for natural philosophy. Deism also offered as an alternative to the demanding God of Calvin—who arbitrarily selects from among the depraved children of Adam some few to receive the gift of salvation—a God who did not need to be flattered like an earthly king but who expects us to devote our intellectual skills to long-term efforts to develop an improved earthly existence.[48] The discoveries of

[45.] Cf. David Hume [1768]: "A miracle is a violation of the laws of nature; and as a firm and unalterable experience has established these laws, the proof against a miracle, from the very nature of the fact, is as entire as any argument from experience can possibly be imagined" ("Of Miracles," 524).

[46.] Cf. Thomas Jefferson [1787]: "it does me no injury for my neighbour to say there are twenty gods, or no god. It neither picks my pocket nor breaks my leg" (*Writings*, ed. Peterson, 285; cf. *Papers of Thomas Jefferson*, 1:546).

[47.] Cf. Thomas Paine [1794]: "I do not believe in the creed professed by the Jewish church, by the Roman church, by the Greek church, by the Turkish church, by the Protestant church, nor by any church that I know of. My own mind is my church. All national institutions of churches, whether Jewish, Christian or Turkish, appear to me no other than human inventions set up to terrify and enslave mankind, and monopolize power and profit" (*Writings*, 4:22).

[48.] Cf. Thomas Jefferson: "I can never join Calvin in addressing *his god*. He was indeed an Atheist, which I can never be; or rather his religion was Daemonism. If ever man worshipped a false god, he did. The being described in his 5. points is not the God whom you and I acknolege and adore, the Creator and benevolent governor of the world; but a daemon of malignant spirit" (Jefferson to John Adams, 11 April 1823, *Writings*, ed. Peterson, 1466; cf. 1464).

the advancing science were delineating the will of God as present in the workings of the cosmos. The world-machine was intricate and beautiful, a good home for humankind.

Deism, as an element of the Enlightenment philosophy of the eighteenth century, offered a generally positive evaluation of the natural human situation. An all-wise and all-good and all-powerful God could be responsible neither for a created world that did not contain divine rationality uncoverable in its workings, nor for humans who would remain unable to rise to their rational potential. While at any given time the understanding of nature would be less than total, Deism's starting point was the assumption that the future held out the promise of a growing good that we would help to advance through our own efforts to replace the dead hand of tradition and the sabotage of superstition with the liberating power of reason. The psychological power of Deism came from its scientific inclinations: its ability to liberate the mind from theological and ecclesiastical restraints, and its ability to redirect religious energies toward human betterment.[49] The great weakness of Deism was its intellectuality. In the place of feelings of Divine presence and of redemption, however arbitrary and limited, Deism offered a managerial God whose indirect involvement with human life accepted no prayers and awakened no emotions, and a salvation of only an indeterminate sort.[50] Moreover, its Enlightenment promise to ameliorate persistent human and natural evils was never satisfied. In the years after Franklin's death, whatever religious power Deism had was lost. By early in the nineteenth century, Deism's moment as a religious movement had passed; and whatever life it still has is as a humanistic philosophy.[51]

A careful survey of Franklin's mature religious ideas will enable

[49.] Cf. Ernest Sutherland Bates: "the illusions of Deism were generous illusions . . . In its time Deism was a gospel of intellectual and spiritual liberation more far-reaching than anything in previous history" (*American Faith*, 224).

[50.] Cf. Conyers Read: "There was a grandeur in the conception—but it was a cold, mechanical sort of grandeur. The personal contact of the man with his Maker was gone, the possibility of any modification in the operation of the great machine in response to the prayers of the worshippers was gone. God retired behind a first cause" ("Doctor Franklin as the English Saw Him," 49; cf. Stifler, *The Religion of Benjamin Franklin*, 86–87).

[51.] For more on American Deism, see: Donald H. Meyer, *The Democratic Enlightenment*, 82–93; Herbert M. Morais, *Deism in Eighteenth Century America*; Riley, *American Philosophy*, 191–320; Harold E. Taussig, "Deism in Philadelphia during the Age of Franklin"; Walters, *The American Deists*, 1–50.

us to place him, for the most part, within the larger picture of Deism that we have just adumbrated. One Deist tenet that Franklin accepted was that of a rational God, inclined toward human well-being rather than toward Divine self-aggrandizement. God's interest in human conduct is not marked by arbitrary hurdles designed to measure religiosity or test faith; rather, it demonstrates concern for our well-being.[52] As Franklin writes of moral codes in general, "vicious Actions are not hurtful because they are forbidden, but forbidden because they are hurtful . . ." (A:158).[53] His understanding of human nature itself was generally favorable; and we see him genuinely puzzled at the success of the evangelist, George Whitefield, whose conversion tactics included large amounts of "Abuse" of his listeners, "assuring them they were naturally *half Beast and half Devils*" (A:175). This Divine inclination that Franklin saw toward human well-being presented itself in a general providence by means of which our natural situation is for the most part tuned to our well-being. As Franklin writes at one point,

> I am much disposed to like the World as I find it, and to doubt my own Judgment as to what would mend it. I see so much Wisdom in what I understand of its Creation and Government, that I suspect equal Wisdom may be in what I do not understand. And thence have perhaps as much Trust in God as the most pious Christian. (18:185; cf. 14:72)

After recognizing this benevolence, our job is to carry forward this concern by aiding our fellows.[54]

Franklin found this high level of Divine concern manifested in the specific circumstances of his own life. In the *Autobiography*, for example, he writes in thanks to God: "I desire with all Humility to

[52] Cf. James Parton: Franklin "escaped the theology of terror, and became forever incapable of worshipping a jealous, revengeful, and vindictive God—the God of the Lord Brethren of Boston" (*Life and Times of Benjamin Franklin*, 1:71).

[53] Cf. A:115; 2:224; David Levin, "The Autobiography of Benjamin Franklin," 270–71.

[54] Cf. Kenneth B. Murdock: Franklin "was conventionally grateful to God but not in the least in awe of him. The world, Franklin thought, was ruled by divine providence, but divine providence was highly ordered and reasonable, operating by Newtonian laws and in accordance with human ideas of justice. He created a God in his own image, a rational advocate of common-sense morality . . ." ("Jonathan Edwards and Benjamin Franklin," 117; cf. Norman S. Fiering, *Jonathan Edwards's Moral Thought and Its British Context*, 346).

acknowledge, that I owe the mention'd Happiness of my past Life to his kind Providence, which led me to the Means I us'd and gave them Success" (A:45). In his wills of both 1750 and 1757, he offers his identical "sincere Thanks to God" for "conducting me hitherto thro' Life so happily" in matters of personality and situation (3:481; 7:204).[55] Further instances of Franklin's belief that God's providence has been showered upon him can be found in his correspondence. In a letter to Whitefield at the end of his sixth decade, for example, he recognizes the God "who gave me Existence, and thro' almost threescore Years has been continually showering his Favours upon me" (11:231; cf. 15:97–98); and in a letter to another correspondent, soon after his eightieth birthday, he writes that he can "with filial Confidence, resign my Spirit to the conduct of that great and good Parent of Mankind, who created it, and who has so graciously protected and prospered me from my Birth to the present Hour" (W9:491). It is worth pointing out, however, that none of these instances prove that Franklin sees in God's "care for the meanest of his Creatures" (3:481; 7:205) any special providences. That is, while, as we have seen (above, 3.2), Franklin speculated about the possibility of Divine intervention, in good Deist fashion he did not attribute these personal benefits to the circumvention of the general laws of nature. Franklin's recognition of Divine concern for his well-being contained no claim of any special providential relationship with God, but only Franklin's personal recognition of the general Divine regard for His creatures.

Throughout his life, Franklin found this same high level of general Providence to be manifest in God's relationship with the American people as a whole. In later life, however, he seems to have found—contrary to the general spirit of Deism—instances of special providences as well. In his 1787 proposal to begin the troubled daily deliberations of the Constitutional Convention with a prayer, for example, Franklin—the oldest member of the Convention—notes that "the longer I live, the more convincing proofs I see of this Truth, *that* GOD *governs in the Affairs of Men. And if a Sparrow cannot fall to the Ground without his Notice, is it probable that an Empire can rise without his Aid? . . . without his*

[55.] This theme of gratitude to God did not appear in his final will of 1788, or in the codicil of 1789. Alfred Owen Aldridge writes: "In his final will, Franklin set forth a number of his political and social opinions but said not a word about his religious beliefs" (*Benjamin Franklin and Nature's God*, 250; cf. W10:493–510).

concurring Aid, we shall succeed in this political Building no better than the Builders of Babel . . ." (W9:601; cf. 24:6–7). It should be clear that this Divine concern for the success of the American Experiment, even if it constituted a particular concern for America rather than other countries and surrendered some of God's normal distance from the specifics of human affairs, did not yet necessarily constitute special providence because it did not yet suggest the violation of natural laws or any intervention in an ordered system of causes and effects to improve the results for America. (A similar instance of Franklin's inclining toward, but not asserting the existence of, special providences can be found in his 1783 statement that "America will, with God's blessing, became a great and happy Country . . ." [W9:23]). When Franklin continues in his Convention speech, however, that we should apply "to the Father of Lights to illuminate our Understandings . . ." (W9:600), it appears that he is suggesting the possibility of special providences through Divine responses to prayers. Elsewhere, in this same speech to the Constitutional Convention, Franklin went still further toward recognizing special providences:

> In the Beginning of the Contest with Britain, when we were sensible of Danger, we had daily Prayers in this Room for the Divine Protection. Our Prayers, Sir, were heard;—and they were graciously answered. All of us, who were engag'd in the Struggle, must have observed frequent Instances of a superintending Providence in our Favour. (W9:600–601)

This passage clearly suggests that there had been Divine intervention in response to the Americans' prayers, intervention that resulted in events different from those that would have followed from the prior arrangement of causes. Elsewhere, Franklin's claim was even stronger: "if it had not been for the Justice of our Cause, and the consequent Interposition of Providence, in which we had Faith, we must have been ruined" (W9:262; cf. 94). As he further writes about the workings of the Constitutional Convention itself:

> I have so much Faith in the general Government of the World by *Providence*, that I can hardly conceive a Transaction of such momentous Importance to the Welfare of Millions now existing, and to exist in the Posterity of a great Nation, should be suffered to pass without being in some degree influenc'd, guided, and governed by

that omnipotent, omnipresent, and beneficent Ruler, in whom all inferior Spirits live, and move, and have their Being. (W9:702–3)

Earlier, Franklin had written about British tactics in the War of Independence: "If God governs, as I firmly believe, it is impossible such Wickedness should long prosper" (W8:196). Clearly this suggests Franklin's belief that God will tire of British perfidy and, unlike the distant God of Deism, eventually intervene in the struggle with appropriate punishment. It is clear then that Franklin, at least with regard to overarching issues like the Revolutionary War—a struggle that, as we shall see (below, 4.1), strongly tested his positive understanding of human nature—and the founding of the new nation, expected, and later reported, instances of special providences to advance American interests. The distant God whose benevolent governing through the general laws of nature long seemed adequate to Franklin was replaced in these grave matters by a God more willing to help America become free and prosperous.[56]

Another Deist position that Franklin held was that "our Souls are immortal" (A:146). In contradistinction to the *Dissertation*, in which he had grudgingly allowed for a minimal kind of immortality but rejected any necessity for it based in justice, later in his life he defended a fuller immortality based at least in part upon the perceived needs of justice. At least as early as 1731 we find the suggestions that God "loves such of his Creatures as love and do good to each other: and will reward them either in this World or hereafter" and that "Men's Minds do not die with their Bodies, but are made more happy or miserable after this Life according to their Actions" (1:213). Later in life he expands upon this view, writing that, "the more I see the Impossibility, from the number and extent of his Crimes, of giving equivalent Punishment to a wicked Man in this Life, the more I am convinc'd of a future State, in which all that here appears wrong shall be set right, all that is crooked made straight" (W8:562).[57] More important to Franklin than this retributive theme, however, was an argument based in the anticipated continuity of past Divine benevolence. As he writes in the letter to

[56.] Cf. Edward Sutherland Bates: Franklin's "frank recognition of the fact that religion was not derived from external evidence but from an inner need of man to worship some power in which he could find security enabled him in his common sense manner to put his finger on the central weakness of Deism: the remoteness of the Deistic Deity from all mundane affairs" (*American Faith*, 229).

[57.] Cf. A:146; W8:231; Aldridge, *Benjamin Franklin and Nature's God*, 253–54.

Whitefield just mentioned, given God's "showering" of "Favours" upon him, "can I doubt that he will go on to take care of me not only here but hereafter? This to some may seem Presumption; to me it appears the best grounded Hope; Hope of the Future; built on Experience of the Past" (11:231–32; cf. 241; W9:491). Franklin also offers a third kind of argument for immortality, one based in essences: "when I see nothing annihilated, and not even a Drop of Water wasted, I cannot suspect the Annihilation of Souls, or believe, that he will suffer the daily Waste of Millions of Minds ready made that now exist, and put himself to the continual Trouble of making new ones." Such inefficiency would be irrational, treating less perfect matter better than more perfect. In consequence, Franklin concludes, "I believe I shall, in some Shape or other, always exist . . ." (W9:334; cf. 512). This cluster of reasons based in justice and benevolence and essence suggested to Franklin the possibility of a Heaven of eternal rewards: "By Heaven we understand, a State of Happiness, infinite in Degree, and eternal in Duration . . ." He long recognized, of course, that there is no real possibility of *earning* such salvation; but his reasoning was based upon the disproportionate amount of the reward, not on any blanket rejection of the Covenant of Works. As Franklin puts it: "I can do nothing to deserve such Reward: He that for giving a Draught of Water to a thirsty Person should expect to be paid with a good Plantation, would be modest in his Demands, compar'd with those who think they deserve Heaven for the little Good they do on Earth" (4:505; cf. 2:385).

Death, as Franklin famously writes, is surely unavoidable: "in this world nothing can be said to be certain, except death and taxes" (W10:69). Death represents, however, not annihilation but release into another realm. As he writes, "all that ever were born are either dead, or must die. It becomes us to submit, and to comfort ourselves with the Hope of a better Life and more happy Meeting hereafter" (11:79). In another formulation, he phrases this point as follows: "I look upon Death to be as necessary to our Constitution as Sleep. We shall rise refreshed in the Morning" (W9:265–66).[58] In his discussions of the inevitability of illness and death, Franklin's thought shows one of the similarities between the Deist and the Stoic.

That bodies should be lent us, while they can afford us pleasure, assist us in acquiring knowledge, or doing good to our fellow

[58.] Cf. 4:301–2; 10:69, 199.

creatures, is a kind and benevolent act of God—when they become unfit for these purposes and afford us pain instead of pleasure— instead of an aid, become an incumbrance and answer none of the intentions for which they were given, it is equally kind and benevolent that a way is provided by which we may get rid of them. Death is that way (6:407; cf. 3:345).[59]

It is thus not rational to complain about the increasingly painful process of continued living. "People who live long, who will drink of the cup of life to the very bottom," he writes, "must expect to meet with some of the usual dregs . . " (W9:560; cf. 682–83). In addition to physical pain, these 'dregs' include the loss of loved ones. As he comments on the death of Jonathan Shipley less than a year before his death, "the longer I live I must expect to be very wretched. As we draw nearer the Conclusion of Life, Nature furnishes with more Helps to wean us from it, among which one of the most powerful is the loss of such dear Friends" (W10:8).[60] Complaints about the difficulties of increasing age are not seemly from those who recognize behind the workings of nature the role of a benevolent Deity. On the related issue of the deaths of others, Franklin realized that these truths will not be always appropriate or instantly recognizable to those who bury loved ones. As he writes to his sister, Jane Mecom, on the death of her daughter, "Consolations however kindly administred seldom afford us any Relief, Natural Affections will have their Course, and Time proves our best Comforter" (14:344). In our natural world, all who are born must die; and, for those who remain behind, "[t]he best Remedy of Grief is Time" (4:511; cf. 12:385; 13:506).

A third Deistic tenet that Franklin accepted was the belief that the primary mode of human learning about nature and our place in it ought to be scientific inquiry rather than scriptural revelation. One clear indication of this empirical stance can be found in the comment that we have seen (above, 2.2) from the *Almanack* for 1753 about the possibility of protecting buildings with lightning rods. In pure Deistic fashion, he connected up improved human well-being with their intellectual efforts to uncover God's plan in nature. In this

[59.] Cf. Thomas Jefferson: "our machines have now been running for 70. or 80. years, and we must expect that, worn as they are, here a pivot, there a wheel, now a pinion, next a spring, will be giving way: and however we may tinker them up for awhile, all will at length surcease motion" (Jefferson to John Adams, 5 July 1814, *Writings*, ed. Peterson, 1339).

[60.] Cf. 10:202; 30:597–598; W9:214, 253, 586.

orderly world of regularities and predictability, people themselves must figure out the workings of the natural world directly through scientific inquiries into experience. They cannot expect that they will be given this information indirectly through the study of scripture.[61] Franklin's position is even sharper when the scriptural passages in question were (or were interpreted as being) in conflict with reason:

> if Reason clearly teaches the Truth of such or such a Proposition, and . . . we find in the holy Scriptures some Passage that seems to contradict the clear Decisions of Reason, we ought not, for we really cannot, admit that Sense of the Passage that does so, altho' it shou'd be receiv'd by all the Divines, that call themselves *orthodox*, upon Earth; So that any Man must be altogether in the right to look out for another Sense of the Passage in Question, which will not contradict the clear Decisions of Reason.

There is no evidence from his later life that would cause us to assume that Franklin ever changed from this position of 1735; for him, it was always much better to "look for a Sense [of the passage] agreeable to Reason . . ." (2:120).

Franklin's anti-scriptural mood is suggested further in the free hand that he took with what were considered 'sacred' texts.[62] We can consider, for example, a little piece he wrote entitled "A Parable against Persecution" that he would on occasion read to friends and acquaintances disguised as a chapter of *Genesis*. In this essay, God angrily rebukes Abraham for having driven a stranger from his tent because the stranger would not bless God. Franklin's God poses the following question to Abraham: "Have I born with him these hundred ninety and eight Years, and nourished him, and cloathed him, notwithstanding his Rebellion against me, and couldst not

[61.] Cf. Thomas Paine [1795]: "though . . . I thus admit the possibility of revelation, I totally disbelieve that the Almighty ever did communicate any thing to man, by any mode of speech, in any language, or by any kind of vision, or appearance, or by any means which our senses are capable of receiving, otherwise than by the universal display of himself in the works of the creation, and by that repugnance we feel in ourselves to bad actions, and disposition to good ones" (*Writings*, 4:184; cf. Becker, *The Heavenly City of the Eighteenth-Century Philosophers*, 50–51).

[62.] Cf. Alfred Owen Aldridge: "Franklin was not averse to rewriting the Scriptures, something that no Puritan in good standing would dream of doing" ("The Alleged Puritanism of Benjamin Franklin," 370; cf. Dunn, "From a Bold Youth to a Reflective Sage," 521).

thou, that art thyself a Sinner, bear with him one Night?" (6:123; cf. 114–28). Franklin also proposed rewriting the English version of the Lord's Prayer (cf. 15:299–303), and later the whole English Bible itself (cf. W7:432–33) to make them clearer and more effective; and he suggested revisions to the *Book of Common Prayer* to make the services briefer and more direct (cf. 20:345–52).[63] In all of these instances, Franklin demonstrated his desire to replace what he took to be the worn-out and barnacled forms of inherited religion with newer ones that would be more true to the 'essentials' of religion and hence more effective.

A fourth tenet of Deism that Franklin accepted was that too much of the traditional efforts of religions had been directed toward developing doctrinal uniformity and enforcing orthodoxy. A concise example of his position appeared in *Poor Richard's Almanack* for 1743: "Many a long dispute among Divines may be thus abridg'd, It is so: It is not so. It is so; It is not so" (2:373; cf. 10:83). Franklin believed that the sectarianism that resulted from such squabbles had harmed both religion and society. As he writes, "vital Religion has always suffer'd, when Orthodoxy is more regarded than Virtue." (He even continues that Scripture agrees with him: "the Scripture assures me, that at the last Day, we shall not be examin'd what we *thought*, but what we *did* . . ." [2:204]).[64] One clear example of this mistaken emphasis upon orthodoxy can be found in the problem of the ordination of Anglican clergy that troubled the new and bishopless country after the Revolution. As Franklin writes in 1784, he was unable to understand why "Men in America, qualified by their Learning and Piety to pray for and instruct their Neighbors, should not be permitted to do it till they had made a Voyage of six thousand Miles out and home, to ask leave of a cross old Gentleman at Canterbury . . ." (W9:240). Surely it would make more sense to anyone except the myopically orthodox, Franklin thought, for the American clergy to ordain each other, using as their certification their evidence of the candidates' virtuous lives. In the place of

[63.] Cf. Robert E. Spiller: "All of his later religious efforts . . . were designed to make more easy and immediate the every-day intercourse between man, the superior of the animals, and God, the supreme in wisdom and judgment of all beings" ("Benjamin Franklin: Student of Life," 98; cf. David Williams, "More Light on Franklin's Religious Ideas"; Aldridge, *Benjamin Franklin and Nature's God*, 166–79).

[64.] Cf. Alfred Owen Aldridge: Franklin "made a vigorous and sincere effort to resolve metaphysical problems common to all religions, but . . . he abandoned the quest as hopeless" (*Benjamin Franklin and Nature's God*, 144).

orthodoxy and sectarianism, Franklin offered tolerance. In a letter to his sister, Jane Mecom, he gently chides his fellow "zealous Presbyterians [as] being too apt to think ourselves alone in the right, and that besides all the Heathens, Mahometans and Papists, whom we give to Satan in a Lump, other Sects of Christian Protestants that do not agree with us, will hardly escape Perdition" (9:17–18). We can also see the essence of Franklin's tolerance in the following passage, again from the *Almanack*: "Different Sects like different clocks, may be all near the matter, tho' they don't quite agree" (3:341).[65] By minimizing both doctrinal disputes between denominations and the destructive effects of the general skepticism to which such sectarianism leads, Franklin hoped to increase the social value of religion in the community.[66]

We have already seen (above, 2.4) his understanding of the proper role of institutions as organizations to foster and focus social inquiry. Religious institutions clearly bear a large portion of this work. Consequently, when these institutions are used on the contrary to advance the vision of one particular sect—for example, "rather to make us Presbyterians than good Citizens" (A:147)—or, worse, to turn the various sects against one another (cf. A:146; 16:51), we have a recipe for serious social problems. Franklin was quite proud of having been called at one point "merely an honest Man, and of no Sect at all" (A:194), and he was for the most part successful in following his plan of avoiding all these sectarian battles. "I have ever let others enjoy their religious Sentiments," he writes, "without reflecting on them for those that appeared to me unsupportable and even absurd" (W10:85).[67] This stance is of special importance in Franklin's thinking because it helps explain his retreat from the iconoclastic stridency of his youth to a position that one

[65] See also Franklin's attack on *-isms* contained in a letter of 1772 in which he reports "the Saying of a Scotch Divine to some of his Brethren who were complaining that their Flocks had of late been infected with *Arianism* and *Socinianism*. Mine, says he, is infected with a worse *ism* than either of those . . . the Rheumat*ism*!" (19:46).

[66] Cf. Robert E. Spiller: Franklin was "more interested in a workable practice of religion than in the formulated dogmatisms and skepticisms of his age" ("Benjamin Franklin: Student of Life," 97).

[67] Cf. Henry F. May: "In his long Philadelphia career as printer and publisher, Franklin was in the center of a unique free market of religions. He sampled its wares with keen and cool interest . . . His observations of Quakers, Dunkards, Baptists, Jews, and Catholics are recorded in the tone of a friendly, but quite uninvolved, student of comparative religion . . ." (*The Enlightenment in America*, 127).

commentator calls "common-sense deism." He thus had come to see that the proper response to such dogmatism was not skepticism in all matters theological, but what another commentator has called a "judicious vagueness" about such matters in the interest of improved communal life.[68]

The one great exception to Franklin's nonsectarian practice was the 1735 trial of Samuel Hemphill, a case that he thought was so extraordinary that it required his involvement. Hemphill was a young Presbyterian preacher who came to Philadelphia in 1734 and took up a position as assistant pastor to the sixty-year-old Jedediah Andrews. Hemphill was an excellent preacher and he attracted Franklin back to church. Unlike Andrews's sermons, that were "chiefly either polemic Arguments, or Explications of the peculiar Doctrines of our Sect" and hence to Franklin "very dry, uninteresting and unedifying, since not a single moral Principle was inculcated or enforc'd," the newcomer's sermons "had little of the dogmatical kind, but inculcated strongly the Practice of Virtue, or what in the religious Stile are called Good Works" (A:147, 167). Soon after his initial successes, however, Hemphill was accused of preaching the primacy of morality or good works over faith (cf. 2:40, 42) and eventually censured and suspended by the synod for teaching doctrines that were declared "unsound and dangerous, [and] contrary to the sacred Scriptures and our excellent Confession and Catechisms . . ." (2:63). Franklin, inclined as he was toward a religious perspective that emphasized works over faith, defended Hemphill on doctrinal and procedural grounds in a series of pieces (cf. 2:37–126). Even after Hemphill was found to have plagiarized his sermons, effectively sealing his fate, Franklin still continued to defend him, commenting that he preferred Hemphill's "giving us good Sermons compos'd by others, than bad ones of his own Manufacture . . ." (A:168; cf. 2:96–97; 3:100–101). After his defeat Hemphill drifted into obscurity and Franklin—more convinced than ever of the primacy of morality and deeply troubled by the institutional religious response to anything that appeared to be heterodox—"quitted the Congregation, never joining it after . . ." (A:168).[69]

[68] Alfred Owen Aldridge, *Benjamin Franklin and Nature's God*, 144; Isaac Woodbridge Riley, *American Thought*, 55.

[69] Cf. Aldridge, *Benjamin Franklin and Nature's God*, 86–98; Anderson, *The Radical Enlightenments of Benjamin Franklin*, 79–85; Buxbaum, *Benjamin Franklin and the Zealous Presbyterians*, 76–115; Merton A. Christensen, "Franklin on the Hemphill Trial."

In this comparison of Franklin's mature religious perspective with the Deistic framework considered previously, we see that for the most part his ideas fit comfortably within that framework. He believed in a personal God who indirectly rules the world with an eye toward human well-being. He believed that the human soul is immortal and that justice will be done in the afterlife. He believed that reason and science, not scriptural traditions, should guide our attempts to organize our lives. And he believed that far too much of our religious energy is wasted on sectarianism instead of using it to improve the human situation. The most obvious differences between Franklin's version and the Deistic framework with which we began have to do with the related questions of the nature and purpose of prayer and the possibility of special providences. In both of these cases, we are left with the problem of understanding why Franklin occasionally endorsed views that were not part of what he called 'the essentials of every religion' (as we saw at the beginning of this section) and that would separate him from Deism.

If we set aside responses designed to avoid this problem—by suggesting, for example, that Franklin is routinely inconsistent or that his adoption of religious language during the revolution was politically motivated[70]—and concentrate on attempting to resolve it, one method is to suggest that Franklin remained in fact something less than a pure Deist. Kerry S. Walters writes that Franklin's Deism demonstrates "a curious ambivalence born of his struggle to accommodate certain aspects of the Calvinist ethos with natural religion." Walters points, for example, to Franklin's belief in special providences, that "the Deity could and occasionally did supernaturally intervene in human affairs,"[71] as evidence of Franklin's ambivalence. Walters is correct that Franklin does not fit the template perfectly; but a broader approach might be to suggest that there were few if any pure Deists. The Deistic framework that we have been considering is just that: an analytical framework, without any power to enforce compliance. Within any rich and developing perspective, individuals will have different emphases. Some will downplay aspects that appear central to others; a few will import material that to the rest seems alien. A degree of theological diversity seems particularly untrouble-

[70.] Cf. Aldridge, *Benjamin Franklin and Nature's God*, 256–59.

[71.] Walters, *Rational Infidels*, xiii, 6; cf. 44–47, 70–71; Walters, *The American Deists*, 27.

some in Deism since its goal is not doctrinal consistency but human betterment; and, if Franklin's God is a bit more personally engaged than the God of some other Deists, this may not be much of a problem. We find Franklin believing in a world where a powerful and good and wise God initially set things to work out for the best and then very occasionally, especially when our opponents have been particularly evil, returns to tilt it back to our benefit. Franklin probably understood that there was an intellectual problem with trying to square the natural science of the Deistic world machine with a God who is involved with the fate of every sparrow and Constitutional Convention. It is more important, however, to consider what Franklin did with this inconsistency. When faced with the seemingly irresolvable problem of a distant, managerial God who still engages in occasional direct action, he let the intellectual problem float and acted to make things better in society. Franklin gave up on the 'metaphysical' question, the question of the level of freedom and fate in the world, and continued to address the more Pragmatically significant question of making the world a happier place to live. Another way to phrase this point would be to suggest that Franklin moved from a more scientific version of Deism to a more humanistic version,[72] from a focus upon the workings of the world machine to a focus upon moral experience.

3.4. Religion as a Social Good

We have been considering Franklin's religious thought, from his early rebellion against and radical response to Puritan strictures through his enduring attachment to a Deistic framework. The clear focus throughout this long quest was not any abiding concern with religious truth but a concern with the practical effects of religious belief and practice upon human existence.[73] As the course of his own religious life demonstrated, the social value of a properly directed

[72] Cf. Alfred Owen Aldridge: Franklin "became a humanitarian deist rather than a scientific deist, establishing his belief in God upon moral rather than scientific principles" (*Benjamin Franklin and Nature's God*, 81).

[73] Cf. Alfred Owen Aldridge: "on the surface Franklin was a pragmatist, advocating beliefs and practices because of their salutary effect upon society. He constantly taught that the primary function of religion was to promote external welfare" (*Benjamin Franklin and Nature's God*, 10; cf. Breitwieser, *Cotton Mather and Benjamin Franklin*, 176).

religious life became increasingly obvious to Franklin.[74] The ability of the religious mood to direct conduct toward advancing the common good, to undergird the life of virtue as an element in the larger pursuit of service, and to foster tranquility by ameliorating ultimate uncertainties, was important for him. A mistaken focus on questions of religious truth, Franklin believed, led only to unresolvable differences and sectarian discord. The empirical Franklin recognized that there are many systems of religious belief and practice that have functioned more or less successfully in the lives of different individuals under different circumstances.[75] Consequently, he would not go beyond the general bases of a "sound Religion" (W10:84) indicated above;[76] and primary among these bases was the requirement that religion play a role in advancing the human good. As he writes, one of the religious beliefs that he never doubted was "that the most acceptable Service of God was the doing Good to Man" (A:146).[77]

With regard to the Christian religion, for example, he writes just a few weeks before his death in 1790 that it was more pure in its original form, before it had suffered over the course of its life "various corrupting Changes" (W10:84).[78] About the central ques-

[74.] Cf. Donald H. Meyer: "Franklin represents not just secularity but the secularization of religious thought. Franklin's role as an agent of secularization both accounts for his originality and establishes his significance as an American philosopher . . . Franklin did not approach religion with the attitude of a scientist: he approached both science and religion with nothing more esoteric than the frame of mind of a no-nonsense workman who saw no reason why alert intelligence and solid common sense should not work as effectively [in] one area as in the other" ("Franklin's Religion," 149, 165).

[75.] Cf. Alfred Owen Aldridge: "Intellectually he had little more faith in orthodox doctrine than in witchcraft or astrology; yet he sympathized with the church as a social institution and supported it so loyally that many sectarians identified him with their causes" (*Benjamin Franklin and Nature's God*, 8).

[76.] Cf. Donald H. Meyer: "Franklin's rule in judging the doctrines of any sect was simple and broad, but inflexible. First, do they conform to the essential principles of every religion, principles which Franklin regarded as basic and universal? Second, insofar as they go beyond these basic principles, do they thereby encourage or undermine public morality and social tranquility?" ("Franklin's Religion," 152; Meyer, *The Democratic Enlightenment*, 86).

[77.] Cf. A:162, 178-179; 3:105, 419n.; W10:84; Parker, *Historic Americans*, 33-35; Van Horne, "Collective Benevolence and the Common Good in Franklin's Philanthropy," 425-26.

[78.] Cf. Thomas Jefferson: "To the corruptions of Christianity I am indeed opposed; but not to the genuine precepts of Jesus himself" (Jefferson to Benjamin Rush, 21 April 1803, *Writings*, ed. Peterson, 1122).

tion of the divinity of Christ, he admits that he had "some Doubts"; but, as he continues, "it is a question I do not dogmatize upon, never having studied it, and think it needless to busy myself with it now, when I expect soon an Opportunity of knowing the Truth with less Trouble." Moreover, he suggests that the belief in Christ's divinity itself seems to have the possibility of practical benefits: "I see no harm, however, in its being believed, if that Belief has the good Consequence, as probably it has, of making his Doctrines more respected and better observed . . ." Overall, his evaluation of the Christian message, in what he took to have been its pure initial form, was quite favorable. "I think the System of Morals and his Religion, as he left them to us," he carefully qualifies, is "the best the World ever saw or is likely to see . . ." (W10:84). As long as there are limits on theological and doctrinal requirements and a fundamental toler-ance of dissenters' beliefs and practices, grounded in a recognition that the central purpose of religion is service to our fellows, Christianity is a highly successful religion.

Franklin did believe, however, that the value of Christianity and other religions was too often simply connected with unsubstantiated claims—claims that ultimately cannot be substantiated—about the value of their sectarian activities, especially worship. We remember that his generally distant, if loving, Creator requires no worship from us; but we remember as well his belief that there is still to be found in all humans some sort of natural inclination toward devotion and worship of some unseen Power (above, 3.2). And Franklin himself, as we have seen, developed his own private worship service. More-over, he writes in the *Autobiography* that, "Tho' I seldom attended any Public Worship, I had still an Opinion of its Propriety, and of its Utility when rightly conducted . . ." (A:147).[79] We get some sense of what Franklin intended by this qualification when we remember what went wrong in the Hemphill case that we have just considered. The role of public worship ought to be to redirect human attention to the more important aspects of living. Franklin makes this point more explicit in a letter to his twenty-one-year-old daughter, Sally, as he departed for his second official mission in England in 1764:

[79.] Cf. Donald H. Meyer: "Franklin's attitude toward prayer appears to be a mixture of social pragmatism and spiritual instrumentalism. That is, he believed in public prayer and public worship as a basis for social unity and moral harmony among people, and in private devotion as a means of integrating one's spiritual energies" ("Franklin's Religion," 159).

Go constantly to Church whoever preaches. The Acts of Devotion in the common Prayer Book, are your principal Business there; and if properly attended to, will do more towards mending the Heart than Sermons generally can do. For they were composed by Men of much greater Piety and Wisdom, than our common Composers of Sermons can pretend to be. And therefore I wish you wou'd never miss the Prayer Days (11:449–50; cf. 6:225).

While we have seen that, especially late in his life, Franklin was inclined to accept instances of special providences that resulted from prayer, it is safe to assume that what he primarily intended for his daughter to gain from prayer was a 'mending' of the heart, a rededication to matters of lasting human import. And, again not closing the door on the possibility of special providences, this internal reform was presumably a large part of what he intended with regard to his call in 1747 for a day of fasting and prayer in the midst of dark times during King George's War. As he writes in the *Autobiography*: "Calling in the Aid of Religion, I propos'd to them the Proclaiming a Fast, to promote Reformation, and implore the Blessing of Heaven on our Undertaking" (A:184). The text of the proclamation lists the sufferings of the province and then notes "there is just Reason to fear, that unless we humble ourselves before the Lord, and amend our Ways, we may be chastised with yet heavier Judgments . . ." As a result of the prayer and fasting, however, the proclamation hopes that "Almighty God would mercifully interpose . . ." (3:228). It is not possible to read Franklin's involvement with this proclamation as a cynical deception on the part of a Deist who expects no Divine response[80] since, as we have seen, Franklin does not rule out special providences. It is still possible, however, to read this call for a fast, and his call for prayer at the Constitutional Convention that we have also considered, primarily as attempts to 'mend' human hearts to allow for higher levels of human cooperation.

Franklin's qualified appreciation of public worship did not lead him to the acceptance of an extreme form of sabbatarianism. Respecting the Sabbath, he thought, should not preclude a day of relaxation and recreation. He himself, as we recall, made Sunday his "Studying-Day" (A:146). He demonstrated his rejection of sabbatar-

[80.] Cf. Aldridge, *Benjamin Franklin and Nature's God*, 147–49.

ianism in a 1762 letter to Jared Ingersoll of Connecticut in which he discussed his visit to Flanders the year before. Unlike in Connecticut, Franklin writes, where there is an "excessively strict Observation of Sunday; and . . . a Man could hardly travel on that day among you upon his lawful Occasions, without Hazard of Punishment," in Flanders he found Sunday a day of travel and diversions of all sorts. Franklin continues that "in the Afternoon both high and low went to the Play or the Opera, where there was plenty of Singing, Fiddling and Dancing"; and, since he looked around "for God's Judgments but saw no Signs of them" in the prosperous and happy land of Flanders, he was led to suspect "that the Deity is not so angry at that Offence as a New England Justice" (10:175–76; cf. 13:47). Thus, greater tolerance for others' more secular practices on the Sabbath was in order.

Most essential to Franklin's conception of religion was the emphasis upon service to our fellow humans. Franklin writes that religious faith is far too often diverted into "Holiday-keeping, Sermon-Reading or Hearing, performing Church Ceremonies, or making long Prayers, fill'd with Flatteries and Compliments, des-pis'd even by wise Men, and much less capable of pleasing the Deity." In the place of these religious rituals, he continues that faith ought to be "more productive of Good Works, than I have generally seen it: I mean real Good Works, Works of Kindness, Charity, Mercy, and Publick Spirit . . ." (4:505; cf. 2:33). Phrased slightly differ-ently, Franklin's point reappeared as follows: "I imagine *Hope* and *Faith* may be more firmly built on *Charity*, than *Charity* upon *Faith* and *Hope*" (8:154).[81] One of the great weaknesses that Franklin found in the religious mentality was that the primacy of service can all too often be forgotten. "The Worship of God is a Duty, the hearing and reading of Sermons may be useful," Franklin writes; but, "if Men rest in Hearing and Praying, as too many do, it is as if a Tree should value itself on being water'd and putting forth Leaves, tho' it never produc'd any Fruit" (4:505). As an example of what he had in mind by this distinction, we can consider his discussion of an incident during his trip to England in 1757, when the ship on which he was sailing narrowly avoided shipwreck near Falmouth, in Corn-

[81] Paul Elmer More suggests that whether or not Franklin is considered a religious person depends upon the reader's evaluation of "his relegation of Faith and Hope to the attic and his choice of earth-born Charity" ("Benjamin Franklin," 153).

wall, because of the fortunate presence of a lighthouse. Franklin indicated how the passengers' gratitude for their well-being might be misdirected into building a chapel to commemorate their deliverance, and suggested that the construction of more lighthouses would be of far greater service to future travellers (cf. A:259; 7:243–44). In another case, he transmitted his unwillingness to provide a bell for the church steeple in a Massachusetts town that had named itself 'Franklin' in his honor, but offered to help found a library in the town instead. His reasoning was simple: "Sense being preferable to Sound" (W9:300).

Parallel with this emphasis upon service to our fellows as the primary embodiment of religious piety, Franklin stressed the important role that religious training can play in advancing the common good.[82] The study of history, he notes in 1749 in discussing his favored curriculum for the proposed Philadelphia Academy, affords "frequent Opportunities of showing the Necessity of a *Publick Religion*, from its Usefulness to the Publick; the Advantage of a Religious Character among private Persons; the Mischiefs of Superstition, etc. and the Excellency of the Christian Religion above all others antient or modern" (3:413).[83] Franklin's sense of the social usefulness of religion, if properly directed, was a point on which he did not waiver. Franklin's view here may seem inconsistent in the sense that he both advocated and opposed religion; but I suspect that the inconsistency is only apparent. Rather, his view contains the two compatible points that religion in its role as moral teacher for

[82.] Cf. Clinton Rossiter: Franklin "had decided, after much observation in Boston and Philadelphia, that one of the essentials of self-government was a high level of public morality. He had decided further that such a condition of public morality was largely the product of organized religion . . . Organized religion had worked, and worked well, in the colonies. It must therefore be supported, even by the skeptic. Franklin went to church, when he went to church, because it was 'decent and proper,' not because he was a believer . . . He abandoned logical deism because 'this doctrine, though it might be true, was not very useful' [A:114]. He turned back to give support to Christianity because this doctrine, though it might be untrue, was highly indispensable to his kind of society" (*Seedtime of the Republic*, 295).

[83.] Note the difference in spirit in the response of George Whitefield to Franklin's position: "the grand end of every christian institution for forming tender minds, should be to convince them of their natural depravity, of the means of recovering out of it, and of the necessity of preparing for the enjoyment of the supreme Being in a future state. These are the grand points in which christianity centers. Arts and sciences may be built on this, and serve to embellish and set off this superstructure, but without this, I think there cannot be any good foundation" (reprinted in 3:467–68).

focussing service to advance the social good is to be supported, whereas religion in its role as elaborator and enforcer of theological doctrines is not. The practical difficulty emerges when we realize that it is impossible to have any religion without some theology (even if this includes only what he saw as the 'essentials'). Perhaps a better way to phrase Franklin's point would be to say that while religion may provide the necessary scaffolding by means of which we can erect a solid and virtuous life, we should not fixate on the theological particularities or peculiarities of the scaffolding itself. As long as scaffolding does the job for which it was erected, we need care little about its material or color. Similarly, as long as religion works to foster service for the social good, indeterminate doctrines—like the Divinity of Christ—may be believed if they seem to contribute. On the other hand, doctrines that appeared to him to be blatantly false—like those opposed to reason or the laws of nature—and doctrines that appeared to be ultimately harmful—like the total depravity of human nature—should be opposed.[84]

Readers may find the potential for dishonesty in what could be seen as a kind of elitism on Franklin's part, especially in a climate as wary of manipulation as ours is.[85] As potential evidence for this elitism, we find, for example, his attempt to dissuade an unnamed individual from the publication of an attack on the doctrine of special providences—a doctrine for which Franklin has some affinity, as we have seen (above, 3.2–3.3)—because he thought that the belief in a benevolent and watchful God was a necessary part the education of youth and the control of the morally unsteady:

[84.] It is at this point that we can address Franklin's confusing statement in the *Autobiography*: "I began to suspect that this Doctrine [Deism] tho' it might be true, was not very useful" (A:114). First, it is clear from the context that the position under discussion was not Deism at all, but his early freethinking. Second, his point was not that freethinking is 'true' but harmful. Rather, his point was that the conclusions at which he arrived in his freethinking were valid deductions—a point open to dispute, of course—from assumptions that he had made, and that since these conclusions had sanctioned conduct that was 'not very useful,' the original assumptions had to have been mistaken.

[85.] Cf. Kerry S. Walters: "Many colonial intellectuals who privately professed the tenets of deism were both suspicious and contemptuous of what they considered to be the 'mob' . . . It was but a short step, in their estimation, from calling into question traditional scriptural and clerical authority to doing the same with economic and social relations . . . Deism was a rational person's religion; but the general populace—illiterate, passionate, and envious of their social betters—was anything but rational" (*The American Deists*, 27–28; Morais, *Deism in Eighteenth Century America*, 14–15, 120).

You yourself may find it easy to live a virtuous Life without the Assistance afforded by Religion; you having a clear Perception of the Advantages of Virtue and the Disadvantages of Vice, and possessing a Strength of Resolution sufficient to enable you to resist common Temptations. But think how great a Proportion of Mankind consists of weak and ignorant Men and Women, and of inexperienc'd and inconsiderate Youth of both Sexes, who have need of the Motives of Religion to restrain them from Vice, to support their Virtue, and retain them in the Practice of it till it becomes *habitual*, which is the great Point for its Security.

While admitting that these restraints are not foolproof, Franklin asks: "If Men are so wicked as we now see them *with Religion* what would they be if *without it?*" (7:294–95). His response is to foster the practical service role of religion in the social training of youth to help them to develop a more community-oriented stance that they could carry into a more cooperative adulthood.[86]

The question of manipulation would seem to be a more serious one if Franklin were an *atheist* rather than a Deist who was simply *agnostic* about most religious doctrines. Had he advocated the teaching of doctrines that he thought were false simply because they might effectively control the 'mob,' then this would be a clear instance of attempted manipulation on his part. His position, however, deals with indeterminate doctrines—like the Divinity of Christ—by suggesting that it is futile to try to find out if they are true or false. As long as they seem to produce positive results, Franklin suggested that such indeterminate doctrines as were deemed necessary to institutional religion might be taught. He was thus attempting to maintain the social value of the institutions without deciding, one way or the other, about the institutional scaffolding.

Ultimately, then, it seems that, for Franklin, to be *virtuous* required that individuals be *religious*, at least in the broad Deistic sense. Isaac Woodbridge Riley writes that "Deism was a product of eighteenth century rationalism, an attempt of the Enlightenment to reduce religion to ethics, revelation to a spiritual law in the natural world."[87]

[86.] Cf. Elizabeth E. Dunn: "Franklin viewed most formal religion as a means to an end, and that end was the inculcation of virtue" ("From a Bold Youth to a Reflective Sage," 521; cf. Pangle and Pangle, *The Learning of Liberty*, 275–76).

[87.] Riley, *American Philosophy*, 191; cf. Donald H. Meyer, *The Democratic Enlightenment*, 79–80, 86.

As we move on from Franklin's religious thought to his moral thought, we can keep in mind this Pragmatic spirit. As he writes to his sister, Jane Mecom, in 1758, far too often "seemingly *pious Discourses*" take the place of "*Humane Benevolent Actions*." Thus misdirected, people fail to actualize the potential power of religion to advance human well-being. "'Tis pity," he continues, "that *Good Works* among some sorts of People are so little Valued, and *Good Words* admired in their Stead . . ." (8:155).

CHAPTER 4
Franklin's Moral Thought

FRANKLIN IS SOMETIMES presented as a pathologically interfering moralist, ready at the drop of a hat to give advice to others on how they should lead their lives.[1] The focus of this busybody's moralizing is very frequently money. There is no question, of course, that Franklin (often in one of his literary *personae*) gave a great deal of moral advice, or that there is a significant economic component to his moral thought. Still, Franklin's morality is a complex business, as this passage from *Poor Richard's Almanack* suggests: "Tis hard (but glorious) to be poor and honest: An empty Sack can hardly stand upright; but if it does, 'tis a stout one!" (3:446). Only a misguided reading of the sort we have seen (above, 1.3) could interpret this aphorism to be suggesting that Franklin was advocating the pursuit of wealth as an ultimate human goal.[2] In this chapter, we will consider Franklin's ideas on morality. To begin, we will examine a narrow sample of his writings that is often used to represent his whole ethical perspective. Then we will consider the fundamental theme of the role of custom in conduct and his emphasis upon developing greater moral imagination. Our third theme will be virtue: its nature and its attainment. Next we will consider Franklin's application of this virtue theme to the cultivation of an industrious and frugal life. Finally, we shall consider whether Franklin's ethics constitutes a Puritan ethics. In all of these aspects of Franklin's moral thinking, his Pragmatism will reveal itself.

[1.] See, for example, the unflattering portrait of Franklin in Herman Melville's *Israel Potter*, especially chapter 7.

[2.] Cf. John Bach McMaster: "Morality he never taught, and he was not fit to teach it . . . The substance of all he ever wrote is, Be honest, be truthful, be diligent in your calling; not because of the injunctions 'Thou shalt not steal, thou shalt not bear false witness against thy neighbor;' but because honesty is the best policy; because in the long run idleness, knavery, wastefulness, lying, and fraud do not pay. Get rich, make money, as a matter of policy, if nothing more, because, as Poor Richard says, it is hard for an empty sack to stand upright" (*Benjamin Franklin as a Man of Letters*, 278).

4.1. Simple Moral Formulations

While questions remain to be answered about the content and value of Franklin's moral thought, there is no doubt that Franklin is essentially a moral thinker. A succinct statement of the primacy of ethics in his thought can be found in his letter to Polly Stevenson of 11 June 1760:

> The Knowledge of Nature may be ornamental, and it may be useful, but if to attain an Eminence in that, we neglect the Knowledge and Practice of essential Duties, we deserve Reprehension. For there is no Rank in Natural Knowledge of equal Dignity and Importance with that of being a good Parent, a good Child, a good Husband, or Wife, a good Neighbour or Friend, a good Subject or Citizen, that is, in short, a good Christian (9:121).

We may want to factor out the sermonizing of a fifty-four-year-old man to a twenty-one-year-old woman, and the simplification of living a good life into a being 'a good Christian.' Even if we do so, however, we are still left with a fundamental statement of Franklin's view that leading a moral life is our primary concern. As we have seen frequently in his consideration of the topics of duty and service in the context of science and religion, the ultimate goal of life is the social and moral one of being a good person. In spite of this seemingly valuable moral stance, however, Franklin's moral thought is routinely disparaged. As Herbert W. Schneider writes, "[t]he type of morality for which he stands in the American tradition, although well-known, is usually scorned and spurned by philosophers as mere journalism, popular precepts, empirical maxims, unworthy of philosophic dignity."[3] The reasons for the disparagment of Franklin's moral thought are, no doubt, many; but I want to concentrate on the central factor that his interests were purely naturalistic—directing his efforts in science and religion to human betterment—in an intellectual and social context that was suspicious (as ours still is) about the nature and value of human betterment.[4]

Even those whose general acquaintance with Franklin is minimal

[3] Schneider, "The Significance of Benjamin Franklin's Moral Philosophy," 294.

[4] Cf. Vernon Louis Parrington's version of this disparagement of Franklin: "A man who is less concerned with the golden pavements of the City of God than that the cobblestones on Chestnut Street in Philadelphia should be well and evenly laid, who troubles less to save his soul from burning hereafter than to protect his neighbors' houses by organizing an efficient fire-company, who is less regardful of

are probably familiar with the standard view of his ethics that we have considered (above, 1.3): that Franklin offers us a mechanical approach to morality, one that would reduce it from the search for justifying absolutes or the quest for spiritual growth to a series of ready responses directed by handy aphorisms like those out of *Poor Richard's Almanack*.[5] What are we to derive from a proverb like *"Sloth, like Rust, consumes faster than Labour wears, while the used Key is always bright . . ."* (7:341) except the suggestion of the superiority of almost any sort of busyness to its opposite? Why attempt to cultivate concern about larger questions of justice when a virtue like thrift can be advanced in the simple statement "a penny sav'd is a penny got" (1:241–42).[6] These and other aphorisms were specifically intended, Franklin reminds us, "to leave *strong* and *lasting* Impressions on the Memory of young Persons"; and his reasoning here is simple: "'Tis easier to prevent bad habits than to break them" (3:100, 8).[7] At issue is whether we should find in these handy aphorisms the totality of, and hence the overall inadequacy of, Franklin's moral thinking. As we have found in earlier chapters, reading more broadly in Franklin will be necessary before we can decide. We can begin with some of his other moral formulae.

Beyond the pages of the *Almanack*, Franklin offers several other significant instances of simple moral formulations. During the summer of 1726, for example, while returning to America from his initial trip to England, he developed the *"Plan"* that we considered (above, 3.2) for regulating his future conduct. The central aim of this plan was to try to "live in all respects like a rational creature"; his means was to be a more conscious and deliberate ordering of his life.

the light that never was on sea or land than of a new-model street lamp to light the steps of the belated wayfarer—such a man, obviously, does not reveal the full measure of human aspiration" (*Main Currents in American Thought*, 1:178).

[5.] Cf. Paul K. Conkin: "the *Almanac*, aside from its success as a business venture and its attractive humor, was a highly popularized, loosely organized manual on morality . . ." (*Puritans and Pragmatists*, 98).

[6.] This particular aphorism is not originally from the *Almanack* but from *The Pennsylvania Gazette* of 1732. It reappeared in the form "*A Penny sav'd is Twopence clear*" in the *Almanack* for 1737 (2:165). Another motto that would suggest a narrow sense of justice appears in his discussion of thirteen virtues, to be considered shortly.

[7.] Franklin later suggested putting such aphorisms on the coins of the United States. By reproducing these useful precepts, he writes, "the frequent Inculcation of which by seeing it every time one receives a Piece of Money, might make an Impression upon the Mind, especially of young Persons, and tend to regulate the Conduct . . ." (30:430).

In writing poetry, Franklin analogizes, "if we would write what may be worth the reading," we need to concentrate on "the art of poetry" and "before we begin, to form a regular plan and design of our piece . . ." Similarly in living life we must replace the "confused variety of different scenes" with "a regular design . . ." This new and rational life that Franklin hoped to develop was to be anchored by four central virtues. The first was to be "extremely frugal for some time, till I have paid what I owe." The second was to practice "truth in every instance . . . sincerity in every word and action . . ." The third virtue was to turn away from foolish schemes to gain sudden wealth and to emphasize instead "industry and patience [as] the surest means of plenty." Finally, Franklin committed himself "to speak ill of no man whatever, not even in a matter of truth" but rather to "speak all the good I know of every body" (1:99–100).

This plan for regulating his conduct in life, which in his *Autobiography* Franklin thought he had "pretty faithfully adhered to quite thro' to old Age" (A:106), underwent a good deal of refinement in the next few years. He notes in particular that about 1728 he "conceiv'd the bold and arduous Project of arriving at moral Perfection." As extreme and futile as such a goal might seem to us, moral perfection was exactly what young Franklin meant: "I wish'd to live without committing any Fault at any time; I would conquer all that either Natural Inclination, Custom, or Company might lead me into" (A:148).[8] The twenty-two-year-old soon recognized, however, that such moral perfection was going to be harder to attain than he had anticipated. He describes his futile quest as follows: "While my *Attention was taken up* in guarding against one Fault, I was often surpriz'd by another. Habit took the Advantage of Inattention. Inclination was sometimes too strong for Reason." Franklin decided that the source of his difficulties was that "the mere speculative Conviction" to be "compleatly virtuous" was insufficient to bring about practical success. Something more effective than good intentions was going to be required, he thought, "the contrary Habits must be broken and good ones acquired and established, before we can have any Dependance on a steady uniform Rectitude of Conduct" (A:148). In the hope of reaching moral perfection, he developed a method to establish these habits more firmly.

[8.] To the question of the possibility of human perfection, Franklin offers the naturalistic response that a person is as capable "of being so perfect here [in this life], as he is capable of being here . . . as perfect as his present Nature and Circumstances admit . . ." (1:262).

Franklin's method began with the constructing of an expanded list of thirteen virtues—"all that at that time occur'd to me as necessary or desirable" (A:149)[9]—that he hoped to make habitual. The virtues themselves, arranged in what he took to be their natural order of progression, were:

1. TEMPERANCE. Eat not to Dulness. Drink not to Elevation.

2. SILENCE. Speak not but what may benefit others or yourself. Avoid trifling Conversation.

3. ORDER. Let all your Things have their Places. Let each Part of your Business have its Time.

4. RESOLUTION. Resolve to perform what you ought. Perform without fail what you resolve.

5. FRUGALITY. Make no Expence but to do good to others or yourself: i.e. Waste nothing.

6. INDUSTRY. Lose no Time. Be always employ'd in something useful. Cut off all unnecessary Actions.

7. SINCERITY. Use no hurtful Deceit. Think innocently and justly; and, if you speak, speak accordingly.

8. JUSTICE. Wrong none, by doing injuries or omitting the Benefits that are your Duty.

9. MODERATION. Avoid Extreams. Forbear resenting Injuries so much as you think they deserve.

10. CLEANLINESS. Tolerate no Uncleanness in Body, Cloaths or Habitation.

11. TRANQUILITY. Be not disturbed at Trifles, or at Accidents common or unavoidable.

12. CHASTITY. Rarely use Venery but for Health or Offspring; Never to Dulness, Weakness, or the Injury of your own or another's Peace or Reputation.

13. HUMILITY. Imitate Jesus and Socrates.

[9.] Cf. Donald H. Meyer: "Franklin was not trying to present a complete ethical system. He was aware of the wider dimensions of the moral life, but was not trying to cover the length and breadth of the subject. One of the virtues that Franklin most assiduously cultivated, as a matter of fact, that of toleration, does not even appear on his list" (*The Democratic Enlightenment*, 67; cf. Fiering, "Benjamin Franklin and the Way to Virtue," 218).

Franklin's long-term intention was "to acquire the *Habitude* of all these Virtues"; but, recognizing that it would be futile to attempt to advance toward moral perfection on all of these fronts at once, he decided to fix his attention "on one of them at a time, and when I should be Master of that, then to proceed to another, and so on till I should have gone thro' the thirteen" (A:149–50).

Franklin then fashioned "a little Book" (A:151) with a page emphasizing each of these thirteen virtues, and he allocated a week to cultivating one after another of them in sequence. The format of all of the pages was similar: there were seven marked columns, one for each day of the week, and thirteen marked lines, one for each of the virtues. All that changed from page to page was the virtue to be focussed upon that week. Then, by a process of daily critical self-examination,[10] Franklin would evaluate his performance with regard to these thirteen central virtues, marking in the proper block "a little black Spot" whenever necessary to indicate the faults that he had committed each day (A:151).[11] Franklin writes:

> Thus in the first Week my great Guard was to avoid every the least Offence against Temperence, leaving the other Virtues to their ordinary Chance, only marking every Evening the Faults of the Day. Thus if in the first Week I could keep my first Line marked T[emperence] clear of Spots, I suppos'd the Habit of that Virtue so much strengthen'd and its opposite weaken'd, that I might venture extending my Attention to include the next, and for the following Week keep both Lines clear of Spots. (A:151–52)

Franklin's plan was to move through the thirteen virtues in weekly sequence and then after the cycle was completed to begin again with the first, thus proceeding through the book four times a year. Each time he hoped to come somewhat closer to his expressed goal of moral perfection.

In the *Autobiography*, Franklin reported the sobering results of

[10] Cf. Cotton Mather: "Frequent SELF-EXAMINATION, is the duty and the prudence, of all that would *know themselves*, or would not *lose themselves*. The great intention of SELF-EXAMINATION is, to find out, the points, wherein we are to *amend our ways*" (*Bonifacius*, 35; cf. 8:123–31).

[11] Cf. William Cabell Bruce: "This project once formed, he went about its execution in a manner as strictly mechanical as if he had been rectifying a smoky chimney or devising a helpful pair of glasses for his defective eyesight" (*Benjamin Franklin Self-Revealed*, 1:26–27; cf. Van Doren, *Benjamin Franklin*, 88).

the exercise: "I was surpriz'd to find myself so much fuller of Faults than I had imagined . . ." Eventually, he was even forced to transfer his record-keeping from the paper pages of the little book that he had worn out "by scraping out the Marks on the Paper of old Faults to make room for new Ones" to "the Ivory Leaves of a Memorandum Book" from which he could "easily wipe out with a wet Sponge" earlier marks. In particular, he found two virtues especially difficult to cultivate. He discovered, first of all, that attempts to bring order to his life — to keep everything in its proper place and time — gave him the most trouble. His inability to lead an orderly life was so pervasive that he even considered rationalizing his weakness as a kind of virtue. As he writes, "a benevolent Man should allow a few Faults in himself, to keep his Friends in Countenance" (A:155–56).[12] In a less jocular mood, he reported that his lack of order continued to haunt him, especially in later life. As he writes in the *Autobiography*, "now I am grown old, and my Memory bad, [and] I feel very sensibly the want of it [order]" (A:156). Franklin also seemed to have had little success developing humility. The virtue itself he had even overlooked in his original listing; he added it only after "a Quaker Friend . . . inform'd me that I was generally thought proud . . . overbearing and rather insolent." Despite his efforts to develop humility, however, his pride remained recalcitrant.

> In reality there is perhaps no one of our natural Passions so hard to subdue as *Pride*. Disguise it, struggle with it, beat it down, stifle it, mortify it as much as one pleases, it is still alive, and will every now and then peep out and show itself . . . For even if I could conceive that I had compleatly overcome it, I should probably . . . [be] proud of my Humility. (A:158–60)[13]

While Franklin admits to little success in developing the desired humility, he did have some additional success in limiting the offense

[12.] Franklin's metaphorical version of this point is: "*a speckled Ax was best*" (A:156). Cf. Paul W. Conner: "By not being repulsively fastidious, he could further that higher ordering, social harmony" (*Poor Richard's Politicks*, 227 n.11; cf. Murdock, "Jonathan Edwards and Benjamin Franklin," 119).

[13.] For another early consideration of Franklin's difficulties with pride, see the *Almanack* for 1748: "PRIDE is said to be the *last* vice the good man gets clear of. 'Tis a meer Proteus, and disguises itself under all manner of appearances, putting on sometimes even the mask of *humility*" (3:343–44; cf. 1:21–22; Stourzh, *Benjamin Franklin and American Foreign Policy*, 16–19).

given to others by his pride by adopting, as we have seen (above, 2.4), a more conciliatory style of conversation.

As early as 1732, Franklin planned to convert what he had learned from undertaking this project for attaining moral perfection into a volume which he described as "a little Work for the Benefit of Youth" (9:104; cf. 375). This never-finished treatise, to have been called *The Art of Virtue*, was to focus upon the 'art' or practice of morality "because it would have shown the *Means* and *Manner* of obtaining Virtue, which would have distinguish'd it from the mere Exhortation to be good, that does not instruct and indicate the Means . . ." (A:157–58; cf. 9:104–5). In line with his Deistic religious perspective, Franklin emphasized that his art of developing virtue was to be free from sectarian bias:

> tho' my Scheme was not wholly without Religion there was in it no Mark of any of the distinguishing Tenets of any particular Sect. I had purposely avoided them; for being fully persuaded of the Utility and Excellency of my Method, and that it might be serviceable to People in all Religions, and intending some time or other to publish it, I would not have any thing in it that should prejudice any one of any Sect against it. (A:157)

Unfortunately, Franklin's intention to complete *The Art of Virtue* was never carried to fruition—made impossible, he notes in 1784, by "the necessary close Attention to private Business in the earlier part of Life, and public Business since . . ." (A:158)—and we are left with only the spirit and the sketch of the intended volume that appear in the *Autobiography*.

Another simple and formulaic consideration of morality that Franklin offered is his "*Moral* or *Prudential Algebra*," a method he developed for evaluating the various reasons for and against particular life choices. He presented this method, which he says he himself had long used, in a letter of 19 September 1772 to Joseph Priestley, who was then troubling over an offer of new employment. Franklin writes that the difficulty in deciding such cases is that "all the Reasons *pro* and *con* are not present to the Mind at the same time . . ." As a result, we vacillate back and forth, pushed by whichever aspects of the decision under consideration seem at the time primary, without being able to come to any abiding decision.

> To get over this, my Way is, to divide half a Sheet of Paper by a Line into two Columns, writing over the one *Pro*, and over the other *Con*. Then during three or four Days Consideration I put down under the different Heads short Hints of the different Motives that at different Times occur to me for or against the Measure. When I have thus got them all together in one View, I endeavour to estimate their respective Weights; and where I find two, one on each side, that seem equal, I strike them both out: If I find a Reason *pro* equal to some two Reasons *con*, I strike out the three.

By means of this process of simplification, Franklin finds "at length where the Balance lies; and if after a Day or two of farther Consideration nothing new that is of Importance occurs on either side, I come to a Determination accordingly." This method of prudential algebra, Franklin was careful to point out, is purely procedural: it cannot advise an individual "*what* to determine" but only "*how*." He recognized, of course, that this 'algebra' lacked the precision of any mathematical abstraction; but he writes that "when each [reason] is thus considered separately and comparatively, and the whole lies before me, I think I can judge better, and am less likely to make a rash Step . . ." (19:299–300).[14]

We can see in this series of simple moral formulations the outline of a morality that neither hesitates over metaphysical doubts nor puzzles over procedural questions. Franklin, rather, simply gets to work: striving to cultivate the accepted virtues in himself and others and to simplify the complexity of making decisions so that human well-being can be advanced. For many moralists, past and present, his approach to morality is totally inadequate. It begs too many of the questions that ethics debates: can morality be taught? are moral goods natural? is there a common good? Franklin's morality, in other words, fails to consider whether morality as a rational activity is possible. For him, the question of the possibility of morality had long been settled by the actualities of our lives together. Of course, we can teach the young to be better than they might be otherwise, and we need to do so. Of course, moral goods are natural, as hunger and illness and our failures to cooperate to deal with them have

[14.] For Franklin's own use of the 'Algebra,' see: 15:233–37; 19:303; 20:336–38; 29:283–84; 31:456–57. For some doubts about its use expressed by his grandnephew, Jonathan Williams, Jr., see: 29:318–19.

repeatedly made clear. Of course, there is a common good, as dishonesty and discrimination and war have taught us. For Franklin, we need to direct our attention toward making these possible goods more actual.[15]

If we put our emphasis too strongly on Franklin's attempts to attain 'moral Perfection' and pay insufficient attention to the equivalent attempt to live a good life (which we saw above narrowed into becoming 'a good Christian'), we will miss the expressed purpose underlying his moral thought. Even under the severe strain of the Revolutionary War—when, for example, Franklin writes to Priestley that he finds humans "very badly constructed, as they are generally more easily provok'd than reconcil'd, more disposed to do Mischief to each other than to make Reparation, much more easily deceiv'd than undeceiv'd, and having more Pride and even Pleasure in killing than in begetting one another" (W8:451–52; cf. 23:238)—we have no reason to assume that Franklin abandoned his intention to work for human well-being, to seek moral perfection and to develop tools for moral evaluation. As Franklin had written to Priestley earlier in the War, his hope was that our "moral Science" could be developed and improved, perhaps even so far that we could hope "that Men would cease to be Wolves to one another, and that human Beings would at length learn what they now improperly call Humanity" (31:456). Included in another contemporary letter was the call for "the Discovery of a Plan; that would induce and oblige Nations to settle their Disputes without first Cutting one anothers Throats" (31:453). While it is doubtful that Franklin ever expected that he, or we, would arrive at the projected goal of 'moral Perfection' or 'Humanity,' he did hope for continued advancement in morality. As Adrienne Koch writes: "Become, he says, not virtuous but a little more virtuous than the day before!"[16] From science, we can learn the spirit of publicity and experimentalism; from religion, the spirit of service.

[15] Cf. David M. Larson: "On the question of what makes certain actions virtuous, Franklin depends upon the general agreement among sensible men that certain actions are obviously beneficial to man and society and consequently are virtuous" ("Franklin on the Nature of Man and the Possibility of Virtue," 115).

[16] Koch, *Power, Morals, and the Founding Fathers*, 17. Cf. Irving Babbitt: "'The highest worship of God,' as Benjamin Franklin assures us blandly, 'is service to man.' If it can be shown experimentally—and a certain amount of evidence on this point has accumulated since the time of Franklin—that service in this sense is not enough to chain up the naked lusts of the human heart, one must conclude that the

4.2. Customs and Evaluation

Throughout Franklin's long life, one continuing theme in his thinking and writing was the necessity for the deliberate and ongoing evaluation of custom.[17] As a young man of twenty-nine in the midst of a religious controversy, he writes that "[i]t is sufficiently known to all the thinking Part of Mankind, how difficult it is to alter Opinions long and universally receiv'd. The Prejudices of Education, Custom and Example, are generally very strong . . ." In the face of these difficulties, Franklin still urges his readers to consider "how glorious a Conquest they make, when they shake off all manner of Prejudice, and bring themselves to think *freely, fairly*, and *honestly*" (2:66). More than a half-century later, the eighty-three-year-old Franklin, now involved in an educational controversy, writes that "there is in Mankind an unaccountable Prejudice in favour of ancient Customs and Habitudes, which inclines to a Continuance of them after the Circumstances, which formerly made them useful, cease to exist" (W10:30). Given our habitual nature, the question of how to make reason primary in the evaluation of the results of our social activities remains an important one.

One particularly humorous instance of Franklin's challenge to custom was his 1747 essay, "The SPEECH of Miss POLLY BAKER." The fictional Connecticut woman in question was being prosecuted—for the fifth time—for bearing an illegitimate child. Recognizing that with her prior record and with the newborn babe as incontrovertible evidence against her she stood little chance of avoiding conviction, Polly hopes only to avoid a repetition of the punishment authorized by the law: "twice I have paid heavy Fines, and twice have been brought to Publick Punishment, for want of Money to pay those Fines." The core of her defense is her position that "I cannot conceive (may it please your Honours) what the nature of my

supreme exemplar of American shrewdness and practicality did not, in the utterance I have just cited, show himself sufficiently shrewd and practical" (*Democracy and Leadership*, 337; cf. Aldridge, *Benjamin Franklin*, 169).

[17.] Cf. Donald H. Meyer: "In Franklin's day Western man was morally like one learning a new skill. Habits that seem natural to us had to be painfully acquired . . . One's earthly destiny was no longer determined by one's birth; unquestioning obedience to the Church was no longer expected; and morality was no longer governed exclusively by custom and tradition" (*The Democratic Enlightenment*, 66; cf. Stifler, *The Religion of Benjamin Franklin*, 77; Parrington, *Main Currents in American Thought*, 1:165).

Offence is." She continues: "I have brought Five fine Children into the World, at the Risque of my Life; I have maintain'd them well by my own Industry, without burthening the Township, and would have done it better, if it had not been for the heavy Charges and Fines I have paid." Polly thus offers as her main defense the claim that the bearing of children is a kind of public service that has been wrongly criminalized as a result of narrow prejudices of religious and social custom. "Can it be a Crime (in the Nature of Things I mean) to add to the Number of the King's Subjects, in a new Country that really wants People?" she wonders. Assuming that the answer to her query should be negative, she pleads that her judges "not turn natural and useful Actions into Crimes, by your Prohibitions" (3:123–25).

There are other strands to her defense. Polly denies, for example, having committed any legitimately criminalizable acts like having "debauched" any other woman's husband or "enticed" any youth. She further denies ever having rejected the opportunity of marriage. Her first child, she tells us, was the offspring of a relationship with the only man who ever offered to marry her. This man, however, after having taken advantage of her, fled when she became pregnant and has "now become a Magistrate of this Country . . ." Polly rejects as well the right of the secular court to punish her for failings of a spiritual sort. "You believe I have offended Heaven, and must suffer eternal Fire: Will not that be sufficient? What Need is there, then, of your additional Fines and Whipping?" In reality, she notes, God does not seem annoyed by her alleged 'crimes' but has given her healthy and happy children, contributing "his Divine Skill and admirable Workmanship in the Formation of their Bodies . . ." Finally, turning to the attack, Polly maintains that if there are any criminals to be found in the area, they are the numerous bachelors who refuse to marry and satisfy the Divine injunction to "*Encrease and Multiply*." Her proposal for dealing with those who shirk their duty is simple: "Compel them, then, by Law, either to Marriage, or to pay double the Fine of Fornication every Year." If the law were to stimulate marriages in this way, young women like herself would no longer have to suffer "Publick Disgrace and Punishment" for fulfilling their part of the injunction. Franklin includes as one final joke Polly's request that, since she has suffered so much in her attempts to follow the Divine command to reproduce, "instead of a Whipping" there should be "a Statue erected to my Memory" (3:124–25). While Franklin wisely does not offer us the verdict in

Polly's case,[18] the point of his story is clear: customs and their consequences must be brought under the evaluation of reason.

This little essay points as well as any that Franklin ever wrote to the additional danger that he saw in covering the problem of unquestioned custom with a verneer of religious moralism. Any attempt to fortify social sanctions with a Divine aura will make even less likely the possibility of evaluating conduct, except with regard to the simple question of its conformity with the assumed template. Franklin further challenged the religious spirit that would proscribe particular types of conduct as sin rather than focus upon increasing service to humankind. In fact, the concept of 'sin' disappears from Franklin's writing, replaced with that of a 'fault' or an *'erratum.'* (The latter term, which has appeared several times already, was drawn from his printing background and refers to the inevitable errors or slips or mistakes that occur in the process of composing lines of type).[19] Among the numerous *errata* which Franklin detailed in his *Autobiography* are the following: leaving his brother's print-shop before his years of service were over (cf. A:70), making use of money that he was holding in trust for another (cf. A:86, 121–22), publishing *A Dissertation on Liberty and Necessity* in 1725 (cf. A:96), attempting "Familiarities" with the mistress of one of his friends (cf. A:99), and letting his relationship with Deborah Read—his eventual wife for over forty years—lapse while he was away from Philadelphia from 1724–1726 (cf. A:114, 129).[20] Franklin did not minimize his responsibility in these cases, nor the harm that he had done; but his confession was to moral failures, however serious, not to *sins*, to

[18.] For more on Polly Baker, see: Alfred Owen Aldridge, *Early American Literature*, 97–130; Aldridge, *Franklin and His French Contemporaries*, 95–104; Max Hall, *Benjamin Franklin and Polly Baker*.

[19.] Cf. Mitchell Robert Breitwieser: "Franklin's faults are downgraded from author's to printer's errors, and so are expelled from the self . . . The compositor's hand slips because he has glanced up from the job to eye some attraction passing the window, and the text is marred by an erratum, which can nonetheless be corrected completely because it has no secret substrate, no positive content. Remorse is irrelevant in such a situation, though a reflective, pragmatic, preventative appraisal would be useful: in each case, the task is to do what can be done to recoup the loss, and then to move on to new business which will render the waste negligible" (*Cotton Mather and Benjamin Franklin*, 239, 289; cf. Conkin, *Puritans and Pragmatists*, 83, 66).

[20.] Cf. Theodore Parker: "In his private morals there were doubtless great defects, and especially in his early life much that was wrong and low . . . He stumbled many times in learning to walk, and, as he was a tall youth, and moved fast, so he fell hard" (*Historic Americans*, 29, 27).

having done harm rather than to having transgressed codes. Such moral mistakes were something with which he, and we all, struggle. Human living for Franklin left an ongoing trail of *errata*. He later admitted to being generally satisfied with his attempts to attain moral perfection and generally happy with his resulting life, and he declares very late in his life that "if I were allowed to live it over again, I should make no objection, only wishing for leave to do, what authors do in a second edition of their works, correct some of my *errata*" (W10:4).[21]

The great human flaw to which Franklin pointed is not *sinfulness* (or whatever else might satisfy his, and our, more theologically inclined contemporaries).[22] Rather than sinfulness, Franklin condemned the lack of moral imagination, the inability to see beyond the inherited and the usual to discover what might be better. To his way of thinking, one key element in any process of social improvement would be to challenge the value of customs by appealing to the social results of their continuation. A second essential element in this process would be to make more readily available to people substitutes for their inherited ways of acting by offering them suggestions of alternative possibilities through correspondence and publication. "Many People," he writes with regard to his intended volume *The Art of Virtue*, "lead bad Lives that would gladly lead good ones, but know not *how* to make the Change." It was clear to him, however, that "[t]o exhort People to be good, to be just, to be temperate, etc. without *shewing* them *how* they shall *become* so . . ." (9:104) is futile. Franklin was not implying, of course, that *he* necessarily had the right answers for how others should act, although the narrowly utilitarian busybody found in some presentations of Franklin does imply this. As an experimentalist, he could hardly maintain that he *knew* that he was right. His point, rather, was about disseminating information and suggestions to offer those who would like to change a sense of the range of possibilities.[23]

[21.] Cf. A:43; 1:111; W9:334.

[22.] Cf. William L. Phelps: "Franklin seemed to have no religious fear, neither fear of God nor of hell nor indeed of anything else. Edwards would lie awake all night thinking of some imaginary sin he might have committed during the day. Franklin, if he had sinned grossly, would merely make an entry in his diary, 'Another erratum,' and proceed with the day's work" ("Two Colonial Americans," 200).

[23.] Cf. Norman S. Fiering: "In some respects Franklin's approach to ethics represented an advanced or progressive position, in particular his emphasis on the importance of nurture rather than nature, and his search for refinements of the

Franklin thought that the rebuilding of society into one that was more concerned with evaluation would be a major and ongoing task, including each of the elements we saw above: recognizing the role of moral formulae like those of the *Almanack* in the education of the young before moral reasoning fully develops; providing individuals with a means of regular self-evaluation of their actions like the 'little book'; and developing a method like the 'moral algebra' to make moral choices rational rather than customary. Underlying all aspects of this social reformation, as might be expected from Franklin, was the desire to foster public service. What this challenge to custom further indicated was that Franklin believed that a moral re-education of society that was aimed primarily at the young, and that attempted by a gradual and incremental process of education to develop more scientifically informed and socially-minded citizens, was possible. Consider in this regard the final paragraph of his proposal for the education of youth in Philadelphia:

> The Idea of what is *true Merit*, should also be often presented to Youth, explain'd and impress'd on their Minds, as consisting in an *Inclination* join'd with an *Ability* to serve Mankind, one's Country, Friends and Family; which *Ability* is (with the Blessing of God) to be acquir'd or greatly encreas'd by *true Learning*; and should indeed be the great *Aim* and *End* of all Learning. (3:419)

This educational remaking of society will not be easy, of course. The costs in human effort, although they will pay great dividends, will be significant.

4.3. The Importance of Virtue

Although Franklin maintained in the *Dissertation* that there could be neither virtue nor vice (above, 3.2), he recognized quite quickly that this position was harmful to the life of society. Social life was possible only in the context of recognizing responsibility for con-duct, including assuming responsibility for our social customs. The call to overcome custom with a reasoned evaluation of consequences must be supplemented, Franklin thought, with the cultivation of

behavior modification technique (that is, the method of habituation) that would make it more effective. We tend to believe that all hope for social progress depends upon premises like Franklin's" ("Benjamin Franklin and the Way to Virtue," 223).

individual virtue. The basic necessity for individual virtue is that rationality alone is not enough to guarantee moral conduct. "So convenient a thing it is to be a *reasonable Creature*," he writes, "since it enables one to find or make a Reason for every thing one has a mind to do" (A:88; cf. 14:250–51). If we consider this witticism carefully, we recognize that behind his joke is the important point to which he alluded earlier: adopting a focus upon consequences does not tell us which consequences to advance. Answers here come from the cultivation of virtues like sincerity and justice and humility. While some other eighteenth-century American thinkers were attracted by the thinking of the moral sense tradition that maintained that there is an innate sense of right and wrong that help to guide human actions,[24] for Franklin this approach no doubt seemed unnecessarily 'metaphysical' when it was possible to guide our actions more directly by an evaluation of their consequences informed by his emphasis upon the thirteen virtues. Thus, while Franklin did not hesitate throughout his long life to call people to live virtuous lives, what little he had to say explicitly about the nature of virtue occurred early in his writings, and in formats—like dialogues and anonymously published essays—that make his own views difficult to identify with certainty.[25] We can begin our consideration of Franklin's understanding of the nature and role of virtue with an examination of a series of contrasts that indicate what he thinks virtue is and is not.

The relationship between virtue and vice was the theme of Franklin's 1735 essay, "A Man of Sense." This piece takes the form

[24.] Cf. Thomas Jefferson: "Man was destined for society. His morality therefore was to be formed to this object. He was endowed with a sense of right and wrong merely relative to this. This sense is as much a part of his nature as the sense of hearing, seeing, feeling . . . The moral sense, or conscience, is as much a part of man as his leg or arm . . . State a moral case to a ploughman and a professor. The former will decide it as well, and often better than the latter, because he has not been led astray by artificial rules" (Jefferson to Peter Carr, 10 August 1787, *Writings*, ed. Peterson 901–2; cf. Garry Wills, *Inventing America*, 248–55).

[25.] Cf. David M. Larson: "Throughout his life Franklin is primarily concerned with finding an effective way of teaching men to behave well, not with building a philosophically consistent theory of virtue. For Franklin the construction of metaphysical theories can serve as an ingenious way of passing time, and he builds them much as he creates magical, mathematical squares during dull legislative debates, but what really matters is living a virtuous life and teaching others to do so. Experience is of primary importance; theory only secondary" ("Franklin on the Nature of Man and the Possibility of Virtue," 114–15).

of a contemporary philosophical dialogue between two characters, named 'Socrates' and 'Crito,' about the proper understanding of what it means to be a sensible person. In the course of their discussion, Socrates brings Crito to recognize that possessing knowledge does not necessarily make a person sensible. The possession of many types of knowledge—whether of "Push-pin" or "Dice" or "Dancing" or "Languages" or "Logic and Rhetoric" or even "Mathematicks, Astronomy, and Natural Philosophy"—cannot guarantee that a person will act sensibly. As Socrates maintains: "no Knowledge will serve to give this Character [i.e. good sense], but the Knowledge of our *true Interest*; that is, of what is best to be done in all the Circumstances of Humane Life, in order to arrive at our main End in View, HAPPINESS" (2:16).[26] So, it would seem that for Franklin virtue is present in the life of a person who lives in accordance with the knowledge of how to attain happiness.

Seizing upon this admission of Socrates that the sensible person has a kind of knowledge, Crito asserts that "there are many Men who *know* their true Interest, etc. and are therefore *Men of Sense*, but are nevertheless vicious and dishonest Men . . ." Socrates's response is to challenge Crito's evidence for the assumption that such malefactors *do* know what they ought to do: "How then does it appear that those vicious Men have the Knowledge we have been speaking of, which constitutes *a Man of Sense*, since they act directly contrary?" Socrates specifically rejects the claim that the ability to talk sensibly would provide by itself adequate evidence of sensibility. Just as with the shoemaker, who must do more than "*talk finely* about Shoemaking," he notes, the person "who is only able to talk justly of Virtue and Vice . . . but notwithstanding his talking thus, continues in those Vices" cannot "deserve the Character of a Temperate and Chaste Man . . ." Is not such a person far more deserving of being described as sensible, Socrates continues, "who having *a thorough Sense* that what the other has said is true, *knows* also *how* to resist the Temptation to those Vices, and embrace Virtue with a hearty and steady Affection?" (2:16–17).

[26.] In one of his earlier "Busy-Body" pieces, Franklin had written: "it is certainly of more Consequence to a Man that he has learnt to govern his Passions; in spite of Temptation to be just in his Dealings, to be Temperate in his Pleasures, to support himself with Fortitude under his Misfortunes, to behave with Prudence in all Affairs and in every Circumstance of Life; I say, it is of much more real Advantage to him to be thus qualified, than to be a Master of all the Arts and Sciences in the World beside" (1:119).

Crito accedes to Socrates's view that "Vicious Men, then, do not appear to have that Knowledge which constitutes *the Man of Sense*"; but he offers as a final challenge to Socrates the response that if knowledge and constant practice are to be necessary to 'the man of sense,' then Socrates has defined such a person out of existence. To this point, Socrates responds in a manner closely in tune with Franklin's familiar position on *errata*: there is "no necessity that to be a Man of Sense, he should never make a Slip in the Path of Virtue, or in Point of Morality; provided he is sensible of his Failing and diligently applys himself to rectify what is done amiss, and to prevent the like for the future." Thus to be 'a man of sense,' to be happy, it is more important to master—or to be continuing to attempt to master—"the SCIENCE OF VIRTUE" than any other (2:18–19).

Franklin published a related discussion of virtue a week after "A Man of Sense." In this second essay, entitled "Self-Denial Not the Essence of Virtue," he challenged those who maintain that "without *Self-Denial* there is no Virtue, and that the greater the *Self-Denial* the greater the Virtue." Franklin argues on the contrary that virtue does not necessarily include self-denial. His reasoning, in its familiar non-Calvinist spirit, is simply that not all of us are vicious cauldrons of evil incessantly bubbling over with the sort of desires that need to be denied. "If Self-Denial be the Essence of Virtue," Franklin writes, "it follows, that the Man who is naturally temperate, just, etc. is not virtuous; but that in order to be virtuous, he must, in spight of his natural Inclinations, wrong his Neighbours, and eat and drink, etc. to excess." The consequences of our actions are what matter in determining virtuous action, he maintains; and the anticipated consequences thus determine whether our inclinations should be followed or denied. As Franklin writes: "The Truth is, that Temperance, Justice, Charity, etc. are Virtues, whether practis'd with or against our Inclinations; and the Man who practices them, merits our Love and Esteem: And Self-denial is neither good nor bad, but as 'tis apply'd . . ." (2:19–21).

When placed in the context of what we have been considering about Franklin's moral thought, these two essays suggest a pair of clear emphases in Franklin's understanding of virtue. The first of these emphases is that he believed that leading a life of virtue is the result of a long process of hard work, not the result of an instantaneous moral insight or spiritual conversion. If we assume, as does Calvinism, that natural humans are totally depraved, then we must

also assume that they cannot save themselves but must be redeemed by the irresistible grace of a transcendent power. If we assume on the contrary, as does Franklin, that the human goal is only accidentally salvation, and that with regard to doing good—their essential goal—humans have varied and mixed natural potentials and can shape in their conduct toward the pursuit of the better, then growing in virtue is the work of a lifetime. As Franklin writes, "Men don't become very good or very bad in an Instant, both vicious and virtuous Habits being acquired by Length of Time and repeated Acts" (2:53).[27] Advances in virtue are, as we have seen, the results of "Art" (A:157); and, as such, they require time and effort. As Franklin writes, an individual who intends to become more virtuous must learn the art as one who would be a better painter or sailor or architect: such a person "must also be taught the Principles of the Art [of virtue], be shewn all the Methods of Working, and how to acquire the *Habits* of using properly all the Instruments; and thus regularly and gradually he arrives by Practice at some Perfection in the Art" (9:105; cf. A:165). Moreover, as Franklin writes in a number of instances, we should never neglect the importance of the early inculcation of good practices. In one formulation he writes: "'Tis easier to prevent bad habits than to break them" (3:8). In another, he tells us, "*early Institution*" is preferable to "*Reformation*" (9:375). In the third, his point appears as follows: "who ever heard of a Sot reclaim'd? If there are any such they are Miracles. People cannot be too cautious of the first Steps that may lead them to be engaged in a Habit the most invincible and the most pernicious of all others" (1:278).[28]

A second emphasis of Franklin's understanding of virtue is that he was far more concerned with evaluating the results of conduct

[27.] Cf. Norman S. Fiering: "his method for individual moral progress placed almost exclusive emphasis on slow, incremental modification of external behavior. He explicitly rejected almost all concern with the reformation of the heart or with the need for internal change as a necessary preliminary and foundation for virtue" ("Benjamin Franklin and the Way to Virtue," 206; cf. 202).

[28.] Cf. David M. Larson: "Franklin believed that most men are inherently neither virtuous nor vicious. He recognized the appearance of an occasional saint or devil among the group, but he believed that most men's behavior depends in large part upon their training and environment. Men have both selfish and unselfish impulses. The purpose of a training in virtue is to foster altruistic impulses and to channel selfish ones into useful activities" ("Franklin on the Nature of Man and the Possibility of Virtue," 118; cf. Reuben Post Halleck, *Romance of American Literature*, 55).

than with evaluating inward states or intentions, considerations that have too often preoccupied moral theorizing. Writing of the New England context, Norman S. Fiering notes:

> The mark of a Puritan in matters of moral psychology is, above all, scrupulosity, or that intense self-examination that worries primarily about purity of intention. In general, Franklin cared little about inward states in and for themselves and surprisingly little about inward states even as they may be understood as necessary preconditions of particular forms of outward conduct . . . Franklin defended an essentially behaviorist approach to virtue, which paid little heed to purity of intention and inward renewal, but concentrated, instead, on habit formation.[29]

The virtuous person, for Franklin, does not live oblivious to internal calm or disorder; but, conscious of the time-consuming aspects of introspection and its ability to divert moral attention away from action that is more necessary toward inaction that is more attractive, Franklin's moral person cultivates those aspects of conscience that focus upon the consequences of action and inaction in our social world.[30] There are clear parallels here with his position on science, focussing upon practical results rather than scientific theory (above, 2.4).

When this external focus is turned back upon Franklin's life and work, there is a possibly sinister reading that questions the relative value of possessing certain virtues versus the value of seeming to others to possess them. Some of Franklin's formulations are even-handed presentations of the need for both:

> In order to secure my Credit and Character as a Tradesman, I took care not only to be in *Reality* Industrious and frugal, but to avoid all *Appearances* of the Contrary. I drest plainly; I was seen at no Places of idle Diversions; I never went out a-fishing or shooting . . . and to show that I was not above my Business, I sometimes brought home the Paper I purchas'd at the Stores, thro' the Streets on a Wheelbarrow. (A:125–26)

[29.] Fiering, "Benjamin Franklin and the Way to Virtue," 207, 217; cf. Breitwieser, *Cotton Mather and Benjamin Franklin*, 179.

[30.] Cf. David M. Larson: "Franklin tests theories of virtue by examining their effects upon men's lives because he values experience more than theory. He is more interested in men's actions than in the beliefs which inspire them" ("Franklin on the Nature of Man and the Possibility of Virtue," 114).

In a similarly balanced fashion, Franklin mentions at times the importance of "Industry visible to our Neighbours" (A:119). Other of his formulations, however, like his claim of "being esteem'd an industrious thriving young Man" (A:126), suggest to some readers the primacy of the external, that to Franklin appearances were more important than reality. One instance, for example, is Franklin's admission with regard to humility that "I cannot boast of much Success in acquiring the *Reality* of this Virtue [humility]; but I had a good deal with regard to the *Appearance* of it" (A:159).[31]

In Franklin's defense, it is important to recognize that he, unlike most of his critics, believed in a kind of transparency of the self. He writes, for example, that "it is impossible for a man, though he has all the cunning of a devil, to live and die a villain, and yet conceal it so well as to carry the name of an honest fellow to the grave with him . . ." (1:78; cf. 8:130). If Franklin is right here, then 'appearance' and 'reality' while distinguishable, are not distinct. Thus, while our lives may not be fully open to others, he thought it was possible to live his life as if it were transparent. As he wrote when he was just setting up his wartime ministry in spy-infested France: "I have long observ'd one Rule . . . It is simply this, to be concern'd in no Affairs that I should blush to have made publick; and to do nothing but what Spies may see and welcome. When a Man's Actions are just and honourable, the more they are known, the more his Reputation is increas'd and establish'd" (23:211). Additionally, in accordance with his commitment to the ongoing examination of one's conduct, Franklin believed that ultimately we must judge ourselves: "One's true Happiness depends more upon one's own Judgement of one's self, on a Consciousness of Rectitude in Action and Intention . . . than upon the Applause of the unthinking undiscerning Multitude, who are apt to cry Hosanna today, and tomorrow, Crucify him." Franklin allows for the contributory evalua-tions "of those few who judge impartially" (13:188; cf. 7:85; 13:488). In general, however, individuals must be the judges of their own moral lives, deciding what is reality and what appearance.

[31.] Cf. Robert D. Habich: "Because Franklin the ethicist recognizes virtues by their effects, he is forced to sanction effects that result from causes less than virtuous. We are reminded, for instance, of his discovery . . . that the appearance of humility may result in the same benefits as the reality of it. For the scientist, establishing that causal relationship may be sufficient; for the ethicist, as for most readers, the duplicity is unacceptable" ("Franklin's Scientific Ethics," 189; cf. Fiering, "Benja-min Franklin and the Way to Virtue," 217).

At this juncture, we can return to Franklin's earlier point that there is a strong relationship between virtue and happiness. As he puts this point in his "Articles of Belief and Acts of Religion" of 1728, "without Virtue Man can have no Happiness in this World" (1:103). Early the next year, he writes further: *"Virtue alone is sufficient to make a Man Great, Glorious and Happy"* (1:119). In the *Almanack*, Poor Richard phrases this point: "Virtue and Happiness are Mother and Daughter" (3:64). If we turn from these endorsements to a consideration of the sort of happiness that Franklin has in mind, we see that his standards seem to be quite modest. Consider the Junto question: "Wherein consists the Happiness of a rational Creature?" Franklin reponds to this query in 1732 that happiness consists "[i]n having a Sound Mind and a healthy Body, a Sufficiency of the Necessaries and Convenciencies of Life, together with the Favour of God, and the Love of Mankind" (1:262). In a later formulation of the commonplace aspects of happiness, he writes in 1768, when he is at the height of his London social life: "Happiness consists more in small Conveniencies or Pleasures that occur every day, than in great Pieces of good Fortune that happen but seldom to a Man in the Course of his Life" (15:60–61). Twenty years later, now at the end of a life fuller of experiences and accomplishments more extraordinary than we can probably imagine, Franklin repeats his view that happiness is to be found in the simple. "Human Felicity is produc'd not so much by great Pieces of good Fortune that seldom happen, as by little Advantages that occur every Day" (A:207). In each of these latter instances, he offers an example from the daily routine of personal grooming (cf. A:207; 15:61), certainly the most commonplace of everyday pleasures. For Franklin, then, happiness was directly related to the simple aspects of well-being rather than to the limitless accumulation of material wealth of which he was so carelessly accused previously (above, 1.3). Should persons be fortunate enough to attain greater wealth, the proper response for them would be to turn from the pursuit of still more wealth and to devote the remainder of their lives to service.

Despite the oversimplifications that crowd his reputation, Franklin recognized that human happiness remains a complex matter. For example, he also believed that personality is a component in an individual's ability to be happy. In commenting on two old friends from the early Junto years, one who constantly fretted in spite of prosperity and another who laughed in the face of poverty, Franklin

maintained that happiness depends upon more than conditions. "It seems, then, that Happiness in this Life rather depends on Internals than Externals," he writes, "and that, besides the natural Effects of Wisdom and Virtue, Vice and Folly, there is such a Thing as being of a happy or an unhappy Constitution" (8:159–60).[32] This does not mean, of course, that we should not seek virtue or do what we can to advance the well-being of humanity. What it means, rather, is that our efforts occur in a system of natural events and human actions that will remain in part unexplained. A further example of Franklin's recognition of the complexity of human happiness can be found in a letter to his Loyalist son, William, in 1784. In the course of this letter, Franklin admits the following: "I ought not to blame you for differing in Sentiment with me in Public Affairs. We are Men, all subject to Errors. Our Opinions are not in our own Power; they are form'd and govern'd much by Circumstances, that are often as inexplicable as they are irresistible . . ." Perhaps this letter is the result of a particularly emotional period for Franklin, who also admits in it that "nothing has ever hurt me so much and affected me with such keen Sensations, as to find myself deserted in my old Age by my only Son . . ." (W9:252).[33] The case of his son points again to the fact that our lives take place as part of the natural and social systems within which we live, where events and actions are neither always favorable nor even always understandable. Happiness remains a complex matter. Still, it is possible—and necessary—to strive on against the limits, whatever they may be, to attain the virtue that would yield happiness.

One final point on the theme of virtue is that, for Franklin, besides being the source of true happiness, virtue is also related to self-interest. One aspect of this relationship was that Franklin viewed vice as a kind of heteronomy; and, by freeing ourselves from "the Domination of Vice" (A:163), we would become better able to recognize and pursue our true interests, and in this way to become more happy. Another aspect of this relationship between virtue and

[32.] Franklin's late bagatelle called "The Handsome and Deformed Leg" suggests a test for determining whether a person has a happy or an unhappy constitution by recognizing in which of the two legs that person is more interested (cf. W8: 162–64).

[33.] My suggestion that this sorrow, while genuine, was a phase is based upon Franklin's more harsh treatment of William in his final Will of 1788 (cf. W10:493–94).

self-interest was that Franklin believed that advancing our true self-interest will not lead to social conflict. It was obvious to him that whatever advanced the common good would advance every individual good; but it was just as obvious that the simple converse—that whatever advanced any individual good would also advance the social good—was not necessarily true.[34]

4.4. Virtues like Industry and Frugality

Franklin is surely less known for his analyses of the nature and importance of virtue than for his numerous calls for industry and frugality. Readers can easily find instances of relevant aphorisms in the *Almanack* and suggestive comments in the *Autobiography*. We must be careful, however, not simply to equate his complete view with these fragments. Even his short listing of virtues, as we saw (above, 4.1), included eleven more. Moreover, we must be careful not unquestioningly to equate his view with some of his more deliberately extreme and humorous formulations.[35]

Two of these formulations were central to Max Weber's evaluation of Franklin that we have seen (above, 1.3). One such piece is his brief "HINTS for those that would be Rich" of 1737, which includes such hints as: "He that loses 5*s.* not only loses that Sum, but all the Advantage that might be made by turning it in Dealing, which by the time that a young Man becomes old, amounts to a comfortable Bag of Money" (2:165). A second example is his longer 1748 essay, "ADVICE TO A YOUNG TRADESMAN, WRITTEN BY AN OLD ONE." This essay begins quickly with a series of admonitions that would have

[34.] Cf. David Levin: "Franklin's faith, then, professes that a true understanding of one's interest even in this world will lead one to virtue. Since the obvious existence of viciousness and folly in every society demonstrates that men do not yet practice the virtues on which most philosophers *have* agreed, finding a way to increase the practice of virtue—the number of virtuous actions—is a sufficiently valuable task to need no elaborate justification" ("The Autobiography of Benjamin Franklin," 271; cf. Pangle and Pangle, *The Learning of Liberty*, 270–71).

[35.] To the criticisms of Franklin that we have encountered already, we can add the following: "remembering of what sort of men were the wise of ancient Greece, can we justly style *a philosopher* such a man as Franklin? The wise men of Greece, heathen though they were, made their aim for the highest good that was possible to human nature. That highest good was virtue. Whatever else that word might include within its meaning, neither wealth nor mere utility was among them . . . With him wealth was both virtue *and* happiness" (R. M. Johnston, "American Philosophy," 99–100).

satisfied Poor Richard at his most pecuniary, like: "Remember that TIME is Money . . . CREDIT is Money . . . Money can beget Money . . ." (3:306). The heart of the essay, however, is Franklin's discussion of the importance of capital to individuals who are embarking on careers in trade, and the necessity for them to secure access to it. Access to capital for the would-be businessman is a practical question. It means first of all the cultivation of good credit, not only *being* a good risk but also taking the necessary efforts to *be recognized as being* one.[36] This latter aspect Franklin emphasizes with the following piece of advice:

> The most trifling Actions that affect a Man's Credit, are to be regarded. The Sound of your Hammer at Five in the Morning or Nine at Night, heard by a Creditor, makes him easy Six Months longer. But if he sees you at a Billiard Table, or hears your Voice in a Tavern, when you should be at Work, he sends for his Money the next Day.

If young entrepreneurs lead lives of "INDUSTRY and FRUGALITY," if they live by the motto "Waste neither Time nor Money, but make the best Use of both," Franklin believed that they will soon be on the road to wealth. As he writes, "the Way to Wealth, if you desire it, is as plain as the Way to Market." Industrious and frugal tradesmen will, with the concurrence of Providence, undoubtedly succeed. Or, as Franklin puts it in a slightly more inflamed version: "He that gets all he can honestly, and saves all he gets (necessary Expences excepted), will certainly become RICH; If that Being who governs the World, to whom all should look for a Blessing on their honest Endeavours, doth not in his wise Providence otherwise determine" (3:307–8; cf. 349–50).

An even more pronounced example of this manic view about the centrality of monetary considerations is the preface to the *Almanack* for 1758, usually referred to as "The Way to Wealth." In this essay, largely a compilation of aphorisms from his earlier almanacs, Franklin presents a purported report on the "Harangue" (7:350) of "a

[36.] The dangers of credit were apparent to Franklin: "Credit is upon the Whole, of more Mischief than Benefit to Mankind" (33:331). Cf. Donald H. Meyer: "Franklin's society was a dangerous place for a young tradesman just starting his career. A person could easily fall into debt and end up in prison or in indentured slavery. Beware of debt, Father Abraham admonished his listeners . . ." (*The Democratic Enlightenment*, 64; cf. John C. Miller, *This New Man, the American*, 490–91).

plain clean old Man, with white Locks" named "Father Abraham" (7:340), who was responding to a question about how to deal with the current high level of taxation. Father Abraham begins his disjointed ramble by emphasizing the impact of the economic burdens, as distinct from taxes, that all citizens voluntarily impose upon themselves: "the Taxes are indeed very heavy, and if those laid on by the Government were the only Ones we had to pay, we might more easily discharge them; but we have many others, and much more grievous to some of us." As examples of these self-imposed 'taxes,' Father Abraham offers the following trio: "We are taxed twice as much by our *Idleness*, three times as much by our *Pride*, and four times as much by our *Folly* . . ." Father Abraham continues with a special emphasis upon the wasting of time. He notes that none would readily tolerate a government that demanded "one tenth Part of their *Time*, to be employed in its Service." Still, he notes, "*Idleness* taxes many of us much more, if we reckon all that is spent in absolute *Sloth*, or doing of nothing, with that which is spent in idle Employments or Amusements, that amount to nothing" (7:341).

At this point, Franklin presents the compilation of economic ideas digested from his earlier almanacs. A representative sample of Father Abraham's continued speech, with the quoted passages italicized as Franklin himself italicized them, runs as follows:

> *dost thou love Life, then do not squander Time, for that's the Stuff Life is made of*, as Poor Richard says . . . What though you have found no Treasure, nor has any rich Relation left you a Legacy, *Diligence is the Mother of Good luck*, as Poor Richard says, and *God gives all Things to Industry*. Then *plough deep, while Sluggards sleep, and you shall have Corn to sell and to keep*, says Poor Dick . . . *One To-day is worth two To-morrows*; and farther, *Have you somewhat to do To-morrow, do it To-day* . . . Leisure, is Time for doing something useful; this Leisure the diligent Man will obtain, but the lazy Man never; so that, as Poor Richard says, a *Life of Leisure and a Life of Laziness are two Things*. (7:341–43)

While there is no question that this essay is extraordinarily creative, surely Franklin is not suggesting that it be followed as an economic policy.[37] Franklin jokes himself that, upon hearing Father Abraham's

[37.] This may be why Weber did not consider "The Way to Wealth" in his discussion of Franklin's ideas, as we saw (above, 1.3).

speech, the people "approved the Doctrine, and immediately prac-
tised the contrary, just as if it had been a common Sermon . . ."
(7:350).[38] There are, of course, hints and suggestions of Franklin's
view to be found beneath the humor of this and the other of his
hyper-pecuniary pieces; but neither it nor they represent the full
range of Franklin's personal ideas on monetary matters. Just as
important to any understanding of Franklin's overall views on
economics are his criticisms of "the general Foible of Mankind, in
the Pursuit of Wealth to no End" and the mistaken goal of "*dying
worth* a great Sum" (3:479).

Any attempt to understand the meaning of Franklin's message on
the relationship of industry and frugality to security and well-being
requires that we first of all locate Franklin within the life of a simple
frontier society that of necessity had to concern itself with building
up the material infrastructure of a society.[39] Here, a level of
enthusiasm for matters economic that might appear later and out of
context as unbalanced seems to make more sense. In *Poor Richard's
Almanack* for 1765, Franklin writes that we must concern ourselves
with a number of virtues. "Righteousness, or *Justice*, is, undoubt-
edly, of all the Virtues, the surest Foundation on which to erect and
establish a new State," he notes. "But there are two humbler Virtues,
Industry and *Frugality*, which tend more to increase the Wealth,
Power and Grandeur of the Community, than all the others without
them" (12:4). Franklin is not ranking industry and frugality over
righteousness—or over the unnamed virtues—on any absolute
scale. He is simply recognizing and advocating that individuals make
the most of their lives within the limitations that circumstances
impose. Some of these limitations are natural, others are political;
these limitations will be addressed when they can be. Other of the
limitations are personal, however, and can be addressed immedi-
ately. Thus, in 1765 he writes: "Idleness and Pride Tax with a heavier
Hand then Kings and Parliaments; If we can get rid of the former we

[38.] Cf. Alfred Owen Aldridge: "*The Way to Wealth* is fundamentally a very
miscellaneous production that Franklin himself never took very seriously, but that
many of his readers loaded with moral significance" (*Franklin and His French
Contemporaries*, 159).

[39.] Cf. Clinton Rossiter: "All that Franklin was trying to tell his fellow
Americans was that first things must be attended to first: When a man had worked
and saved his way to success and independence, he could then begin to live a fuller
or even quite different life" (*Seedtime of the Republic*, 304; cf. John C. Miller, *This
New Man, the American*, 490).

may easily bear the Latter" (12:208).[40] In another example, report-
ing from Paris in 1782 to likely American immigrants, Franklin
writes of the importance of hard work and virtue: "The almost
general Mediocrity of Fortune that prevails in America obliging its
People to follow some Business for subsistence, those Vices, that
arise usually from Idleness, are in a great measure prevented"
(W8:613). It is thus within this social situation—and not within the
more comfortable world of later critics—that Franklin's advice
about industry and frugality must be understood. He was writing to
individuals like himself, who were starting from scratch, without the
benefits of social status or inheritance, and attempting to rise by their
own personal diligence.[41] He was at the same time communicating
to the residents (and future residents) of a young country the gospel,
later chronicled by Frederick Jackson Turner,[42] that this is a land
where nothing is given to anyone and where individuals' efforts will
pay off. In this "Land of Labour" (W8:607), people succeed for the
most part of their own efforts.

Industry and frugality are virtues that support each other.[43] They
are not ends in themselves, but rather means essential to progress.[44]
They are, moreover, virtues that humankind in general recognizes.
While individuals may fall victim to sloth and luxury, he writes,
"there seems to be in every Nation a greater Proportion of Industry
and Frugality, which tend to enrich, than of Idleness and Prodigali-

[40] This theme became even more pronounced, as we shall see (below, 5.1) as the
British defenses of their mercantilist policies brought the American colonists into
deeper economic conflicts with London.

[41] See his reminders of this reality to his daughter, Sally, regarding her marriage
to Richard Bache: "By Industry and Frugality you may get forward in the World,
being both of you yet young. And then what we may leave you at our Deaths may be
a pretty Addition, tho' of itself far from sufficient to maintain and bring up a
Family" (19:46; cf. 14:193–94, 220–21; 19:47).

[42] Cf. Turner, *The Frontier in American History*.

[43] Cf. Joseph Lathrop [1786]: "Industry and *frugality* are kindred virtues and
similar in their principles and effects. They ought always to accompany each other
and go hand in hand, for neither without the other can be a virtue, or answer any
valuable purpose to the individual or to society. He that is laborious only that he
may have the means of extravagance and profuseness; and he that is parsimonious
only that he may live in laziness and indolence, are alike remote from virtue"
("Frugality," 663; cf. Lathrop, "A Sermon on a Day Appointed for Public
Thanksgiving," 876).

[44] Cf. Whitfield J. Bell: "Neither in *Poor Richard*, nor in his own conduct, did
Franklin regard thrift and industry as desirable in themselves" ("Benjamin Franklin
as an American Hero," 128).

ty, which occasion Poverty . . . " (W10:121; cf. W9:247–48). As we have seen (above, 4.1), Franklin describes the virtue of industry as follows: "Lose no Time. Be always employ'd in something useful. Cut off all unnecessary Actions" (A:149). In the *Almanack* for 1751, he expands on this virtue:

> the Industrious know how to employ every Piece of Time to a real Advantage in their different Professions: And he that is prodigal of his Hours, is, in Effect, a Squanderer of Money . . . If we lose our Money, it gives us some Concern. If we are cheated or robb'd of it, we are angry: But Money lost may be found; what we are robb'd of may be restored: The Treasure of Time once lost, can never be recovered . . . (4:86–87)[45]

This admonition to remain busy and focussed meant recognizing that in his America the commitment to extraordinary levels of hard work had to become ordinary. This focus was also to be found in Franklin's condemnation of 'get-rich-quick' schemes that usurp long-term diligence (cf. 1:100, 136–39). Americans must recognize that while it is true that there is in human nature a "proneness . . . to a life of ease, of freedom from care and labour . . ." (4:481), it is also true that "when Men are employ'd they are best contented" (A:234).[46] In times of employment, they are also for the most part improving their condition.

Its companion virtue, frugality, meant to Franklin attempting to resist the incursions of luxury that continued industry makes possible and to live as simply as possible. While he grants that the pursuit of luxury may at times serve a positive function—"Is not the Hope of one day being able to purchase and enjoy Luxuries a great Spur to Labour and Industry?" (W9:243)—in general, his focus is upon living a simple life. Franklin at times formulates this viewpoint as follows: *"How many things there are in the World that I don't want!"* (18:210). In another formulation, Poor Richard suggests

[45.] Franklin's concern with saving time was connected with his plan for saving daylight (cf. A:207; W9:183–89; Marcus M. Marks, "Franklin, the Father of Daylight Saving"; Fischer, *Albion's Seed*, 158–62).

[46.] Cf. Harold A. Larrabee: "Franklin's problem as a moralist was that of maintaining enough tension to keep men hard at work in their daily callings without a belief in the traditional theological rewards and punishments, and without succumbing to the lure of selfish greed. His own motivation was a fusion of scientific curiosity, love of conversation, and unabashed humanitarianism" ("Poor Richard in an Age of Plenty," 67).

delaying the purchase of an unnecessary item: "I would not be so hard with you, as to insist on your absolutely *resolving against it*; all I advise, is, to *put it off* (as you do your Repentance) *till another Year* . . ." (6:323). As Franklin described frugality in his list of thirteen virtues, it means: "Make no Expence but to do good to others or yourself: i.e. Waste nothing" (A:149). He offers as a breakfast-table instance of creeping luxury Deborah's replacement of what he maintains was a perfectly adequate "twopenny earthen Porringer with a Pewter Spoon" with her unnecessary present of "a China Bowl with a Spoon of Silver" (A:145). More serious is his admonition from London in 1771 in support of nonimportation that the colonists recognize "all they save in refusing to purchase foreign Gewgaws, and in making their own Apparel . . ." (18:81). Far more serious are his many condemnations from France during the Revolutionary War. "The extravagant Luxury of our Country in the midst of all its Distresses," he writes, "is to me amazing . . . much the greatest part of the Congress Interest Bills come to pay for Tea, and a great Part of the Remainder is order'd to be laid out in Gewgaws and Superfluities" (30:471).[47]

While there still remain some difficulties in interpreting Franklin's moral thinking, especially with regard to lingering suspicions of his sincerity,[48] our understanding can perhaps be advanced by a consideration of his analysis of the public realm and of the citizens' role of public service. While the advice contained in the various manic formulations that we have been considering admittedly focusses on the value and methods of getting rich, still the purpose of this striving for economic well-being was not the amassing of a limitless fortune to fund a life of private excess.[49] It was, rather, attaining the level of personal security that would make possible a

[47.] Cf. 29:96, 132, 359, 614–15; 30:598–99; 31:73–75; 32:572.

[48.] Cf. Elizabeth Flower: "In the light of today's cynicism, it is difficult to accept the fact that Franklin's morality was not hypocritical. We are still too close to an era of moralistic apologetics for economic ruthlessness to see the difference between Franklin and Horatio Alger. But the difference is there . . ." (Flower and Murphey, *A History of Philosophy in America*, 1:112–13).

[49.] Cf. Perry Miller: Franklin's plan was "a far remove from the schemes of the normal aspirant for success in the American system, who works in his calling in order eventually to make some sort of splurge, in a mansion, yacht, collection of paintings or of race horses. Franklin put the benefit of mankind in the place of the Puritan's glory of God; thus he could move at ease from Calvinism into the Enlightenment" ("Benjamin Franklin, Jonathan Edwards," 87; cf. Pangle and Pangle, *The Learning of Liberty*, 268).

higher level of social service. As he writes of himself, "I would rather have it said, *He lived usefully*, than, *He died Rich*" (3:475; cf. 479).[50] We find a similar spirit of service in his request written from France in 1783, after seven years abroad on his French mission and at the age of seventy-seven, that he be replaced: "if the Congress shall think my continuing here necessary for the public Service, I ought, as a good Citizen, to submit to their Judgment and Pleasure . . ." (W9:141). While a return to private life where he might take up again his researches in natural philosophy was more attractive, duty remained more important. Thus, his moral thought attempts to connect up, by assumptions about the nature of the public realm, the individual life of discipline and duty with the practical possibilities of cooperative social advance.

We have already seen two central instances of the importance of Franklin's theme of beneficence: the nature of the cooperative scientific endeavor to advance the common good (above, 2.4) and his conception of Divine worship to be properly service to others (above, 3.4). To these two we can now add another. This new instance of beneficence is Franklin's conception of our natural debt as contained in his question from the *Almanack* of 1737: "The noblest question in the world is *What Good may I do in it?*" (2:171). As he demonstrates when he writes to his wife in 1765, there is often a religious current to his view:

> God is very good to us both in many Respects. Let us enjoy his Favours with a thankful and chearful Heart; and, as we can make no direct Return to him, show our Sense of his Goodness to us, by continuing to do Good to our Fellow Creatures, without Regarding the Returns they make us, whether Good or Bad. For they are all his Children . . . (12:169)

At other times, Franklin's view about passing on goods that we have received is equally naturalistic or secular:

[50.] Cf. William S. Hanna: "Some of his beliefs are expressed in the personal maxims, the ways of wealth, and the hints on self-improvement that seem to form his philosophy of the successful life and are the despair of those who seek in his writings some philosophical profundity comparable to that of his great contemporary Jonathan Edwards. While these simplistic, 'Poor Richard' formulas appear shallow and superficial, they were in fact only means he devised in an attempt to reach the higher goals of service to mankind, the increase and dissemination of knowledge, and the improvement of the physical and moral conditions in society" (*Benjamin Franklin and Pennsylvania Politics*, 29–30; cf. Conkin, *Puritans and Pragmatists*, 100–101).

when I am employed in serving others, I do not look upon myself as conferring Favours, but as paying Debts . . . I have received much Kindness from Men, to whom I shall never have any Opportunity of making the least direct Return. And numberless Mercies from God, who is infinitely above being benefited by our Services. These Kindnesses from Men, I can therefore only return to their Fellow-Men; and I can only show my Gratitude for those Mercies from God, by a Readiness to help his other Children and my Brethren. (4:504–5)

As a specific example of this latter spirit, we can consider the following. After giving an unfortunate man a loan in 1784, Franklin instructed that the recipient should not expect to repay *him* personally. Rather, after the borrower is back on his feet, Franklin writes, "when you meet with another honest Man in similar Distress, you must pay me by lending this Sum to him; enjoining him to discharge the Debt by a like operation, when he shall be able, and shall meet with such another opportunity" (W9:197).[51] Through such service, individuals can repay in part some of the kindnesses and mercies that they have received from their fellows and from God. Franklin believed that we will be able to do this if we have been good stewards of what we have received, if we have worked with diligence and used only what we needed.

4.5. A Puritan Morality?

I have suggested (above, 3.1) that Franklin was, at least theologically, no Puritan. By this I meant that his positions on such topics as God, human nature, and the road to salvation were clearly outside the Calvinist tradition. I also suggested (above, 3.3) that if Franklin is to wear any religious label at all, it must be that of a Deist. Undecided in that consideration of religion, however, was the question of whether it might still be accurate to characterize Franklin's moral thought as Puritan. On the most direct level, numerous commentators have

[51.] Cf. W8:299. In a codicil to his will of 1789, Franklin gave £1000 each to the cities of Boston and Philadelphia to be loaned out "to assist young married artificers in setting up their business . . ." Franklin's reasoning behind this sort of bequest was to demonstrate to the inhabitants of the two cities "a mark of my good will, a token of my gratitude, and a testimony of my earnest desire to be useful to them after my departure" (W10:504, 507).

maintained that the moral earnestness, discipline, and (perhaps) severity present in Franklin—as we have just seen in our consideration of industry and frugality—demonstrate his roots in Puritanism. Many of them carry the point further, often suggesting that Franklin offers a Puritan ethics. Elaborating and evaluating this issue is what will engage us in this section.

We can begin with a representative sample of such evaluations from the last six decades or so presented in chronological order. Paul R. Anderson views Franklin's emphasis upon discipline as "largely attributable to his Puritan background." The role that this background plays, Anderson continues, is to offer a realistic counterbalance to Franklin's dreams of human progress. "Although influenced strongly by the prophets of the Age of Reason who emphasized the essential goodness of man, Franklin never lost sight of man's tendency toward evil." In the words of Henry Steele Commager, "in a Franklin could be merged the virtues of Puritanism without its defects . . ." For Stow Persons, Franklin's thirteen virtues "were the virtues of the Puritan ethic, now stripped of their theological trappings." Perry Miller puts it this way: "This child of New England Puritanism simply dumped the whole theological preoccupation overboard; but, not in the slightest ceasing to be a Puritan, he went about his business." For David Levin, "[w]e see the Puritan influence in [Franklin's] insistence on frugality, simplicity, and utility as standards of value; and we see it just as clearly in his acceptance of public duty, his constant effort to improve the community, his willingness at last to serve the local and international community without pay." Finally, Larzer Ziff writes that "Benjamin Franklin's *Autobiography* is the record of what Puritan habits detached from Puritan beliefs were capable of achieving in the eighteenth-century world of affairs . . . Morality replaced piety for Franklin . . ."[52]

These, and the similar comments we have encountered (above, 3.1), suggest that whatever Franklin's theological position, it is initially quite plausible to characterize Franklin as an 'ethical' or 'moral' Puritan. I believe, however, that we need to consider this characterization more carefully. It is one thing to discuss the

[52] Anderson and Fisch, *Philosophy in America*, 125; Commager, *The American Mind*, 26; Persons, *American Minds*, 80; Miller, "Benjamin Franklin, Jonathan Edwards," 86; Levin, "The Autobiography of Benjamin Franklin," 262; Ziff, *Puritanism in America*, 218.

theologically-grounded ethics of a Puritan; it is something else to present those ethics ungrounded as still being 'Puritan.' Are Franklin's Puritan roots just biographical, or is there something remaining in his presumptive 'Puritan' ethic that is of philosophic interest? The problem here is twofold. On the one hand, we need to consider whether it is really possible to extract the theological core of Puritanism, leaving only its moral manifestations in behavior. In other words, is it possible to successfully naturalize the Puritans' driving notions like work, guilt, sin, and salvation in such a way that they still remain 'Puritan'? On the other hand, if we assume that this naturalizing of Puritan morality is possible, we need to consider whether it is accurate to continue to characterize the resultant product as narrowly 'Puritan.' Keeping in mind his long career in Philadelphia, would it not be equally sensible to characterize Franklin's ethics as 'Quaker'?[53] Or perhaps we would be better off following Weber and characterizing Franklin's ethical perspective as 'Protestant.' I am much more partial to analyzing Franklin's ethics as Pragmatic. On the assumption, however, that there might be something important about Franklin's moral thought that is essentially related to Puritanism, we should consider in more detail one further response to this question.

One important philosophical commentator who long studied the topic of Franklin's moral thought was Herbert W. Schneider, and he returned to it in writing on a number of occasions. In Schneider's view, Franklin was a Puritan, but an "ungodly" one. "In his austere moralism," he writes, "Franklin was undoubtedly a Puritan, however much he may have revolted against Calvinism." For Schneider, moreover, the key element in being a Puritan was not theological but moral. The issue that needed to be settled in the context of late Puritanism in America was the adoption of a moral criterion; and what he saw in Franklin's "attempt to maintain the Puritan virtues in all their rigor, but to abandon entirely their theological sanctions" was the desire to place "the frontier morality on a utilitarian footing" and

[53.] Cf. John Stephenson Rowntree: "Is it merely a *coincidence*, or is it a *consequence*, that the lofty profession of spirituality made by the Friends has gone hand in hand with shrewdness and tact in the transaction of mundane affairs? Real piety favours the success of a trader by insuring his integrity, and fostering habits of prudence and forethought—important ideas in obtaining that standing and credit in the commercial world, which are requisite for the steady accumulation of wealth" (*Quakerism, Past and Present*, 95–96; cf. Tolles, *Meeting House and Counting House*, 45–62, 247–50; John T. McNeill, *Modern Christian Movements*, 39).

to give it "empirical foundations."[54] Schneider writes that the necessity for this conversion to naturalism was environmental.

> The real basis of Benjamin Franklin's ethics is empirical and can be found in the facts of life in Puritan New England. Recent historical writings have emphasized the importance of frontier conditions in the development of American life. No where is this more evident than in early New England, where the colonists were face to face with a most difficult situation.

In this heretical fashion, Schneider continues: "The New Englanders were forced to be Puritans because of their desire to build a New England, not, as is commonly supposed, because of their Calvinism."[55] In other words, they were compelled by the severity of their situation to adopt a stance of severe industry and frugality, a stance that they then cloaked in familiar theological terms. Schneider is thus attempting to undercut the theological seriousness of much of our thinking about Puritanism while still keeping the name to describe the moral system.

Schneider recognizes, of course, that philosophers often prefer that issues be more complicated. "Philosophers are offended by the simplicity, almost simpleness, of [Franklin's] morality," he writes. "Surely there can be nothing profound in a doctrine which a Pennsylvania farmer could understand."[56] Schneider continues with regard to the thirteen virtues:

> In its naive simplicity this hardly seems worthy of study as a philosophy. It makes no pretense of being founded on a cosmology, a metaphysics, a theory of knowledge, or an analysis of human nature. It is derived merely from the experience of an ordinary business man, and yet as a moral regime and an outline of "the art of virtue," it has a clarity and a power that command respect and study.

In his focus upon the primacy of consequences, Franklin recognizes that virtues were necessary and vices were to be avoided; and he

[54.] Schneider, *The Puritan Mind*, 237, 255, 241.

[55.] Schneider, "The Significance of Benjamin Franklin's Moral Philosophy," 300–301.

[56.] Schneider, *The Puritan Mind*, 246. Cf. Norman S. Fiering: "Historians have been content to talk vaguely of the moral legacy of Puritanism, which in fact has almost nothing to do with Franklin's work in ethics, and philosophers have ignored it as beneath consideration" ("Benjamin Franklin and the Way to Virtue," 200).

persisted in the belief that no further theological justification was required. As Schneider puts it, "for a human being good and evil must be relative to a human point of view." Rather than interpreting morality through a theological lens, Schneider writes, "he treated virtues and vices in their own terms, as elements of human experience, as facts to be understood and estimated in terms of their relations to the rest of life." This shift is, moreover, not to be viewed as a compromise or a 'declension' but rather as a positive achievement that focusses ethical concerns directly on human conduct. Schneider continues: "The freedom of this morality from 'entangling alliances' with cosmology, psychology, and epistemology is in itself a philosophic achievement, and its detachment from the speculative dispositions of the time was deliberate."[57]

Schneider is unconvinced by those who suggest that Franklin's ethics is "merely instrumental; that it converts means into ends," or who would view Franklin as "merely a typical American business man who, without stopping to evaluate, simply adopts the business principles of thrift for thrift's sake, money for money's sake, the more the better."[58] For Schneider, on the contrary, "Franklin was not interested in establishing his puritanic discipline as an end in

[57.] Schneider, "The Significance of Benjamin Franklin's Moral Philosophy," 297–300. Cf. Adrienne Koch: "His morality, like his science, deliberately cuts free of metaphysics and theology by urging concentration, not on abstract thought or ideal virtue, but on human deeds and their consequences for good or evil . . . Franklin's wisdom in steering clear of the demand for metaphysical or theological agreement or truth, the most elusive of all age-old quests, is shown by his recommendation of procedures that can issue in agreements, concentrating on the increase of agreement by a common method of negotiation to meet common ends . . . Mind the *consequences in experience* of human action, rather than the assumed antecedent metaphysical, theological, or even epistemological premises, is the burden of his enlightened moral advice" (*Power, Morals, and the Founding Fathers*, 16–17; cf. Weintraub, "The Puritan Ethic and Benjamin Franklin," 233; Anderson and Fisch, *Philosophy in America*, 128.

[58.] Schneider, "The Significance of Benjamin Franklin's Moral Philosophy," 305; *The Puritan Mind*, 248–49. Cf. Charles William Eliot: "The moral philosophy of Franklin consisted almost exclusively in the inculcation of certain very practical and unimaginative virtues, such as temperance, frugality, industry, moderation, cleanliness, and tranquillity . . . all his moral precepts seem to be based on observation and experience of life, and to express his convictions concerning what is profitable, prudent, and on the whole satisfactory in the life that now is . . . Nevertheless, it omits all consideration of the prime motive power, which must impel to right conduct, as fire supplies the power which actuates the engine. That motive power is pure, unselfish love—love to God and love to man" (*Four American Leaders*, 28–29).

itself." Throughout his writing Franklin makes it clear that he recognized that individuals already have myriad ends of their own. They want a comfortable home and a good education for their children, a place of respect within the community; and Schneider continues that in this context these individuals understand wealth, for example, "as merely the necessary means for enjoying the real ends of leisure society." Schneider thus sees Franklin's ethics not as rejecting the importance of ends but as shifting the discussion to means as an instrumental counterbalance to the traditional focus of Western ethics upon ends, especially in their ideal form. "To discuss means is as legitimate in moral philosophy as to discuss ends," he writes. There is no necessary reason why "Greek virtues"—"balance, wisdom, beauty, and the rest"—are matters of moral import, but "Franklin's virtues"—"frugality, industry, sincerity, honesty, and the rest"—are not.[59]

As Schneider recognizes, Franklin talks about ends as well, as in his famous passage: "Early to bed and early to rise, makes a man healthy wealthy and wise" (2:9). Schneider continues: "Health, wealth, and wisdom—this combination is not a bad summary of the natural goods of human life. But none of them occurs in Franklin's table of virtues, which is concerned exclusively with the 'early to bed and early to rise' side of life." Thus while Franklin and his correspondents may occasionally mention ends, neither he nor they felt any need to discuss them too carefully. As Schneider notes, "the time and circumstances in which Franklin lived . . . made the problem of means exceedingly urgent; the ends were fairly obvious. At another time and under other circumstances the wisdom of Franklin might be taken for granted and criticism devoted to ends."[60] Franklin is thus not conflating means with ends; he is, rather, telling us that in his situation we need to focus primarily on the means to build a good society and increase human well-being. "If you want to achieve anything, these old-fashioned Puritan virtues are the necessary means: temperance, silence, order, resolution, frugality, indus-

[59.] Schneider, *A History of American Philosophy*, 35–36; "The Significance of Benjamin Franklin's Moral Philosophy," 307. Cf. Donald H. Meyer: "Franklin was not concerned here with ultimate goals but with what John Dewey calls instrumental ends. He was saying, in effect: 'Define "virtue" as you will; here is a practical way to go about the business of self-improvement, however you measure it'" (*The Democratic Enlightenment*, 68; Larrabee, "Poor Richard in the Age of Plenty," 66).

[60.] Schneider, *A History of American Philosophy*, 36; "The Significance of Benjamin Franklin's Moral Philosophy," 311.

try, sincerity, justice, etc.," Schneider writes. "And if you ask for proof, Franklin could point to his own experience and to the colonies themselves as evidence." Franklin is thus not suggesting that we substitute instrumental virtues like industry and frugality, for example, for beauty and wisdom; his goal is not, Schneider continues, to replace "Aristotelian ethics" with "bourgeois commercialism." Franklin's position is not a challenge to ends at all, but rather a challenge to the virtues that functioned as means in traditional Christian ethics. Schneider writes:

> If the Franklin morality substitutes for anything, it is for the traditional Christian virtues, for they, too, constitute a philosophy of the discipline of life. The Christian life is traditionally portrayed as one of humility, charity, penitence, poverty, self-denial, a forgiving spirit. These are obviously instrumental virtues and not ideal perfections, for they disappear in heaven. This traditional code of the feudal ages proved ill-adapted to the pioneer life in New England.[61]

For the early New Englanders, creating their new home in the wilds of America, the virtues that were more appropriate all involved the practical aspects of living.

Schneider stresses, of course, the importance of Franklin's emphasis upon discipline. He saw in Franklin's work the realization that "the liberal theologians and the city churches were relaxing from the gospel of work and discipline which the Puritans had preached during the generations of strenuous building, and were becoming acclimated to the habits of luxury and leisure." For Franklin, it was clear that "[t]he spirit of work was giving way to the theology of having arrived . . . ,"[62] Schneider maintains; and it was to this creeping sloth and luxury that Franklin's 'Puritan' discipline was addressed. Through industry and frugality, it would be possible to continue to progress; without them, stagnation and decline were assured. It is important to emphasize that Schneider sees this Puritan

[61.] Schneider, *The Puritan Mind*, 241, 253–54.

[62.] Schneider, *The Puritan Mind*, 240–41. Cf. John C. Miller: "just when Puritanism seemed to be losing its hold, along came Benjamin Franklin to remind Americans that time was money. Through Franklin, more than through any other single individual, Puritan morality entered the mainstream of American life and thought. Generations of Americans who had lost the religious zeal of the founding fathers discovered in Franklin's writings a new and compelling sanction for adopting the Puritan way of life" (*This New Man, the American*, 491).

emphasis upon discipline as badly misunderstood if it is divorced from Franklin's focus upon the common good and filtered instead through nineteenth-century individualism and then seen merely as the means of individual advance. He notes sadly that many of Franklin's presumed followers lost sight of his benevolence and refashioned his virtues "into the stuff of unbridled competition and sordid business."[63]

Thus, we can understand Schneider's position that while Franklin's approach to ethics "is usually scorned and spurned by philosophers as mere journalism, popular precepts, empirical maxims, unworthy of philosophic dignity," it should rather be seen as "a significant achievement in ethical theory" and "basic in American moral traditions."[64] Still, some questions remain to be answered, even under Schneider's analysis. The first of these is to determine whether, in his desire to present what he sees as the values of Franklin's moral thought, Schneider goes too far in downplaying the consideration of ends. Consider Schneider's following comment:

> Final values, being taken for granted, seldom become consciously defined and discussed, for in America (and elsewhere too for that matter) ends are adopted early and easily, much as religions are adopted by children; they are taken for granted as part of the intellectual environment and there seldom arises an occasion for criticizing them seriously.[65]

While the fact that an intellectual climate provides little incentive for the evaluation of a society's ends may be a good historical reason for understanding why little evaluation takes place, from a philosophical perspective it tells us little. It is the job of philosophy to foster critical distance from the society's intellectual climate, and a major portion of the job of ethics is the criticism of inherited moral values. Schneider is simply wrong in suggesting that there is ever a time free from evaluation. Moreover, Schneider is also wrong in not giving

[63] Schneider, *A History of American Philosophy*, 36. Cf. Harold A. Larrabee: "Franklin became the patron saint of American business in the eyes of those who, unfortunately, could not see beyond his instrumentalist ethics to the humane ends which he had in view . . ." ("Naturalism in America," 331).
[64] Schneider, "The Significance of Benjamin Franklin's Moral Philosophy," 294.
[65] Schneider, "The Significance of Benjamin Franklin's Moral Philosophy," 304.

Franklin full credit here for his efforts to foster evaluation. Franklin spent a good deal of time, as we have repeatedly seen, criticizing the customary ends of his society. In chapter 5, we will see more, especially his emphases upon expanding the common good and democracy. (We will also see some areas, like those related to his society's fundamental weakness with regard to equality, especially related to the native population and imported slaves, where Franklin should have been more critical.)

A second question is whether it is still valuable to discuss Franklin, whom Schneider describes as an "embodiment of secularized humanitarianism,"[66] as a Puritan. For Schneider, the Puritans had to become Calvinists to survive. Certainly Franklin had Puritan roots. Certainly he was a moralist who emphasized virtues close to the heart of the Puritans. But these same virtues had proponents well beyond the realm of Calvinism, and Franklin was never a captive to his roots. Franklin was a naturalist, for whom happiness in life was an end in itself; and, to me, it seems much more valuable to emphasize Franklin's connections with other practical-minded moral thinkers for whom, unlike the Puritans, a social and naturalistic conception of human well-being was the central interest. My suggestion would be, rather, that Franklin be grouped among the Pragmatists.[67] Readers, of course, will need to decide for themselves the issue of Franklin's Puritan ethics and, more importantly the value of Franklin's moral thought.

[66.] Schneider, *A History of American Philosophy*, 34.

[67.] Cf. Donald H. Meyer: "Virtue is not an ornament of nobility but an ennobling of the common life. The way to promote virtue, Franklin found, is not to hold forth a high ideal, nor to preach endless sermons, but to begin with life as it is, seek out what is potentially good and fine in it, and cultivate these qualities . . . Franklin helped establish an ethical tradition in America that was to have its culmination in pragmatism" (*The Democratic Enlightenment*, 72).

CHAPTER 5

Franklin's Vision of the Social Good

I N THE *ALMANACK* for 1743, we find Poor Richard commenting: "Experience keeps a dear school, yet Fools will learn in no other" (2:373). If this is so—and I have no reason to assume that it is not— it is a fair question to ask whether any of us can completely avoid the characterization of 'fool.' Certainly Franklin learned a great deal from his public experience. Now that we have considered aspects of his understanding of science, religion, and ethics, in this chapter we will move into the political realm. In this brief consideration of Franklin's political thought, I do not want to consider, except incidentally, his career as a political figure for a half-century, from the time he 'retired' in 1748 until he stepped down from the Presidency of Pennsylvania in 1788.[1] My focus will be rather upon trying to extract from his writings, seen in their political context, some sense of his vision of the social good and the means for its attainment. The themes to be considered in this chapter are five in number. The first is Franklin's understanding of the relationship between Britain and the American colonies, especially as this relationship soured into the American Revolution. Second, we will examine his recognition of the need for unification and his various calls for the creation of political structures to institutionalize it. Our third theme will be a consideration of his advocacy of various procedures of democracy—dialogue, social reason, education—to advance the common good. The next topic is a consideration of Franklin's vision of the good life that explores his ideas on agriculture, commerce, economics, and so on. Finally, we shall consider some of the wrinkles in his democratic perspective, especially as they

[1.] Nor do I want to consider, again except incidentally, his advice to various political practitioners, for example, such comments as his suggestion to proposers of public projects to stay "out of sight" (A:143).

are illuminated under the searching light of equality. In this consideration of his social vision, his Pragmatic spirit will be prominent.

5.1. Britain and America

When Franklin was born in Boston in 1706, the future United States was a series of colonial outposts of less than 400,000 individuals clinging to the seashore and riverbanks of a section of North America and looking eastward to Britain for a source of meaning. When he died in Philadelphia in 1790, the United States was an independent country with a population of over four million, with its eye turned toward Westward expansion. Increasingly there grew during his lifetime a sense that America and Americans represented a new beginning, an experiment in democracy and freedom and equality.[2] This sense of American and its possibilities grew in Franklin as well.

When Franklin was a young man, he saw Great Britain and America as continuous sections of a broad fabric. He writes, for example, in his *Pennsylvania Gazette* in 1729 that England could be proud of the fact that "her SONS in the remotest Part of the Earth, and even to the third and fourth Descent, still retain that ardent Spirit of Liberty, and that undaunted Courage in the Defence of it, which has in every Age so gloriously distinguished BRITONS and ENGLISHMEN from all the Rest of Mankind" (1:161; cf. 8:356). This sense of identification continues in his 1754 comment that "the people of Great Britain and the people of the Colonies" should recognize that they constitute "one Community with one Interest" (5:449–50). It is found as well a decade later when he writes that "[t]he people of England and America are the same; one King, and one law; and those who endeavour to promote a distinction, are truly enemies of both" (12:120). Even as late as 1770, Franklin maintains that the American colonists "love and honour the name of English-

[2] Cf. Bruce E. Johansen: "Several generations had been born in the new land. The English were becoming, by stages, 'Americans'—a word that had been reserved for Indians . . . a group of colonies occupied by transplanted Europeans were beginning to develop a new sense of themselves; a sense that they were not solely European, but American as well . . . It would be a nation that combined the heritages of two continents—that of Europe, their ancestral home, and America, the new home in which their experiment would be given form and expression" (*Forgotten Founders*, 34, 55).

man"; and, before the recent round of troubles that had been
inflicted upon them by shortsighted British policies, "they had no
desire of breaking the connection between the two countries . . ."
(17:268–69; cf. 20:389).

Moreover, throughout most of his life, Franklin considered
himself to be at least as 'British' as he was 'American.' In 1760, living
in London, he writes to Lord Kames of his joy at "the Reduction of
Canada" brought about by the defeat of the French in Québec the
year before. Franklin rejoices, moreover, "not merely as I am a
Colonist, but as I am a Briton." His imperial convictions are obvious
as he continues: "I have long been of Opinion, that the Foundations
of the future Grandeur and Stability of the British Empire, lie in
America; and tho', like other Foundations, they are low and little
seen, they are nevertheless, broad and Strong enough to support the
greatest Political Structure Human Wisdom ever yet erected"
(9:6–7). Speaking more as a Briton than a colonist, Franklin
continues in the "Canada Pamphlet": "Our North American colo-
nies are to be considered as the frontier of the British Empire on that
side"; and, with Canada in British hands, "our people in America
will increase amazingly . . . doubling their numbers every twenty
five years by natural generation only, exclusive of the accession of
foreigners." With that rate of population growth in America,
Franklin sees the strong likelihood that in another century "the
number of British subjects on that side the water [would be] more
numerous than they now are on this . . ." (9:74, 77). Allowing only
for his recent relocation from Philadelphia to London, these com-
ments match exactly with his earlier position in *Observations Con-
cerning the Increase of Mankind* of 1751: there are "now upwards of
One Million English Souls in North-America . . . This Million
doubling, suppose but once in 25 Years, will in another Century be
more than the People of England, and the greatest Number of
Englishmen will be on this Side the Water" (4:233).[3] And the theme
of both of these pieces is that Great Britain, rather than seeing itself
somehow outdone or superseded should rejoice in its own advance
through the growth of British America (cf. 9:79). British America's
growth and well-being would be Britain's imperial advance.

One further indication of Franklin's sense of the identity of
interests between America and Britain is his frequent and uncon-

[3.] Cf. 4:121; 23:119; Lewis J. Carey, *Franklin's Economic Views*, 46–60.

scious use of 'home' to refer to England.[4] He writes, for example, of the difficulties that arise when colonial legislation and proposals must be submitted for approval 'at home.'[5] Later, on the eve of his trip from Philadelphia in 1757 as an agent of the Pennsylvania Assembly to challenge the proprietary powers of the Penn family, Franklin describes his commission as having been "order'd home to England" (7:136). After his return to Philadelphia following a stay of over five years in England, he writes back to his successor, Richard Jackson, that the colonies—lacking in organization and the spirit of cooperation—will remain weak until the British government takes "some Measures at home to unite us" (10:405). Back in London in 1765 to continue his agency for Pennsylvania, he writes to Philadelphia complaining of the Proprietors' failure to have "sent their Laws home [i.e. to Britain] as they ought to have done" (12:207). In early 1770, as tensions were increasing between Britain and America, Franklin—this time, very self-consciously—writes in a piece in the English press that Americans had long sent "their Children home (for that was the affectionate Term they always used when speaking of England) for Education" (17:59).[6] Thereafter, however, this use of 'home' to refer to Britain virtually disappears.[7] The concept now contracts to allow for only private and American uses. He writes to his son, William, for example, in January 1772 that if he were to return to America "it is not probable that being once at home I should ever again see England" (19:53). In the course of that year, he writes to others of his "Longing for home" and of his plans "to return home this summer" (19:91, 104; cf. 259). On 6 October 1773, still in London, he wrote to Deborah that the concerns of age and health made him anxious to return so he could be "where I would chuse to die—at home" in America (20:436).

This troubled mood of a homesick American patriot was far

4. Such references to Britain as 'home' were part of normal colonial discourse. See some uses by others reprinted in: 7:109; 11:405, 477–78; 12:261; 17:276.

5. Cf. 1:157; 4:131; 5:454.

6. Franklin on occasion had used 'home' to refer to America in contrast to England in his public writing (cf. e.g. 3:386; 4:35); and he had, of course, always used 'home' in his personal correspondence, as when he writes to Deborah in October of 1768 about his failure to have come 'home' from England (15:223).

7. One later contrary instance when he uses 'home' to refer to Britain is in a discussion of Governor Thomas Hutchinson of Massachusetts in 1773. In this case, however, Franklin might have been referring to England deliberately as the unpopular governor's proper 'home' (cf. 20:439).

different from his intentions a decade earlier when Franklin was planning to make England literally his 'home.' At that point, he had been living at the center of the empire for over five years—from mid-1757 to mid-1762[8]—and he found the location and the companionship to his liking. As he was setting out on his return to America in August of 1762, he writes to William Strahan: "I shall probably make but this one Vibration and settle here [i.e. in England] for ever. Nothing will prevent it, if I can, as I hope I can, prevail with Mrs. F. to accompany me . . ." (10:149). Back in Philadelphia, he writes again to Strahan in December of that year: "In two Years at farthest I hope to settle all my Affairs in such a Manner, as that I *may* then conveniently remove to England, provided we can persuade the good Woman to cross the Seas" (10:169).[9] Recognizing, however, that because of Deborah's continued refusal that condition would never be satisfied, and perhaps with a certain amount of personal reluctance to move to England, he writes to Polly Stevenson on 14 March 1764, "*old Trees cannot safely be transplanted*" (11:110). Soon after this apparent resignation to his American fate, however, Franklin became embroiled in an increasingly nasty political campaign against the proprietary party; and, writing to Strahan in September of that year, he suggests that if he were to lose his seat in the Pennsylvania Assembly he would become "a Londoner for the rest of my Days" (11:332). Franklin, as it turned out, did lose his seat and he did find himself, as anticipated without Deborah, back 'home' in London before the end of 1764 in his familiar role as agent of the Pennsylvania Assembly.

The depth of the feeling that Franklin had for the British Empire and America's place within it can be seen in his comments on Britain's favorable conclusion of the French and Indian War. He writes in 1763 that "in America she has laid a broad and strong Foundation on which to erect the most beneficial and certain Commerce, with the Greatness and Stability of her Empire." Franklin continues: "The Glory of Britain was never higher than at present, and I think you never had a better Prince . . ." (10:302). To his mind what held this empire together was its constitutional system, focused on the monarch; and he had long been deeply

[8.] Franklin had earlier lived in England from December 1724 to July 1726, and was to return for over a decade, from December 1764 to March 1775.

[9.] Cf. 10:237, 401, 406–7.

enamored of both. As he wrote to the governor of Massachusetts in 1754, "the Body of the People in the Colonies are as loyal, and as firmly attach'd to the present Constitution and reigning Family, as any Subjects in the King's Dominions . . ." (5:443–44). Two years later, he wrote to George Whitefield about undertaking a projected colony in the West which would embody "the Service of our gracious King, and (which is the same thing) the Publick Good" (6:469). Even at the height of the Stamp Act crisis in 1765, we find him calling for "a firm Loyalty to the Crown and faithful Adherence to the Government of this Nation [i.e. Britain], which it is the Safety as well as Honour of the Colonies to be connected with . . ." (12:235; cf. 14:253). In 1768, Franklin was still of the same opinion, noting that Britain had "the best Constitution and the best King any Nation was ever blest with" and that "there is not a single Wish in the Colonies to be free from Subjection to their amiable Sovereign *the King* of Great Britain, and the constitutional Dependance then arising . . ." (15:129, 239). The following year he continues along the same lines that he could "scarcely conceive a King of better Dispositions, of more exemplary Virtues, or more truly desirous of promoting the Welfare of all his Subjects" (16:118). Even if we factor in Franklin's caution due to the delicacy of his positions as colonial agent and Deputy Postmaster General for North America, it is clear that Franklin's attachment to the monarch and the British imperial system was in no way diminished throughout these troubled times.

Franklin was very careful to emphasize, however, that America's constitutional relationship was with the monarch—whom Franklin had characterized in late 1767 as "the common *father* of his people" (14:317)—and not with Parliament. Defending the King while at the same time attacking the Parliament became a growing theme in Franklin's writing. At the beginning of January, 1768, he published in London a summary of what he calls "American Discontents" up to that point. After a stinging survey of deliberate slights and unfair burdens, he concludes:

> there is not a single native of our country, who is not firmly attached to his King by principle and by affection. But a new kind of loyalty seems to be required of us, a loyalty to P[arliamen]t; a loyalty, that is to extend, it is said, to a surrender of all our properties, whenever a H[ouse] of C[ommons], in which there is not a single member of our

chusing, shall think fit to grant them away without our consent . . .
(15:12)

Later that same month, Franklin published in London a briefer but
more pointed essay entitled "Subjects of Subjects." The theme of
this essay, as revealed in its title, was the unfortunate but growing
tendency of some of the king's subjects to presume a status of
superiority over other of the king's subjects. "The British state or
empire consists of several islands and other distant countries,
asunder in different parts of the globe," he writes, *"but all united in
allegiance to one Prince,* and to the *common law* (Scotland excepted) as
it existed in the old provinces or mother country, before the colonies
or new provinces were formed." In each of these provinces, Franklin
continues, "[t]he prince, with a select parliament, or assembly, make
the legislative power . . ." While it may be true, he continues, that
for reasons of convenience "all Great Britain and its contiguous isles,
are unitedly represented in one assembly in parliament," nothing of
substance should be concluded from this fact about the American
situation. Ireland "though lying very near" maintains its own
parliament and is not part of the British system, a precedent that
Franklin finds not inappropriate to the situation of the provinces of
America "which lie at a great distance" (15:36–37; cf. 234).

In Franklin's mind, the question of separate parliaments would
not affect the fact that "the allegiance of the distant provinces to the
crown will remain for ever unshaken, while they enjoy the rights of
Englishmen . . ." By these rights he means especially the following:
"with the consent of their sovereign, the right of legislation each for
themselves . . ." For the good imperialist Franklin, possessing this
right of legislation puts the Americans "on an exact level, in this
respect, with their fellow subjects in the old provinces, and better
than this they could not be by any change in their power." If these
rights were called into question, however, "if the old provinces
should often exercise the right of making laws for the new," then the
American would have to conclude that in the eyes of Parliament they
were no longer "fellow subjects," but (in the title phrase) the
"subjects of subjects." This possibility of subjection represented to
Franklin an uncomfortable shift in status, one to which he doubts
"the people of England [would] quietly acquiesce" if other subjects
of the king should assert the right to govern them (15:37; cf. 19).

A pair of related themes from this essay continue to appear in

Franklin's writing and they need to be distinguished. The first has to do with the relationship between the monarch and the various provinces. It was Franklin's view, a view held more widely in America than in Britain, that the colonies were possessions of the King, not of Parliament. As he writes in September, 1768, there are no colonies "belonging to GREAT BRITAIN"; they belong, rather, "to the King of Great Britain" (15:206). He later notes that the American colonies—like the other royal territories: Jersey, Guernsey, Ireland, and Hanover—are "Governed by the King according to their own Laws and Constitutions, and not by Acts of the British Parl[iamen]t . . ." (16:325). In 1770, Franklin phrases this same point as follows: "the British empire is not a single state; it comprehends many; and though the parliament of Great Britain has arrogated to itself the power of taxing the colonies, it has no more right to do so, than it has to tax Hanover. We have the same king, but not the same legislatures" (17:233).[10] The second theme, reintroduced in the last passage, was the status of the various components of the empire, with Franklin rejecting the British claim to priority in favor of parity. He complains in 1770 that "[e]very Englishman considers himself as King of America, and peculiarly interested in our Subjection . . ." (17:214); and he repeats this point in March of 1774 when, writing as "A Londoner," he asserts that "the Americans are Subjects of the King, not *our* Subjects, but our *Fellow-Subjects* . . ." (21:137–38).[11]

Between the years of 1766 and 1769, Franklin's view shifted from the suggestion to Parliament that by repealing the Stamp Act it could once again be viewed by Americans "as the great bulwark and security of their liberties and privileges . . ." (13:136) to the much less sanguine view that "I hope nothing that has happened or may happen will diminish in the least our Loyalty to our Sovereign, or Affection for this Nation in general . . . But as to the Parliament!" (16:118; cf. 17:163–64, 268–69). In June of 1771, he continues in this dual theme of respect for the monarch and resistance to Parliament: "while we are declining the usurped Authority of Parliament, I wish to see a steady dutiful Attachment to the King and his Family maintained among us . . ." (18:123). On 6 October

[10.] Cf. 13:212, 215, 220–21; 15:76; 16:284–85, 316–17; 17:320, 350; W9:486.

[11.] Cf. 5:449; 14:65; 16:279, 316; 17:163, 321, 324.

1773, he offers his son, William, the royal Governor of New Jersey and as he put it "a thorough government man" (20:437)[12] and thus unlikely to be converted, his understanding of the colonial situation: "the parliament has no right to make any law whatever, binding on the colonies . . . the king, and not the king, lords, and commons collectively, is their sovereign; and . . . the king with their respective parliaments, is their only legislator" (20:437).[13] In the midst of these various formulations about the limited nature of Parliamentary power, on 11 June 1770 Franklin returns to wonder how Britain might respond to similar treatment.

> It is a curious Question, how far it is agreable to the British Constitution, for the King who is Sovereign over different States, to march the Troops he has rais'd by Authority of Parliament in one of the States, into another State, and quarter them there in a time of Peace, without the Consent of the Parliament of that other State. Should it be concluded that he may do this, what Security has Great Britain, that a future King, when the Colonies shall become more powerful, may not raise Armies there, transport them hither, and quarter them here without Consent of Parliament, perhaps to the Prejudice of their Liberties, and even with a View of subverting them? (17:169; cf. 162)

Surely the answer would be outrage on the part of the British because it would constitute, Franklin writes, "an Invasion of the separate Right of each State to be consulted . . . and to give or refuse its Consent as shall appear most for the Public Good of that State" (17:162).

Franklin's rejection of Parliamentary meddling in American affairs was not normally controlled by a consideration of 'natural rights,' although he does at times appeal to them.[14] In 1773, he writes for example: "it is a natural Right of Men to quit when they please the Society or State, and the Country in which they were born, and either join with another or form a new one as they may think

[12.] In another letter in 1774, he wrote to William: "you who are a thorough Courtier, see every thing with Government Eyes" (21:287).

[13.] Cf. 14:68–69; 17:349, 352; 20:280.

[14.] Such appeals to 'natural rights' will appear infrequently in this chapter. Cf. Verner Winslow Crane: "In his own writings he had usually avoided the language of natural rights that Jefferson instinctively used" (*Benjamin Franklin*, 168–69; cf. Rossiter, *Seedtime of the Republic*, 290).

proper" (20:303; cf. 527–28).[15] Perhaps such arguments were too 'metaphysical' for the Pragmatic Franklin, who knew that generally talk about rights tends to short-circuit the potential for cooperative dialogue. His rejection of Parliamentary meddling was based rather upon two specific aspects of the interference: a denial, based in tradition, of any Parliamentary authority to make decisions for the American colonies, and a condemnation of the pro-British partiality of the decisions that Parliament had been making. The historical basis for Franklin's former claim that Parliament had no authority to meddle in the internal operations of the American colonies—for example, rejecting duly passed colonials laws, revoking charters, and especially imposing taxes—was the fact that the various colonies were established by agreements between the Crown and the emigrating colonists, without the involvement of Parliament.[16] In particular, Franklin stressed that the colonies were established without the monetary support of Parliament. As he writes from London to Lord Kames on 25 February 1767: "It is a common but mistaken Notion here, that the Colonies were planted at the Expence of Parliament, and that therefore the Parliament has a Right to tax them, etc. The Truth is, they were planted at the Expence of private Adventurers, who went over there to settle with Leave of the King given by Charter" (14:67–68).[17] In addition to Franklin's rejection of a Parliamentary role in the establishment of the American colonies, he maintains as well that Parliament had not been supporting them in the years since. Rather, Franklin writes in one of his *personae* in the British press that the funds expended for the defense of America were spent "for the protection of our [i.e. British] commerce, and not for the protection of the people of America" (14:111–12).

[15.] Cf. Thomas Jefferson [1774]: "our ancestors, before their emigration to America, were the free inhabitants of the British dominions in Europe, and possessed a right which nature has given to all men, of departing from the country in which chance, not choice, has placed them, of going in quest of new habitations, and of there establishing new societies, under such laws and regulations as to them shall seem most likely to promote public happiness" (*Writings*, ed. Peterson, 105–6).

[16.] Cf. James Wilson [1774]: "Permitted and commissioned by the crown, they [the American colonists] undertook, at their own expense, expeditions to this distant country, took possession of it, planted it, and cultivated it. Secure under the protection of their king, they grew and multiplied, and diffused British freedom and British spirit, wherever they came" (*Works*, 2:740).

[17.] Franklin explicitly excludes Nova Scotia and Georgia from this generalization, characterizing them as "little better than Parliamentary Jobbs" (14:68; cf. 110–11).

Moreover, he maintains that regardless of the true purpose of these expenses the Americans had always paid their fair share.[18] Thus, Franklin summarizes, these American colonies—"so many separate little States, subject to the same Prince"—accept royal sovereignty, but reject at the same time the "common" British opinion that asserts "the *Sovereignty of Parliament*, and the *Sovereignty of this Nation* over the Colonies . . ." (14:68–69).

With regard to the authority question, Franklin was willing to grant two small historical points to his opponents. The first had to do with past colonial compliance with Parliamentary meddling. While it may be true, Franklin admits in 1766, that "[w]e have submitted to your Laws," he sees in this submission "no Proof of our acknowledging your Power to make them." Rather, what he finds there is "an Acknowledgement of their Reasonableness or of our own Weakness" (13:211; cf. 16:244). In 1771, Franklin suggests a policy for correcting the prior failing to Thomas Cushing of Massachusetts. "We have indeed in a manner consented to some of them [i.e. Parliamentary laws], at least tacitly," he writes. "But for the future methinks we should be cautious how we add to those Instances, and never adopt or acknowledge an Act of Parliament but by a formal Law of our own . . ." (18:123). Franklin's second admission was that the Parliament might have some general managerial authority over the whole empire. As he writes in 1767, "it seems necessary for the common Good of the Empire, that a Power be lodg'd somewhere to regulate its general Commerce; this, as Things are at present circumstanc'd, can be plac'd no where so properly as in the Parliament of Great Britain . . ." (14:69; cf. 13:142). Franklin's allowance of Parliamentary control of 'general commerce,' as distinct from control of the commercial affairs within each colony, was related to the then popular distinction—popular, that is, in America—between 'internal' and 'external' taxes. The distinction can be found in Franklin's examination in February of 1766 by the House of Commons about the likely impact of the Stamp Act. Under his interpretation, "[a]n external tax is a duty laid on commodities imported; that duty is added to the first cost, and other charges on the commodity, and when it is offered to sale, makes a part of the price." The important point was that paying such a tax is in some sense voluntary: "If the people do not like it at that price, they refuse

18. Cf. 12:411; 14:112–13; 17:45–46.

it; they are not obliged to pay it." Franklin continues that "an internal tax" is different because it is "forced from the people without their consent, if not laid by their own representatives." As an example of this compulsion, Franklin points to the effects of the Stamp Act: "we shall have no commerce, make no exchange of property with each other, neither purchase nor grant, not recover debts; we shall neither marry, nor make our wills, unless we pay such and such sums, and thus it is intended to extort our money from us, or ruin us by the consequences of refusing to pay it" (13:139; cf. 14:114–15). The intent of this Act was not the regulation of 'general commerce,' Franklin thought. It reflected, rather, a Parliamentary decision about how to generate revenue, a matter the colonists thought to be their own internal decision. As a result of this kind of Parliamentary interference, the colonies did not control their own revenue collection or distribution. By March of 1768, Franklin was ready to abandon the internal/external distinction—"it being difficult to draw lines between duties for regulation and those for revenue" (15:75; cf. 188)—and put all of his emphasis directly on what he had come to see as the more essential point: the right of Englishmen to give their consent to any taxes that are to be laid upon them.

Franklin, as Speaker of the Pennsylvania Assembly, had written to the colony's agent in London on 22 September 1764 that pending British tax policies "will have a Tendency to deprive the good People of this Province of their most essential Rights as British Subjects, and of the Rights granted to them by the Royal Charter of King Charles the Second . . ." The latter part of Franklin's dual response was that the tax policies violated the colonists' guaranteed status: "That by the said Charter, among other Privileges, the Right of assessing their own Taxes, and of being free from any Impositions but those that are made by their own Representatives, is fully granted to the People of this Province . . ." His former, and presumably more fundamental, claim was that the proposed tax policies violated "the indubitable Right of all the Colonists as Englishmen" (11:348–49). Back in London on 13 February 1766, as part of his examination in the House of Commons on the topic of the likely effects of the Stamp Act (above, 1.2), Franklin responds to a question about the opinion of Americans regarding pending Parliamentary resolutions asserting the right to tax America: "They will think them unconstitutional, and unjust" (13:137). This unconstitutionality and injustice were

the result of the resolutions' violation of, as he writes elsewhere, "the right of Englishmen to give their own money with their own consent" (15:38).[19] Asserting again the parity of the American colonists' position in the empire and their entitlement to what he had earlier called "the rights and privileges of Englishmen" (12:245), Franklin again challenges the British public on 4 January 1770 to try to understand the situation through the Americans' eyes:

> The British Subjects on the West Side of the Atlantick, see no Reason why they must not have the Power of giving away their own Money, while those on the Eastern Side claim that Privilege. They imagine, it would sound very unmelodious in the Ear of an Englishmen, to tell him, that, by the Rapidity of Population in our Colonies, the Time will quickly come when the Majority of the Subjects will be in America; and that in those Days there will be no House of Commons in England, but that Britain will be taxed by an American Parliament, in which there will not be one Representative for either of the British Kingdoms. (17:7; cf. 21:132)

A few days later, Franklin continues in the same *persona*: "To an American Colonist our Parliament is (as far as concerns the giving and granting of his Property) the same as the Parliament of Paris. He has as much Representation in one as in the other" (17:17).[20] Franklin thus rejects the usual British reliance upon the doctrine of *virtual* representation, by means of which each member of Parliament was considered to be a representative of the welfare of all members of the British empire wherever they lived.[21] Given the

[19.] Cf. 5:443–47; 12:244–46, 411–13, 416; 13:156; 15:3–6; 17:18–22, 35, 53, 75, 268–69, 276; 21:132. Cf. the statement of the Massachusetts House of 1764, asserting that recent acts of Parliament "have a Tendency to deprive the Colonists of some of their most essential Rights as British Subjects, and as Men; particularly the Right of assessing their own Taxes and being free from any Impositions but such as they consent to by themselves or Representatives" (reprinted in 11:242; cf. Edmund S. Morgan, "The Puritan Ethic and the American Revolution," 13–14; John C. Miller, *Origins of the American Revolution*, 171–72).

[20.] Cf. James Wilson [1774]: "it is repugnant to the essential maxims of jurisprudence, to the ultimate end of all governments, to the genius of the British constitution, and to the liberty and happiness of the colonies, that they should be bound by the legislative authority of the parliament of Great Britain . . . the American colonies are not bound by the acts of the British parliament, because they are not represented in it" (*Works*, 2:735, 738).

[21.] Cf. 12:414; 15:37; 17:345; John C. Miller, *Origins of the American Revolution*, 212–15.

choice between the claim that Parliament should be seen as having the "power to make *all laws* for us" or the "power to make *no laws* for us," Franklin's position was the latter (15:76).

The second aspect of Franklin's rejection of Parliamentary meddling was thus that it had resulted in policies that both harmed the American colonies and failed to advance the well-being of the empire as a whole. In the face of reigning mercantilist assumptions that worked to "the Partial Advantage of Britain" (16:244) and thus identified the welfare of the empire with that of only one part, Franklin repeatedly stressed that the true interests of the empire *could* be advanced to the benefit of all the parts, as long as no part of the empire was considered to be primary. At the height of the controversy over the Stamp Act, in January 1766, he writes that "[t]he ordaining of laws in favor of *one* part of the nation, to the prejudice and oppression of *another*, is certainly the most erroneous and mistaken policy" (13:71). This theme continued to be prominent in his writing until the break with Britain occurred a decade later. "It is of no importance to the common welfare of the empire," he writes in London in 1768, "whether a subject of the King's gets his living by making hats on this or that side of the water" (15:10).[22] To the British way of thinking, however, it made a great deal of difference. Blinded by its own partialism, Franklin writes in London,

> that Wisdom which sees the Welfare of the Parts in the Prosperity of the Whole, seems not yet to be known in this Country. We are so far from conceiving that what is best for Mankind, or even for Europe, in general, may be best for us, that we are ever studying to establish and extend a separate Interest of Britain, to the Prejudice of even Ireland and our own Colonies! (15:181).

It is in this spirit that Franklin could note that the existence of "*common*" interests among trading partners does not necessarily translate into their being the "*same*" interests. Especially in the pursuit of common but "*separate*" interests, "one of them may endeavour to impose on the other, may cheat him in the Accounts, may draw to himself more than his Share of the Profits, may put upon

[22.] Cf. Thomas Jefferson's 1774 appeal to the King: "Only aim to do your duty, and mankind will give you credit where you fail. No longer persevere in sacrificing the rights of one part of the empire to the inordinate desires of another; but deal out to all equal and impartial right" (*Writings*, ed. Peterson, 121).

the other more than an equal Share of the Burthen" (16:281). Franklin developed this theme further in 1774, when he writes from London that in the current climate of thought "every one who wishes the good of the *whole empire*, may nevertheless be an enemy to *the welfare of Great Britain*, if he does not wish its good *exclusively* of every other *part*, and to see its welfare built on their servitude and wretchedness" (21:7; cf. 171–77).

The central mercantilist partiality involved economic restraints that retarded the growth of the colonial economies, and thereby caused them to be harmed, to benefit Britain. Franklin pointed especially to the narrowing restraints on trade and on manufacturing. In his discussions of "American Discontents" in 1768, Franklin notes that "[t]here cannot be a stronger natural right than that of a man's making the best profit he can of the natural produce of his lands, provided he does not thereby hurt the state in general." Given that, for example, iron and beaver furs are the common produce of America, and that "hats and nails, and steel, are wanted there as well as here," it would seem sensible that these simple manufacturers would take hold in America. That they had not was the direct result of Parliamentary prohibitions designed to benefit "the Hatters of England" and "a few Nailmakers" (15:10).[23] Believing that British partialism, if allowed to stand unchallenged, would only continue to spread, the colonists finally responded with a series of boycotts. In 1769 Franklin wrote to the merchants of Philadelphia in support of their efforts to limit British imports:

> the country will be enrich'd by its industry and frugality, those virtues will become habitual, farms will be more improved, better stock'd, and render'd more productive by the money that used to be spent in superfluities; our artificers of every kind will be enabled to carry on their business to more advantage; gold and silver will become plenty among us, and trade will revive after things shall be well settled, and become better and safer than it has lately been; for an industrious frugal people are best able to buy, and pay best for what they purchase. (16:175)[24]

[23.] Cf. Thomas Jefferson [1774]: "By an act passed in the 5th Year of the reign of his late majesty king George the second, an American subject is forbidden to make a hat for himself of the fur which he has taken perhaps on his own soil; an instance of despotism to which no parrallel can be produced in the most arbitrary ages of British history" (*Writings*, ed. Peterson, 109).

[24.] Cf. 15:12; 16:117–20; 17:114–19, 312–13; 18:81–82.

These benefits were, of course, incidental to the larger benefit of imperial parity that he hoped to attain.

A second example of the British willingness to burden one portion of the empire to benefit another was the policy of transporting British criminals to America, where they often resumed their lives of crime. Franklin addressed this highly emotional issue in an anonymous essay printed in his *Pennsylvania Gazette* as early as 1751. He sarcastically attacks the "tender *parental* Concern in our *Mother Country* for the *Welfare* of her Children" as demonstrated in her policy of transporting convicted felons to America in spite of the protest laws of the colonials. And Franklin attacks as well the imperial dismissal of these protests because, as he quotes it, "*such Laws are against the Publick Utility, as they tend to prevent the* IMPROVEMENT *and* WELL PEOPLING *of the Colonies.*" In response to this Parliamentary policy "by virtue of which all the Newgates and Dungeons in Britain are emptied into the Colonies," Franklin suggests that the Americans should demonstrate their gratitude for these "*Human Serpents*" by shipping to Britain some "RATTLE-SNAKES; Felons-convict from the Beginning of the World . . ." As Franklin envisages his plan, "some Thousands might be collected annually, and *transported* to Britain," where they could be distributed around various public parks and private gardens, "particularly in the Gardens of the *Prime Ministers*, the *Lords of Trade* and *Members of Parliament*; for to them we are *most particularly* obliged" (4:131–32; cf. 8:351).

In a more serious tone fifteen years later, Franklin again addressed the policy of shipping criminals to America in a petition to Parliament in April 1766. After pointing out the ongoing harm that these transported felons were causing in America—they "not only continue their evil Practices . . . but contribute greatly to corrupt the Morals of the Servants and poorer People among whom they are mixed"—he returned to an emphasis upon of the common good. He emphasizes that "the Easing one Part of the British Dominions of their Felons by burthering another Part with the same Felons, cannot increase the common Happiness of his Majesty's Subjects . . ." Franklin thus petitioned that this transportation of felons to America be stopped, or at least not expanded (as was then under consideration) to include in addition Scottish felons among the transported. Returning to his prior sarcastic tone, Franklin requested that if transporting felons to America was to continue, and if

Scottish felons were to be included, that the American "Plantations be also by an equitable Clause in the same Bill permitted to transport their Felons to Scotland" (13:241–42).[25]

One way out of this dual crisis of Parliamentary meddling that would have settled the issue of the traditional rights of Englishmen and the problem of British partiality would have been some sort of political restructuring of the empire that resulted in American representation in Parliament. As Franklin writes to William Shipley on 22 December 1754, "such an Union would be very acceptable to the Colonies," and he could see no reason why the former colonies would not be regarded "as so many Counties gained to Great Britain . . ." He was then still in his imperial phase, hoping that both sides would learn to consider themselves as "one Community with one Interest . . ." (5:449–50). As he reported from London a dozen years later, however, the lesson had not been learned. "My private Opinion concerning a union in Parliament between the two Countries, is, that it would be best for the Whole," he writes in 1766. "But I think it will never be done." The causes of Franklin's pessimism came from both sides of the conflict. "The Parliament here at present think too highly of themselves to admit Representatives from us if we should ask it," he notes, "and when they will be desirous of granting it, we shall think too highly of ourselves to accept of it" (13:268–69).[26] Franklin attempted to make the British recognize that their policies were not only harming the American colonies but also the larger empire and consequently themselves. He also emphasized that America's status was changing regardless of British policies. "America, an immense Territory," he writes in early 1767, "favour'd by Nature with all Advantages of Climate, Soil, great navigable Rivers and Lakes, etc. must become a great Country, populous and mighty . . ." The American colonies will thus eventually achieve parity within the empire, or break free from it because of a British failure to yield them parity; and, as Franklin judged the

[25.] Cf. 15:11; 17:33, 41-42; W9:628–30.

[26.] By early 1767, Franklin believed that the American understanding of the relationship between Britain and the Colonies had changed markedly. While he continued to believe "that a consolidating Union, by a fair and equal Representation of all the Parts of this Empire in Parliament, is the only firm Basis on which its political Grandeur and Stability can be founded," the time has passed "when the Colonies might have been pleas'd with it; they are now indifferent about it; and, if 'tis much longer delay'd, they too will refuse it" as the Irish had done before them (14:65; cf. 336).

situation, it seemed more likely that British policies would drive the Americans toward "their final Revolt" (14:69–70).[27] Each future restraint or oppression will only serve to increase the likelihood of a break because, as he writes, "the Seeds of Liberty are universally sown there, and nothing can eradicate them" (14:70).

Franklin writes, in an anonymous letter in *The Public Advertizer* of 25 August 1768, that it is a serious lack of insight on the part of the British people to fail to see in the American protests "the British spirit of liberty now rising in the Colonies" (15:191; cf. 21:134). He also hints that the British government and populace should not be confident that a war between these two would be resolved either quickly or in a way that they would consider favorable. Franklin predicts, on the contrary, a *"perpetual"* civil war (15:192). In early 1769, he admits to a correspondent that "Things daily wear a worse Aspect, and tend more and more to a Breach and final Separation" (16:48). By September, he is writing to Whitefield that the British government's decision to send troops to attempt to subdue Boston "seems like setting up a smith's forge in a magazine of gunpowder" (16:192; cf. 21:570); and in November he writes to William Strahan that he envisions an escalating process of "Mutual Provocations" that will "go on to complete the Separation" and result in "an implacable Malice and Mutual Hatred" (16:248–49; cf. 21:551). By May of 1771, Franklin reports as agent to the Massachusetts House of Representatives that he can see in planned Parliamentary enactments "the seeds sown of a total disunion of the two countries, though, as yet, that event may be at a considerable distance." Whether or not a break could be forestalled will depend, however, on actions still to be taken, in Britain and America; but, "without a greater share of prudence and wisdom, than we have seen both sides to be possessed of," he was not hopeful. And, should war ensue, "the bloody struggle will end in absolute slavery to America, or ruin to Britain by the loss of her colonies; the latter most probable, from America's growing strength and magnitude" (18:102–4).

[27.] In January of 1770, Franklin presented this point in a fable about a bullying mastiff and a lion club: "The young Lion . . . grew daily in Size and Strength, and . . . he became at last a more equal Match for the Mastiff; who continuing his Insults, received a stunning Blow from the Lion's Paw that fetched his Skin over his Ears, and deterred him from any further Contest with such growing Strength; regretting that he had not rather secured it's Friendship than provoked it's Enmity" (17:4).

Franklin satirized these worsening developments with a pair of companion pieces that demonstrated his lasting humor and hope for rational action even in the heat of the worsening crisis. On 11 September 1773, he published "RULES *by which a* GREAT EMPIRE *may be reduced to a* SMALL ONE." This essay fabricated a set of twenty 'rules' which had allegedly guided recent ministerial policy, but which also resembled the actual policy decisions closely enough to be taken seriously as the determining government policies. One of these rules was that ministers should "take special Care the Provinces are never incorporated with the Mother Country, that they do not enjoy the same common Rights, the same Privileges in Commerce, and that they are governed by *severer* Laws, all of *your enacting*, without allowing them any Share in the Choice of the Legislators" (20:391). Another was that ministers should harrass the colonials with "novel" and "arbitrary" taxes and make these taxes "more grievous to your Provinces, by public Declarations importing that your Power of taxing them has *no limits*, so that when you take from them without their Consent a Schilling in the Pound, you have a clear Right to the other nineteen" (20:394; cf. 15:11). To cite just one more of these twenty rules: "Redress no Grievance, lest they should be encouraged to demand the Redress of some other Grievance. Grant no Request that is just and reasonable, lest they should make another that is unreasonable" (20:398).

Franklin followed this essay with "An Edict by the King of Prussia," which he published on 22 September 1773. The purport of this 'edict' was to re-establish Prussian control over "the Island of Britain." The Prussian king notes, in Franklin's edict, that Britain had been settled by Germans, "and that the said Colonies have flourished under the Protection of our august House, for Ages past, [but] have never been *emancipated* therefrom . . ." (20:415).[28] Consequently, 'Frederick' now declares that he is imposing a series of restrictions on British manufacturing and trade, restrictions that resembled closely the British ones about which Franklin and the Americans had been complaining. Moreover, the king maintains,

[28.] Cf. Thomas Paine [1776]: "The first king of England, of the present line (William the Conquerer) was a Frenchman, and half the peers of England are descendants from the same country; wherefore, by the same method of reasoning, England ought to be governed by France" (*Writings*, 1:88; cf. Jefferson, *Writings*, ed. Peterson, 9; Silas Downer, "A Discourse at the Dedication of the Tree of Liberty," 104).

since his restraints on the British were "copied from their own Statutes . . . and from other equitable Laws made by their Parliaments, or from Instructions given by their Princes, or from Resolutions of both Houses entered into for the GOOD *Government* of their own Colonies in Ireland and America," he is confident that the people of Britain will recognize them to be *"just* and *reasonable."* Finally, the edict threatens to treat any opposition to the royal policies of imposing custom duties, restricting shipping and manufacturing, and emptying Prussian jails "into the said Island of Great Britain *for the* BETTER PEOPLING *of that Country"* as "HIGH TREASON" for which all suspects would be "tried and executed according to the *Prussian Law"* (20:418; cf. 437–40).

It is not clear that either of these essays had any positive effect on the situation; but Franklin still hoped that a break between Britain and the Colonies could be averted. Verner Crane writes that "[a]mong the patriot leaders of the American Revolution the last great imperialist was Benjamin Franklin."[29] With the ever-growing tension between Britain and the Colonies, however, Franklin began to recognize that his position as interpreter between the two sides was being destroyed. His attempts to act with impartiality, he writes in late 1768, had made him the object of suspicion from both sides, "in England of being too much an American, and in America of being too much an Englishman" (15:273).[30] As we have seen, there were personal and public reasons for Franklin's deliberate caution. Personally, there was his presumed desire to retain his royal position as Deputy Postmaster General for North America, and his ongoing involvement with the company that was attempting to obtain a grant of land in the West. In addition, as an agent for Pennsylvania, Massachusetts, New Jersey, and Georgia, Franklin surely had a desire to remain politically useful that went beyond his employability. It is likely, moreover, that Franklin was still able to recognize values present on the British side of the conflict. In this regard, we can consider his statement of March 1768 that "there is much good will towards America in the generality of this nation; and that however government may sometimes happen to be mistaken or mislead, with relation to American interests, there is no general intention to

[29.] Crane, *Benjamin Franklin: Englishman and American*, 72.
[30.] Cf. 14:101; 15:16, 159; 19:362; 20:202; 21:106, 417.

oppress us . . ." (15:67). We must recognize as well his severely limited supply of information about the fast-developing events in America, and even in Pennsylvania, because of his long time away and the nature of his sources.[31] The need for a decision seems to have been brought to a head by early 1774. After his humiliation by Alexander Wedderburn over the Hutchinson letters in Parliament on 29 January and his immediate dismissal from his postmaster job (see above, 1.2), his subsequent status as *persona non grata* made him unable to function as a colonial agent. Moreover, it was not clear that anyone else could have persuaded the British government to entertain complaints. As Franklin writes soon thereafter, "all petitions and complaints of grievances are so odious to government, that even the mere pipe which conveys them becomes obnoxious . . ." As a result, he continues, "I am at a loss to know how peace and union is to be maintained or restored between the different parts of the empire. Grievances cannot be redressed unless they are known; and they cannot be known but through complaints and petitions . . ." (21:93–94; cf. 18:12–16).

Franklin finally seemed willing to admit that an impasse had been reached in late September, 1774, when he writes to Thomas Cushing that in the face of American resistance, the King seems committed to push for victory, "whatever may be the Consequences" (21:306). When Franklin received the petition of 21 October 1774 from the First Continental Congress (cf. 21:336–39), he must have known that the end of all of his imperial hopes was near. The British empire—what he later called "a large and beautiful porcelain vase" (W9:347)—was about to be broken apart. On 20 March 1775 Franklin left London; and back in Philadelphia, on 5 June, he admits that "a Civil War [has] begun" (22:59). All that remained to be done to complete his conversion from conciliator to revolutionary was for him to reject what he had considered to be the imperial linch-pin: the Crown. One representative example of his contempt can be found in

[31] Cf. William S. Hanna: "After 1766, Franklin was increasingly out of touch with political conditions in Pennsylvania. What he knew of local affairs came from newspapers and from his official and private correspondence. Throughout the period, until his return in 1775, his closest advisers and correspondents were his son, William, and [Joseph] Galloway. From both he received a narrow, partisan, increasingly conservative interpretation of affairs in the province" (*Benjamin Franklin and Pennsylvania Politics*, 199–200).

this passage from an unsent letter of 1778: "Your Parliament never had a Right to govern us: And your King as forfeited it by his bloody Tyranny" (27:6).[32] By 1782, as the war was drawing to a close, Franklin's hatred for the King and his anger at how the war had been conducted is almost uncontrollable:

> Why has a single Man in England, who happens to love Blood and to hate Americans, been permitted to gratify that bad Temper by hiring German Murderers, and joining them with his own, to destroy in a continued Course of bloody Years near 100,000 human Creatures, many of them possessed of useful Talents, Virtues and Abilities to which he has no Pretension! (W8:561–62)[33]

After the war had ended, Franklin was able to return to his more level self, one who could write on 2 February 1780 that "there hardly ever existed such a thing as a bad Peace—or a good War . . ." (31:437).[34] He writes from Paris in June, 1785, without apparent malice: "No people were ever known more truly loyal, and universally so, to their soverigns. The Protestant succession in the House of Hanover was their idol." What caused the rupture was that the Americans "were equally fond of what they esteemed their rights . . . if they resisted when those were attacked, it was a resistance in favour of a British constitution . . . a resistance in favour of the liberties of England . . ." (W9:350).

Of course, Franklin's dreams about the future greatness of America did not die with his dream of empire. He thought that America, as a young and moral country, would continue to advance. He writes from London in early 1775, comparing "the extream Corruption prevalent among all Orders of Men in this old rotten State, and the glorious publick Virtue so predominant in our rising Country . . ." (21:509). Later that year, he writes from Philadelphia of "the difference between uncorrupted new states, and corrupted

[32.] Cf. 28:461–62. Cf. Thomas Jefferson's draft of the Declaration of Independence [1776]: "The history of the present king of Great Britain is a history of unremitting injuries and usurpations, among which appears no solitary fact to contradict the uniform tenor of the rest but all have in direct object the establishment of an absolute tyranny over these states" (*Writings*, ed. Peterson, 19; cf. 19–23, 115–20, 336–38; Paine, *Writings*, 1:94).

[33.] This was the same 'wicked man' about whom Franklin speculated about the need for an afterlife so that he could be adequately punished for 'the number and extent of his crimes' (above, 3.3).

[34.] Cf. 21:583; W8:454; W9:12, 74, 96, 107–8, 493.

old ones" (22:93).[35] America was an advancing country, one that further would lead other countries into a different kind of world. As he writes after his final return to America, it was his hope that the meaning of the American Revolution would spread worldwide: "God grant, that not only the Love of Liberty, but a thorough Knowledge of the Rights of Man, may pervade all the Nations of the Earth, so that a Philosopher may set his Foot anywhere on its Surface, and say, 'This is my Country'" (W10:72; cf. 63).[36]

5.2. Structures of Unification

We have seen (above, 2.4), Franklin's recognition of the importance of institutions—the Junto, the Library Company, the American Philosophical Society, and so on—in successfully carrying forward work in the broad field of natural philosophy. In this section, we want to consider the political equivalent of this institutional theme. Franklin's attempts to advance the social good by means of structures and procedures that foster dialogue, cooperation, and unity were based upon a number of basic assumptions. One was the assumption of the sociability of human nature. "Almost every Man has a strong natural Desire of being valu'd and esteem'd by the rest of his Species," he writes in one early formulation (1:120). In another he suggests that "Man is a sociable being, and it is for aught I know one of the worst of punishments to be excluded from society" (1:85). This assumption of sociability grounded all of his social thinking and writing and directed them toward advancing the social good by means of cooperation. As he writes in the *Almanack* for 1744: "He that drinks his Cyder alone, let him catch his Horse alone" (2:395). A second assumption was the democratic and

[35.] Cf. 13:64; 15:78–80; 31:548. Cf. Vernon Louis Parrington: "Before he went abroad Franklin had been a democrat by temperament and environment; when he returned he was a democrat by conviction, confirmed in his preference for government immediately responsible to the majority will" (*Main Currents in American Thought*, 1:168).

[36.] Cf. Benjamin Rush [1787?]: "There is nothing more common than to confound the terms of the American Revolution with those of the late American War. The American War is over: but this is far from being the case with the American Revolution. On the contrary, nothing but the first act of the great drama is closed. It remains yet to establish and perfect our new forms of government; and to prepare the principles, morals, and manners of our citizens, for these forms of government, after they are established and brought to perfection" (*Selected Writings*, 26).

common-sense point that we have already seen (above, 4.3): "Happiness consists more in small Conveniencies or Pleasures that occur every day, than in great Pieces of good Fortune that happen but seldom to a Man in the Course of his Life" (15:60–61). This assumption inclined his thinking on the nature of the social good toward the simple well-being of average people. A third assumption was that our shared life leads indirectly to communal problems— problems of education and information, health and security—that can be ameliorated only by the efforts of philanthropic individuals or, more effectively, by the philanthropic efforts of these same individuals acting in groups to construct institutions able to advance the group's interests. This assumption grounded all of his well-known social activism.[37] A fourth assumption was that, as we might expect, abstract and general thinking in political affairs is likely to be of less value than a kind of adaptive experimentalism. As Franklin writes in 1786 about attempts to improve government: "We are, I think, in the right Road of Improvement, for we are making Experiments. I do not oppose all that seem wrong, for the Multitude are more effectually set right by Experience, than kept from going wrong by Reasoning with them" (W9:489). For example, he continues, "[o]ur modes of collecting taxes are indeed as yet imperfect, and we have need of more skill in financiering; but we improve in that kind of knowledge daily by experience" (W9:496). Experimentalism presumes that there will be setbacks and failures; but it also requires that they be treated as *errata*, legitimate if unfortunate failures by sincere fellow citizens who are attempting to do what is right. Here and elsewhere, for Franklin, "[i]t is the persisting in an Error, not the Correcting it that lessens the Honour of any Man or any body of Men" (16:244); and, with a focus on improving the lives of the common people, advances in the social good can be made. This assumption emphasized the values of empirical adaptability over those of rational consistency. "The best public Measures," he writes, are "seldom *adopted from previous Wisdom,* but *forc'd by the Occasion*" (A:212).

The importance of this generally Pragmatic theme to Franklin's

[37.] Cf. Carl Van Doren: "In Europe the social contract might be a more or less metaphysical theory. In America it, or something like it, was ordinary practice. Associations of men everywhere, from the first settlement, had regularly come together to do what was beyond the strength or capacity of individuals. Mutual help was taken for granted" (*Benjamin Franklin*, 213).

political thinking has frequently been indicated by commentators. Adrienne Koch, for example, writes of "Franklin's apparent disbelief in the value of political theory per se." She notes further that while

> Franklin cared much about liberty and the dignity of the common people, and even about "the family of mankind" . . . perhaps he felt that theories of the state or of sovereignty or abstract questions of "who should rule" were somewhat like those contentious theological arguments that never issued in resolution but often poisoned the good feeling that might otherwise have developed as men naturally drew together to solve urgent, but at least in part manageable, common problems.[38]

In a similar vein, Clinton Rossiter writes:

> Pragmatism as a rule of conscious political action has never had a more eminent exponent than Benjamin Franklin . . . in Franklin's life and political arguments this method became an acknowledged if yet nameless American fundamental . . . He was not a political philosopher; he was not a philosopher at all. He was prepared to investigate every principle and institution known to the human race, but only through practical and unspeculative methods. He limited his own thought-process to the one devastating question: *Does it work?*, or more exactly, *Does it work well?*[39]

In a negative sense, this Pragmatic emphasis is away from time wasted in speculative theorizing. As Ralph L. Ketcham notes, Franklin "would have denied that he was a political philosopher, or that he had any understanding of their inquiries." The basis of Ketcham's claim here is that Franklin's "mind was too complex, too subtle, too versatile, and above all too practical to engage in the kind of systematic philosophizing about politics that passes for political theory in the grand and formal manner."[40] In a more positive sense, Franklin's emphasis was upon dealing with the realities that have been presented. In the words of Carl L. Becker, Franklin's "mind, essentially pragmatic and realistic, by preference occupied itself with what was before it, with the present rather than with the past or the

[38]. Koch, *Power, Morals, and the Founding Fathers*, 20.

[39]. Rossiter, *Seedtime of the Republic*, 294; cf. 289; Crane, *Benjamin Franklin and a Rising People*, 63, 205–6.

[40]. Ketcham, "Introduction" to *The Political Thought of Benjamin Franklin*, xxvii, vii.

future, with the best of possible rather than with the best of conceivable worlds."[41]

Another essential element in almost every instance of Franklin's political thinking was a deliberate focus upon the common good. While he did little to clarify the meaning of the concept 'the common good' itself, we have already seen clear indications of what he had in mind by the term in his ongoing engagement with the practical elements of any wholesome social situation: peace, education, health, freedom, friendship, economic well-being, etc.[42] These are the collective aspects of the human condition that provide the social framework that makes it possible for individuals to find fulfillment in the pleasures of everyday life. Moreover, he frequently cited the political importance of a deliberate focus upon the general interest, if not yet "the Good of Mankind" at least "the Good of their Country" (A:161). As Franklin writes elsewhere: "There is no Science, the Study of which is more useful and commendable than the Knowledge of the true Interest of one's Country; and perhaps there is no Kind of Learning more abstruse and intricate, more difficult to acquire in any Degree of Perfection than This, and therefore none more generally neglected" (1:141–42; cf. 157). As an example of focussing upon the common good we find him writing in *Plain Truth* in 1747, at a time of serious external threats to Pennsylvania, to challenge those who reject the necessity for dealing with mutual defense as a common problem. Are not the various parts of Pennsylvania, he wonders, "united in Interest, and mutually useful and necessary to each other?" He continues: "When the Feet are wounded, shall the Head say, *It is not me; I will not trouble myself to contrive Relief!* Or if the Head is in Danger, shall the Hands say, *We*

[41] Becker, "Benjamin Franklin," 596. Cf. Malcolm R. Eiselen: Franklin's desire for "a practical working system rather than an absolutely perfect one was the goal of his political philosophy" (*Franklin's Political Theories*, 67; cf. 1, 8).

[42] Cf. Donald H. Meyer: "He viewed society not as something existing in itself, apart from the individuals composing it, but as the sum of a multitude of individual variables. Thus, although he might speak of the public good, to his mind the public good and private interests were never far apart . . . The individual, in devoting himself to his own intellectual and moral improvement, insures his success in life. His moral and intellectual growth, moreover, is what ultimately determines his society's moral progress, which, in turn, insures its material progress. A society's material progress is measured by the success and productivity of the citizens composing it. Finally . . . both the individual's and society's material progress are to be regarded as enabling conditions for future moral progress" (*The Democratic Enlightenment*, 73, 75).

are not affected, and therefore will lend no Assistance!" His position, on
the contrary, is to emphasize that "the whole Province" is "one
Body, united by living under the same Laws, and enjoying the same
Priviledges . . ." (3:195).

To advance the life of this 'one body,' it is at times necessary for
individuals to set aside their private goods, a term that seems initially
more amenable to definition. For Franklin, private goods involve
advantages that are "not being *general* for the Commonwealth; but
particular, to private Persons or Bodies in the State who procur'd
them, and *at the Expence of the rest of the People*" (11:182). This sense
of 'private,' as opposed to 'common,' good can be broadened as we
have just seen (in 5.1) to include the partial interests of Great
Britain—or, slightly less broadly, of some segment of the British
populace—as opposed to the shared interests of all the diverse
segments of the empire. Discussing the workings of Parliament, for
example, Franklin condemns the machinations of crafty individuals
"who mislead the Legislature, proposing something under the
specious Appearance of Public Good, while the real Aim is, to
sacrifice that to their own private Interest" (16:1). As another
example of the failure to consider the common good, we can
examine his discussion of smuggling. Franklin analogized what he
saw as the attempt to evade the payment of a fair share of taxes in
support of the common good to the attempt of an individual to shirk
a group debt. "What should we think of a companion," he writes,
"who having sup'd with his friends at a tavern, and partaken equally
of the joys of the evening with the rest of us, would nevertheless
contrive by some artifice to shift his share of the reckoning upon
others, in order to go off scot-free?" (14:316). Franklin maintained
on the contrary, as we have seen in his refusal to patent the
Pennsylvania fireplace (above, 2.3), that we should be willing to
accept personal cost for advancing the common good.[43]

In a number of serious social problems on the American scene,
Franklin translated this general emphasis upon the common good

[43.] See also Franklin's correspondence with Cadwallader Colden about the
possibility of publishing Colden's *Causes of Gravitation* (1746). Here Franklin
writes: "If I can be a Means of Communicating anything valuable to the World, I do
not always think of Gaining, nor even of Saving by my Business . . ." (3:46).
Further, on at least two occasions—providing wagons for General Braddock in
1755 and offering to pay for the tea destroyed in Boston in 1773—Franklin
assumed serious personal risk to advance the common good (cf. A:221; 6:13-27;
21:482, 574, 586, 596).

into a call for the creation of political structures adequate to the task of embodying the necessary unity. One early instance was his just-mentioned *Plain Truth* of 1747, a pamphlet that advocated cooperative measures to make the city of Philadelphia and the rest of Pennsylvania more secure against attack toward the end of King George's War. In this pamphlet, as Franklin writes in the *Autobiography*, "I stated our defenceless Situation in strong Lights, with the Necessity of Union and Discipline for our Defence, and promis'd to propose in a few days an Association to be generally signed for that purpose" (A:182–83). His discussion of the need for union—the whole province as "one Body"—we have just seen. His discussion of the specific nature of the danger and the potential means of self-defense available to the "middling People, the Tradesmen, Shopkeepers, and Farmers" (3:199) who could not flee and thus had to remain to face any potential enemy take up most of the rest of the pamphlet. His discussion of the proposed military measures to safeguard the province appeared as promised a few days later, and lead to the creation of "a Militia of FREEMAN" (3:211), the Association, which developed shortly into an extensive and well-armed citizens' defense force, fitted with leaders of their own choosing. The overriding call for unification in the face of a common threat remains the central theme in both of these documents. "At present we are like the separate Filaments of Flax before the Thread is form'd, without Strength because without Connection," Franklin writes in *Plain Truth*, "but UNION would make us strong and even formidable . . ." (3:202; cf. 238–39).

A second example of Franklin's interest in fashioning a political skeleton for advancing the common good can be found in his contributions to the Albany Plan of 1754 "for the Union of all the Colonies, under one Government so far as might be necessary for Defence, and other important general Purposes" (A:209–10). Franklin, as the Joint Deputy Postmaster General for North America, was one of the few colonials who had been able to experience the North American colonies as a whole; and, cognizant as he was of the problem of internal unification in Pennsylvania, he was even more aware of the difficulties that stood in the way of intercolonial unification. The difficulties within and among the various colonies—and between the colonies and Britain—were to come to a head in the French and Indian War (1755–1763). Franklin summarizes the dangerous situation in his *Pennsylvania Gazette* on 9 May 1754 as follows:

The Confidence of the French in this Undertaking seems well-grounded on the present disunited State of the British Colonies, and the extreme Difficulty of bringing so many different Governments and Assemblies to agree in any speedy and effectual Measures for our common Defence and Security; while our Enemies have the very great Advantage of being under one Direction, with one Council, and one Purse. (5:274)[44]

It was in this context that "a Congress of Commissioners from the different Colonies, was by an Order of the Lords of Trade, to be assembled at Albany . . ." Their business, Franklin continues, was two-fold: "to confer with the Chiefs of the Six Nations, concerning the Means of defending both their Country and ours" (A:209), and to develop some frameworks for intercolonial defensive unification. Franklin developed a series of "Short Hints" toward the proposed unification, which he showed around prior to the conference (cf. 5:335–38), and which in a slightly revised form he presented at the conference, which met from 19 June to 11 July 1754 (cf. 5:357–64). The plan that the conference later adopted closely followed Franklin's suggestions. It called for a royal "President General" and a "Grand Council" chosen by the various colonial assemblies. This council, scheduled to meet annually, was to be chosen for three-year terms, and the number of delegates allocated to each colony—from two to seven—was to reflect the monetary contributions of the various colonies. The powers and duties of the President General and the council included managing relations with the Indians, establishing new colonies, coordinating defense and taxation, and so on (cf. 5:374–92). Although the plan was accepted unanimously at the conference, it went no further. As Franklin writes: "The [colonial] Assemblies did not adopt it as they all thought there was too much *Prerogative* in it; and in England it was judg'd to have too much of the *Democratic* . . ." (A:210; cf. 5:417, 453–54).[45] Regardless of this temporary failure, however, the Albany

[44.] It was at the end of this piece that Franklin printed the "JOIN, or DIE" cartoon of the dismembered snake (cf. 5:275).

[45.] Franklin also thought that the enactment of the Albany Plan would be a further step toward the recognition of the colonists as equals with the residents of Britain. By means of this union, with a parliament in North America, he writes, "the people of Great Britain and the people of the Colonies would learn to consider themselves, not as belonging to different Communities with different Interests, but to one Community with one Interest . . ." (5:449–50).

Plan helped to create a mind-set among the colonists that was inclined toward the need for unification.[46]

A third instance of Franklin's recognition of the need for unifying structures was his insistence during the pre-Revolutionary era for cooperative unity among the colonies to resist the attempts of the British government to split them apart. "I flatter myself that neither New York nor any other Colony will be cajol'd into a Separation from the common Interest," Franklin writes to Charles Thompson, the Secretary of the Continental Congress, just before his departure from London in March 1775. "Our only Safety is in the firmest Union, and keeping strict Faith with each other" (21:522–23). Back in Philadelphia and acting in this spirit of unity, Franklin proposed to the Second Continental Congress what he called "Articles of Confederation and perpetual Union" for *"The United Colonies of North America."* This proposed confederation envisioned "a firm League of Friendship . . . for their common Defence against their Enemies, for the Security of their Liberties and Propertys, the Safety of their Persons and Families, and their mutual and general welfare." This proposal included articles related to the size, selection, and powers of the "General Congress," the composition and role of the "executive Council," relations with the Six Nations and with the remaining British Colonies, and the procedures for the adoption and amendation of the Articles themselves (22:122–25).[47] Franklin's uncertainty about future developments can be seen in the final lines of his Articles: they were to remain in effect until there was a reconciliation with Britain, or "on Failure thereof this Confederation is to be perpetual" (22:125). Reconciliation, of course, did not come; and, as the colonies moved toward separation from Britain over the next year, the need for American unity became increasingly important, culminating in Franklin's apocryphal comment at the signing of the Declaration of Independence: "we must

[46.] For more on the Albany Plan, see: 4:117–21; 5:344–53, 397–417; Eiselen, *Franklin's Political Theories*, 13–20; Lawrence Henry Gipson, "Thomas Hutchinson and the Framing of the Albany Plan of Union, 1754"; Gipson, "The Drafting of the Albany Plan of Union"; Johansen, *Forgotten Founders*, 68–75; Lois K. Matthews, "Benjamin Franklin's Plans for a Colonial Union, 1750–1775."

[47.] The actual Articles of Confederation were approved in the Congress on 15 November 1777, and finally ratified by the states on 1 March 1781. During all of this time, Franklin was in France.

indeed all hang together, or most assuredly we shall all hang separately."[48]

A fourth instance that demonstrated Franklin's understanding of the need for unifying structures can be found in his support for ratification of the new Federal Constitution that, while an admittedly imperfect document, would still advance the common cause of the thirteen states. His spirit of focussing upon the common good and creating the necessary institutional skeleton was clearest in his final speech at the Constitutional Convention on 17 September 1787. In this speech, the eighty-one-year-old Franklin urged the delegates to balance off their sense that the proposed Constitution does not appear perfect to everyone with a recognition of their desperate need for a "general Government." Thus, when Franklin asserts that he accepts the Constitution "because I expect no better, and because I am not sure that it is not the best" (W9:607–8), he is asserting a kind of democratic fallibilism that anticipates the advance of the common good in the ongoing search of different-minded but sincere individuals. In the difficult early years of the Republic, Franklin admitted the existence of "Parties and Discords"; but he asserts as well that "[s]uch will exist wherever there is Liberty; and perhaps they help to preserve it. By the Collision of different Sentiments, Sparks of Truth are struck out, and political Light is obtained. The different Factions, which at present divide us, aim all at the Publick Good; the Differences are only about the various Modes of promoting it" (W10:120).[49] Thus for Franklin the willingness to accept the provisionally grounded ideas and suggestions of others should not be misunderstood as a submission to their will, or as an abandonment of one's own principles. Rather, it demonstrated an ongoing commitment to the position that self-government is possible among a people pledged to the fallibilistic advancement of the common good.[50]

[48.] Cf. Carl Van Doren: "Though it would have been like him to make a pun at that dramatic moment and this is such a pun as he might have made, there seems to be no contemporary record to show that he did" (*Benjamin Franklin*, 551; cf. W10:297).

[49.] Cf. James Madison: "Liberty is to faction what air is to fire, an aliment without which it instantly expires. But it could not be less folly to abolish liberty, which is essential to political life, because it nourishes faction, than it would be to wish the annihilation of air, which is essential to animal life, because it imparts to fire its destructive agency" ("The Federalist, No. 10" [23 November 1787], 55).

[50.] Cf. Thomas Jefferson: "No experiment can be more interesting than that we are now trying, and which we trust will end in establishing the fact, that man may be governed by reason and truth" (Jefferson to John Tyler, 28 June 1804, *Writings*, ed. Peterson, 1147).

5.3. Processes of Cooperation

Franklin's belief in the importance of developing structures of political unity was directly related to his sense of the futility of disputation as a means of advancing the common good and to his call for developing more cooperative processes.[51] This was not a rejection of dialogue, but rather an emphasis upon true dialogue in the place of disputatious counterfeits. Franklin believed that publicity and debate were as essential to any attempts to advance the common good in political matters as they were to science. We had to remain cognizant, however, that controversies could take on lives of their own, lives in which the advancement of the common good and the marshalling of evidence toward that end could be forgotten in the pursuit of personal or factional victory. In this regard, Franklin favorably contrasts the procedures followed in an Indian Council with those followed in Parliament:

> He that would speak, rises. The rest observe a profound Silence. When he has finish'd and sits down, they leave him 5 or 6 Minutes to recollect, that, if he has omitted any thing he intended to say, or has any thing to add, he may rise again and deliver it . . . How different this is from the conduct of a polite British House of Commons, where scarce a day passes without some Confusion, that makes the Speaker hoarse in calling *to Order* . . . (W10:99)

This spirit of dialogue as a replacement for discord was a central aspect of Franklin's guarded commitment to the efficacy of social reason.

Franklin carried this consciously developed spirit of fostering dialogue over from the rest of his life. He writes, for example, in the *Autobiography*, of the ease with which conversations can become disputatious, and his own deliberate adoption of the stance of "the humble Enquirer and Doubter" who attempts to avoid unnecessary disputes (A:64).[52] With this congenial spirit in mind, and with his recognition that "the Opinions of Men are almost as various as their Faces . . ." (1:194), we can understand his 1731 defense of the

[51.] Cf. Whitfield J. Bell: "In political action too Franklin was too moderate not to see reason in the opposing position. He formed no political party, developed no political philosophy . . . His talent lay in finding common ground" ("Benjamin Franklin as an American Hero," 130–31).

[52.] Cf. A:60, 65; 1:177–81; 4:73–74.

tentative stance of a printer as one who makes information available for public discussion without personally certifying its accuracy. "Printers are educated in the Belief," he writes, "that when Men differ in Opinion, both Sides ought equally to have the Advantage of being heard by the Publick; and that when Truth and Error have fair Play, the former is always an overmatch for the latter . . ." Moreover, he continues, "if all Printers were determin'd not to print any thing till they were sure it would offend no body, there would be very little printed" (1:195). As long as the material in question did not seem to be abusive or harmful to society (cf. A:165; 1:196), he was likely to print it. Nine years later he rephrases this point as follows: "It is a Principle among Printers, that when Truth has fair Play, it will always prevail over Falsehood . . . If what is thus publish'd be good, Mankind has the Benefit of it: If it be bad . . . the more 'tis made publick, the more its Weakness is expos'd, and the greater Disgrace falls upon the Author . . ." (2:260; cf. W9:102). By means of dialogue, the free interchange of ideas and the revision of opinion over time—returning to the printshop metaphor, the possibility of correcting *errata* in later editions—Franklin advocated sincere inquiry over the defense of certainties, and anticipated that topics under discussion would continue to approximate the truth.

This stance was also similar to the one that he adopted in his work in natural philosophy. "I have never entered into any Controversy in defence of my philosophical Opinions," he writes, "I leave them to take their Chance in the World. If they are right, Truth and Experience will support them. If wrong, they ought to be refuted and rejected" (25:26). Consider, for example, his comments in the *Autobiography* on his electrical work: "my Writings contain'd only a Description of Experiments, which any one might repeat and verify, and if not to be verify'd could not be defended; or of Observations, offer'd as Conjectures, and not delivered, dogmatically, therefore not laying me under any Obligation to defend them . . ." Recognizing that public disputes in science were (then as now) often more a matter of personality and reputation than scientific substance, Franklin's focus continued to be on attempting new studies, "believing it was better to spend what time I could spare from public Business in making new Experiments, than in Disputing about those already made" (A:243–44). His method was thus to answer new questions with new data that might settle the disputed issue rather than to enter into controversies with others about the meaning of old data.

Negatively, his belief in the possibilities of social reason indicated his belief that public power need not find its basis in force; positively, it suggested his belief in the possibility of cooperative inquiry. In our attempts to evaluate our customs and traditions, and to decide policies and responses adequate to our new situations, his position was that we must make use of the collective wisdom of the community. Early in his public career, he writes that "reasonable sensible Men, can always make a reasonable Scheme appear such to other reasonable Men, if they take Pains, and have Time and Opportunity for it; unless from some Circumstances their Honesty and good Intentions are suspected" (4:118). Unfortunately, it seemed that all too often under circumstances that were accepted as normal these vital conditions were unsatisfied. As he wrote to Lord Kames in January 1769,

> I am glad to find you are turning your Thoughts to political Subjects, and particularly to those of Money, Taxes, Manufactures, and Commerce. The World is yet much in the dark on these important Points; and many mischievous Mistakes are continually made in the Management of them. Most of our Acts of Parliament for regulating them, are, in my Opinion, little better than political Blunders, owing to Ignorance of the Science, or to the Designs of crafty Men . . . (16:1)

Rather than continuing on in a blundering fashion, Franklin thought that it would be possible, especially in the new American situation, to follow more justifiable procedures. By ongoing processes of discussion and reading and thought—by self-education through social inquiry—Franklin believed that the American people would be able to advance the common good. It was his hope that by means of continued social inquiry his current society would develop over time into a new and truly revolutionary nation that might eventually approximate the ideals it had professed in its Declaration of Independence.

The purpose of representative assemblies, Franklin writes in 1784, is "to have the benefit of their collective wisdom . . ." He recognized, however, that we assemble as well the individuals' "collected passions, prejudices, and private interests" by means of which "artful men" are able to "overpower" this collective wisdom and "dupe its possessors . . ." (W9:241). One possible means of strengthening the side of wisdom in this struggle would be to

increase the amount of truth available to the members of the assemblies. One particular institution that he hoped would help provide some of this increased truth was the Society for Political Enquiries, an organization founded in Philadelphia early in 1787 — the year and the place in which the Constitutional Convention was soon to meet — of which Franklin served as president. Foreshadowing the spirit of Ralph Waldo Emerson's "American Scholar" of 1837[53] by half a century, this society calls on Americans to challenge their inherited ideas and customs. By following them "with undistinguishing reverence," we find ourselves with laws and opinions and manners that contain hidden errors. In particular, this document continues, we have "grafted on an infant commonwealth the manners of ancient and corrupted monarchies." It is to this inheritance that we must now turn:

> In having effected a separate government, we have as yet accomplished but a partial independence. The revolution can only be said to be compleat, when we shall have freed ourselves, no less from the influence of foreign prejudices than from the fetters of foreign power. When breaking through the bounds, in which a dependent people have been accustomed to think, and act, we shall properly comprehend the character we have assumed and adopt those maxims of policy, which are suited to our new situation.

Such revolutionary thinking requires political inquiries to advance "the arduous and complicated science of government," which has too long been left "to the care of practical politicians, or the speculations of individual theorists." Deliberate cooperative inquiry could make the difference between passing on inherited prejudice or discovering revolutionary wisdom, and the Society for Political Enquiries took as its ideal the "mutual improvement in the knowledge of government, and . . . the advancement of political science."[54] While the ideal of this Society was still in the future, the means for approximating it — cooperative self-education through social inquiry — were real. "Every man among us reads," Franklin had written a few years before, "and is so easy in his circumstances as to have leisure for conversations of improvement, and for acquiring Information" (W9:88). Whether this estimation of the discipline of

[53.] Emerson, *Complete Works*, 1:79–115.
[54.] *Rules and Regulations of the Society for Political Enquiries*, 1–2.

the average American was accurate for his day—or is accurate for ours—in no way undermines the validity of the claim that growth of this sort is possible through discussion and reading and thought.[55]

In preparation for this life of citizenship in the new Republic, the role of education is central. Franklin himself, as we have seen (above, 1.2), received only two years of formal education; and as a young man he showed little respect for the formal education with which he was familiar. He notes in *Poor Richard's Almanack* for 1749 that "Most of the Learning in use, is of no great Use" (3:347; cf. 1:14–18). He did, however, come to appreciate the educational possibilities of cooperative inquiries, as demonstrated in his evaluation of the informal Junto as the premier "school of philosophy, morals and politics" in Pennsylvania (above, 2.4). Further, his interest in expanding education that he thought advanced the well-being of average citizens guided his efforts to establish the Academy in Philadelphia (above, 2.4).

Education must concern itself, Franklin believes, with both knowledge and character. As he writes to Samuel Johnson, a clergyman and philosopher whom he hoped to induce to head up the Academy, on 23 August 1750, "nothing is of more importance for the public weal, than to form and train up youth in wisdom and virtue. Wise and good men are, in my opinion, the *strength* of a state: much more so than riches or arms . . ." (4:41). We have considered already (above, 3.4) the social importance of religious education to Franklin. It is, however, equally important to recognize his desire to shift the content to be pursued in education to reflect his skeptical stance toward tradition.[56] Franklin's inclination—as demonstrated, for example, during the founding of the Academy—was much more strongly toward the 'English' rather than the 'Latin' school. This meant that, instead of the usual curriculum of Greek and Roman

[55.] Cf. Adrienne Koch: "Although it is easy to recognize Franklin's empirical temper in meeting political questions generally, I think that what is present is formally describable as experimental humanism and informally as pragmatic wisdom. For Franklin *is* consistent in maintaining a liberal concern for applied intelligence in every area where he senses a real issue . . ." (*Power, Morals, and the Founding Fathers*, 20–21).

[56.] Cf. Robert Middlekauff: "Somehow education must prepare one for change; and it must be prefatory to further learning and change, for Franklin saw life as a process of continual reconstruction" (*Ancients and Axioms*, 125; cf. Robert Ulich, *History of Educational Thought*, 236).

authors designed to prepare youth for the 'learned professions' of the ministry, law, and medicine, the intention behind the Academy was, as Franklin writes later, to focus upon "a complete English Education" (W10:11). This curriculum, while still incorporating mathematics, history, natural philosophy, and so on, was to be built around English grammar and spelling, speaking and rhetoric, composition of verse and prose, and the study of English stylists or others in English translation (cf. 3:404–19; 4:102–8).[57] Franklin's hope for this sort of education was that "Youth will come out of this School fitted for learning any Business, Calling or Profession, except such wherein Languages are required; and tho' unacquainted with any antient or foreign Tongue, they will be Masters of their own, which is of more immediate and general Use" (4:108).[58] The students, rather than devoting their time to efforts to master "antient and foreign" languages, "often without Success," would better spend their time "in laying such a Foundation of Knowledge and Ability, as, properly improv'd, may qualify them to pass thro' and execute the several Offices of civil Life, with Advance and Reputation to themselves and Country" (4:108; cf. 36).[59] While the actual development of the Academy failed to carry forward Franklin's vision, falling victim to education's customary partialities toward the classics,[60] he himself never gave up his commitment to an

[57] Cf. Lorraine Smith Pangle and Thomas L. Pangle: "Franklin deepened and made respectable previously emerging challenges to the Latin and Greek philological and literary training that had bulked so large as the secular component of the 'liberal' education offered in the 'Latin Grammar' schools of New England and Britain" (*The Learning of Liberty*, 78; cf. 78–86; Cremin, *American Education*, 500–505; Robert Middlekauff, "A Persistent Tradition").

[58] Franklin thought that the young men could pick up modern languages as necessary, as he had done. Cf. Charles William Eliot: "He believed that any one who had acquired a command of good English could learn any other modern language that he really needed when he needed it . . ." (*Four American Leaders*, 16).

[59] Cf. Lawrence A. Cremin: "However much Franklin may have borrowed the parts of his educational plan or at least sought authority for the parts, the schemes in their entirety are as original and autochthonous as the rephrased commonplaces of Poor Richard. The schemes have from time to time been labeled narrowly vocational, crassly materialistic, and even vaguely anti-intellectual; but they are actually none of these. If anything, they are anti-academicist, seeking to bring education into the world and place it in the service of particular men as well as mankind in general" (*American Education*, 377; cf. Spiller, "Benjamin Franklin: Promoter of Useful Knowledge," 41; Pangle and Pangle, *The Learning of Liberty*, 79; Mott and Jorgensen, "Introduction" to *Benjamin Franklin*, xlii; Bridenbaugh and Bridenbaugh, *Rebels and Gentlemen*, 67).

[60] Cf. W10:9–31; Pangle and Pangle, *The Learning of Liberty*, 88–90.

education that would be useful to the average, hard-working members of his society.

We have just seen (above, 5.1) Franklin's long-lived faith in the monarchy and the British imperial system, a faith that survived well into his seventh decade. This faith forces the question of the extent to which Franklin should be considered a democrat. In colonial and postcolonial America, of course, the term 'democracy' frequently carried a heavily negative connotation, conjuring up images of society torn apart by anarchy at the hands of benighted mobs. What the American Founders wanted instead of democracy was a mixed form of government—a republic—that recognized the people as the source of the power of government but then delegated that power to what Jefferson called "a natural aristocracy," sifted by elections, to govern.[61] One commentator has described Franklin's view as a combination of "an unqualified acceptance of the democratic ideal with a certain distrust of its practicability as applied to actual government." Another emphasized the importance of indirect democracy in Franklin's thought: "Agreeing fully with the eighteenth-century, pejorative meaning of 'popular' and 'democratic,' Franklin wanted no such leveling principles expressed in the [Albany] Plan of Union. He saw no virtue in the mass participation of people in politics."[62] A third suggests that Franklin's were the "conventional views for his day" balancing off fears about "the turmoil of mob rule" with the belief that "the people, properly educated, properly led, and under wise institutions of government, could be good and effective rulers."[63] If we set aside (until 5.5) the broad questions of

[61.] Jefferson to John Adams, 28 October 1813, *Writings*, ed. Peterson, 1305. Cf. Ralph Henry Gabriel: "The group of anxious men who assembled at Philadelphia in 1787 to frame a constitution for the new United States had almost universally . . . confidence in human reason . . . True to the Enlightenment, their social philosophy emphasized atomism . . . Democracy is the appropriate political expression of the atomistic social emphasis, yet many of the framers had a healthy skepticism of democracy. To some it suggested the triumph of mediocrity and to others the substitution of the rule of passion for that of reason" (*The Course of American Democratic Thought*, 12; cf. Roy N. Lokken, "The Concept of Democracy in Colonial Political Thought"; Elisha P. Douglass, *Rebels and Democrats*, 156–58).

[62.] Malcolm R. Eiselen, *Franklin's Political Theories*, 77; William S. Hanna, *Benjamin Franklin and Pennsylvania Politics*, 75. As Franklin wrote in the Albany Plan in 1754, "as the choice [of representatives] was not immediately popular, they would be generally men of good abilities for business, and men of reputation for integrity . . ." (5:405).

[63.] Ralph L. Ketcham, "Introduction" to *The Political Thought of Benjamin Franklin*, li.

equality, and place ourselves as best we can within the 'conventional' views of his day, we recognize that Franklin was, in our contemporary understanding of the term, less than fully committed to the democratic ideal. He was a patriot and a rebel against foreign rule. He was an opponent of heredity government, comparing hereditary legislators in 1775 to "Hereditary Professors of Mathematicks" (21:583).[64] He was an individual who, as we have seen (above, 1.2), had arisen from "Poverty and Obscurity" (A:43), and who still appreciated the simple lives of common people and wanted the policies of the state to foster their advance. Still, for Franklin government need not reflect the unfiltered wishes of the citizenry.

Franklin did not celebrate life as much as he appreciated its potential for contribution. He was never, as could be surmised from our consideration of the intensity and inclination of his moral thought (above, 4.4–4.5), particularly enamored of unearned leisure or approving of unproductive enjoyments. He felt no apparent joy in the spontaneous, and took no obvious pleasure in the undirected. (This discipline is presumably the real basis of the complaints of 'Puritanism' lodged against Franklin.) For him, the human was ever on call to be useful, to advance in a reasoned fashion the cooperative possibilities of a better tomorrow. Franklin was a planner and organizer whose personal vision of human wellbeing valued material progress (though not luxury); and, as such, he respected property and prized order. All of this put Franklin in direct opposition to the more spontaneous outbursts of mass democracy.[65]

The following examples should help adumbrate this aspect of his understanding of democracy more fully. In 1765, we find Franklin in London, commenting on the "Outrages committed by the Frontier People" in America who were "emboldened" by their "Impunity for former Riots" and who had begun "to destroy

[64.] Cf. Thomas Paine [1791]: "the idea of hereditary legislators is as inconsistent as that of hereditary judges, or hereditary juries; and as absurd as an hereditary mathematician, or an hereditary wise man; and as ridiculous as an hereditary poet-laureate" (*Writings*, 2:323; cf. 419).

[65.] Cf. Paul W. Conner: "The antithesis of Franklin's political ideal was disorder, and its incarnation was the mob. Mobs flit in and out of Franklin's writings like spectors. They serve as haunting reminders of the fate that lurked in the shadows, waiting to seize the society which turned aside from the virtuous quest" (*Poor Richard's Politicks*, 136).

Property publick and private . . ." (12:172–73).[66] As might be expected, Franklin had no higher regard for British mobs; and, in a letter of 1768, he describes the rioting in London. "All respect to law and government seems to be lost among the common people," he writes, "who are moreover continually enflamed by seditious scribblers to trample on authority and every thing that used to keep them in order" (15:127; cf. 129). He similarly characterizes the Boston protests of the same year as "Riots," the work of "a few of the lower sort" (16:33).[67] Back in America after his successful efforts in Paris, Franklin became increasingly convinced that the disorders of the infant Republic under the Articles of Confederation pointed to the need for a stronger and more unified central government. One such instance was Shay's Rebellion of 1786, the suppression of which he communicated to Jefferson as follows: "The Insurgents in the Massachusetts are quelled, and I believe a great Majority of that People approve the Measures of Government in reducing them" (W9:573–74).[68] Later, in distancing himself from the anti-Federalist opposition with which ratification of the new Constitution was meeting in the various states, Franklin writes in 1788 that "though there is a general dread of giving too much power to our *governors*, I think we are more in danger from too little obedience in the *governed*" (W9:638). The following year, Franklin returned to this theme of a lack of popular responsibility when he writes: "We have been guarding against an evil that old States are most liable to, *excess of power* in the rulers; but our present danger seems to be *defect of obedience* in the subjects" (W10:7). In the light of these and other

[66.] Cf. 12:209; 13:416; 15:99. 1765 was also the year that Franklin's own house in Philadelphia was threatened by a mob rioters opposed to the Stamp Act, as we saw (above, 1.2).

[67.] In addition to his concern with actual damage caused by the mobs, Franklin was also worried that the British might use the continuation of riots in America as justification for further repression. He writes to Thomas Cushing of Massachusetts on 9 March 1773 of the need "to keep our People quiet, since nothing is more wish'd for by our Enemies, than that by Insurrections we should give a good Pretence for increasing the Military among us, and putting us under more severe Restraints" (20:99).

[68.] Jefferson was not in exact agreement. See his comments to William Stephens Smith on 13 November 1787: "can history produce an instance of rebellion so honourably conducted? . . . God forbid we should ever be 20 years without such a rebellion . . . what country can preserve it's liberties if their rulers are not warned from time to time that their people preserve the spirit of resistance? Let them take arms . . . The tree of liberty must be refreshed from time to time with the blood of patriots and tyrants. It is it's natural manure" (*Writings*, ed. Peterson, 911).

comments, the depth of Franklin's commitment to democracy must be seen as limited.[69]

Operating within his political situation, Franklin clearly was not what we would now consider to be a full democrat. He remains skeptical of the citizenry, of its tendency toward sudden and irrational eruptions of mob violence, and critical of its unwillingness to accept direction toward what the consensus of the leadership thought was the common good. Still, it is not difficult to find in Franklin the seeds of significant democratic advance beyond his situation. It is these seeds of democratic spirit that commentators point to when one, for example, characterizes Franklin as "the great democrat of colonial America" and "the leading democrat of the age," and another points to his position as "the earliest outstanding American exponent of the democratic principle." For a third, Franklin was especially important in the years following independence when aristocratic thinking was dangerously prevalent: Franklin "saw no cause to lose faith in government immediately responsive to the majority will. He was . . . firm in the conviction that government was good in the measure that it remained close to the people."[70]

Franklin was a believer in the republican form of government, a representative rather than a direct democrat. He believed, moreover, that those properly chosen to represent the populace should wield real power to address common problems. Under the Articles of Confederation, for example, he supported a powerful legislature; and he maintained that it could exist without significant danger to the general populace: "If the Congress were a permanent Body, there would be more Reason in being jealous of giving it Powers," he writes. "But its Members are chosen annually, cannot be chosen more than three Years successively, nor more that three Years in

[69] Cf. Jesse Bier: "We might well ask if the mature man ever became the full democrat, the truly casual common man. Why did he boast in the full tide of his life that he had 'stood before five kings,' unless royalty still counted that significantly to him?" ("Benjamin Franklin: Guilt and Transformation," 92–93; cf. A:144; Douglass, *Rebels and Democrats*, 18–19).

[70] Clinton Rossiter, *Seedtime of the Republic*, 290, 309; Malcolm R. Eiselen, *Franklin's Political Theories*, 77; Vernon Louis Parrington, *Main Currents in American Thought*, 1:176–77. Cf. Elisha P. Douglass: "Franklin the politician did much less for the cause of democratic government from 1764 to 1776 than Franklin the philosopher has done during the twentieth century" (*Rebels and Democrats*, 237 n.78).

seven; and any of them may be recall'd at any time, whenever their Constituents shall be dissatisfied with their Conduct." More important than these mechanical restraints, Franklin discusses the democratic spirit behind this representative system: "They are of the People, and return again to mix with the People, having no more durable preeminence than the different Grains of Sand in an Hourglass . . . They are the Servants of the People, sent together to do the People's Business, and promote the public Welfare . . ." (W9:336–37).[71] These democratic sentiments from his eightieth year are the same as those found in one of his earliest essays. As he wrote in 1723, when he was seventeen, "Adam, was never called *Master* Adam; we never read of Noah *Esquire*, Lot *Knight* and *Baronet*, nor the *Right Honourable* Abraham, *Viscount Mesopotamia*, *Baron of Caran*; no, no, they were plain Men, honest country Grasiers, that took Care of their Families and their Flocks" (1:52). He stood up for the average person—the simple craftsman with a humble origin like himself—who had ideas of demonstrated worth and who could serve the community. He offered criteria of success for social policies that were popular and broad. And he advocated political systems that would advance these values.

Franklin's favorite political machinery emphasized expanded democracy through popular sovereignty—within the ordered bounds of government—rather than restraints on the will of the majority through systems of balance. For example, Franklin opposed a bicameral legislature in Pennsylvania and favored a unicameral one, rejecting the belief that the balancing of two houses yields wiser policies:

> Has not the famous political Fable of the Snake, with two Heads and one Body, some useful Instruction contained in it? She was going to a Brook to drink, and in her Way was to pass thro' a Hedge, a Twig of which opposed her direct Course; one Head chose to go on the right side of the Twig, the other on the left; so that time was spent in the Contest, and, before the Decision was completed, the poor Snake died with thirst. (W10:57–58)[72]

[71.] Cf. William G. Carr, *The Oldest Delegate*, 165.

[72.] Cf. Thomas Paine's 1805 report of Franklin's defense of unicameralism from the Pennsylvania Constitutional Convention of 1776: " 'It appears to me,' said he, 'like putting one horse before a cart and the other behind it, and whipping them both. If the horses are of equal strength, the wheels of the cart, like the wheels of government, will stand still; and if the horses are strong enough, the cart will be torn to pieces' " (*Writings*, 4:465; cf. 22:515).

He preferred a unicameral system for the Federal government as well.[73] Franklin also advocated the adoption at both levels of a system of multiple executives, rather than a single executive, to be chosen by the relevant legislature (Cf. W9:603–4; W10:54). Legislatures themselves, Franklin believed, should also be chosen in proportion to population, rather than according to some formula that gave a privileged status to individuals with large amounts of property. With regard to Pennsylvania, he writes:

> The Combinations of Civil Society are not like those of a Set of Merchants, who club their Property in different Proportions for Building and Freighting a Ship, and may therefore have some Right to vote in the Disposition of the Voyage in a greater or less Degree according to their respective Contributions; but the important ends of Civil Society, and the personal Securities of Life and Liberty, these remain the same in every Member of the society; and the poorest continues to have an equal Claim to them with the most opulent, whatever Difference Time, Chance, or Industry may occasion in their Circumstances. (W10:59–60; cf. 130)

With regard to the Federal Congress, his position was initially the same (cf. W9:595–99); but the stalemate at the Convention over representation led to his compromise proposal that, while the Senate should have equal representation, representation in the House of Representatives should be in proportion to each state's contribution to the Federal treasury. His argument for this compromise uses the following analogy: "When a broad table is to be made, and the edges of planks do not fit, the artisan takes a little from both, and makes a good joint. In like manner here both sides must part with some of their demands, in order that they may join in some accomodating proposition."[74] The result of Franklin's great compromise was to have equal representation on matters that might affect "the Sovereignties of the Individual States" or "their Authority over their own Citizens" or "the Authority of the General Government" over them or the appointment of individuals to offices in "the *General Government*," but to have proportional representation on matters having to do with "Appropriations and Dispositions of Money" related to

[73.] Cf. W9:674; Aldridge, *Franklin and His French Contemporaries*, 86–90; J. Paul Selsam, *The Pennsylvania Constitution of 1776*, 183–87.

[74.] Cited in Carr, *The Oldest Delegate*, 158.

their contribution to the national treasury (W9:602).[75] This proposal when modified in committee gave rise to our Congressional system.

Another point that emphasized popular sovereignty was Franklin's view that public office should not be allowed to become a source of wealth. He reports favorably to those who might immigrate to America that "it is a Rule establish'd in some of the States, that no Office should be so profitable as to make it desirable," and he later rejects as a fundamental mistake allowing "*enormous salaries, emoluments*, and *patronage* of great offices" (W8:605; W9:169).[76] He was particularly wary of salaries for the Executive(s) because by such a combination of "a Post of *Honour*" with "a Place of *Profit*" the door had been opened to a new kind of potential ruler—"the men of strong Passions and indefatigable Activity in their selfish Pursuits"—and to the possibility of a monarchy, toward which he believed humanity already had "a natural Inclination," being imposed (W9:591–93).

Franklin's opposition to the remnants of aristocracy left him dismayed by the movement of a group of Revolutionary War veterans to establish the Society of the Cincinnati. As he writes in 1784 from Paris, he was puzzled why,

> when the united Wisdom of our Nation had, in the Articles of Confederation, manifested their Dislike of establishing Ranks of Nobility, by Authority either of the Congress or of any particular State, a Number of private Persons should think proper to distinguish themselves and their Posterity, from their fellow Citizens, and form an Order of *hereditary Knights*, in direct Opposition to the solemnly declared Sense of their Country! (W9:161)[77]

[75.] Cf. William G. Carr: Franklin "played the role of the honest broker, driving toward compromise and conciliation among a group of younger, more militant partisans. It was an essential role that none could play better than he" (*The Oldest Delegate*, 77; cf. Lemay, "Benjamin Franklin: Universal Genius," 10; Eiselen, *Franklin's Political Theories*, 70–71; Van Doren, *The Great Rehearsal*, 110–15).

[76.] Cf. 33:389; W9:171–72, 259–60; W10:501–2.

[77.] Cf. Thomas Jefferson: the Order of the Cincinnati "is against the confederation—against the letter of some of our constitutions;—against the spirit of all of them—that the foundation on which all these are built is the natural equality of man, the denial of every preeminence but that annexed to legal office, and particularly the denial of a preeminence by birth . . ." (Jefferson to George Washington, 16 April 1784, *Writings*, ed. Peterson, 791).

The focus of Franklin's complaint was not the honoring of those whose personal military efforts had help save America in its time of crisis. His complaint, rather, was with the Society's intention to project these honors into the future in the persons of the members' descendants. "Honour, worthily obtain'd," he writes, "is in its Nature a *personal* Thing, and incommunicable to any but those who had some Share in obtaining it." As such, honor cannot descend to a person's children; honor cannot be inherited. In part, Franklin's opposition to the members' intention of transmitting of such honors onto their posterity is purely mathematical: after nine generations, or approximately three centuries, "our present Chevalier of the Order of Cincinnatus's Share in the then existing Knight, will be but a 512th part . . ." More importantly, he maintained that if honors are to be passed beyond those who have personally earned them they should be given, contrary to the Cincinnati system, to the parents of the veterans rather than to their children. As Franklin writes, "*ascending* Honour is therefore useful to the State, as it encourages Parents to give their Children a good and virtuous Education." On the other hand, to grant a "*descending Honour*, to Posterity who could have no share in obtaining it, is not only groundless and absurd," he writes, "but often hurtful to that Posterity, since it is apt to make them proud, distaining to be employ'd in useful Arts, and thence falling into Poverty, and all the Meannesses, Servility, and Wretchedness attending it . . ." All in all, he believed that if there was to be such a society, it would be best if the distinction were to "die with those who have merited it" (W9:162–65).[78]

5.4. A Simple Life of Democratic Equality

The procedures of cooperation that we have just considered were to have as their product an advanced common good. Franklin's own sense of the specific content of this common good, while less important to us now than the social method that he advocated for its advancement, remains of significance. The key element in his position was simplicity, a value that was appropriate to life on the

[78.] Cf. 1:51; 4:97–98; W9:336. Later in his life, Franklin was apparently offered 'honorary' membership in the Pennsylvania division of the Cincinnati—cf. Aldridge, *Benjamin Franklin*, 351; Van Doren, *Benjamin Franklin*, 780—although there is no evidence that he accepted it.

American Frontier. Franklin was never a backwoodsman himself, of course, and he was often not enamored of the actions and attitudes of the actual backwoodsmen. He writes in 1760, for example: "The people that inhabit the [North American] frontiers, are generally the refuse of both nations [France and Britain], often of the worst morals and the least discretion, remote from the eye, the prudence, and the restraint of government" (9:65). Still, he frequently asserts his belief in the superiority of life in semi-frontier America, where existence was "a general happy Mediocrity" (W8:604).

In particular, American society, unlike European society, was not economically fragmented. He writes of his encounters with poverty during his travels in 1771 to Ireland and Scotland where, in spite of the opulent life of the few, "[t]he Bulk of the People [are] Tenants, extreamly poor, living in the most sordid Wretchedness in dirty Hovels of Mud and Straw, and cloathed only in Rags" (19:7; cf. 22–23, 71). In America, on the contrary, "[t]here are few great Proprietors of the Soil, and few Tenants," he writes in 1782, "most People cultivate their own Lands, or follow some Handicraft or Merchandise; very few rich enough to live idly upon their Rents or Incomes . . ." (W8:604). The Americans, as a consequence, led lives that were thus both simpler and happier than those of Europeans:

> Whoever has travelled thro' the various Parts of Europe, and observed how small is the Proportion of People in Affluence or easy Circumstances there, compar'd with those in Poverty and Misery; the few rich and haughty Landlords, the multitude of poor, abject, and rack'd Tenants, and the half-paid and half-starv'd ragged Labourers; and views here the happy Mediocrity, that so generally prevails throughout these States, when the Cultivator works for himself, and supports his Family in decent Plenty . . . (W10:120)[79]

Franklin believed that such individuals, intimately connected with the day-to-day realities of making their own living, would demonstrate priorities proper to a simple life and avoid the temptation to pursue material luxuries.[80]

[79] Cf. Thomas Jefferson: "Whenever there are in any country uncultivated lands and unemployed poor, it is clear that the laws of property have been so far extended as to violate natural right. The earth is given as a common stock for man to labor and live on" (Jefferson to James Madison, 28 October 1785, *Writings*, ed. Peterson, 841–42).

[80] Cf. Earle D. Ross: "the small independent farmer appeared to him as the basis of social and political security alike in the colonies and in the new nation. The even

Moreover, America was a land where common folk—like Franklin himself—could rise. "If they are poor, they begin first as Servants or Journeymen," he writes, "and if they are sober, industrious, and frugal, they soon become Masters, establish themselves in Business, marry, raise Families, and become respectable Citizens" (W8:608), just as he had done. Franklin's explicit focus in this self-improvement process was the ability of individuals to rise above the dependencies that they would have known in Europe. His concern was thus with the absolute advance in economic status that was possible for virtually all in America, not with the possibility of occasional individual advances relative to the more limited advances of other Americans.[81] In such a country, he hoped it would be possible to develop a self-directing democracy free of the restraints of European custom. And, of course, underlying all of this discussion of pursuing the common good was his belief that the physical situation in America represented the nearest-possible approximation to utopia in his contemporary world, offering "a good Climate, fertile Soil, wholesome Air and Water, plenty of Provisions and Fuel, good Pay for Labour, kind Neighbours, good Laws, Liberty, and a hearty Welcome . . ." (W9:21).[82] In America, Franklin saw the possibility of happiness held out to those whose efforts were sufficient and whose goals were simple, to the industrious and frugal.

Franklin writes to a European correspondent in late 1775 that "[t]his is a good country for artificers or farmers, but gentlemen, of mere science in *les belles lettres*, cannot so easily subsist here, there being little demand for their assistance among an industrious people, who, as yet, have not much leisure for studies of that kind" (22:287). A few years later he reinforces this point with the observation that "the natural Geniuses" of America who were possessed of special talents in art and architecture "have uniformly quitted that Country

distribution of wealth and the predominance of small laboring owners largely averted 'those Vices that arise usually from Idleness' [W8:613]. Such social evils as did exist were to be found mainly in the towns . . ." ("Benjamin Franklin as an Eighteenth-Century Agrarian Leader," 61–62).

[81] Cf. Benjamin Rush [1790]: "From the numerous competitions in every branch of business in Europe, success in any pursuit may be looked upon in the same light as a prize in a lottery. But the case is widely different in America. Here there is room enough for every human talent and virtue to expand and flourish" (*Letters*, 1:556).

[82] Cf. 29:56; 30:264; W9:90, 150.

for Europe, where they can be more suitably rewarded" (W8:604).[83] As Franklin understood their situation, the natural condition of almost all Americans, at least for the forseeable future, was to be agriculture. "For one Artisan, or Merchant," he writes, "we have at least 100 Farmers, by far the greatest part Cultivators of their own fertile Lands . . ." (W10:117–18). Franklin, as we have seen, was an urban person himself and thus remained part of the one percent throughout his life.[84] As he admits to one of his British correspondents in 1784, "I am not much acquainted with Country Affairs, having been always an Inhabitant of Cities . . ." (W9:160; cf. 149). While it is true that Franklin never was a farmer himself,[85] living as he did in semi-frontier America, he recognized the importance of farming to humankind in general, and to the colonies and the young Republic in particular. And, being Franklin, he acted to advance it. For example, his proposals for both the American Philosophical Society and the Philadelphia Academy have agricultural components. In his original "Proposal for Promoting USEFUL KNOWLEDGE among the British Plantations in America" of 1743, Franklin included within the purview of this planned Philosophical Society: "All new-discovered Plants, Herbs, Trees, Roots, etc. their Virtues, Uses, etc. Methods of Propagating them, and making such as are useful, but particular to some Plantations, more general" (2:381). In his "Proposals Relating to the Education of Youth in Pennsylvania" of 1749, Franklin notes that the "Improvement of Agriculture" is "useful to all, and Skill in it no Disparagement to any." He consequently suggested that the students in the Academy learn such

[83.] Cf. Benjamin Rush [1790]: "Men who are philosophers or poets, without other pursuits, had better end their days in an old country . . . Painting and sculpture flourish chiefly in wealthy and luxurious countries . . . To the cultivators of the earth the United States open the first asylum in the world" (*Letters*, 1:550).

[84.] Cf. Virgle Glenn Wilhite: "Franklin was born and reared in Boston. He lived most of his adult life in Philadelphia and in large European cities. Like many city dwellers, he tended to exaggerate the joys of rural life, and minimize the hardships of agricultural pursuits. His longing for the serenities of rural surroundings and the enjoyment of nature's abundance was one of the reasons why he exalted agriculture and depreciated manufacturing industry" (*Founders of American Economic Thought and Policy*, 295).

[85.] In spite of the earlier belief that Franklin had maintained some sort of experimental farm in New Jersey (cf. Earle D. Ross, "Benjamin Franklin as an Eighteenth-Century Agricultural Leader," 55; Carey, *Franklin's Economic Views*, 170–71), more recent evidence has proven that this belief was mistaken (cf. 3:436; Carl R. Woodward, "Benjamin Franklin: Adventures in Agriculture," 179–89).

valuable agricultural skills as: *"Gardening, Planting, Grafting, Inoculating,* etc." (3:417). He was active as well in the distribution, both to and from America, of plants and seeds thought to be of value, and in the dissemination of instructional books about agriculture.[86] Franklin also seemed to have come upon the idea of crop insurance to protect farmers against "storms, blight, insects, etc." (cf. W9:674).

A large part of Franklin's interest in agriculture was attributable to his recognition that deliberate and careful farming is the key to advances in human well-being. By means of farming, humanity had been able to make the tremendous advance from the subsistence level of existence, that a life of hunting and gathering had made possible, to the level of comfortable agricultural surplus that was now supporting a progressing civilization: "From the Labour arises a *great Increase* of vegetable and animal Food, and the Materials for Clothing, as Flax, Wool, Silk, etc. The Superfluity of these is Wealth. With this Wealth we pay for the Labour employed in building our Houses, Cities, etc. which are therefore only Subsistence thus metamorphosed" (16:108). Moreover, because of the settlers' fortunate situation in a New World, their potential for tapping the riches of America's land and waters, "the true Sources of Wealth and Plenty" (16:209), was limitless. He later describes their success as fellows: "The Agriculture and Fisheries of the United States are the great Sources of our encreasing Wealth. He that puts a Seed into the Earth is recompens'd, perhaps, by receiving twenty out of it; and he who draws a Fish out of our Waters, draws up a Piece of Silver" (W10:122). In addition to recognizing its actual centrality at the heart of the growing American economy, Franklin was also committed to the moral primacy of agriculture.[87] As he writes, agriculture is "the only *honest Way*; wherein Man receives a real Increase of the Seed thrown into the Ground, in a kind of continual Miracle wrought by the Hand of God in his Favour, as a Reward for his innocent Life, and virtuous Industry" (16:109). In this mood, he

[86.] Cf. 16:200–201; 17:22–23; 18:32; 19:134–39, 268, 316–17, 323–24; 20:40, 95–97; 24:89; Carey, *Franklin's Economic Views*, 168–95; Woodward, "Benjamin Franklin: Adventures in Agriculture," 193–97.

[87.] Here Franklin was influenced by the French Physiocrats (cf. 15:181–82; Aldridge, *Franklin and His French Contemporaries*, 23–30; Carey, *Franklin's Economic Views*, 134–67; Mott and Jorgensen, "Introduction" to *Benjamin Franklin*, lxxiv–lxxxi).

continues elsewhere that agriculture is "the most useful, the most independent, and therefore the noblest of Employments" (W9:491; cf. 19:6). Franklin puts special emphasis upon this independence: "The farmer has no need of popular favour, nor the favour of the great; the success of his crops depending only on the blessing of God upon his honest industry" (W10:3).[88]

The actual and moral primacy of agriculture was the keystone of Franklin's larger conception of a good economy that additionally incorporated some level of manufacturing and trade. While he may maintain that "the true Source of Riches is Husbandry" (15:52), he recognized as well that producing agricultural surplusses does not occur in an economic vacuum. Farming is hard work and farmers will only cultivate what they anticipate being able to use. They grow as much as they need for themselves and their families; and, if they think that they can sell any surplus for a gain, they will grow it as well. Depending on their location and transportation realities, however, selling the surplus is often difficult. For some farmers, Franklin writes, "the Expence of Carriage will exceed the Value of the Commodity." For these individuals, selling their surplus crops is not an option; and "if Some other Means of making an Advantage of it are not discovered, the Cultivator will abate of his Labour and raise no more than he can consume in his Family." The advantage that was discovered was that this fragile surplus could be transformed into a manufactured product—like "Linnen and Woollen Cloth" (18:273)—that could be used in trade. Manufacturing produces no new value; it changes the form of the old.

> Agriculture is truly *productive* of *new wealth*; Manufactures only change Forms; and whatever value they give to the Material they work upon, they in the mean time consume an equal value in Provisions, etc. So that Riches are not *increased* by Manufacturing; the only advantage is, that Provisions in the Shape of Manufacturers are more easily carried for Sale to Foreign Markets.

Thus, when it becomes economically feasible to transport the reworked agricultural products to a desirable market, it becomes

[88.] Cf. Thomas Jefferson [1787]: "Those who labour in the earth are the chosen people of God, if ever he had a chosen people, whose breasts he has made his peculiar deposit for substantial and genuine virtue . . . Corruption of morals in the mass of cultivators is a phaenomenon of which no age nor nation has furnished an example" (*Writings*, ed. Peterson, 290).

economically worthwhile to produce them. This manufacturing might be conducted on a very small scale, using only family members: "Spinning or Knitting etc. to *gather up the fragments* (of Time) *that nothing may be lost*" (15:52). Or it might be conducted on a far larger scale, using the labor of many individuals whom the entrepreneur puts to work:

> if he can draw around him working People who have no Lands on which to subsist, and who will for the Corn and other Subsistence he can furnish them with, work up his Flax and Wooll into Cloth, then is his Corn also turn'd into Cloth, and with his Flax and Wooll render'd portable, so that it may easily be carry'd to Market, and the Value brought home in Money. This seems the chief Advantage of Manufactures. (18:273–74; cf. 16:108)

Regardless of the scale of production, however, Franklin was careful to emphasize repeatedly that manufacturing produces no new value. "When a Grain of Corn is put into the Ground it may produce ten Grains: After defraying the Expence, here is a real Increase of Wealth"; manufacturers, on the other hand, "make no Addition to [wealth], they only change its Form" (18:274).

Franklin's understanding of a well-balanced economy was thus dual. The first aspect of his position was that manufacturing should not be allowed to expand too greatly. He was concerned that the Americans not increase manufacturing "beyond reasonable Bounds" so that it became necessary to import food (15:52). In their selection of areas for manufacturing expansion, he was mindful as well that in some industries America stood at a competitive disadvantage. "The buying up Quantities of Wool and Flax, with the Design to employ Spinners, Weavers, etc., and form great Establishments, producing Quantities of Linen and Woollen Goods for Sale," he writes, "has been several times attempted in different Provinces; but those Projects have generally failed, goods of equal Value being imported cheaper" (W8:610). Any further expansion into these noncompetitive areas would presumably meet with similar failure. The second aspect of his position was that manufacturing was not likely to expand too greatly as long as the fundamental economy of the country remained in balance. "Manufactures," he writes, "are founded in poverty."

> It is the multitude of poor without land in a country, and who must work for others at low wages or starve, that enables undertakers to

carry on a manufacture, and afford it cheap enough to prevent the importation of the same kind from abroad, and to bear the expence of its own exportation. But no man who can have a piece of land of his own, sufficient by his labour to subsist his family in plenty, is poor enough to be a manufacturer and work for a master. Hence while there is land enough in America for our people, there can never be manufactures to any amount or value. (9:73; cf. W8:611)[89]

In Franklin's mind, it was to the advantage of America and its residents that it remain a primarily agricultural country into the forseeable future. Such an agricultural country, balanced with manufacturing and trade in modest amounts, would be more virtuous and happy.

Some commentators on Franklin's economic thought have found his assertion of the primacy of agriculture to be in conflict with his earlier position that suggested a labor theory of value.[90] This earlier view, presented in "The Nature and Necessity of a Paper-Currency" (1729), argues that labor—not gold or silver—is the proper measure of value. As he writes there, "Silver it self is of no certain permanent Value, being worth more or less according to its Scarcity or Plenty"; and, if we are to seek a permanent *"Measure of Values,"* we should look to *"Labour."*

> Suppose one Man employed to raise Corn, while another is digging and refining Silver; at the Year's End, or at any other Period of Time, the compleat Produce of Corn, and that of Silver, are the natural Price of each other; and if one be twenty Bushels, and the other twenty Ounces, then an Ounce of that Silver is worth the Labour of raising a Bushel of that Corn. (1:149)

Thus, if we are attempting to determine the relative worths of goods, Franklin believed that such comparisons should be conducted in terms of the units of labor necessary to produce them. Once equivalencies of worth are determined, exchanges of comparable worth are facilitated by money. "Men have invented MONEY, properly called a *Medium of Exchange*, because through or by its

[89.] Cf. Thomas Jefferson [1787]: "While we have land to labour then, let us never wish to see our citizens occupied at a work-bench, or twirling a distaff. Carpenters, masons, smiths, are wanting in husbandry: but, for the general operations of manufacture, let our work-shops remain in Europe" (*Writings*, ed. Peterson, 291).

[90.] Cf., for example, Carey, *Franklin's Economic Views*, 146–47; Conkin, *Puritans and Pragmatists*, 105–6.

Means Labour is exchanged for Labour, or one Commodity for another" (1:148). We must remain careful, however, to remember that monetary values are derivative: "Trade in general being nothing else but the Exchange of Labour for Labour, the Value of all Things is, as I have said before, most justly measured by Labour" (1:150).[91]

The key to recognizing that this support for a labor theory of value was not opposed to his later views on the primacy of agriculture is to be found in Franklin's claim that value is 'most justly measured' by labor. The two views are thus fully compatible when we distinguish between the *origin* of value—the productivity of the earth—and the *standard* of human values—as represented in units of labor. Franklin suggests this interpretation when he writes that "[t]he first Elements of Wealth are obtained by Labour, from the Earth and Waters" (W9:246). Value thus is not created by labor, although it is obtained by and to be measured in labor. Agricultural labor is, moreover, its primary form.

> Food is *always* necessary to *all*, and much the greatest Part of the Labour of Mankind is employ'd in raising Provisions for the Mouth. Is not this kind of Labour therefore the fittest to be the Standard by which to measure the Values of all other Labour, and consequently of all other Things whose Value depends on the Labour of making or procuring them?

What would result from Franklin's view here is the following sort of equivalency: "If the Labour of the Farmer in producing a Bushel of Wheat be equal to the Labour of the Miner in producing an Ounce of Silver, will not the Bushel of Wheat just measure the Value of the Ounce of Silver?" In this way—and enhanced by the fact that "[t]he Miner must eat, the Farmer indeed can live without the Silver . . ." (16:47)—the value of all products is to be pegged on a labor scale. "Necessaries of Life that are not Foods, and all other Conveniencies, have their Values estimated by the Proportion

[91] Karl Marx refers to this passage in *Capital* when he writes: "One of the first economists, after William Petty, to have seen through the nature of value, the famous Franklin . . . is not aware that in measuring the value of everything 'in labour' he makes abstraction from any difference in the kinds of labour exchanged—and thus reduces them all to equal human labour. Yet he states this without knowing it" (*Capital*, 142 n.18; cf. John R. Aiken, "Benjamin Franklin, Karl Marx, and the Labor Theory of Value").

of Food consumed while we are employed in procuring them" (16:107).[92]

The labor theory of value as presented by Franklin emphasized a measurement in units of time. It also recognized the need for the labor in question to be put to some good use. Franklin's understanding of the importance of labor to advancing human well-being can be seen in his belief that "if every Man and Woman would work for four Hours each Day on something useful, that Labour would produce sufficient to procure all the Necessaries and Comforts of Life, Want and Misery would be banished out of the World, and the rest of the 24 hours might be Leisure and Pleasure." It was Franklin's belief that the prevalence of poverty in his contemporary situation was the result of the unfortunate fact that the legitimate contributions of those who were doing useful work were being squandered by those who did not work and those whose work was wasted. As he writes, "the Employment of Men and Women in Works, that produce neither the Necessaries nor Conveniences of Life, who, with those who do nothing, consume the Necessaries raised by the Laborious." For example, in a productive household the individuals busy themselves throughout their days and years with the activities of agriculture broadly conceived. "Spinning . . . hewing Timber and sawing Boards . . . making Bricks, etc." fill their working hours. All of these are useful forms of labor and result in a surplus. Franklin stresses, however, that not all labor is this productive: "if, instead of employing a Man I feed in making Bricks, I employ him in fiddling for me, the Corn he eats is gone, and no Part of his Manufacture remains to augment the Wealth and Convenience of the family; I shall therefore be the poorer for this fiddling Man . . ." (W9:246). While Franklin's stance here sets an impossibly high and narrowly pecuniary standard of usefulness—we recall that he 'fiddled' a good bit himself[93]—still it

[92.] Cf. Virgle Glenn Wilhite: "value is created by nature rather than by man; however the *magnitude* of the value of food products is indicated by, and equal to, the labor expended in their production; whereas *the amount* of the value of other economic goals is measured by the quantity of labor required to produce the food that is consumed by laborers while they are engaged in the production of these other necessities and conveniences of life" (*Founders of American Economic Thought and Policy*, 298; cf. V. Dennis Golladay, "The Evolution of Benjamin Franklin's Theory of Value," 49–50).

[93.] Franklin certainly engaged in a good deal of activity that would seem to have been useless under this particular formulation: his memoirs, his various hoaxes, his

suggests his combined moral and socio-economic point. "Look round the World and see the Millions employ'd in doing nothing," he writes, "or in something that amounts to nothing, when the Necessaries and Conveniences of Life are in question" (W9:247). If they too were to become productive by doing a significant amount of useful labor, the 'necessaries and conveniencies' of life would become more widespread and human well-being would be advanced.[94]

In his early writings, Franklin was favorably inclined toward commerce, seeing trade as the generally beneficial result of a number of economic factors: locales and peoples are differently productive, and the voluntary exchanges of surpluses are to "the mutual Advantage and Satisfaction of both" and thus commerce is "highly convenient and beneficial to Mankind" (1:148). As the years went on, however, while Franklin continued to see value in commerce,[95] he began to question its value with a special emphasis upon two lines of inquiry. The first dealt with the balance between trade, which he saw as itself unproductive, and any values that trade brought. The most obvious advantage of trade is variety, which he describes as follows: "each Party increases the Number of his Enjoyments, having, instead of Wheat alone or Wine alone, the Use of both Wheat and Wine" (16:108). One potentially negative aspect of this enjoyment, as we saw (above, 4.4), was its ability to undermine the life of industry and frugality. "Foreign Luxuries and needless Manufactures imported and used in a Nation," he writes, "diminish the People of the Nation that uses them" (4:231). At times, Franklin saw this aspect to be so strongly negative as to make trade unnecessary. In September 1775, just as the Colonial troubles were about to boil over into war, Franklin thought that the Americans were willing, if necessary, to surrender their seacoast and forego commerce. The "internal Country" would be enough, he writes. "It is a good one and fruitful . . . Agriculture is the great Source of Wealth and Plenty. By cutting off our Trade [the British] have thrown us *to the Earth*, whence like *Antaeus* we shall rise yearly with fresh Strength

magical squares and circles, his chess playing, and so on (cf. 4:392–403; 12:146–49; 29:750–57; Van Doren, *Benjamin Franklin*, 143–46).

[94.] This would seem to strengthen the claims of Whitfield J. Bell and Herbert W. Schneider (above, 4.4–4.5) that Franklin did not see work itself as virtuous in some abstract sense, but rather as particularly necessary in the colonial situation.

[95.] Cf. W8:263; W9:19, 63.

and Vigour" (22:199). He continues in the same theme in 1780 that America "can very well subsist and flourish without a Commerce with Europe, a Commerce that chiefly imports Superfluities and Luxuries . . ." (W8:107). Further, there was the actual expense of the trading, which became a more relevant factor as the focus of consideration moves from necessities to conveniencies. "What is the Bulk of Commerce," he wonders in 1784, "but the Toil of Millions for Superfluities, to the great Hazard and Loss of many Lives by the constant Dangers of the Sea?" Especially with regard to such items as tea, coffee, sugar, and tobacco that made up a large portion of America's imports and exports, Franklin believed that trade was largely wasteful. "These things cannot be called the Necessaries of Life, for our Ancestors lived comfortably without them" (W9:247). Moreover, there were even cases in which the specific 'products' involved in the trading make the commerce, however profitable, morally wrong. The primary instance of immoral commerce was the slave trade (that we shall consider in the next section). The first line of criticism that Franklin made against commerce, then, was that it was itself unproductive and tended to undermine a life of industry and frugality.

Franklin's second line of criticism against commerce was that it tended to be unfair to one of the trading partners. As a result, at the same time that the unneeded goods 'diminish' the importing country, they also "increase the People of the Nation that furnishes them" (4:231). This inequality was the result of an imbalance, either in the level of political power between the participants in the exchange or in their relative knowledge of values. While it was possible for any particular instance of trade to be fair, which he defines as a trade in which "equal Values are exchanged for equal the Expence of Transport included," it was just as possible for it to be unfair. Setting aside mercantilist and other political interference, the bulk of unfair trades resulted when one of the partners in the exchange did not know the value—in terms of the amount of invested labor—of the material to be received in the exchange. While this may occur with regard to agriculture, it was especially likely in the case of manufactures, where

> there are many expediting and facilitating Methods of working, not
> generally known; and Strangers to the Manufactures, though they

know pretty well the Expences of raising Wheat, are unacquainted with those short Methods of working, and thence being apt to suppose more Labour employed in the Manufactures than there really is, are more easily imposed on in their Value, and induced to allow more for them than they are honestly worth.

Formulating this point about unfairness more strongly, Franklin writes "the Advantage of Manufactures is, that under their shape Provisions may be more easily carried to a foreign Market; and by their means our Traders may more easily cheat Strangers." These two criticisms of the commercial life bring us back to Franklin's emphasis upon the primacy of agriculture. As he writes, "there seem to be but three Ways for a Nation to acquire Wealth":

> The first is by *War* as the Romans did in plundering their conquered Neighbours. This is *Robbery*. The second by *Commerce* which is generally *Cheating*. The third by *Agriculture* the only *honest Way*; wherein Man receives a real Increase of the Seed thrown into the Ground, in a kind of continual Miracle wrought by the Hand of God in his Favour, as a Reward for his innocent Life, and virtuous Industry. (16:108–9)

Franklin believed that by means of a balanced economy that places primacy in agriculture, and complements this with a small amount of manufacturing and trade, America would grow into a powerful and progressive country of happy and virtuous citizens.

The other side of Franklin's hopefulness about America as a potential utopia and the likely success of even average individuals who were willing to work hard was his apparent harshness toward the poor.[96] I say 'apparent' harshness not because I have any doubts about either the intended or the likely short-term effects of his program, but because he himself saw the eventual result to be beneficence. "I am for doing good to the poor," he writes, "but I differ in opinion of the means" (13:515). Many individuals, he maintains, fail to see that maintenance programs that provide short-term help also cause long-term damage to those who are helped and

[96.] Cf. Alfred Owen Aldridge: "The greatest intellectual puzzle of Franklin's life is found in his political philosophy—the contrast between some of his reactionary social concepts and his practical benevolent ethics. He opposed poor relief but worked to establish schools and hospitals . . ." (*Benjamin Franklin*, 415).

to the society in general.[97] As Franklin understood the human situation, our natural inclination to "a life of ease, of freedom from care and labour" (4:481) was held in check under normal circumstances by the opposing realities of physical need and social virtue. Short-term help, however, weakens this check by satisfying the physical need while at the same time undermining shame; and, as a consequence, the inclination to live an easy life stands unopposed. Franklin believed that such short-term help is thus harmful:

> I fear the giving mankind a dependance on any thing for support in age or sickness, besides industry and frugality during youth and health, tends to flatter our natural indolence, to encourage idleness and prodigality, and thereby to promote and increase poverty, the very evil it was intended to cure; thus multiplying beggars, instead of diminishing them (15:104).

In consequence, anything that we might do to diminish individuals' inducements to industry, frugality, and sobriety would ultimately harm them.[98]

Franklin believed in general that we need to be extremely cautious in any attempts to restructure our world. "Whenever we attempt to mend the scheme of Providence and to interfere in the Government of the World," he writes, "we had need be very circumspect lest we do more harm than Good" (4:480). Sometimes, as we saw in the case of lightning rods (above, 2.2), our efforts resulted in improvements in human well-being. In other cases, as in the case of illness, he suggests intervention as well. In 1751,

[97] Cf. Herbert Hoover: "Benjamin Franklin should be the patron saint of that altogether characteristic American, the self-made man. Those real men were the product from the noblest of American ideals . . . Obviously, the ideal today [1938] has shifted from the self-made man toward the government-coddled man" ("On Benjamin Franklin," 366; cf. Wilhite, *Founders of American Economic Thought and Policy*, 313–19; Howell V. Williams, "Benjamin Franklin and the Poor Laws").

[98] Franklin did favor some social arrangements that he thought preserved his long-term values. In 1772, for example, he praises an attractive system of elderly housing operating in Holland: "These Institutions seem calculated to *prevent* Poverty which is rather a better thing than *relieving* it. For it keeps always *in the Public Eye* a state of Comfort and Repose in old Age, with Freedom from Care, held forth as an Encouragement to so much Industry and Frugality in Youth as may at least serve to raise the required Sum, (suppose £50,) that is to intitle a Man or Woman at 50 to a Retreat in these Houses. And in acquiring this Sum, Habits may be acquired that produce such Affluence before that Age arrives as to make the Retreat unnecessary and so never claimed" (19:180).

Franklin's support for the Pennsylvania Hospital as an institution of organized charity (above, 2.4) was based in part on the fact that health and illness result, at least to some extent, from a natural lottery: "We are in this World mutual Hosts to each other; the Circumstances and Fortunes of Men and Families are continually changing . . . how careful should we be not to *harden our Hearts* against the Distresses of our Fellow Creatures . . ." (4:149). With regard to efforts to palliate poverty, however, he anticipated that harm rather than good would ultimately result from our misguided efforts:

> To relieve the misfortunes of our fellow creatures is concurring with the Deity, 'tis Godlike, but if we provide encouragements for Laziness, and supports for Folly, may it not be found fighting against the order of God and Nature, which perhaps has appointed Want and Misery as the proper Punishments for, and Cautions against as well as necessary consequences of Idleness and Extravagancy. (4:480; cf. 11:101)

This was the crux of his criticism of various 'poor laws.' As he wrote in 1766 with regard to one particular British law, "you offered a premium for the encouragement of idleness, and you should not now wonder that it has had its effect in the increase of poverty" and the creation of a class that is increasingly "idle, dissolute, drunken, and insolent." He continues that "the more public provisions were made for the poor, the less they provided for themselves, and of course became poorer. And, on the contrary, the less was done for them, the more they did for themselves, and became richer." Franklin thus believed that the correct program would not attempt to palliate poverty, but rather would leave the poor exposed to its ravages unmitigated: "the best way of doing good to the poor, is not making them easy *in* poverty, but leading or driving them *out* of it." By holding individuals responsible for their own conditions, and those of their families, they will be made better: "more will be done for their happiness by inuring them to provide for themselves, than could be done by dividing all your estates among them" (13:515–16).[99]

[99.] Cf. 15:103–7; W10:64. Cf. Robert H. Bremner: "Penn demanded that money, instead of being hoarded or spent on impious luxuries, should be used for comforting the poor. Mather dreamed of a city in which each house would have an alms-box bearing the message '*Think* on the Poor.' Franklin, however, conceived of a society in which there would be no poor and little need for relief or charity" (*American Philanthropy*, 16; cf. Howell V. Williams, "Benjamin Franklin and the Poor Laws," 85–86).

The initial harshness of Franklin's position on poverty should be clear: no palliatives will be offered to assist those who are deficient in the virtues of industry and frugality. As I suggested earlier, however, this harshness may be only apparent when viewed over the long-term. One key element in his longer view was that in the potential utopia of the New World, where the Frontier beckons and where individuals' well-being depends primarily on their own efforts, where there are boundless woods that "afford Freedom and Subsistence to any Man who can bait a Hook or pull a Trigger" (13:232), Franklin believed that there were alternatives not present in the more developed economies of Europe. Using his own experience as an indication of what was possible for an industrious and frugal American,[100] Franklin urged his fellows to work hard on the seemingly minor aspects of their present situation—as we have seen (above, 4.1), "a penny sav'd is a penny got" (1:241–42)—with faith in eventual prosperity.

A further mitigation of the apparent harshness of Franklin's discussion of the poor is his larger theme of the public ownership of wealth, a kind of partial and sketchy socialism that sounds little like the individualism of many of Poor Richard's familiar aphorisms. Shortly after his retirement from the printing business to free up more time for his philosophical experiments, Franklin criticized those who pursue wealth without end and who believe there is importance in amassing, as we have seen (above, 4.4), a great 'dying worth.' He asserts, on the contrary, the superiority of claims of human need to claims of property ownership, writing that "what we have above what we can use, is not properly *ours*, tho' we possess it . . ." (3:479).[101] We have seen instances already where Franklin

[100.] Cf. Paul K. Conkin: "With enough discipline, with enough hard work, with the requisite habits, with Franklin's good advice drawn from his experience, anyone could rise to the limits of his talents, and many could rise as far as Franklin . . . In Europe it was different, and [there] Franklin often located the source of misery and poverty in society rather than in deficiencies of character or education . . . the America Franklin knew, [was] an America where it seemed obvious that opportunity abounded, that success was largely a matter of intelligence and determination, and that impoverishment was a matter of stupidity or poor character" (*Puritans and Pragmatists*, 100, 106–7).

[101.] Cf. Thomas Jefferson: "By an universal law, indeed, whatever, whether fixed or movable, belongs to all men equally and in common, is the property for the moment of him who occupies it; but when he relinquishes the occupation, the property goes with it. Stable ownership is the gift of social law, and is given late in the progress of society" (Jefferson to Isaac McPherson, 13 August 1813, *Writings*, ed. Peterson, 1291).

limited his acquisition of wealth—as in his refusal to patent the Pennsylvania stove (above, 2.3)—and risked the wealth that he had accumulated—as when he offered his personal bond to secure wagons and horses for General Braddock (above, 1.2). Late in his life, Franklin develops this suggestion of public ownership of wealth further:

> All the Property that is necessary to a Man, for the Conservation of the Individual and the Propagation of the Species, is his natural Right, which none can justly deprive him of: But all Property superfluous to such purposes is the Property of the Publick, who, by their Laws, have created it, and who may therefore by other Laws dispose of it, whenever the Welfare of the Publick shall demand such Disposition. (W9:138)

Franklin continues that, because "Private Property . . . is a Creature of Society," it is therefore "subject to the Calls of that Society, whenever its Necessities shall require it, even to the last Farthing . . ." Moreover, he writes that these "Contributions" to alleviate public need "are not to be considered as conferring a Benefit on the Publick, entitling the Contributors to the Distinctions of Honour and Power, but as the Return of an Obligation previously received, or the Payment of a just Debt" (W10:59). On a related theme, he criticized the use of capital punishment for crimes against property as a perversion of justice resulting from the desires of the wealthy to remain secure. When part of the society "accumulated Wealth and grew powerful," he writes, they enacted more severe laws, and "would protect their Property at the Expence of Humanity" (W9:293).

Thus it would seem that Franklin's call for the deliberate pursuit of personal improvement, while often individualistic in its aphoristic form, should always be seen as being more socially oriented in its ultimate goal of advancing the common good.[102] In this way, Franklin could assert, for example, the primacy of society on questions of 'superfluous' property. "He that does not like civil

[102.] Cf. Alfred Owen Aldridge: "His strong self-identification with the political fortunes of his country had developed in him a social concept which he had never before expressed—the notion that the state is an all-important entity, superseding the private interests and desires of any and all of its individual members. Now he even modified his earlier individualistic economic views, which were, as we remember, harshly opposed to schemes of social welfare. In condemning the remissness of his countrymen in paying their taxes, he expressed a theory of property almost socialistic" (*Benjamin Franklin*, 352).

Society on these Terms, let him retire and live among Savages," he writes. "He can have no right to the benefits of Society, who will not pay his Club towards the Support of it" (W9:138). Moreover, we need to keep ever conscious the fact that this was not Franklin's analysis of our current situation but of his. His ideal was of a prosperous middle class whose members lived simple lives of democratic equality. Those who met with greater economic success in life were responsible to help those in genuine need; but those who from a lack of virtue failed to pull their own weight could expect no help from society. With simplicity, the individual citizens of this new country would direct their energies toward endeavors that would result in personal improvement. With democracy, the citizens of this new country would be free to direct the choices of the society toward the common good. And with equality, the citizens of this new country would not suffer the deadening restraints of custom that would keep the industrious and frugal from prospering and advancing.

5.5. Equality, Race, and Slavery

While Franklin was one of the great democratizing forces in the colonies and the young Republic, his efforts were generally circumscribed by narrow eighteenth-century ideas about other cultures and about human equality. As we shall see in this section, there was much in Franklin's mindset that is unattractive and about which perhaps the best that can be said is that, on some of these points, he changed his positions as he grew older. Franklin's actions and ideas in these areas were mixed in the way that most of the American Founders' actions and ideas were mixed. My aim at this point is neither absolution nor condemnation of his or their failings. They were all citizens of an emerging world, as are we; they proved to be blind to much that later became obvious, as we will no doubt also prove to be. My aim is simply to keep cognizant that adequately understanding his and their work means grasping it in the context of the rest of their world.

A quick overview at some of Franklin's prejudices is disconcerting. He is justly condemned, for example, for his characterization in the mid-1750s, when he was nearing the end of his fifth decade, of a certain segment of the German immigrant population as "the Refuse

of their People" and "the most ignorant Stupid Sort of their own Nation," and as "Palatine Boors" who should not be allowed "to swarm into our Settlements" and turn Pennsylvania into "a Colony of *Aliens* . . ." (6:40; 4:483, 234).[103] We have seen (above, 3.1) instances of his anti-Catholicism. We also find in his writings occasional instances of anti-Semitism, one of the strongest of which describes an individual with whom he had business in France during the Revolution as "as much a Jew as any in Jerusalem" (W8:332).[104]

Franklin's discussions of the relation between men and women are more extensive, although on ocasion just as unfortunate. We have seen (above, 4.2) his strong defense of Polly Baker in her attempts to avoid sole responsibility for bearing an illegitimate child. There are also his defenses of women, offered by such figures as 'Silence Dogood' and 'Celia Single,' against charges of idleness and extravagence (cf. 1:18–21, 240–43). Another of his positive evaluations of women is to be found in his discussions of the importance of marriage to humans. "It is the most natural State of Man," he writes (23:311). "The married State," he continues elsewhere, is

> the happiest, being conformable to our Natures. Man and Woman have each of them Qualities and Tempers, in which the other is deficient, and which in Union contribute to the common Felicity. Single and separate, they are not the compleat human Being; they are like the odd Halves of Scissors; they cannot answer the end of their Formation. (W9:14)[105]

But, while he repeatedly emphasized the importance of marriage as 'the most natural state' for humans—and pregnancy as a great gift[106]—he also views marriage as "the proper Remedy" for "the violent natural Inclinations" of sex to which men are primarily

[103.] Cf. 4:120–21; Conner, *Poor Richard's Politicks*, 84–87; Glenn Weaver, "Benjamin Franklin and the Pennsylvania Germans," 549–50.

[104.] Cf. 13:407; 14:341–42; 15:82; 24:353–54; 26:160; W10:74. In the mid-1930s, Franklin was accused of being the author of an anti-Semitic "Prophecy" which was later proven to be a forgery (cf. Charles A. Beard, "Exposing the Anti-Semitic Forgery about Franklin"; Nian-Sheng Huang, *Benjamin Franklin in American Thought and Culture, 1790–1990*, 174–80; Claude-Anne Lopez, "Prophet and Loss: Benjamin Franklin, the Jews, and Cyber-Bigotry").

[105.] Cf. 2:396; 5:471; 15:183–85; 19:111; W9:583.

[106.] In the *Almanack* for 1735 we find the following: "A Ship under sail and a big-bellied Woman, Are the handsomest two things that can be seen common" (2:7).

subject; and, to those men who are unwilling or unable to take the 'proper' remedy of marriage, he suggests taking a mistress. He further offered a number of selfish reasons why in the choice of a mistress a man should "*prefer old Women to young ones*" (3:30). In his *Autobiography*, Franklin described his own frequent "Intrigues with low Women" (A:128), that presumably resulted in the birth of his illegitimate son, William (born c.1731); but, although these 'violent natural inclinations' were seen primarily as a male problem, he still discussed 'intrigues with low women' rather than, say, 'low intrigues with women.' With regard to women's lives outside of sex and marriage, he had little to say beyond occasional comments about their education and religious upbringing.[107]

While Franklin is often and justly praised for being able to transcend contemporary social 'truths,' in all of these areas, and in others still to follow, he showed himself to be trapped in the habitual prejudices of his society. The themes that we have considered so far, however, play a much smaller role in his thought than do his ideas about the natives of the American continent and those brought to America as slaves. Franklin was, for example, untroubled in describing some Native Americans as "ignorant Savages" (4:119) or as "barbarous tribes of savages that delight in war and take pride in murder . . ." (9:62), and in condemning their brutal attacks on frontier settlers as examples of "their Perfidy and Inhumanity" (11:62).[108] He was similarly untroubled at recommending that these 'savages' be tracked by "large, strong and fierce" dogs (6:235; cf. 11:239). He attributed their attacks on the settlers to several causes, including the Indians "Relish for Plunder" (10:304; cf. 274, 342) and the colonists' failure to have punished them sufficiently for their prior attacks. As he writes in late 1763, "I only fear we shall conclude a new Peace before those Villains have been made to smart sufficiently for their perfidious Breach of the last; and thereby make them

[107.] Cf. A:166–67; 2:21–26; 6:225; 8:92; 11:448–50. Cf. Alfred Owen Aldridge: "Probably Franklin himself believed that men and women should not be treated disproportionately for the same transgression of the law, which is essentially all that Polly is saying, but at no time in his life did he ever suggest women's equality in any other sense" (*Early American Literature*, 118; Christian Lerat, "Essay at Revisiting Benjamin Franklin as a Philogynist," 107).

[108.] Franklin was particularly outraged at the reported cooperation between some of the Native Americans and the British during the Revolution. See: 23:310; W8:437–42, 447–48, 561–63.

less apprehensive of breaking with us again hereafter" (10:405).[109] In December of that same year, however, Franklin condemned in the strongest terms the two-stage massacre of twenty peaceful Indians in Lancaster County carried out under the justification of revenge by the so-called 'Paxton Boys,' whom he called "CHRISTIANS WHITE SAVAGES" (11:66). In defense of the murdered Conestogas, he writes:

> The only Crime of these poor Wretches seems to have been, that they had a reddish brown Skin, and black Hair; and some People of that Sort, it seems, had murdered some of our Relations. If it be right to kill Men for such a Reason, then, should any Man, with a freckled Face and red Hair, kill a Wife or Child of mine, it would be right for me to revenge it, by killing all the freckled red-haired Men, Women and Children, I could afterwards any where meet with. (11:55)

By means of this pamphlet, "A Narrative of the Late Massacres," and his later cooperative actions with others to face down the encroaching Paxton Boys in nearby Germantown, Franklin helped prevent a repetition of those horrors against a group of Delawares in Philadelphia (cf. 11:22–29, 42–78).

Franklin's relationship with Indians in general seems to have been broad but not deep, resulting in a good bit of familiarity but little understanding. In particular, Franklin was not very successful at appreciating the folkways of the various native groups in America as part of the creative diversity of the human experience. He was for the most part unable to see beyond his society's fundamental commitment to advancing its own model of progress that assumed, among other things, the superiority of husbandry to hunting and gathering.[110] He was consequently unable to fully grasp the Indians' rejection of farming, seeing it only as a rejection of "an Attempt to make Women of them, as they phrase it: It being the Business of

[109.] Cf. 6:487; 10:296, 342, 401–2; 11:337.

[110.] Cf. Franklin's support for a 1771 scheme to bring the advances of progress to the inhabitants of New Zealand. As he writes, those who have been blessed should—in good Deist fashion—pass on the good: "Many Voyages have been undertaken with views of profit or of plunder, or to gratify resentment; to procure some advantage to ourselves, or to do some mischief to others: but a voyage is now proposed, to visit a distant people on the other side the Globe; not to cheat them, not to rob them, not to sieze their lands, or enslave their persons; but merely to do them good, and enable them as far as in our power lies, to live as comfortably as ourselves" (18:216).

Women only to cultivate the Ground: their Men are all Warriors"
(10:296). In general, rather than being industrious and frugal in
pursuit of material progress, the Indians preferred to live lives with
"few artificial Wants" and consequently they have an "abundance of
Leisure . . ." (W10:97). Franklin recognized full well, although he
opposed any compromise with, the seductiveness of the natives'
primitive ways. "The proneness of human Nature to a life of ease, of
freedom from care and labour," he writes, can lead colonists who
had lived among the Indians to a disgust for "the care and pains"
that are necessary to sustain "our manner of life" (4:481–82). Even
Franklin's admission of some of the advantages of the Indians'
ways—for example, that "Happiness is more generally and equally
diffus'd among Savages than in our civiliz'd Societies. No European
who has once tasted Savage Life, can afterwards bear to live in our
Societies" (17:381)—is not enough to cause him to question the
pursuit of material progress. Only when confronted with the worst
aspects of the British land system, as he was during his tour of
Ireland and Scotland in 1771, did Franklin express doubt about the
value of 'progress':

> Had I never been in the American Colonies, but was to form my
> Judgment of Civil Society by what I have lately seen, I should never
> advise a Nation of Savages to admit of Civilisation: For I assure you,
> that in the Possession and Enjoyment of the various Comforts of Life,
> compar'd to these People every Indian is a Gentleman: And the Effect
> of this kind of Civil Society seem only to be, the depressing Multitudes
> below the Savage State that a few may be rais'd above it. (19:7)

The British system, however, was not what he was advocating in
America. Rather, it was the industrious and frugal life of a simple
husbandman whose actual progress in America Franklin held up as
the model for the Indians to adopt.

At times, Franklin's blindness to possibilities other than those of
his culture was racist. He writes, for example, in his *Autobiography* of
an incident at Carlisle in 1753, during which a group of Indians fell
under the influence of alcohol:

> they had made a great Bonfire in the Middle of the Square. They
> were all drunk Men and Women, quarrelling and fighting. Their
> dark-colour'd Bodies, half naked, seen only in the gloomy Light of

the Bonfire, running after and beating one another with Firebrands, accompanied by their horrid Yellings, form'd a Scene the most resembling our Ideas of Hell that could well be imagin'd. (A:198)

Franklin's response to their apologetic defense offered the next day—that such a reaction to rum must be in accordance with the designs of the Great Spirit—included both a fair sample of his quick wit and a hint of the Americans' potential for genocide. He writes: "indeed if it be the Design of Providence to extirpate these Savages in order to make room for Cultivators of the Earth, it seems not improbable that Rum may be the appointed Means. It has already annihilated all the Tribes who formerly inhabited the Sea-coast" (A:199).[111]

These negative elements in Franklin's understanding of the American natives, it needs to be emphasized, are not the whole of the story. One late pamphlet entitled "Concerning the Savages of North America" begins: "Savages we call them, because their Manners differ from ours, which we think the Perfection of Civility; they think the same of theirs" (W10:97). We frequently find him pointing to injustices done to them by Whites. On one occasion, for example, while not pretending to justify the "Perfidy and Inhumanity" of a group of Indians, his characterization of them as "Rum-debauched, Trader-corrupted Vagabonds and Thieves" (11:62–63) indicated where he thought a substantial portion of the blame for their conduct should be fixed. On another occasion, he admitted that "our Frontier People are yet greater Barbarians than the Indians, and continue to murder them in time of Peace" (13:416). In 1787 he summarized his view that the ultimate blame for violence between Whites and the Indians should be assigned primarily to the misdeeds of the constantly encroaching settlers: "During the Course of a long Life in which I have made Observations on public Affairs, it has appear'd to me that almost every War between the Indians and

[111.] Cf. Cotton Mather's 1720 account of God's preparation for the Puritans' arrival in New England: "the good hand of God now brought them to a country wonderfully prepared for their entertainment, by a sweeping *mortality* that had lately been among the natives . . . The Indians in these parts had newly, even about a year or two before, been visited with such a prodigious pestilence, as carried away not a *tenth*, but *nine parts* of *ten*, (yea, 'tis said, *nineteen* of *twenty*) among them: so that the woods were almost cleared of those pernicious creatures, to make room for a *better growth*" (*Magnalia Christi Americana*, 1:51).

Whites has been occasion'd by some Injustice of the latter towards the former" (W9:625).[112]

With regard to Blacks, the other major racial group in Franklin's American situation, his writings repeat the standard prejudices. We find here and there the usual stereotypes—for example, "[t]hey make good Musicians" (21:151)—and the occasional piece of speculative physiology—for example, as to the 'causes' of what he thought might be their ability "to bear the sun's heat better than whites do" although "they do not bear cold weather so well . . ." (8:111).[113] At times, Franklin moved beyond such prejudice to explicit racism. One such instance was when he writes that the majority of American Negro slaves are "of a plotting Disposition, dark, sullen, malicious, revengeful and cruel in the highest Degree" (17:41).[114] Another was when he wonders why the colonists should "increase the Sons of Africa, by Planting them in America, where we have so fair an Opportunity, by excluding all Blacks and Tawneys, of increasing the lovely White and Red?" In defense of this attitude he notes that "such Kind of Partiality is natural to Mankind" (4:234). While such prejudice may be 'natural,' Franklin realized later that it functioned to exacerbate inequalities by sanctioning discriminatory actions in areas like education. He reports, for example, that after a thorough visit to "the Negro School" in Philadelphia in 1763, during which he oversaw classes in reading and catechism, he had developed "a higher Opinion of the natural Capacities of the black Race, than I had ever before entertained. Their Apprehension seems as quick, their Memory as strong, and their Docility in every Respect equal to that of white Children" (10:395–96). Still, little changed in the education situation of Black children in spite of Franklin's efforts, and in 1774 he could still write that free Blacks "are not deficient in natural Understanding, but they have not the Advantage of Education" and as a consequence find themselves "improvident and poor" (21:151).

With regard to human slavery, Franklin moved during the course

[112] Cf. 7:23–24; 8:99–101, 264–76, 299. For more on Franklin's relationship with the American natives, see: Julian P. Boyd, "Dr. Franklin: Friend of the Indians"; Johansen, *Forgotten Founders*, 54–97.

[113] Cf. Thomas Jefferson [1787]: "In music they are more generally gifted than the whites . . . [they are] more tolerant of heat, and less so of cold . . ." (*Writings*, ed. Peterson, 266, 265).

[114] Cf. A:213–14; 3:198; 17:43.

of his long life from accomplice to opponent. As a young man, Franklin printed advertisements in his *Pennsylvania Gazette* detailing the qualities of certain slaves available for sale[115]; and he, or members of his family, held slaves throughout most of his adult life.[116] He was able to live with the institution of slavery in part because of the eighteenth century's larger climate of apprenticeship and indenture,[117] and in part because of what he took to be the temporary economic realities behind American slavery. In his 1751 discussion of population increase, for example, he suggested that slavery was not economically viable on its own in the New World and that it persisted only because the Americans, suffering from what he saw as artificial immigration restrictions imposed by the British, could not find a sufficient number of laborers in any other way. Americans purchase slaves, he writes, for the simple reason that "Slaves may be kept as long as a Man pleases, or has Occasion for their Labour; while hired Men are continually leaving their Master (often in the midst of his Business,) and setting up for themselves" (4:230). From Franklin's point of view, the economics of the issue were simple: no potential slaveholder would put up with the expenses, risks and inefficiencies of slaveholding if free laborers were readily available; and, when an abundance of free laborers became available, slavery would end.

Franklin's one extended, pre-Revolution discussion of slavery can be found in his 1770 essay, "A Conversation on Slavery." In this piece, written in London while Franklin was a colonial agent, he offers not a defense of slavery itself but rather a counterattack on some aspects of the antislavery position.[118] This essay, in the form of a dialogue, begins with the attack by an 'Englishman' on an 'American' for the colonists' willingness to own slaves despite the Americans' own "great Clamour upon every little imaginary In-

[115] For some examples, see: 1:186, 272, 345, 378; 2:389–90.

[116] Cf. 3:474; 6:425; 7:203; 8:425; 9:174–75; 12:45 n.3. In his will of 17 July 1788, Franklin forgives a substantial debt of his son-in-law, Richard Bache, "requesting that, in consideration thereof, he would immediately after my decease manumit and set free his negro man Bob" (W10:495).

[117] Carl Van Doren reports that Franklin's maternal grandmother "had been an indentured servant whom Peter Folger had bought for twenty pounds and afterwards married" (*Benjamin Franklin*, 7; cf. 128-129; 1:liii; Gladys Eleanor Meyer, *Free Trade in Ideas*, 30-32).

[118] Franklin was at about the same time defending aspects of slavery in his role as the agent of Georgia (cf. 17:137, 203).

fringement of what you take to be your Liberties . . ." The response of the 'American' begins by minimizing the slavery problem, if not in terms of the number of slaves at least in terms of breadth of white complicity: "In Truth, there is not, take North-America through, perhaps, one Family in a Hundred that has a Slave in it" (17:37–39).[119] The second aspect of Franklin's response was to attempt to minimize the severity of the enslavement itself, especially in those areas where slaves were few in number: "of those who do keep Slaves, all are not Tyrants and Oppressors. Many treat their Slaves with great Humanity, and provide full as well for them in Sickness and in Health . . ." Franklin's next point was to remind the Englishman of his country's deep involvement in the development of American slavery: "You bring the Slaves to us, and tempt us to purchase them." While the American recognized that this could not "justify our falling into the Temptation," it certainly should undercut any pretense on the part of the Englishman to be merely a spectator. "To be sure," the former continues, "if you have stolen Men to sell us, and we buy them, you may urge against us the old and true saying, that *the Receiver is as bad as the Thief*"; but, at the same time, it remains undeniable that "*the Thief is as bad as the Receiver*." Moreover, Franklin points out, no colony was permitted to take action against slavery: "your Government will not suffer a Colony by any Law of it's own to keep Slaves out of the Country . . ." (17:39–41).[120] His final point was that conditions in the mother country were far from perfect for the "working Poor" (17:39), and were especially bad for some. Franklin mentions first the condition of the miners in Scotland. "All the Wretches that dig Coal for you, in those dark Caverns under Ground, unblessed by Sunshine, are absolute Slaves by your Law, and their Children after them, from the

[119.] The accuracy of Franklin's data is questioned in the following counterestimate of Claude-Anne Lopez and Eugenia W. Herbert: "Not one family in a hundred kept slaves, he declared at a time when the number was closer to one family in five even in Philadelphia (including his own)" (*The Private Franklin*, 298; cf. Gary B. Nash, "Slaves and Slaveowners in Colonial Philadelphia," 236, 243).

[120.] Cf. Thomas Jefferson [1774]: "The abolition of domestic slavery is the great object of desire in those colonies, where it was unhappily introduced in their infant state. But previous to the enfranchisement of the slaves we have, it is necessary to exclude all further importations from Africa; yet our repeated attempts to effect this by prohibitions, and by imposing duties which might amount to a prohibition, have been hitherto defeated by his majesty's negative . . ." (*Writings*, ed. Peterson, 115–16; cf. 22, 337).

Time they first carry a Basket to the End of their Days." Secondly, Franklin points to the situation of their sailors and especially their soldiers, who are deprived of any effective freedom and, in the case of the soldiers, of freedom of conscience as well. In America, he writes,

> We cannot command a Slave of ours to do an immoral or a wicked Action. We cannot oblige him, for Instance, to commit MURDER! If we should order it, he may refuse, and our Laws would justify him. But Soldiers must, on Pain of Death, obey the Orders they receive; though, like Herod's Troops, they should be commanded to slay all your Children under two Years old, cut the Throats of your Children in the Colonies, or shoot your Women and Children in St. George's Fields. (17:43–44; cf. W9:298)

While this "Conversation" certainly represented no defense of slavery, it attempted to undermine the case of slavery's opponents and thus prefigured the numerous nineteenth-century counterattacks on Abolitionism.

Another part of Franklin's belated recognition of the evil of slavery was his inability to grasp the nature of living in enslavement from the point of view of the slaves. We can contrast, for example, his just-mentioned claims that not all slave owners are 'tyrants and oppressors' and that many treat their slaves 'with great humanity' with his own severe chafing at the inconveniences of his much gentler and temporary apprenticeship to his older brother, James. Franklin writes quite convincingly from his own point of view of the effect of this apprenticeship on him, noting that James's "harsh and tyrannical Treatment of me, might be a means of impressing me with that Aversion to arbitrary Power that has stuck to me thro' my whole Life" (A:69n).[121] While he may have had this aversion, Franklin failed until very late in his life to carry it far enough and generalize its meaning. He writes in the 1751 edition of his essay on population increase, for example, that one of the economic disadvantages of

[121.] For another instance of Franklin's unbalanced rhetoric, see his message to the Massachusetts House of Representatives of 15 May 1771, in which he predicts that the two possibilities of a war with Britain are "ruin to Britain" or "absolute slavery to America" (18:103; cf. 30:549). Franklin, of course, was not alone in this linguistic abuse. Cf. Silas Downer [1768]: "The *common people* of *Great-Britain* very liberally give and grant away the property of the *Americans* without their consent, which if yielded to by us must fix us in the lowest bottom of slavery: For if they can take away one penny from us against our wills, they can take all" ("A Discourse at the Dedication of the Tree of Liberty," 104).

depending upon slavery was that "almost every Slave [is] *by Nature* a Thief . . ." (4:229). Such a myopic reaction both violated his own sense of the potentials of human nature and blamed the slaves for their attempts to survive within the crippling institution.[122] Blinder still to the reality of living in enslavement were such comments as Franklin's outraged attacks on England's attempts—during the Revolutionary War based upon the assertion that all men are created equal—to interfere with America's war effort by attempting to get "our Slaves to murder their Masters" (23:310).[123] If all humans were truly equal, then a more consistent Franklin, egalitarian as well as revolutionary, should at least have been calling for immediate emancipation himself.

It took Franklin—the champion of common persons in their attempts to build better lives for themselves and their families and communities—until nearly the end of his life to grasp the necessity to end slavery and to repair its human damages. While a long-time participant in the system, Franklin had never been an advocate of slavery; and, throughout his public career he maintained—at least sometimes—that it was harmful even to the nonslaves. "The Whites who have Slaves, not labouring, are enfeebled," he writes in 1751. "Slaves also perjorate the Families that use them; the white Children become proud, disgusted with Labour, and being educated in Idleness, are rendered unfit to get a Living by Industry" (4:231).[124]

[122.] In the 1769 edition, the phrase "*by Nature*" is wisely replaced by the phrase "from the nature of slavery" (4:229 n.9). Cf. Benjamin Rush [1773]: "we are to distinguish between an African in his own country, and an African in a state of slavery in America. Slavery is so foreign to the human mind, that the moral faculties, as well as those of the understanding are debased, and rendered torpid by it. All the vices which are charged upon the Negroes in the southern colonies and the West-Indies, such as Idleness, Treachery, Theft, and the like, are the genuine offspring of slavery, and serve as an argument to prove that they were not intended for it" ("An Address to the Inhabitants of the British Settlements in America Upon Slave-Keeping," 218; cf. Jefferson, *Writings*, ed. Peterson, 269; *Papers*, 14:492).

[123.] Cf. 22:97, 196, 200, 519; 23:118; 25:65; 28:359; W8:622; W10:110–12. Cf. Thomas Paine, who had written in 1775 that the Americans should consider "[w]ith what consistency, or decency they [the Americans] complain so loudly of attempts to enslave them, when they hold so many hundred thousands in slavery; and annually enslave many thousands more, without any pretence of authority, or claim upon them . . ." (*Writings*, 1:7).

[124.] Cf. Anthony Benezet [1772]: "The low contempt with which they [blacks] are generally treated by the whites, lead children from the first dawn of reason, to consider people with a black skin, on a footing with domestic animals, form'd to serve and obey, whom they may kick, beat, and treat as they please, without their having any right to complain; and when they attain the age of maturity, can scarce be

Another instance is contained in John Adams's account of Franklin's remarks in the confederation debates of 1776 on the harmfulness of slavery to the common good. As Adams reports, Franklin said: "Slaves rather weaken than strengthen the State, and there is therefore some difference between them and Sheep. Sheep will never make any Insurrections."[125]

Only late in his life did Franklin come to accept the moral argument against slavery. This came about through an expansion of his earlier moral claim that the proper service to God was to do good to our fellows by including the slaves among that group. One strong factor in this shift was the ongoing impact of his membership in the Associates of the Late Dr. Bray that began in 1760. While not itself an abolition society—rather, one of its purposes was the instruction and religious conversion of Negroes, enslaved and free—membership in this association helped him to recognize the broader realities of the institution of slavery. Franklin's philanthropic activities had initially attracted the Associates to him for his assistance in setting up various schools in America; and, after his brief return to America in 1762, it was a visit to one of their schools that brought about Franklin's recognition of the Black childrens' intellectual equality cited above. Through his work for this association, and through his interactions with the Quaker, Anthony Benezet, Franklin grew slowly into an abolitionist.[126]

Franklin's earliest abolition piece was brought about by the commotion over the judicial emancipation of one run-away slave, James Sommersett, in England in 1772. Franklin's position here was that it was unseemly for all of this self-congratulation to be taking place over the fate of one person, however important in itself, when at the same time 850,000 Africans were still enslaved in British

brought to believe that creatures they have always looked upon so vastly below themelves, can stand on the same footing in the sight of the Univeral Father, or that justice requires the same conduct to them as to whites . . ." (*A Mite cast into the Treasury*, iii; cf. Jefferson, *Writings*, ed. Pederson, 288).

[125.] Adams, *Diary and Autobiography*, 2:246. For some of Franklin's relevant earlier comments, see: 6:398, 475; 20:296; 22:537.

[126.] For more on the development of Franklin's abolitionism, see: 7:98–101, 356; 9:12–13; 10:395–96; 19:112–16, 269; 20:40–41, 296; Bridenbaugh and Bridenbaugh, *Rebels and Gentlemen*, 253–60; Arthur Stuart Pitt, "Franklin and Quaker Movement against Slavery"; Richard I. Shelling, "Benjamin Franklin and the Dr. Bray Associates"; William E. Juhnke, "Benjamin Franklin's View of the Negro and Slavery."

colonies throughout America and 100,000 more were introduced through the slave trade each year.

> *Pharisaical Britain*! to pride thyself in setting free *a single Slave* that happens to land on thy coasts, while thy Merchants in all thy ports are encouraged by thy laws to continue a commerce whereby so many *hundreds of thousands* are dragged into a slavery that can scarce be said to end with their lives, since it is entailed on their posterity!

What possible justification for slavery could be offered? "Can sweetening our tea, etc. with sugar, be a circumstance of such absolute necessity?" he wonders. "Can the petty pleasure thence arising to the taste, compensate for so much misery produced among our fellow creatures, and such a constant butchery of the human species by this pestilential detestable traffic in the bodies and souls of men?" (19:188).[127] Rather than to continue rejoicing in its little victory, Franklin called upon the antislavery elements in the British public to turn their attention to the larger questions of emancipation of all the slaves or, failing that, of at least ending the slave trade and "declaring the children of present Slaves free after they become of age" (19:188).[128]

During his diplomatic efforts before and during the Revolutionary War, slavery was reduced to a background concern in Franklin's thought; but after his return to Philadelphia from France, he became more outspoken in his condemnation of slavery and of "the abominable African Trade . . . the diabolical Commerce" (W9:627). He also served as the President of the Pennsylvania Society for Promoting the Abolition of Slavery from 1787 to his death in 1790.[129] The 1787 constitution of this Society asserts that God was pleased "to make of one flesh, all the children of men," and that the members of the Society took it as their job "to extend the blessings of freedom to every part of the human race," especially the enslaved.[130] In a 1789

[127] Cf. W9:6, 404. Cf. Benjamin Rush [1773]: "No manufactory can ever be of consequence enough to society to admit the least violation of the Laws of justice or humanity" ("An Address to the Inhabitants of the British Setlements in America Upon Slave-Keeping," 219).

[128] Cf. W10:61–62; Conner, *Poor Richard's Politicks*, 83–84.

[129] This society had been founded in 1775, but was restructured in 1787 with Franklin as its head.

[130] *Constitution of the Pennsylvania Society for Promoting the Abolition of Slavery, and the Relief of Free Negroes, Unlawfully Held in Bondage*; cf. W10:127–29.

general appeal for support and funding for the Society, Franklin asserts that slavery itself is "an atrocious debasement of human nature." As an elaboration of what is intended by this phrase, the appeal continues:

> The unhappy man, who has long been treated as a brute animal, too frequently sinks beneath the common standard of the human species. The galling chains, that bind his body, do also fetter his intellectual faculties, and impair the social affections of the heart. Accustomed to move like a mere machine, by the will of a master, reflection is suspended; he has not the power of choice; and reason and conscience have but little influence over his conduct, because he is chiefly governed by the passion of fear.

So severe in fact were the long-term deleterious effects of enslavement that the simple emancipation of a slave would be "a misfortune to himself, and prejudicial to society." Instead, we find a call for an organized social program: "To instruct, to advise, to qualify those, who have been restored to freedom, for the exercise and enjoyment of civil liberty, to promote in them habits of industry, to furnish them with employments suited to their age, sex, talents, and other circumstances, and to procure their children an education calculated for their future situation in life . . ." (W10:67–68). These were not, of course, extraordinary skills that Franklin and his colleagues hoped to develop in the freedmen. They were rather the simple powers of adult persons who have been allowed to choose and direct their own lives, who have experienced the educating choices of normal living.

By this time, however, slavery had been incorporated into the Constitution, in spite of the fact that it asserts in its Preamble that one of its aims is to "secure the Blessings of Liberty to ourselves and our posterity." Moreover, at the Convention Franklin had assented to the inclusion of slavery. As he remarked later, it was necessary to yield on some points to achieve union: "the wisest must agree to some unreasonable things, that reasonable ones of more consequence may be obtained . . ." (W9:659). In the light of subsequent history, we may well wonder whether the better consequences *were* obtained or whether, as Theodore Parker asserts, Franklin's acquiescence to the continuation of slavery at the Constitutional Convention was "the great fault of his

life."[131] In any case, Franklin was soon resuming his abolition efforts. Franklin appealed as the president of the Pennsylvania abolition society to the members of the first Congress, meeting in New York City in 1790, to recognize the unity of humankind and to adopt the belief of the society "that equal liberty was originally the portion, and is still the birth-right of all men . . ." In this way, Franklin and the other members of the society hoped to get the federal government to address the issue of slavery and "devise means for removing this inconsistency from the character of the American People . . ."[132]

This and other agitation against slavery did not go unnoticed by pro-slavery congressmen; and many spoke out sharply in its defense. On 11 and 12 February 1790, Representative James Jackson of Georgia, responded to Franklin's just mentioned petition, and to another by the Quakers that called for the elimination of "the gross national iniquity of trafficking in the persons of fellow-men . . ." In addition to offering a number of economic arguments in defense of slavery, Jackson asserts that if the opponents of slavery "were to consult that book [i.e. the Bible], which claims our regard, they will find that slavery is not only allowed but commended." The record of his remarks continues: "Their Saviour, who possessed more benevolence and commiseration than they pretend to, has allowed of it; and if they fully examine the subject, they will find that slavery has been no novel doctrine since the days of Cain" and that anyone who examines "that evidence upon which the Christian system is founded" will find that "from Genesis to Revelations . . . religion is not against it . . ."[133] On 23 March 1790, less than a month before his death, Franklin published an attack on slavery in the form of a parody of Jackson's remarks. In this response, transformed from his contemporary American racial context into an Arabic religious one

[131.] Parker, *Historic Americans*, 16. Cf. James Parton: "Benjamin Franklin was an abolitionist; but he felt it to be his duty to assent to the compromises of the Constitution, rather than see the Confederation broken up, and the malign predictions of European ill-wishers so speedily fulfilled . . . The very compromises of the Constitution, which seemed to give a kind of national sanction to slavery, were admitted only because the majority of the Convention took it for granted that an anomaly so palpably absurd and inconsistent as slavery, would not, could not stand its ground against the new spirit of the age" (*Life and Times of Benjamin Franklin*, 2:578, 606).

[132.] Joseph Gales, *Debates and Proceedings of the Congress of the United States*, column 1198.

[133.] Gales, *Debates and Proceedings*, columns 1183, 1187, 1200.

of a century earlier, 'Sidi Mehemet Ibraham' defends the continued enslavement of 'infidels.' As Franklin presented this 'defense' of enslaving Christians, it contained all of the familiar economic points from the Congressional debate, now directed against the Christians: "If we forbear to make Slaves of their People, who in this hot Climate are to cultivate our Lands? Who are to perform the common Labours of our City, and in our Families? . . . who is to indemnify their Masters for the Loss? . . . if we set our Slaves free, what is to be done with them?" In addition to these questions, there are the familiar excuses that "Men long accustom'd to Slavery will not work for a Livelihood when not compell'd," and (in a fashion nearly identical to his own remarks in "A Conversation on Slavery" of twenty years earlier) that "[t]he Labourers in their own Country are, as I am well informed, worse fed, lodged, and cloathed." Franklin reports that the climax of the speech was—parallel to Jackson's claim that slavery has biblical roots—the religious justification: "How grossly are they mistaken in imagining Slavery to be disallow'd by the Alcoran!" (W10:88–90).

CHAPTER 6
Franklin and the Pragmatic Spirit

In the *ALMANACK* for 1749, Poor Richard reminds us: "*Words may shew a man's Wit, but Actions his Meaning*" (3:336). In this and other instances of Franklin's essentially Pragmatic spirit we see the fundamental direction of his thinking. Actions, results, consequences are what matter to the lives of humans; discussions, theorizing, and speculation that do not contribute to human betterment are secondary. (This is not to say, of course, that they cannot be enjoyable diversions—like the chess playing and magical squares and circles that we have considered [above, 5.4]—only that in our world of limits and needs such diversions are secondary). Now that we have considered the central topics of Franklin's thought and we have developed a fuller sense of who Franklin, the scientific and religious and moral and political thinker, was through examining his writings and his actions, we can once again consider the questions of the meaning of Franklin with which we began. The answer that has emerged during the course of this study is that Franklin was a Pragmatist, a thinker who presented the advancement of a richly conceived model of human well-being as his goal. As such, Franklin was offering for our consideration a model of wisdom, a philosophy. This interpretation of Franklin's meaning, which has provided the skeleton of the preceding chapters, can now be made explicit.

6.1. Franklin's Pragmatism

Paul Conkin writes that Franklin "may be the American Socrates," but he questions at the same time "whether this is a compliment to America or a horrible indictment of it?"[1] We have encountered a number of interpreters (above, 1.3) who suggested that the latter was

[1] Conkin, *Puritans and Pragmatists*, 74.

the case. I hope that my presentation of the various facets of Franklin's life and work has convinced readers that these negative evaluations are misinterpretations—of both Franklin and America—and perhaps even convinced them that the idea of Franklin as the 'American Socrates' is a compliment to both. The latter evaluation will be possible, however, only if we are able to recognize the positive value of a perspective that advocates practicality and discipline and service.

In our examination of Franklin's work in science or natural philosophy, we found him to be a dedicated and successful experimentalist who could look back late in his life with some regret on his shortened periods of research as times "in which I always found the highest Satisfaction" (31:128). The brevity of these research periods resulted from the fact that he could have time for scientific inquiry only when his efforts were not needed elsewhere. When he was able to do research, Franklin addressed clearly recognizable scientific issues and problems—like electricity and lightning, heating, geology, navigation, music, medicine, and so on—and worked with available materials toward solutions that he hoped would advance human well-being. The job of the scientist, he thought, was to uncover the facts about nature and ultimately to produce practical benefits; without such advancements in human well-being, the scientist's efforts may be personally diverting and even fulfilling, but they remain a social loss. As Franklin wrote to Cadwallader Colden in 1750:

> I wish you all the Satisfaction that Ease and Retirement from Publick Business can possibly give you: But let not your Love of Philosophical Amusements have more than its due Weight with you. Had Newton been Pilot but of a single common Ship, the finest of his Discoveries would scarce have excus'd, or atton'd for his abandoning the Helm one Hour in Time of Danger; how much less if she had carried the Fate of the Commonwealth. (4:68)

There are thus two sorts of Pragmatic limits on our scientific inquisitiveness: our time and effort must not be more needed elsewhere, and we must remember that eventually we will be called upon to pay some sort of social dividends for the years spent on the social dole.

At times, this Pragmatic stance may seem a little short-sighted. For example, as we have seen (above, 2.1), Franklin writes that it is of

little importance "to know the Manner in which Nature executes her Laws; 'tis enough, if we know the Laws themselves" (4:17). The obvious reading of this and similar statements is that it is necessary to know *how* things work, but unnecessary to know *why*; and the equally obvious criticism of these statements would be that it is short-sighted on Franklin's part to fail to see that we are not likely to attain much control beyond the most simple cases unless we are able to uncover *why* things work as they do. A fuller reading of this and similar passages, however, would include the moral theme of dealing with the necessary constraints on our time. For Franklin, it is a mistake to keep searching fruitlessly for the *why* when the *how* can be put to use already. It is, moreover, an even greater mistake if in our ongoing searches for the *why*, and the *why* of the *why*, we happen to forget that we were looking for a *how*. There is, in addition to these charges of short-sightedness, the further charge of crudeness in this dedication to the task at hand. Franklin's desire to advance the ordinary lives of simple folk has caused him at times to dismay many of his critics: as evidenced, for example, in his often expressed preference for a recipe for parmesan cheese over a transcription of the writings on an ancient tablet (above, 2.4). Still, for all his potential to be read as short-sighted and crude, Franklin is offering us a vision of the role of science, tempered by fallibility and committed to public inquiry, as a tool in the advancement of humankind. This aspect of Franklin's thought and work is Pragmatic.

Franklin's religious life began in Puritanism, reacted early to its strictures, and then swerved widely from the orthodox path in a brief period of free thought. At the extreme, in *A Dissertation on Liberty and Necessity, Pleasure and Pain*, he rejects human freedom and declares responsibility irrelevant. Soon after, however, in his essay, "On the Providence of God in the Government of the World," he supports the opposite position of the reality of freedom. Eventually Franklin concluded that this issue, like many other issues of a broadly religious nature, did not lend itself to resolution. In consequence, he decided that this sort of inquiry itself should be abandoned in favor of the pursuit of "*Truth, Sincerity and Integrity* in Dealings between Man and Man" (A:114), and his Pragmatic emphasis upon responsibility directed the rest of his life. Franklin thus turned from what he saw as the futility of doctrinal disputes to a focus upon advancing human well-being through service. The religious stance that he eventually adopted, Deism, offered a kind of

minimal theological perspective: in a universe created by a loving but distant God, we are basically on our own to use our reason to solve through cooperative and rational means the mysteries of nature so that we might live more comfortable lives. With this theological scaffolding in place, Franklin was able to reject more complex religious systems, maintaining that they absorb valuable time and deflect limited energy from service into theological debates. Worse still, these more complex religious systems often follow these inconclusive debates with attempts to enforce their orthodoxies against the claims of conflicting systems. Throughout Franklin's religious thought runs the central importance of naturalized religion for directing our concerns to human well-being. This aspect of Franklin's thought and work is Pragmatic.

Franklin's moral thinking, once it is expanded beyond the economic texts of *Poor Richard* that fascinated individuals like Max Weber, becomes a rich philosophical defense of service to advance the common good. As we have seen in chapter 3, Franklin began with a focus upon a personal moral regimen—so alien to D. H. Lawrence and others—by means of which he hoped to develop virtues like temperance and order and justice. His moral vision was not exclusively personal, however, and he also considered the worth of social customs through an evaluation of the results that they produced. Throughout, his emphasis was upon the development of a morality that aimed at expanding happiness. It is only in this Pragmatic context of seeking to advance human well-being that it is possible to understand adequately his emphasis upon the development of certain virtues, especially industry and frugality, and upon the curtailment of religious interference in people's lives. Franklin's is thus a natural morality, a moralty that emphasizes human consequences over theological grounding and sanctioned precedents. His is also an intense morality that, whether or not we decide to characterize it as 'Puritan,' certainly brings home to all who consider it seriously the necessity for increased efforts to expand human well-being. This aspect of Franklin's thought and work is Pragmatic.

Finally, we have considered Franklin's political efforts. His understanding of social life and the institutional machinery that is necessary to make it successful led him to advocate a series of unifying structures to advance the common good. His recognition of necessities beyond the structural led him to emphasize cooperative procedures like dialogue and education to foster greater democracy.

(All of this needs to be understood, of course, within the unfortunate limits of his social situation on matters of gender and race and class—customary limits that he was by and large *not* able to escape.) His political goal was always the advancement of a working system of self-government rather than the formulation of an ideal system; his focus was upon advocating a policy or opposing a proposed law, not producing a treatise. His belief was that for a system of self-government to work it must be responsive to the realities of new situations and new developments. This Pragmatic spirit is often disparaged in politics (and ethics) because it seems devoid of 'principle'; but, of course, acting to advance human well-being, and fostering lives of virtue and service to make this advance possible, surely demonstrates some kind of principle. If we concern ourselves with addressing specific political problems rather than with theorizing about more abstract topics, and if we continue our attempts at cooperative inquiry and experimentation to address these problems, we should be able to create better social lives for ourselves and our children. This aspect of Franklin's thought and work is Pragmatic.

Overall, Franklin's Pragmatism represents a rejection of what he saw as metaphysical inquiry and its replacement with inquiries that are aimed at enlightening common experience and advancing the common good.[2] While the notion of 'metaphysics' in general may carry a vague meaning, we have a fairly clear sense of what Franklin meant when he considered the topic. In the *Almanack* for 1743, he writes for example: "Men differ daily, about things which are subject to Sense, is it likely then they should agree about things invisible" (2:368). The metaphysical enemy that Franklin opposed was the invisible and the unknowable, especially as it was able to draw us into speculative discussions and away from our service obligations. As an instance, we can point again to his own contradictory analyses of freedom contained in his *Dissertation* and in the subsequent essay on the providence of God. He soon realized that this metaphysical inquiry was to have no positive results, leading rather to both wasted time and actual harm. His focus remained therefore on the natural world and our likelihood of practical success within it; and his interest in freedom was naturalized into the pursuits of economic

[2.] Franklin, of course, was not alone here. As Carl L. Becker writes of the general mood of the eighteenth-century philosophers: "They scorned metaphysics, but were proud to be called philosophers" (*The Heavenly City of the Eighteenth-Century Philosophers*, 30-31; cf. 35; Read, "Doctor Franklin as the English Saw Him," 50).

security and (later) political independence. One commentator writes that "Franklin simply passes by the problem of the relation between reality and appearance. In this world, appearance is sufficient."[3] My response to this comment would be to suggest that Franklin is in no way satisfied with 'appearance.' As I have suggested (above, 4.4), for Franklin appearances almost always supplement reality rather than replace it: it is important for a young shopkeeper not only *to be* a good business risk but also *to be recognized to be* one. It is, moreover, almost always foolish to expect to appear to be a good risk without actually being one. For Franklin, occasional slippages aside, experience can be trusted; and what appears to be, is. There is no other realm to which metaphysics can introduce us.

Franklin wrote in a number of places of the inherent problems of metaphysical inquiry, especially of our inability to test our ideas and speculations when no direct experience is possible. We have just seen his warning about seeking agreement regarding 'things invisible.' In another place, he puts his point as follows:

> The great Uncertainty I have found in that Science [i.e. metaphysics]; the wide Contradictions and endless Disputes it affords; and the horrible Errors I led my self into when a young Man, by drawing a Chain of plain Consequences as I thought them, from true Principles, have given me a Disgust to what I was once extreamly fond of. (3:88–89)[4]

Elsewhere he returned to the issue of metaphysical freedom and wrote of his earlier interest, "[t]he great Uncertainty I found in Metaphysical Reasonings, disgusted me, and I quitted that kind of Reading and Study, for others more satisfactory" (31:59). In the *Autobiography*, he again complains of the problem "common in

[3] John William Ward, *Red, White, and Blue*, 138–39. Cf. Mitchell R. Breitwieser: Franklin had a "resolute ideological avoidance of mystery—everything that counts, for Franklin, is in the open . . ." (*Cotton Mather and Benjamin Franklin*, 178).

[4] Cf. Gerald Stourzh: "He sacrificed 'reason' to 'experience.' He turned away from metaphysics for the very pragmatic reason that his denial of good and evil [in the *Dissertation*] did not provide him with a basis for the attainment of social and individual happiness . . . Reason, as a temper in the conduct of human affairs, counted much with Franklin . . . Reason, as a faculty of the human mind stronger than our desires or passions, counted far less . . . Trial and error appeared to Franklin a better guide to public and private felicity than abstract reasoning" (*Benjamin Franklin and American Foreign Policy*, 9, 13; cf. Dunn, "From a Bold Youth to a Reflective Sage," 518).

metaphysical Reasonings" of having errors insinuate themselves "unperceiv'd into my Argument . . ." (A:114). It seems clear, then, that for Franklin arguments about speculative topics like freedom (and immortality and the Divine) are 'metaphysical' because they begin without any initial agreement on the interpretation of evidence and they drag on unable to agree on what would constitute a decisive conclusion. Metaphysical debates about 'things invisible,' guided by abstract rules of reasoning, will yield no resolutions, and such speculation is thus interminable. At the same time, we remember that for Franklin "Opinions should be judg'd of by their Influences and Effects . . ." (2:203). The effects of disputes over metaphysical opinions are far too often negative, whether we intend to indicate by this the harmful effects of the morally repugnant conduct of Franklin and his rudderless young comrades (cf. A:114; 3:88–89) or simply the unfortunate effects of wasting too much time and energy when it is more important to focus upon *this* world.[5]

Franklin was no doubt indifferent to questions that he saw as having no practical impact. I would maintain, however, that pointing to this indifference should not of itself throw into doubt Franklin's intellectual or philosophical status. In a limited world that requires us to evaluate how we are to direct our finite energies, indifference to thought that has no impact on practical conduct—especially when 'practical' is conceived in the broad way that Franklin conceives it— is not necessarily an intellectual or philosophical vice. Such indifference similarly should not be read to suggest further, as one commentator believes it does, that Franklin suffered from "mental aversion to abstract thought."[6] It is a mistake to allege either that Franklin had a problem with all abstraction, or that this alleged problem resulted from mental aversion. Is it not possible, rather, to see his indifference to some abstract thinking as a rational choice for allocating finite

[5] Cf. Albert Henry Smyth: Franklin "knew no sad torment of the thoughts that lie beyond the reaches of our souls; he was undisturbed by the burden of the mystery of the heavy and the weary weight of all this unintelligible world. While the New Englanders were contemplating with awe the dread mysteries of Eternity, he was minding his shop and his small concerns of earth. A frank acceptance of the material world and a desire to do some practical good in it—these things were the life of Franklin . . . He did not squander his thought in desperate ventures of new-found and foggy metaphysics" (*The Life of Benjamin Franklin*, 160–61; cf. Levin, "The Autobiography of Benjamin Franklin," 272–73).

[6] Paul K. Conkin, *Puritans and Pragmatists*, 79; cf. Eiselen, *Franklin's Political Theories*, 1; Noah Porter, "Philosophy in Great Britain and America," 451.

time and effort? Elizabeth Flower seems much closer to a proper estimation of Franklin's Pragmatism when she writes that in his view: "speculative thought which has no practical application has no value. Metaphysical dogmas which do not yield empirical consequences, religious faith which does not issue in good works, and ethical convictions which do not affect conduct he considered worthless."[7] Further, Herbert W. Schneider points to Franklin's separation, one necessary in an intellectual climate where, as we have seen (above, 2.2), the installation of a lightning-rod carried theological and metaphysical implications, between work in ethics and work in theology (above, 4.5). Schneider praises Franklin for making this separation: "this divorce between morals and 'philosophy' is a mark not of his philosophical ignorance, but of his moral wisdom."[8]

Following Flower and Schneider, I would maintain that this Pragmatic separation is the mark of a philosopher; and such a Pragmatic stance can certainly be a philosophical position. We might well wonder how the pursuit of wisdom, philosophy's historic mission, was ever allowed to separate from a broad sense of human well-being. Franklin himself poses the question this way: "What signifies Philosophy that does not apply to some Use?" (9:251). When he busied himself with practical problems like inventing a new type of stove for more effectively heating a home, or developing procedures for avoiding theological disputes, or constructing an algebra for more easily solving moral dilemmas, or establishing an institution to better organize the availability of books, he was applying philosophy to some use.[9] While Franklin admits that these practical problems may appear on some philosophical scales as "trifling Matters" or affairs of a "seemingly low Nature" (A:207), for him, and I would maintain for us, they are the elements of

[7] Flower and Murphey, *A History of Philosophy in America*, 1:111. Cf. Robert Ulich: Franklin "was a man of action, not of theory; thinking was for him a means, not an end in itself; the end for him was a better life" (*History of Educational Theory*, 234).

[8] Schneider, "The Significance of Benjamin Franklin's Moral Philosophy," 300.

[9] Cf. Henry Cabot Lodge: "Franklin was certainly devoid of enthusiasm, and yet one unbroken purpose ran strongly through his life and was pursued by him with a steadiness and force which are frequently wanting in enthusiasts. He sought unceasingly the improvement of man's condition here on earth . . . he was always seeking to instruct and help his fellow-men and to make their lot a better and happier one" (*A Frontier Town and Other Essays*, 261).

human life, and their solutions represent a part of the advancing of wisdom that has always been philosophy's task.

I am not alone in suggesting this Pragmatic connection. It is possible to find numerous comments scattered in the secondary literature to the effect that Franklin was the original American Pragmatist. Let us consider a few of them. "If he is to be classified as a *mental* philosopher at all," Howard McClenahan writes, distinguishing Franklin from a *natural* philosopher, then, far from being a "metaphysical speculator," Franklin "must certainly be classed as the original American Pragmatist." Gaylord P. Harnwell notes that Franklin was "sage and ultimate pragmatist of the Colonies . . ." Paul H. Douglas, drawing upon Franklin's emphases upon scientific method and its prudential application to the advancement of human well-being, maintains that he was "the real founder in this country of the philosophy of life which later became called pragmatism . . ." For Charles Hartshorne, Franklin "was a pragmatist more than a century before the movement bearing that name." Alfred Owen Aldridge writes that Franklin "was devoted to the spirit of compromise rather than to formal consistency—a pragmatist in the best sense." Elizabeth E. Dunn comments that "Franklin's pragmatism" demonstrates "doubts concerning the practicality and utility of basing one's philosophy on truths and principles divorced from their effects and the behavior they precipitate." Finally, Richard B. Morris writes: "To the first American pragmatist what was moral was what worked and what worked was moral."[10] This quick survey of the secondary literature offers us a general sense of what the authors take to be Franklin's Pragmatic spirit rather than any coherent presentation of what Pragmatism means. Thus, without being wedded to the potentially errant implications of any of these formulations, it is possible to note that they collectively recognize the following important points in Franklin's thinking: that we are social creatures, that this world and our experience in it must be the focus of our thinking, that this thinking is of necessity evaluative. This social and practical and evaluative core of Franklin's thinking is Pragmatic in nature.

[10] McClenahan, "Franklin, the Philosopher and Scientist," 172; Harnwell, "Franklin's Impetus to Education," 111; Douglas, "Two Eighteenth Century Philadelphians," 132; Hartshorne, *Creativity in American Philosophy*, 32; Aldridge, *Benjamin Franklin*, 415; Dunn, "From a Bold Youth to a Reflective Sage," 518; Morris, *Seven Who Shaped Our Destiny*, 12.

6.2. Pragmatism and the American Spirit

In this final section, I would like to consider the contributions of Franklin's Pragmatism to the history of American philosophical thought. In the course of this study, we have seen occasional commentators defending the position that Franklin was a philosopher. We remember, for example, Hume's evaluation of Franklin as America's 'first philosopher' and Jefferson's endorsement of him as 'the father of American philosophy' (above, 1.1). We have also seen others who, while willing to grant that Franklin was certainly a 'sage,' strongly maintained that he was not a philosopher. The majority of historians of American philosophy, whose opinions certainly deserve serious attention, have in this fashion rejected Franklin as a philosopher. Before we simply affirm or deny that Franklin is properly characterized as a philosopher, however, we must consider the complexity of the question. We should remember that all of these suggested answers partake in the richness and diversity of two hundred years of development in the meaning of the term 'philosophy' itself, and that the fine points of any particular usage seldom accompany it. If we allow for a sense of 'philosopher' that incorporates the broad pursuit of wisdom and the inherited sense of 'natural' philosophy that connects up through this pursuit of wisdom with inquiries into our place in nature, then Franklin's status as a philosopher seems secure.[11] If, on the contrary, we decide to limit ourselves to something like our current academic meaning of 'philosophy'—focussing upon technical academic questions, or the meanings of concepts, or the machinery of reasoning, or the nature of consciousness, or metaethics, or even surveys of the ideas of significant past philosophers—whatever other merits Franklin might have, *as a philosopher* he would probably drop out.

Using the narrower conception of 'philosophy' provisionally, suggestions as to why Franklin should be excluded seem to result from his Pragmatic, and therefore 'nonphilosophical,' orientation.

[11.] Cf. Daniel Boorstin: "The meaning of 'philosophy' under American conditions had been vividly exemplified in Franklin himself, who was the first president of the [reorganized] Philosophical Society. The model of the American Philosopher, he was neither a profound nor a reflective man, but pre-eminently observant and inventive . . . To cast up the national debt, to collect fossils, to experiment with electricity, to measure an eclipse, to shape a constitution or a moral creed—all were part of a single 'philosophic' enterprise" (*The Lost World of Thomas Jefferson*, 11–12).

As William P. Grampp notes, Franklin was "not so much concerned with the logical sequence of his ideas as with their practicability."[12] I. Bernard Cohen connects up this point with the one about metaphysics that we have just considered: "Skeptical of any sort of metaphysics, Franklin was not a systematic philosopher, and doctrines of the origin of ideas held no great interest for him."[13] When we move from this pair of commentators, who were not themselves philosophers, to commentators who were more specifically trained in philosophy we continue to find similar sorts of narrow evaluations. Adam Leroy Jones writes, for example, that: "Benjamin Franklin's direct contribution to philosophy was small. Preeminent in political and practical affairs, he thought metaphysics little worthy of attention, as he believed there was no practical benefit to be derived from such study." The evaluation of Franklin by Harvey Gates Townsend was that "[a]s a philosopher, he is unimportant." For Morton G. White, Franklin was one of the "giants on the American scene," but "not primarily" a philosopher. The position of Vincent Buranelli is more detailed. For him, Franklin was a "remarkable man" who, although best described as "not a philosopher" should not be thought of as being "of no consequence to philosophy," since his work has "a certain rigor that is quasi-philosophical (and not pseudophilosophical) . . ." Buranelli then contrasts Franklin with "the genuine philosophers who lived and wrote before the Revolution, the thinkers who attacked the technical problems of being and knowledge, and who reasoned out solutions that still challenge interest." Using this narrower sense of philosophy, Buranelli continues "there are four colonial philosophers who deserve the title in its full meaning: Jonathan Edwards, Samuel Johnson, Cadwallader Colden, and John Witherspoon." To consider just one more instance of a rejection of Franklin as a philosopher, we can turn to Isaac Woodbridge Riley. For Riley, Franklin was "[a] kind of Socrates in small clothes" in whom "the love of wisdom for its own sake, had

[12] Grampp, "The Political Economy of Poor Richard," 140.

[13] Cohen continues: "Franklin was not a true philosopher in the sense that Jonathan Edwards was, but he was a natural philosopher—in that larger sense in which scientific learning and a general outlook on God, man, nature and the world were included within a single expression in a day when scientists were not merely physicists or chemists or astronomers or biologists" ("Introduction" to *Benjamin Franklin: His Contribution to the American Tradition*, 51, 58).

disappeared . . ." Franklin cared, rather, about the uses of thinking. "Instead of advancing to the Aristotelian view that thinking is in itself a good, he returns to the Socratic standpoint which values only the present good, in so far as it leads to the redemption of the individual and the regeneration of society from the the disturbances of life." Riley's specific criterion for exclusion is apparently Franklin's lack of lasting "metaphysical" interests: "With the year 1731, Franklin's metaphysical activities ended; hereafter he showed himself a man of parts, but with one part missing; he was educator, scientist, politician, essayist, diplomat, but no philosopher in the strict sense of the word."[14]

Is it not possible, as I have suggested above, that Franklin could remain a philosopher without ongoing 'metaphysical' interests? Should his failure to address technical issues of central concern to later philosophers eliminate him? Clearly, Franklin was operating with a conception of 'philosophy' that was broader than the more recent conceptions that would force his exclusion from the philosophic ranks. In his eighteenth-century world where philosophy's inclusion of the moral and the natural sciences fostered the broad application of reason as a means to advance human well-being, Franklin offered a broad vision of the pursuit of wisdom.[15] This vision still has value today and deserves to be called 'philosophic.' Moreover, I would maintain that this vision should be considered philosophic, not *in spite of* its being Pragmatic, but *because of* it. Franklin's vision of the human good incorporated the role of education in the process of expanding knowledge as the key to improving the daily lives of average women and men rather than to the personal advancement of the few. This concern with the well-being of these average citizens reflected what Franklin believed was our moral task. "At the day of Judgment," he writes, "we shall not be asked, what Proficiency we have made in Languages or Philosophy; but whether we have liv'd virtuously and piously . . ." (7:89; cf. W8:146). It also reflected what he thought was the broader practical

[14.] Jones, *Early American Philosophers*, 12; Townsend, *Philosophical Ideas in the United States*, 68; White, *Science and Sentiment in America*, 317 n.1; Buranelli, "Colonial Philosophy," 353–54; Riley, *American Philosophy*, 256–57.

[15.] Cf. Adrienne Koch: In the eighteenth-century world, "'philosophy' meant at once the physical sciences and the moral sciences, pursued in the independent secular spirit of experimental and applied intelligence and thus committed to the emancipation of the mind from superstition and prejudice" (*Power, Morals, and the Founding Fathers*, 22).

concerns of his society. In America, he writes, "people do not inquire concerning a Stranger, *What is he?* but, *What can he do?*" (W8:606).

It is possible to misread this last passage as suggesting some sort of exclusive concern with masks or *personae*[16]; but what Franklin was really interested in was the elimination of ascribed status, of social hierarchies derived from the assumed superiority of persons' origins and ancestors. His context for this consideration of 'what' a person is was a discussion of "Birth." He writes: "In Europe it has indeed its Value; but it is a Commodity that cannot be carried to a worse Market than that of America" where people are unconcerned with such forms of presumed status. What earns a person status in America, Franklin writes, is the ability to perform socially useful work: "If he has any useful Art, he is welcome . . ." (W8:605–6). Persons, for Franklin, are thus not holders of antecedent status, but agents of cooperation and contribution who create by their efforts a place for themselves in an advancing society. In the struggle to build this better world, Franklin emphasized the potential role of each in advancing the common good. This democratic and practical conception of the pursuit of wisdom, the heart of Franklin's Pragmatism demonstrated a philosophic approach to the meaning of human existence.

I mentioned in the preface that H. S. Thayer characterizes the Pragmatism of Franklin as "nascent." In a context very different from the familiar academic one in which turn-of-the-century professors explored the nature of the possible integration of intellectual work with life outside of the university through the formulation of a Pragmatic philosophy, Franklin developed an intellectual spirit or a way of life that was equally Pragmatic.[17] His broader sense of Pragmatism envisioned advancing the common good through at-

[16.] Cf. John William Ward: "Think how often in our kind of society when we meet someone for the first time how our second or third question is apt to be, 'What do you do?' Never, 'Who are you?' The social role is enough, but in our more reflective moments we realize not so, and in our most reflective moments we realize it will never do for our own selves" (*Red, White, and Blue*, 139; cf. Ziff, *Puritanism in America*, 307–8).

[17.] Thayer, *Meaning and Action*, 7. Cf. Robert Clifton Whittemore: "With the *theory* of pragmatism [Franklin] was unconcerned. It is doubtful that he would have appreciated the dialectics of Peirce and Dewey. To him the pragmatic was rather a way of life . . ." (*Makers of the American Mind*, 79; cf. Boorstin, *The Americans*, 1:168).

tempts to improve science, religion, ethics and politics, and through rebuilding social institutions by means of cooperative inquiry and education. His broader sense of Pragmatism was a living intellectual perspective that began with the attempt to address specific problems in a tentative and cooperative fashion, that emphasized the importance of duty and service, and that fostered a criterion of weighing the social consequences of our actions as the key to determining proper conduct. And Franklin's broader sense of Pragmatism resembled in many ways the later Social Pragmatism of such figures as James Hayden Tufts, George Herbert Mead, and John Dewey.[18]

It is possible to develop this theme of Franklin and the Pragmatic strain in American culture almost without limit. Henry Steele Commager, for example, writes that theoretical and speculative work "disturbed the American, and he avoided abstruse philosophies of government or conduct as healthy men avoid medicines." Commager continues:

> If he failed to explore those higher reaches of philosophical thought which German and English philosophers had penetrated, it was rather because he saw no necessity for such exploration than because he was incapable of undertaking it; he felt instinctively that philosophy was the resort of the unhappy and the bewildered and knew that he was neither.

Such an individual lived by a Pragmatic philosophy. "Benjamin Franklin was his philosopher, not Jonathan Edwards," Commager continues, "[n]o philosophy that got much beyond common sense commanded his interest . . ." We have seen that there is more to Franklin's philosophy than just common sense, of course, or it could not have carried forward thinking about nature and religion and morality and politics as it did. Still, Franklin always *returns* to the practical realm of common experience, the favored realm of Commager's Pragmatic America. James MacGregor Burns advances along a similar Pragmatic line when he writes that, more than Europeans, Americans had "a willingness to experiment. Americans were accustomed to being tested, in their churches, on their farms, out in the wilderness. They were used to trying something, dropping it, and trying something else. They were good at figuring, probing, calculat-

[18.] For an exploration of aspects of the topic of Social Pragmatism, see: James Campbell, *The Community Reconstructs*.

ing, reasoning things out." In this new American culture, the test of these actions was Pragmatic: what were their consequences. I. Bernard Cohen writes that Franklin attempted to make "each abstraction live in its productive effect upon society rather than live a life of its own. This may not be the dominant philosophy in our history, but Americans have often acted as if it were." They have acted—and continue to act—in a naturalistic and fallible spirit. As Cohen continues, "there is a sense in which practicality implies expediency, and its ascription to the American character would rob our history of the lofty ideals and high purposes which have motivated so many of our leaders and our ordinary citizens; it would make a parody of Franklin as a guide through life."[19]

Many thinkers are unhappy with any sort of naturalism, and with an America that is naturalistic. To such people, Franklin's Pragmatism appears essentially negative. We have encountered individuals earlier in this study who present an extreme interpretation of Franklin and his role in America. All of these negative evaluations must be taken into account, even if we have little reason to accept them, because they are indicators of a vision of society that is hostile to naturalism. He may function for some, as we have seen, as a gross embarrassment to the potential of America or for others as proof that America had no potential. From some comfortable and secure platform of economic well-being, Franklin may now appear to be the original wealth-crazed proto-capitalist. From some refined and exalted platform of cultural superiority, Franklin may now appear to be the original lowbrow. From some specialized and narrow platform of academic isolation, Franklin may now appear to be the original myopic anti-intellectual. To this litany we can add the interpretation of one more commentator, Paul Elmer More. More notes that "both in Franklin's strengths and his limitations . . . he was the typical American." By this, More means especially that Franklin suffered from "the predominance of that essentially American trait—contemporaneity." Franklin lived in the present.

> One gets the impression that here was almost, if not quite, the most alert and most capacious intellect that ever concerned itself entirely with the present. He was, of course, an exemplar of prudence, and

[19.] Commager, *The American Mind*, 8–9; Burns, *The Vineyard of Liberty*, 21; Cohen, "Introduction," to *Benjamin Franklin: His Contribution to the American Tradition*, 63, 49; cf. Matthews, *An Introduction to American Literature*, 36–38.

thus in a way had his eye on the immediate future; but it was the demands of the present that really interested him, and the possession of the past, the long backward of time, was to him a mere oblivion.

As a result of this concentration on the present, Franklin "lacks also that depth of background which we call imagination, and which is largely the indwelling of the past in the present."[20] For More, and for all the others like him that we have considered, Franklin's Pragmatism is a defect, an illness with which he was infected by American society and which he later gave back to American society in a more virulent and damaging form.

Readers must ultimately decide for themselves. These criticisms may all be accurate, and Franklin may be nothing more than an unimaginative 'typical American' with no sense of the past and no value for the future. In addition, the people who have taught and learned from Franklin over the years may be condemned by their naturalism. Philosophers, moreover, may have better things to do than to attempt to refine and reinterpret his Pragmatism. My position, of course, is quite different. For me, Franklin was an individual of tremendous imagination who applied its fruits to the future benefits of his fellows. He understood quite well 'the indwelling of the past in the present'; but, for him, as for Bacon and Newton and Locke, it was the movement of the present into the future that mattered. Franklin's commitment to science and service makes him a model of the Pragmatic intellect by which the American mind has always been drawn. And philosophers, whose task is to pursue wisdom, will seldom find anything wiser to do than to try to advance human well-being.

One commentator who grasped this understanding of the role of Franklin in America and sketched it out in a series of essays was Robert E. Spiller. He writes that "Franklin was our first intellectual leader to master for himself the wisdom of the Western world and to re-examine it strictly in its applicability to American experience." Spiller continues that for Franklin "the inheritance of the Enlightenment—revolt as it was in itself from ancient authority—was worthless unless it could be applied in this philosophical sense to the century and more of fresh experience in settling the new continent." This means for Spiller that in the American context

[20.] More, "Benjamin Franklin," 152–54.

some sort of Pragmatism was necessary. "Whatever his predilections may be toward a life of contemplation and dogmatic belief," Spiller continues, "the American philosopher from the earliest days has been forced out of his assumptions and into a mold of vigorous pragmatism by the very circumstances of his life." An individual like Franklin, whether we characterize him as a philosopher in some narrow sense or not, cannot live in a realm of theory, or retire for contemplation. In Franklin's world "the immediate need for action has always been too great to allow any system of thinking which cannot justify itself by providing swiftly the needs and the minimal comforts of life." Thus Spiller can write that Franklin was "[a] pragmatist long before William James defined the term," and "a pragmatist in that he believes with William James that virtue, like truth, can be measured only by its workability . . ." Moreover, this commentator continues that "[w]hen I call Franklin 'pragmatic,' therefore, I am attempting to describe his whole personality and the meaning of his attitude toward life."[21]

Clearly, Spiller is much closer to a proper understanding of the Pragmatic Franklin and his role in America than the critics just considered. I think that Spiller is also right when he goes on to note that "we can only appreciate Franklin's pragmatism by discovering the same trait in other Americans and seeing it as a dominant strain throughout the long history of our intellectual development." One figure to whom Spiller points is Ralph Waldo Emerson, who offers us in the pragmatism of "The American Scholar" an understanding of the American experience that directs the scholar's focus toward an active existence in nature and away from a passive and second-hand existence through books. As Spiller writes, Emerson "preached an idealization of the moral code of which Franklin was, in many respects, an example. Impatience with books as books is countered by a plea for closer communion with nature and for action." Spiller sees this Pragmatic strain also in James: "It was left to William James to return to the foundations which Franklin had laid by the pattern of his life and to formulate a theory which Franklin had lived

[21.] Spiller, "Benjamin Franklin: Promoter of Useful Knowledge," 40; "Benjamin Franklin: Student of Life," 99; *The Cycle of American Literature*, 15; "Benjamin Franklin: Promoter of Useful Knowledge," 30; "Benjamin Franklin: Student of Life," 84. At times, Spiller himself goes astray in his presentation of Pragmatism, as when he writes that Franklin "believed that whatever works is true because it demonstrates a natural law" (*The Cycle of American Literature*, 15).

without formulation," he writes. Whether or not James succeeded in formulating this theory is not a matter to consider at this point, of course; Spiller's emphasis is rather upon the Pragmatic approach to experience becoming self-conscious. "There is much reason to believe that this modern pragmatism is the characteristic American philosophy, the one which our experience has dictated from the start." Spiller sees this Pragmatic strain as well in Dewey. Dewey's special focus is the education of youth, and Spiller points to Franklin's "lack of concern for abstract theory" and his "practical and far-sighted wisdom with reference to fact." Then, writing of Dewey's educational thought, he notes that "[t]he modern 'activity' school which has developed from John Dewey's pragmatic theories of education, with its emphasis upon the study of the immediate environment, is largely a rediscovery of practices which Franklin advocated in 1749."[22]

My overview of Spiller's fertile sketch of Franklin and Pragmatism is intended to suggest that the interpretation of Franklin that I am offering is not totally novel. Spiller's presentation, however, was no more than a sketch. In this volume, I have laid out Franklin's Pragmatic vision of human well-being through a consideration of his scientific, religious, ethical, and political work, presenting it within the context of a philosophical background. In each of these areas, I have shown that Franklin presents a vision that is both fundamentally Pragmatic on its own terms and clearly within the stream of American philosophy that sought the wisdom necessary to advance a natural and social conception of human well-being. Franklin's vision is thus continuous with those of Emerson, James, and Dewey. I see these four figures as the central pillars of American Pragmatism because each saw as the proper aim of the philosophical endeavor the advance of the common good of society and the overall well-being of the average person. In particular, they addressed the creating and shaping power of social institutions and the place of the individual as interpreter and modifier of this process.

We can sketch out this Pragmatic vision by considering four of its central themes, each of which Franklin, Emerson, James, and Dewey address in compelling ways. One aspect of this large picture is the attempt to understand our *natural place*. Here we find Franklin's presentation of humans as experimenters who are striving for

[22.] Spiller, "Benjamin Franklin: Student of Life," 99–100, 101, 103, 89–90.

control of our natural situation and Emerson's celebration of our relationship with nature. We find as well the post-Darwinian explorations of James and Dewey: the former discussing the embodiment of the live organism; the latter, the meaning of evolutionary thinking for our reconception of our place in nature. A second aspect of this Pragmatic vision is the discussion of *experience*, and again here these four philosophers present vital insights. Franklin offers us an unquestioned appeal to experience in the face of the tyranny of dogma. Experience is central to Emerson as well, only for him the issue is finding all that is of value in a world prone to routinization. For James, what matters is unprejudiced attendance to the stream of experience as it comes so that we can better grasp its meaning. Adopting a critical stance toward experience, hunting for true values amidst the numerous apparent goods, is Dewey's emphasis. The third theme that I see as central to American Pragmatism is the recognition of *possibility*. Franklin focusses on how the individual can make more of his or her life in a directly Pragmatic fashion. Emerson, on the other hand, focusses on the possibilities of appreciation that connect the everyday with the eternal. For James, the issue of possibility has to do with the individual's ability (and responsibility) to create a system of living beliefs that is compelling and free from the interference of others. Dewey's focus is on education, by means of which society can either present the next generation with vibrant possibilities or foreclose on this openness. The fourth theme central to an adequate understanding of American Pragmatism is that of *community*. Franklin's emphasis is on the importance of constructing and maintaining political unification; Dewey's, on the need for ongoing democratic reconstruction. Emerson and James, although often seen as 'individualists,' were both intensely public figures who participated in the intellectual life of their society and who call on us to do the same.

Franklin was thus the presenter of a vision of life that grew in the hands of others into a self-conscious, articulated philosophy. Emerson and James and Dewey performed this task without being themselves particularly cognizant of his contribution.[23] Still, if this

[23.] Some of Emerson's references to Franklin have been cited previously (above, 1.3). James, in a rare reference to Franklin, points to our need to get beyond "the coarse and more commonplace moral maxims" of *Poor Richard* (*Writings*, 612). Dewey's interest in Franklin was primarily as a contemporary of Jefferson (cf. "Presenting Thomas Jefferson"). Peirce's more relevant comments were cited in the discussion of Franklin's science (above, 2.4).

Pragmatic vision of human well-being is as valuable as I believe it is, and if Franklin is clearly at the head of this tradition, then it does seem fair to categorize him as a Pragmatist. As such, it also seems sensible to categorize him as a philosopher, and to treat him as one who deserves a more central place in our discussions of American philosophy. We have, by and large, drifted from his broad social conception of philosophy and from this Pragmatic focus upon the common good. For us, all too often, philosophy is an inward-looking pursuit of the means to begin to prepare to attempt to understand. Similarly, the common good, when it appears as a value at all, is simply connected to whatever we are interested in exploring. This narrower conception of what we are about as philosophers leaves us largely blind to the vision of a thinker like Franklin. It is our sense of what we are about, however, that should be called into question. Recovering Franklin's understanding of the role of a broad conception of science in recognizing possibilities for advancing human well-being, and of service for actualizing these possibilities, will bring us a long way toward changing our conception of philosophy.

Works Cited

Adams, John. *The Works of John Adams*. 10 vols. Edited by Charles Francis Adams. Boston: Little Brown, 1856.

————. *Papers of John Adams*. Edited by Robert J. Taylor, Gregg L. Lint, Richard Alan Ryerson, and Celeste Walker. Cambridge: Harvard University Press, 1977– .

————. *Diary and Autobiography of John Adams*. 4 vols. Edited by Lyman Henry Butterfield, Leonard C. Faber, and Wendell D. Garrett. Cambridge: Harvard University Press, 1961.

Adams, John, et al. *Warren-Adams Letters: Being Chiefly a Correspondence among John Adams, Samuel Adams, and James Warren*. Vol. 2. Boston: Massachusetts Historical Society, 1925.

Adams, Samuel. *The Writings of Samuel Adams*. 4 vols. Edited by Harry Alonzo Cushing. New York: Putnams, 1904–1908.

Ahlstrom, Sydney E. *A Religious History of the American People*. New Haven: Yale University Press, 1972.

Aiken, John R. "Benjamin Franklin, Karl Marx, and the Labor Theory of Value." *Pennsylvania Magazine of History and Biography* 90, no. 3 (July 1966): 378–84.

Aldridge, Alfred Owen. "Benjamin Franklin and Jonathan Edwards on Lightning and Earthquakes." *Isis* 41 (July 1950): 162–64.

————. "Benjamin Franklin and Philosophical Necessity." *Modern Language Quarterly* 12, no. 3 (September 1951): 292–309.

————. *Franklin and His French Contemporaries*. New York: New York University Press, 1957.

————. *Benjamin Franklin: Philosopher and Man*. Philadelphia: Lippincott, 1965.

————. *Benjamin Franklin and Nature's God*. Durham: Duke University Press, 1967.

————. *Early American Literature: A Comparist Approach*. Princeton: Princeton University Press, 1982.

————. "The Alleged Puritanism of Benjamin Franklin." *Reappraising Benjamin Franklin*. Edited by Lemay, 362–71.

Allen, Henry Butler. *Benjamin Franklin, Philosophical Engineer.* Princeton, NJ: Newcomen Society, 1943.

_____. "Benjamin Franklin—Philosopher for Human Rights." *New Outlook* 10, no. 6 (June 1957): 25-29, 86-88.

Amacher, Richard E. *Benjamin Franklin.* New York: Twayne, 1961.

[American Philosophical Society]. *Transactions of the American Philosophical Society, held at Philadelphia, for Promoting Useful Knowledge.* Philadelphia: Bradford, 1771– .

Anderson, Douglas. *The Radical Enlightenments of Benjamin Franklin.* Baltimore: Johns Hopkins University Press, 1997.

Anderson, Paul Russell, and Max Harold Fisch. *Philosophy in America: From the Puritans to James.* New York: Appleton-Century, 1939.

Angoff, Charles. *A Literary History of the American People.* Vol. 2, *1750–1815.* New York: Knopf, 1931.

Babbitt, Irving. *Democracy and Leadership.* Indianapolis: Liberty Classics, [1924] 1979.

Bacon, Francis. *Selected Writings of Francis Bacon.* Edited by Hugh G. Dick. New York: Modern Library, 1955.

Balestra, Gianfranca, and Luigi Sampietro, eds. *Benjamin Franklin: An American Genius.* Rome: Bulzoni, 1993.

Baltzell, E. Digby. *Puritan Boston and Quaker Philadelphia: Two Protestant Ethics and the Spirit of Class Authority and Leadership.* New York: Free Press, 1979.

Barbour, Brian M. "*The Great Gatsby* and the American Past." *Southern Review* 9, no. 1 (January 1973): 288-99.

_____. "Introduction: Franklin, Lawrence, and Tradition." *Benjamin Franklin: A Collection of Critical Essays*, ed. Barbour. Englewood Cliffs: Prentice-Hall, 1979, 1-8.

Bates, Ernest Sutherland. *American Faith: Its Religious, Political, and Economic Foundations.* New York: Norton, 1940.

Beard, Charles A. "Exposing the Anti-Semitic Forgery about Franklin." *Jewish Frontier* 2 (March 1935): 10-13.

Becker, Carl L. "Benjamin Franklin." *Dictionary of American Biography.* Edited by Allen Johnson and Dumas Malone. New York: Scribners, 1931, 6:585-98.

_____. *The Heavenly City of the Eighteenth-Century Philosophers.* New Haven: Yale University Press, 1932.

Beers, Henry A. *Initial Studies in American Letters.* Cleveland: Chautauqua Press, 1899.

Bell, Whitfield J. "The Scientific Environment of Philadelphia, 1775–

1790." *Proc. of the American Philosophical Society* 92, no. 1 (March 1948): 6–14.

―――――. "The Father of All Yankees." In *American Story: The Age of Exploration to the Age of the Atom.* Edited by Earl Schenck Miers. Great Neck, NY: Channel Press, 1956, 67–74.

―――――. "Benjamin Franklin as an American Hero." *Association of American Colleges Bulletin* 43, no. 1 (March 1957): 121–32.

―――――. "The Worlds of Benjamin Franklin." *Proc. of the XIIIth Annual Meeting and Convention of the National Microfilm Association* (Annapolis, 1964): 31–40.

―――――. *The Colonial Physician and Other Essays.* New York: Science History Publications, 1975.

Benezet, Anthony. *A Mite cast into the Treasury: or, Observations on Slave-Keeping.* Philadelphia, 1772.

Bier, Jesse. "Weberism, Franklin, and the Transcendental Style." *New England Quarterly* 43, no. 2 (June 1970): 179–92.

―――――. "Benjamin Franklin: Guilt and Transformation." *Pennsylvania Magazine of History and Biography* 106, no. 1 (January 1982): 89–97.

Boorstin, Daniel. *The Lost World of Thomas Jefferson.* Boston: Beacon, [1948] 1960.

―――――. *The Americans.* 3 vols. New York: Vintage, 1958–1973.

Boyd, Julian P. "Dr. Franklin: Friend of the Indians." *Meet Doctor Franklin,* 201–20.

Brasch, Frederick Edward. "The Newtonian Epoch in the American Colonies (1680–1783)." *American Antiquarian Society* 49 (October 1939): 314–32.

Breitwieser, Mitchell Robert. *Cotton Mather and Benjamin Franklin: The Price of Representative Personality.* Cambridge: Cambridge University Press, 1984.

Bremner, Robert H. *American Philanthropy.* Chicago: University of Chicago Press, 1960.

Bridenbaugh, Carl. "Philosophy Put to Use: Voluntary Associations for Propagating the Enlightenment in Philadelphia, 1727–1776." *Pennsylvania Magazine of History and Biography* 101, no. 1 (January 1977): 70–88.

Bridenbaugh, Carl, and Jessica Hill Bridenbaugh. *Rebels and Gentlemen: Philadelphia in the Age of Franklin.* New York: Oxford University Press, 1962.

Brooks, Van Wyck. *America's Coming-of-Age.* Garden City: Anchor, [1934] 1958.

Bruce, William Cabell. *Benjamin Franklin Self-Revealed: A Biographical and Critical Study Based Mainly on His Own Writings*. 3rd edition. 2 vols. New York: Putnams, 1942.

Buranelli, Vincent. "Colonial Philosophy." *William and Mary Quarterly* 16, no. 3 (July 1959): 343–62.

Burns, James MacGregor. *The Vineyard of Liberty: The American Experiment*. New York: Knopf, 1982.

Bushman, Richard L., "On the Uses of Psychology: Conflict and Conciliation in Benjamin Franklin," *History and Theory* 5, no. 3 (1966): 225–40.

Buxbaum, Melvin H. *Benjamin Franklin and the Zealous Presbyterians*. University Park: Pennsylvania State University Press, 1975.

———. "Introduction" to *Critical Essays on Benjamin Franklin*. Edited by Buxbaum. Boston: G. K. Hall, 1987.

Calverton, V. F. *The Liberation of American Literature*. New York: Scribners, 1932.

Campbell, James. *The Community Reconstructs: The Meaning of Pragmatic Social Thought*. Urbana: University of Illinois Press, 1992.

———. *Understanding John Dewey: Nature and Cooperative Intelligence*. La Salle: Open Court, 1995.

———. "The Pragmatism of Benjamin Franklin." *Transactions of the Charles S. Peirce Society* 31, no. 4 (Fall 1995): 745–92.

Carey, Lewis J. *Franklin's Economic Views*. Garden City: Doubleday, Doran, 1928.

Carr, William G. *The Oldest Delegate: Franklin in the Constitutional Convention*. Newark: University of Delaware Press, 1990.

Caruso, John Anthony. *The Appalachian Frontier: America's First Surge Westward*. Indianapolis: Bobbs-Merrill, 1959.

Cheyney, Edward Potts. *History of the University of Pennsylvania, 1740–1940*. Philadelphia: University of Pennsylvania Press, 1940.

Christensen, Merton A. "Franklin on the Hemphill Trial: Deism versus Presbyterian Orthodoxy." *William and Mary Quarterly* 10, no. 3 (July 1953): 422–40.

Clark, Ronald W. *Benjamin Franklin: A Biography*. New York: Da Capo, 1983.

Cohen, I. Bernard. *Benjamin Franklin's Experiments*. Cambridge: Harvard University Press, 1941.

———. "Benjamin Franklin as Scientist and Citizen." *American Scholar* 12, no. 4 (Autumn 1943): 474–81.

————. "In Defense of Benjamin Franklin." *Scientific American* 179, no. 2 (August 1948): 36–43.

————. "Foreword" and "Introduction" to *Benjamin Franklin: His Contribution to the American Tradition.* Indianapolis: Bobbs-Merrill, 1953, xi–xix, 27–67.

————. *Franklin and Newton: An Inquiry into Speculative Newtonian Experimental Science and Franklin's Work in Electricity as an Example Thereof.* Philadelphia: American Philosophical Society, 1956.

————. *Benjamin Franklin: Scientist and Statesman.* New York: Scribners, 1975.

————. *Benjamin Franklin's Science.* Cambridge: Harvard University Press, 1990.

————. *Science and the Founding Fathers: Science in the Political Thought of Jefferson, Franklin, Adams, and Madison.* New York: Norton, 1995.

Commager, Henry Steele. *The American Mind: An Interpretation of American Thought and Character since the 1880's.* New Haven: Yale University Press, 1950.

Compton, Arthur H., "The World of Science in the Late Eighteenth Century and Today," *Proc. of the American Philosophical Society* 100, no. 4 (August 1956): 296–303.

Conkin, Paul K. *Puritans and Pragmatists: Eight Eminent American Thinkers.* Bloomington: Indiana University Press, 1976.

Conner, Paul W. *Poor Richard's Politicks: Benjamin Franklin and His New American Order.* New York: Oxford University Press, 1965.

Crane, Verner Winslow. *Benjamin Franklin: Englishman and American.* Baltimore: Williams and Wilkins, 1936.

————. *Benjamin Franklin and a Rising People.* Boston: Little, Brown, 1954.

Cremin, Lawrence A. *American Education: The Colonial Experience, 1607–1783.* New York: Harper and Row, 1979.

Defoe, Daniel. *Selected Writings of Daniel Defoe.* Edited by James T. Boulton. Cambridge: Cambridge University Press, 1975.

Dewey, John. *Reconstruction in Philosophy.* Vol. 12 of *The Middle Works of John Dewey.* Edited by Jo Ann Boydston. Carbondale: Southern Illinois University Press, [1920] 1982.

————. *Experience and Nature.* Rev. ed. Vol. 1 of *The Later Works of John Dewey.* Edited by Jo Ann Boydston. Carbondale: Southern Illinois University Press, [1929] 1981.

————. "Presenting Thomas Jefferson" [1940]. In vol. 14 of *The Later*

Works of John Dewey. Edited by Jo Ann Boydston. Carbondale: Southern Illinois University Press, 1998, 201–23.

Dewey, John, and James Hayden Tufts. *Ethics*. Vol. 5 of *The Middle Works of John Dewey*. Edited by Jo Ann Boydston. Carbondale: Southern Illinois University Press, [1908] 1978.

Dorfman, Joseph. *The Economic Mind in American Civilization, 1606–1865*. 2 vols. New York: Viking Press, 1946.

Dos Passos, John. "Two Eighteenth-Century Careers: I—Benjamin Franklin." *New Republic* 103 (11 November 1940): 654–57.

Douglas, Paul H. "Two Eighteenth Century Philadelphians: Benjamin Franklin and John Woolman." *The General Magazine and Historical Chronicle* 54, no. 3 (Spring 1952): 131–38.

Douglass, Elisha P. *Rebels and Democrats: The Struggle for Equal Political Rights and Majority Rule during the American Revolution*. Chicago: Quadrangle, [1955] 1965.

Downer, Silas. "A Discourse at the Dedication of the Tree of Liberty" [1768]. In *American Political Writing during the Founding Era*. Edited by Hyneman and Lutz, 1:97–108.

Dunn, Elizabeth E. "From a Bold Youth to a Reflective Sage: A Reevaluation of Benjamin Franklin's Religion." *Pennsylvania Magazine of History and Biography* 111, no. 4 (October 1987): 501–24.

Edgerton, Samuel Y., Jr. "The Franklin Stove." Supplement to I. Bernard Cohen's *Benjamin Franklin's Science*, 199–211.

Edwards, Jonathan. "Personal Narrative" [1739]. *Jonathan Edwards: Representative Selections*. Edited by Clarence H. Faust and Thomas H. Johnson. New York: Hill and Wang, 1962, 57–72.

Eiselen, Malcolm R. *Franklin's Political Theories*. Garden City: Doubleday, Doran, 1928.

Eliot, Charles William. *Four American Leaders*. Boston: American Unitarian Association, 1906.

Emerson, Ralph Waldo. *Complete Works of Ralph Waldo Emerson*. 12 vols. Edited by Edward Waldo Emerson. Boston: Houghton Mifflin, 1904.

———. *Journals of Ralph Waldo Emerson*. 10 vols. Edited by Edward Waldo Emerson and Waldo Emerson Forbes. Boston: Houghton Mifflin, 1909.

Evans, William B. "John Adams' Opinion of Benjamin Franklin." *Pennsylvania Magazine of History and Biography* 92, no. 2 (April 1968): 220–38.

Faÿ, Bernard. *Franklin, the Apostle of Modern Times*. Boston: Little Brown, 1929.

Fiering, Norman S. "Benjamin Franklin and the Way to Virtue." *American Quarterly* 30, no. 2 (Summer 1978): 199–223.

————. *Jonathan Edwards's Moral Thought and Its British Context*. Chapel Hill: University of North Carolina Press, 1981.

Fischer, David Hacket. *Albion's Seed: Four British Folkways in America*. New York: Oxford University Press, 1989.

Flower, Elizabeth, and Murray G. Murphey. *A History of Philosophy in America*. 2 vols. New York: Putnams, 1977.

Franklin, Benjamin. *A Dissertation on Liberty and Necessity, Pleasure and Pain*. Edited by Lawrence C. Wroth. New York: Facsimile Text Society, [1725] 1930.

————. *The Autobiography of Benjamin Franklin*. Edited by Leonard W. Labaree, Ralph L. Ketcham, Helen C. Boatfield, and Helene H. Fineman. New Haven: Yale University Press, 1964.

————. *The Autobiography of Benjamin Franklin: A Genetic Text*. Edited by J. A. Leo Lemay and Paul M. Zall. Knoxville: University of Tennessee Press, 1981.

————. *The Works of Benjamin Franklin*. 10 vols. Edited by Jared Sparks. Boston: Tappan, Whittemore and Mason, 1840.

————. *The Works of Benjamin Franklin*. 12 vols. Edited by John Bigelow. New York: Putnams, 1904.

————. *The Writings of Benjamin Franklin*. 10 vols. Edited by Albert Henry Smyth. New York: Macmillan 1907.

————. *A Benjamin Franklin Reader*. Edited by Nathan G. Goodman. New York: Thomas Y. Crowell, 1945.

————. *The Papers of Benjamin Franklin*. Edited by Leonard W. Labaree, William B. Willcox, and Barbara B. Oberg. New Haven: Yale University Press, 1959– .

Gabriel, Ralph Henry. *The Course of American Democratic Thought: An Intellectual History since 1815*. New York: Ronald Press, 1940.

Gales, Joseph, ed. *Debates and Proceedings of the Congress of the United States*. 42 vols. Washington, DC: Gales and Seaton, 1834–1856.

Gaustad, Edwin Scott. *Dissent in American Religion*. Chicago: University of Chicago Press, 1973.

Gilmore, Michael T. *The Middle Way: Puritanism and Ideology in American Romantic Fiction*. New Brunswick: Rutgers University Press, 1977.

Gipson, Lawrence Henry. "Thomas Hutchinson and the Framing of the

Albany Plan of Union, 1754." *Pennsylvania Magazine of History and Biography* 74, no. 1 (January 1950): 5–35.

————. "The Drafting of the Albany Plan of Union: A Problem in Semantics." *Pennsylvania History* 26 (1959): 291–316.

Glenn, William W. L. "Benjamin Franklin: Physician and Philosopher." *American Journal of Surgery* 149 (April 1985): 426–34.

Golladay, V. Dennis. "The Evolution of Benjamin Franklin's Theory of Value." *Pennsylvania History* 37, no. 1 (January 1970): 40–52.

Grampp, William D. "The Political Economy of Poor Richard." *Journal of Political Economy* 55, no. 2 (April 1947): 132–41.

Gray, Austin K. *Benjamin Franklin's Library: A Short Account of the Library Company of Philadelphia, 1731–1931.* New York: Macmillan, 1937.

Greene, John C. *American Science in the Age of Jefferson.* Ames: Iowa State University Press, 1984.

Griffith, John. "Franklin's Sanity and the Man behind the Masks." *The Oldest Revolutionary.* Edited by Lemay, 123–38.

Grimm, Dorothy F. "Franklin's Scientific Institution." *Pennsylvania History* 23, no. 4 (October 1956): 437–62.

Griswold, A. Whitney. "Three Puritans on Prosperity." *New England Quarterly* 7, no. 3 (September 1934), 475–93.

Habich, Robert B. "Franklin's Scientific Ethics: Exemplary Rhetoric in the *Autobiography.*" In *Early American Literature and Culture: Essays Honoring Harrison T. Meserole.* Edited by Kathryne Zabelle Derounian-Stodola. Newark: University of Delaware Press, 1992, 184–91.

Hale, Edward Everett. "Franklin as Philosopher and Moralist." *Independent* 60 (11 January 1906): 89–93.

Hall, Alice J. "Philosopher of Dissent: Benjamin Franklin." *National Geographic.* 148, no. 1 (July 1975): 92–123.

Hall, Max. *Benjamin Franklin and Polly Baker: The History of a Literary Deception.* Chapel Hill: University of North Carolina Press, 1960.

Hall, Robert Lee. *Benjamin Franklin Takes the Case: The American Agent Investigates Murder in the Dark Byways of London.* New York: St. Martins, 1988.

Halleck, Reuben Post. *Romance of American Literature.* New York: American Book, 1934.

Hanna, William S. *Benjamin Franklin and Pennsylvania Politics.* Stanford: Stanford University Press, 1964.

Harnwell, Gaylord P. "Franklin's Impetus to Education." *Journal of the Franklin Institute* 261, no. 1 (January 1956): 111–19.

Hartshorne, Charles. *Creativity in American Philosophy*. Albany: SUNY Press, 1984.

Hawthorne, Nathaniel. *Tales, Sketches, and Other Papers*. Vol. 12 of *The Complete Works of Nathaniel Hawthorne*. Edited by George Parsons Lathrop. Boston: Houghton Mifflin, 1883.

Hedges, William L. "From Franklin to Emerson." *The Oldest Revolutionary*. Edited by Lemay, 139–56.

Heilbron, J. L. *Electricity in the 17th and 18th Centuries: A Study of Early Modern Physics*. Berkeley: University of California Press, 1979.

————. "Franklin as an Enlightened Natural Philosopher." *Reappraising Benjamin Franklin*. Edited by Lemay, 196–220.

Hindle, Brooke. *The Pursuit of Science in Revolutionary America, 1735–1789*. Chapel Hill: University of North Carolina Press, 1956.

Hoover, Herbert. "On Benjamin Franklin." *Addresses upon the American Road (1933–1938)*. New York: Scribners, 1938, 362–68.

————. "Benjamin Franklin." *Representative American Speeches: 1953–1954*. Edited by A. Craig Baird, New York: H. W. Wilson, 1954, 81–85.

Hornberger, Theodore. *Benjamin Franklin*. Minneapolis: University of Minnesota Press, 1962.

Huang, Nian-Sheng. *Benjamin Franklin in American Thought and Culture, 1790–1990*. Philadelphia: American Philosophical Society, 1994.

Hume, David. *An Inquiry concerning Human Understanding*. Edited by Charles W. Hendel. Indianapolis: Bobbs-Merrill, [1748] 1955.

————. "Of Miracles" [1768]. In *Essays: Moral, Political and Literary*. Oxford: Oxford University Press, 1963, 519–44.

Hyneman, Charles S., and Donald S. Lutz. *American Political Writing during the Founding Era, 1760–1805*. 2 vols. Indianapolis: Liberty Press, 1983.

Jacobs, Wilbur R., ed. *Benjamin Franklin: Statesman-Philosopher or Materialist?* New York: Holt, Rinehardt and Winston, 1972.

James, Alfred P. "Benjamin Franklin's Ohio Valley Lands." *Proc. of the American Philosophical Society* 98, no. 4 (August 1954): 255–65.

James, William. *The Writings of William James*. Edited by John J. McDermott. New York: Random House, 1967.

Jefferson, Thomas. *The Writings of Thomas Jefferson*. 10 vols. Edited by Paul Leicester Ford. New York: Putnams, 1892–1899.

————. *The Papers of Thomas Jefferson*. Edited by Julian P. Boyd. Princeton: Princeton University Press, 1950– .

————. *Writings*. Edited by Merrill D. Peterson. New York: Library of America, 1984.

Jennings, Francis. *Benjamin Franklin, Politician*. New York: Norton, 1996.

Johansen, Bruce E. *Forgotten Founders: Benjamin Franklin, the Iroquois and the Rationale for the American Revolution*. Ipswich, MA: Gambit, 1982.

Johnston, R. M. "American Philosophy." *Catholic World* 42, no. 1 (October 1885): 91–102.

Jones, Adam Leroy. *Early American Philosophers*. Columbia University Contributions to Philosophy, Psychology and Education. Vol. 2, no. 4. New York: Macmillan, 1898.

Juhnke, William E. "Benjamin Franklin's View of the Negro and Slavery." *Pennsylvania History* 41, no. 4 (October 1974): 375–88.

Ketcham, Ralph L. *Benjamin Franklin*. New York: Washington Square Press, 1965.

————. "Introduction" to *The Political Thought of Benjamin Franklin*. Indianapolis: Bobbs-Merrill, 1965, xxvii–lv.

Knollenberg, Bernhard. "Benjamin Franklin: Philosophical Revolutionist." *Meet Doctor Franklin*, 127–33.

Koch, Adrienne. *Power, Morals, and the Founding Fathers: Essays in the Interpretation of the American Enlightenment*. Ithaca: Cornell University Press, 1961.

Kraus, Michael. *The Atlantic Civilization: Eighteenth-Century Origins*. Ithaca: Cornell University Press, 1949.

Labaree, Leonard Woods. "Franklin and the Presbyterians." *Journal of the Presbyterian Historical Society* 35, no. 4 (December 1957): 217–27.

Larrabee, Harold A. "Poor Richard in an Age of Plenty." *Harper's Magazine* 212 (January 1956): 64–68.

————. "Naturalism in America." *Naturalism and the Human Spirit*. Edited by Yervant H. Krikorian. New York: Columbia University Press, 1944, 319–53.

Larson, David M. "Franklin on the Nature of Man and the Possibility of Virtue." *Early American Literature* 10, no. 2 (Fall 1975): 111–20.

Lathrop, Joseph. "Frugality" [1786]. In *American Political Writing during the Founding Era*. Edited by Hyneman and Lutz, 1:663–64.

————. "A Sermon on a Day Appointed for Publick Thanksgiving" [1787]. In *Political Sermons of the American Founding Era*. Edited by Sandoz, 865–81.

Lawrence, D. H. "Benjamin Franklin." *English Review* 27 (1918): 397–408.

—————. *Studies in Classic American Literature*. New York: Viking Press, 1923.

Lemay, J. A. Leo. "Franklin and the *Autobiography*." *Eighteenth-Century Studies* 1 (1967–1968): 185–211.

—————. "Benjamin Franklin." *Major Writers of Early American Literature*. Edited by Everett Emerson. Madison: University of Wisconsin Press, 1972, 205–43.

—————. "Benjamin Franklin, Universal Genius." *The Renaissance Man in the Eighteenth Century*. Los Angeles: Clark Memorial Library, 1978, 1–44.

—————. *The Canon of Benjamin Franklin, 1722–1776: New Attributions and Reconsiderations*. Newark: University of Delaware Press, 1986.

—————, ed. *The Oldest Revolutionary: Essays on Benjamin Franklin*. Philadelphia: University of Pennsylvania Press, 1976.

—————, ed. *Reappraising Benjamin Franklin: A Bicentennial Perspective*. Newark: University of Delaware Press, 1993.

Lemay, J. A. Leo, and Paul M. Zall. "Introduction" to *The Autobiography of Benjamin Franklin: A Genetic Edition*, xv–lviii.

Lerat, Christian. "Essay at Revisiting Benjamin Franklin as a Philogynist." In *Benjamin Franklin: An American Genius*. Edited by Balestra and Sampietro, 99–119.

Levin, David. "The Autobiography of Benjamin Franklin: The Puritan Experimenter in Life and Art." *Yale Review* 53, no. 2 (December 1963): 258–75.

Locke, John. *A Letter concerning Toleration*. Edited by James H. Tulley. Indianapolis: Hackett, [1689] 1983.

—————. *An Essay concerning Human Understanding*. 2 vols. Edited by Alexander Campbell Fraser. New York: Dover, [1690] 1959.

Lodge, Henry Cabot. *A Frontier Town and Other Essays*. New York: Scribners, 1906.

Lokken, Roy N. "The Concept of Democracy in Colonial Political Thought." *William and Mary Quarterly* 16, no. 4 (October 1959): 568–80.

Lopez, Claude-Anne. "Prophet and Loss: Benjamin Franklin, the Jews, and Cyber-Bigotry." *New Republic* (27 January 1997): 28–31.

Lopez, Claude-Anne, and Eugenia W. Herbert. *The Private Franklin: The Man and His Family*. New York: Norton, 1975.

Lucas, F. L. *The Art of Living: Four Eighteenth-Century Minds*. London: Cassell, 1959.

Lynen, John F. *The Design of the Present: Essays on Time and Form in American Literature*. New Haven: Yale University Press, 1969.

Lyttle, Charles. "Benjamin Franklin's Change from Radicalism to Conservatism in Religious Thought." *Meadville Theological School Quarterly Review*. 12, no. 2 (January 1928): 3–20.

Macdonald, William. "The Fame of Franklin." *Atlantic Monthly* 96, no. 4 (October 1905): 450–62.

Madison, James, Alexander Hamilton, and John Jay. *The Federalist: A Commentary on the Constitution of the United States*. Edited by Edward Mead Earle. New York: Modern Library, [1788] 1937.

Marks, Marcus M. "Franklin, the Father of Daylight Saving." *The Amazing Benjamin Franklin*. Edited by J. Henry Smythe, Jr., 202–6.

Marnell, William H. *Man-Made Morals: Four Philosophies That Shaped America*. Garden City: Anchor, 1968.

Marx, Karl. *Capital: A Critique of Political Economy*. Vol. 1. Translated by Ben Fowkes. New York: Vintage, [1859] 1977.

Mather, Cotton. *Magnalia Christi Americana; or, The Ecclesiastical History of New England*. 2 vols. New York: Russell and Russell, [1702] 1967.

———. *Bonifacius: An Essay upon the Good*. Edited by David Levin. Harvard University Press, [1710] 1966.

———. *The Christian Philosopher*. Edited by Winton U. Solberg. Urbana: University of Illinois Press, [1721] 1994.

Mathews, Lois K. "Benjamin Franklin's Plans for a Colonial Union, 1750–1775." *American Political Science Review* 8, no. 3 (August 1914): 393–412.

Matthews, Brander. *An Introduction to the Study of American Literature*. Revised edition. New York: American Book Co., 1918.

May, Henry F. *The Enlightenment in America*. New York: Oxford University Press, 1976.

Mayhew, Jonathan. *Popish Idolatry: A Discourse*. Boston: Draper, Edes, and Gill, 1765.

McClenahan, Howard. "Franklin, the Philosopher and Scientist." *The Amazing Benjamin Franklin*. Edited by J. Henry Smyth, Jr., 161–73.

McEwen, Gilbert D. "'A Turn of Thinking': Benjamin Franklin, Cotton Mather, and Daniel Defoe on 'Doing Good.'" In *The Dress of Words*. Edited by Robert B. White, Jr. Lawrence: University of Kansas Libraries, 1978, 53–65.

McMahon, A. Michal. "'Small Matters': Benjamin Franklin, Philadelphia, and the 'Progress of Cities.'" *Pennsylvania Magazine of History and Biography* 116, no. 2 (April 1992): 157–82.

McMaster, John Bach. *Benjamin Franklin as a Man of Letters*. Boston: Houghton Mifflin, 1887.

McNeill, John T. *Modern Christian Movements*. Philadelphia: Westminster Press, 1954.

Meet Doctor Franklin. Philadelphia: Franklin Institute, 1943.

Melville, Herman. *Israel Potter: His Fifty Years of Exile*. Evanston: Northwestern University Press, [1855] 1982.

Meyer, Donald H. *The Democratic Enlightenment*. New York: Putnams, 1976.

————. "Franklin's Religion." *Critical Essays on Benjamin Franklin*. Edited by Buxbaum, 147–67.

Meyer, Gladys Eleanor. *Free Trade in Ideas: Aspects of American Liberalism Illustrated in Franklin's Philadelphia Career*. Morningside Heights: King's Crown, 1941.

Middlekauff, Robert. "A Persistent Tradition: The Classical Curriculum in Eighteenth-Century New England." *William and Mary Quarterly* 18, no. 1 (January 1961): 54–67.

————. *Ancients and Axioms: Secondary Education in Eighteenth-Century New England*. New York: Arno, 1971.

————. *Benjamin Franklin and His Enemies*. Berkeley: University of California Press, 1996.

Miles, Richard Donald. "The American Image of Benjamin Franklin." *American Quarterly* 9, no. 2 (Summer 1957): 117–43.

Miller, John C. *Origins of the American Revolution*. Revised edition. Stanford: Stanford University Press, 1959.

————. *This New Man, the American: The Beginnings of the American People*. New York: McGraw-Hill, 1974.

Miller, Perry. *The New England Mind*. 2 vols. Boston: Beacon, [1939, 1953] 1961.

————. "Benjamin Franklin, Jonathan Edwards." *Major Writers of America*. Edited by Miller. New York: Harcourt, Brace and World, 1962, 1:83-98.

————. *Nature's Nation*. Cambridge: Harvard University Press, 1967.

Millikan, Robert A. "Benjamin Franklin as a Scientist." *Meet Doctor Franklin*, 11–26.

Morais, Herbert M. *Deism in Eighteenth Century America*. New York: Columbia University Press, 1934.

More, Paul Elmer. "Benjamin Franklin." In *Shelburne Essays: Fourth Series*. New York: Phaeton Press, [1906] 1967, 129–55.

Morgan, David T. *The Devious Dr. Franklin, Colonial Agent: Benjamin*

Franklin's Years in London. Macon, GA: Mercer University Press, 1996.

Morgan, Edmund S. "The Puritan Ethic and the American Revolution." *William and Mary Quarterly* 24, no. 1 (January 1967): 3–43.

Morris, Richard B. *Seven Who Shaped Our Destiny: The Founding Fathers as Revolutionaries*. New Harper and Row, 1973.

Mott, Frank Luther, and Chester E. Jorgenson. "Introduction" to *Benjamin Franklin: Representative Selections*. New York: American Book Company, 1936, xiii–clxxxviii.

Murdock, Kenneth B. "Jonathan Edwards and Benjamin Franklin." *The Literature of the American People: An Historical and Critical Survey*. Edited by Arthur Hobson Quinn. New York: Appleton-Century-Crofts, 1951, 106–23.

Nash, Gary B. "Slaves and Slaveowners in Colonial Philadelphia." *William and Mary Quarterly* 30, no. 2 (April 1973): 225–56.

Newton, Isaac. *Mathematical Principles of Natural Philosophy [Philosophiae Naturalis Principia Mathematica]*. In Great Books, vol. 32. Chicago: Encyclopaedia Britannica, [1687] 1992, 1–372.

————. *Optics*. In Great Books, vol. 32. Chicago: Encyclopaedia Britannica, [1704] 1992, 373–544.

Nolan, James Bennett. *General Benjamin Franklin: The Military Career of a Philosopher*. Philadelphia: University of Pennsylvania Press, 1936.

Oberg, Barbara B., and Harry S. Stout. "Introduction" to *Benjamin Franklin, Jonathan Edwards, and the Representation of American Culture*. Edited by Oberg and Stout. New York: Oxford University Press, 1993.

Pace, Antonio. *Benjamin Franklin and Italy*. Philadelphia: American Philosophical Society, 1958.

Paine, Thomas. *The Writings of Thomas Paine*. 4 vols. Edited by Moncure Daniel Conway. New York: Putnams, 1894–1896.

Pangle, Lorraine Smith, and Thomas L. Pangle. *The Learning of Liberty: The Educational Ideas of the American Founders*. Lawrence: University Press of Kansas, 1993.

Parker, Theodore. *Historic Americans*. Edited by Samuel A. Eliot. Boston: American Unitarian Association, 1908.

Parrington, Vernon Louis. *Main Currents in American Thought: An Interpretation of American Literature from the Beginnings to 1920*. 3 vols. New York: Harcourt, Brace, 1930.

Parton, James. *Life and Times of Benjamin Franklin*. 2 vols. Boston: Houghton Mifflin, [1865] 1887.

Peirce, Charles Sanders. *Collected Papers*. 8 vols. Edited by Charles Hartshorne, Paul Weiss, and Arthur W. Burks. Cambridge: Harvard University Press, 1931–1958.

Pemberton, Henry. *A View of Sir Isaac Newton's Philosophy*. London: Palmer, 1728.

Penn, William. "A Seasonable Caveat against Popery" [1670]. In *Select Works of William Penn*. 3 vols. New York: Kraus Reprint, [1825] 1971, 2:165–92.

[Pennsylvania Society for Promoting the Abolition of Slavery]. *Constitution of the Pennsylvania Society for Promoting the Abolition of Slavery, and the Relief of Free Negroes, Unlawfully Held in Bondage* (1787).

Pepper, William. *The Medical Side of Benjamin Franklin*. Philadelphia: William J. Campbell, 1911.

Perry, Ralph Barton. *Puritanism and Democracy*. New York: Vanguard, 1944.

Persons, Stow. *American Minds: A History of Ideas*. New York: Henry Holt, 1958.

Phelps, William L. "Two Colonial Americans." *Proc. of the Society of Colonial Wars in the State of Connecticut* 2 (1910): 193–204.

Pitt, Arthur Stuart. "Franklin and the Quaker Movement against Slavery." *Bulletin of the Friends Historical Association* 32, no. 1 (Spring 1943): 13–31.

Porter, Noah. "Philosophy in Great Britain and America: A Supplementary Sketch." Appendix to the fourth edition of Friedrich Ueberweg, *History of Philosophy: From Thales to the Present Time*. Translated by George Sylvester Morris. New York: Scribners, 1901, 2:441–60.

Pupin, Michael I. "Franklin, the Natural Philosopher." In *The Amazing Benjamin Franklin*. Edited by J. Henry Smyth, Jr., 174–77.

Randall, John Herman, Jr. *The Making of the Modern Mind: A Survey of the Intellectual Background of the Present Age*. Revised edition. Cambridge: Houghton Mifflin, 1940.

———. *The Career of Philosophy*. 3 vols. New York: Columbia University Press, 1962–1977.

Read, Conyers. "Doctor Franklin as the English Saw Him." *Meet Doctor Franklin*, 43–61.

Riley, Isaac Woodbridge. *American Philosophy: The Early Schools*. New York: Russell and Russell, [1907] 1958.

———. *American Thought: From Puritanism to Pragmatism and Beyond*. New York: Greenwood Press, [1915] 1969.

Ross, Earle D. "Benjamin Franklin as an Eighteenth-Century Agricultural Leader." *Journal of Political Economy* 37, no. 1 (February 1929): 52–72.

Ross, Sydney. "*Scientist*: The Story of a Word." *Annals of Science* 18, no. 2 (June 1962): 65–85.

Rossiter, Clinton. *Seedtime of the Republic: The Origin of the American Tradition of Political Liberty.* New York: Harcourt, Brace and World, 1953.

Rowntree, John Stephenson. *Quakerism, Past and Present: Being an Inquiry into the Causes of Its Decline in Great Britain and Ireland.* London: Smith, Elder, 1859.

Rush, Benjamin. *Letters of Benjamin Rush.* 2 vols. Edited by Lyman Henry Butterfield. Princeton: Princeton University Press, 1951.

————. *Selected Writings of Benjamin Rush.* Edited by Dagobert D. Runes. New York: Philosophical Library, 1947.

————. "An Address to the Inhabitants of the British Settlements in America Upon Slave-Keeping" [1773]. In *American Political Writing during the Founding Era, 1760–1805.* Edited by Hyneman and Lutz, 1:217–30.

Rutman, Darrett B. *American Puritanism: Faith and Practice.* Philadelphia: Lippincott, 1970.

Sandoz, Ellis, ed. *Political Sermons of the American Founding Era, 1730–1805.* Indianapolis: Liberty Press, 1990.

Sayre, Robert Freeman. *The Examined Self: Benjamin Franklin, Henry Adams, Henry James.* Princeton: Princeton University Press, 1964.

Schiller, Andrew. "Franklin as a Music Critic." *New England Quarterly* 31, no. 4 (December 1958): 505–14.

Schneider, Herbert Wallace. "The Significance of Benjamin Franklin's Moral Philosophy." *Studies in the History of Ideas.* Vol. 2. New York: Columbia University Press, 1925, 293–312.

————. *The Puritan Mind.* Ann Arbor: University of Michigan Press, [1930] 1958.

————. "Introduction" to *Benjamin Franklin: The Autobiography and Selections from His Other Writings.* New York: Liberal Arts Press, 1952, ix–xiv.

————. *A History of American Philosophy.* 2nd edition. New York: Columbia University Press, 1963.

Schonland, B. F. J. "Benjamin Franklin: Natural Philosopher." *Proceedings of the Royal Society of London*, Series A, vol. 235 (12 June 1956): 433–44.

Scott, James Brown. "Franklin—Political Philosopher." *Proceedings of the American Philosophical Society* 71 (1932): 217–23.

Seavey, Ormond. *Becoming Benjamin Franklin: The* Autobiography *and the* Life. University Park: Pennsylvania State University Press, 1988.

Selsam, J. Paul. *The Pennsylvania Constitution of 1776: A Study in Revolutionary Democracy*. Philadelphia: University of Pennsylvania Press, 1936.

Shelling, Richard I. "Benjamin Franklin and the Dr. Bray Associates." *Pennsylvania Magazine of History and Biography* 63, no. 3 (July 1939): 282–93.

Sherman, Stuart P. "Franklin," *The Cambridge History of American Literature*. 3 vols. Edited by William Peterfield Trent, John Erskine, Sherman, and Carl Van Doren. New York: Macmillan, 1917–1921, 1:90–110.

———. "What is a Puritan?" *Atlantic Monthly* 128 (September 1921): 342–56.

Smyth, Albert Henry. "Introduction" to his edition of *The Writings of Benjamin Franklin*, 1:1–217.

———. *The Life of Benjamin Franklin* in his edition of *The Writings of Benjamin Franklin*, 10:139–510.

Smythe, J. Henry, Jr., ed. *The Amazing Benjamin Franklin*. New York: Frederick A. Stokes, 1929.

[Society for Political Enquiries]. *Rules and Regulations of the Society for Political Enquiries*. Philadelphia: Robert Aitken, 1787.

Solberg, Winton U. "Introduction" and notes to Cotton Mather, *The Christian Philosopher*, xix–cxxxiv and passim.

Sombart, Werner. *The Quintessence of Capitalism: A Study of the History and Psychology of the Modern Business Man*. New York: Fertig, [1915] 1967.

Spiller, Robert E. "Benjamin Franklin: Student of Life." *Meet Doctor Franklin*, 83–103.

———. "Benjamin Franklin: Promoter of Useful Knowledge." *The American Writer and the European Tradition*. Edited by Margaret Denny and William H. Gilman. Minneapolis: University of Minnesota Press, 1950, 29–44.

———. *The Cycle of American Literature: An Essay in Historical Criticism*. New York: Macmillan, 1955.

———. "Franklin on the Art of Being Human." *Proc. of the American Philosophical Society* 100, no. 4 (August 1956): 304–15.

Stearns, Raymond Phineas. *Science in the British Colonies of America*. Urbana: University of Illinois Press, 1970.

Stifler, James Madison. *The Religion of Benjamin Franklin*. New York: Appleton, 1925.

Stourzh, Gerald. *Benjamin Franklin and American Foreign Policy*. 2nd edition. Chicago: University of Chicago Press, 1969.

Taussig, Harold E. "Deism in Philadelphia during the Age of Franklin," *Pennsylvania History* 37, no. 3 (July 1970): 217–36.

Thayer, H. S., *Meaning and Action: A Critical History of Pragmatism*. 2nd edition. Indianapolis: Hackett, 1981.

Tolles, Frederick B. *Meeting House and Counting House: The Quaker Merchants of Colonial Philadelphia, 1682–1763*. New York: Norton, [1948] 1963.

Townsend, Harvey Gates. *Philosophical Ideas in the United States*. New York: American Book, 1934.

Turner, Frederick Jackson. *The Frontier in American History*. New York: Holt, Rinehart and Winston, [1920] 1962.

Ulich, Robert. *History of Educational Thought*. New York: American Book Co., 1950.

Van Doren, Carl. "Introduction" to *Benjamin Franklin and Jonathan Edwards: Selections from Their Writings*. New York: Scribners, 1920, ix–xxxiv.

———. *Benjamin Franklin*. New York: Viking, 1938.

———. "Meet Doctor Franklin." In *Meet Doctor Franklin*, 1–10.

———. *The Great Rehearsal: The Story of the Making and Ratifying of the Constitution of the United States*. New York: Viking, 1948.

———. "Benjamin Franklin." In *Literary History of the United States*. Edited by Robert E. Spiller, et al. New York: Macmillan, 1948, 1:101–12.

Van Horne, John C. "Collective Benevolence and the Common Good in Franklin's Philanthropy." *Reappraising Benjamin Franklin*. Edited by Lemay, 425–40.

Victory, Beatrice Marguerite. *Benjamin Franklin and Germany*. Americana Germanica, vol. 21. Philadelphia: University of Pennsylvania, 1915.

Walsh, C. M. "Franklin and Plato." *Open Court* 20, no. 3 (March 1906): 129–33.

Walters, Kerry S. *The American Deists: Voices of Reason and Dissent in the Early Republic*. Lawrence: University Press of Kansas, 1992.

———. *Rational Infidels: The American Deists*. Durango, CO: Longwood Academic, 1992.

———. "A Note on Benjamin Franklin and Gods." *Transactions of the Charles S. Peirce Society* 31, no. 4 (Fall 1995): 793–805.

Ward, John William. *Red, White, and Blue: Men, Books, and Ideas in American Culture*. New York: Oxford University Press, 1969.

Weaver, Glenn. "Benjamin Franklin and the Pennsylvania Germans." *William and Mary Quarterly* 14, no. 4 (October 1957): 536–59.

Weber, Max. *The Protestant Ethic and the Spirit of Capitalism*. New York: Scribners, [1904–1905] 1958.

Wechter, Dixon. *The Hero in America: A Chronicle of Hero-Worship*. Ann Arbor: University of Michigan Press, [1941] 1963.

Weintraub, Karl J. "The Puritan Ethic and Benjamin Franklin." *Journal of Religion* 56, no. 3 (July 1976), 223–37.

Wertenbaker, Thomas J. *The Golden Age of Colonial Culture*. Ithaca: Cornell University Press, 1949.

White, Morton G. *Science and Sentiment in America: Philosophical Thought from Jonathan Edwards to John Dewey*. New York: Oxford University Press, 1972.

Whittemore, Robert Clifton. *Makers of the American Mind: Three Centuries of American Thought and Thinkers*. New York: Morrow, 1964.

Wilhite, Virgle Glenn. *Founders of American Economic Thought and Policy*. New York: Bookman Associates, 1958.

Williams, David. "More Light on Franklin's Religious Ideas." *American Historical Review* 43, no. 4 (July 1938): 803–10.

Williams, Elisha. *The Essential Rights and Liberties of Protestants* [1744]. In *Political Sermons of the Amercian Founding Era, 1730–1805*. Edited by Sandoz, 51–118.

Williams, Howell V. "Benjamin Franklin and the Poor Laws." *Social Service Review* 18, no. 1 (March 1944): 77–91.

Williams, Samuel Cole. *History of the Lost State of Franklin*. Revised edition. New York: Press of the Pioneers, 1933.

Williams, William Carlos. *In the American Grain*. New York: New Directions, [1925] 1956.

Wills, Garry. *Inventing America: Jefferson's Declaration of Independence*. Garden City: Doubleday, 1978.

Wilson, James. *The Works of James Wilson*. 2 vols. Edited by Robert Green McCloskey. Cambridge: Harvard University Press, 1967.

Wilson, R. Jackson. *Figures of Speech: American Writers and the Literary Marketplace, from Benjamin Franklin to Emily Dickinson*. New York: Knopf, 1989.

Woodward, Carl R. "Benjamin Franklin: Adventures in Agriculture." *Meet Doctor Franklin*, 179–200.

Wright, Esmond. *Franklin of Philadelphia*. Cambridge: Harvard University Press, 1986.

Wright, Louis B. "Franklin's Legacy to the Gilded Age." *Virginia Quarterly Review* 22, no. 2 (Spring 1946): 268–79.

Ziff, Larzer. *Puritanism in America: New Culture in a New World*. New York: Viking, 1973.

Index

Adams, John, 5 n.9, 19, 21, 74
 n.82
 on Franklin, 3–5, 6, 247
Adams, Samuel, 92 n.2
Agriculture, 222–26, 231
Albany Conference (1754), 15,
 202–4
Aldridge, Alfred Owen,
 on Franklin and ethics, 161
 n.38
 on Franklin and poverty, 231
 n.96
 on Franklin as a Pragmatist,
 261
 on Franklin and property, 235
 n.102
 on Franklin as a Puritan, 99
 n.20, 121 n.62
 on Franklin and rationality, 30
 n.54
 on Franklin and religion, 122
 n.64, 124, 126 n.72, 126
 n.73, 127 n.75
 on Franklin and women, 238
 n.107
 on Franklin's *Dissertation*, 101,
 106 n.33
 on Franklin's will, 116 n.55
Algebra, Moral, 142–43
Amacher, Richard E.,
 on Franklin's *Autobiography*,
 24–25
 on Franklin's *Dissertation*,
 106–7 n.34
American Philosophical Society,
 14, 18, 80–81, 87
Anderson, Douglas, 101 n.26

Anderson, Paul R., 167
Angoff, Charles, 31–33
Anti-Semitism, 237
Aristotle, vii
Armonica, 16, 73
Associates of the Late Dr. Bray,
 16, 247
Aviation, 21, 72–73

Babbitt, Irving, 144–45 n.16
Bache, Richard (son-in-law), 162
 n.41, 243 n.116
Bache, Sarah ("Sally") Franklin
 (daughter), 14, 128–29, 162
 n.41
Bacon, Francis, 43, 45 n.22, 98,
 268
Baker, Polly, 145–47
Baltzell, E. Digby,
 on Franklin, 25
 on Philadelphia, 39
Barbour, Brian M.,
 on Franklin, 31
 on Franklin's *Autobiography*, 25
Bartram, John, 80
Bates, Ernest Sutherland,
 on Deism, 114 n.49, 118 n.56
 on printers, 11 n.22
Beccaria, Giambatista, 73
Becker, Carl L.,
 on Franklin, 67, 199–200
 on metaphysics, 257 n.2
 on nature, 67 n.72
Bell, Whitfield, J.,
 on Enlightenment science,
 40–41, 87

on Franklin's ethics, 163 n.46,
 173 n.63
Larson, David M.,
 on Franklin and virtue, 144
 n.15, 150 n.25, 153 n.28,
 154 n.30
Lathrop, Joseph, 162 n.43
Lawrence, D. H., 29–31, 256
Lemay, J. A. Leo,
 on Franklin, 2–3, 25
 on science, 41–42
Levin, David,
 on Franklin's ethics, 158 n.34,
 167
Library Company of Philadelphia,
 13, 14, 79–80
Lightning, 15, 57–66. *See also*
 Electricity
Locke, John, vii, 44–45, 98, 268
 as anti-Catholic, 92 n.2
Lodge, Henry Cabot, 260 n.9
Lopez, Claude-Anne, and
 Eugenia W. Herbert, 244
 n.119
Lucas, F. L., 2

McClenahan, Howard,
 on Franklin as a Pragmatist,
 261
 on Franklin as a scientist, 38
McEwen, Gilbert D., 76 n.88
McMaster, John Bach, 135 n.2
Madison, James, 205 n.49
Manufacturing and commerce,
 224–26, 229–31
Marx, Karl, 227 n.91
Mather, Cotton,
 on doing good, 100 n.23
 on lightning, 64,
 on Native Americans, 241
 n.111
 on poverty, 233 n.99
 and Puritanism, 76–77,
 95–97, 99–100

on self-examination, 140 n.10
May, Henry F., 123 n.67
Mayhew, Jonathan, 92 n.2
Mead, George Herbert, 266
Mecom, Jane Franklin (sister), 9
 n.18, 107, 120, 123, 134
Medicine and health, 74–75
Meliorism, 86
Melville, Herman, 135 n.1
Mesmer, Friedrich Anton, 21
Metaphysics, 257–60, 264
Meyer, Donald H.,
 on Franklin and debt, 159
 n.36
 on Franklin and religion, 127
 n.74, 127 n.76, 128 n.79
 on Franklin's ethics, 139 n.9,
 145 n.17, 171 n.59, 174
 n.67
 on Franklin's political thought,
 200 n.42
Middlekauff, Robert, 210 n.56
Miles, Richard D., 22 n.40
Mill, James, vii
Miller, John C.,
 on Enlightenment science,
 42–43
 on Franklin, 45 n.24
 on Franklin's ethics, 172 n.62
 on science in America, 38 n.4,
 41
Miller, Perry,
 on Franklin and Jonathan
 Edwards, 98
 on Franklin as a representative
 American, 34, 34 n.64
 on Franklin's ethics, 164 n.49,
 167
Millikan, Robert A., 66 n.70
Mitchell, S. Weir, 12 n.24
More, Paul Elmer,
 on Franklin as a man of letters,
 33 n.59